INSIGHT GUIDES
TRAVEL
PHOTOGRAPHY

APA PUBLICATIONS **L**

Part of the Langenscheidt Publishing Group

INSIGHT GUIDE
TRAVEL PHOTOGRAPHY

Editorial

Editor
Tony Halliday
Art Editors
Richard Cooke & Ian Spick
Picture Manager
Steven Lawrence
Picture Researchers
Tom Smyth & Prudence Korda
Series Manager
Rachel Fox

Distribution

UK & Ireland
GeoCenter International Ltd
Meridian House, Churchill Way, West
Basingstoke, Hampshire RG21 6YR
sales@geoce⌐ ⌐o.uk

United States
Langenscheidt Publishers, Inc.
36–36 33rd Street 4th Floor
Long Island City, NY 11106
orders@langenscheidt.com

Australia
Universal Publishers
1 Waterloo Road
Macquarie Park, NSW 2113
sales@universalpublishers.com.au

New Zealand
Hema Maps New Zealand Ltd (HNZ)
Unit 2, 10 Cryers Road
East Tamaki, Auckland 2013
sales.hema@clear.net.nz

Worldwide
**Apa Publications GmbH & Co.
Verlag KG (Singapore branch)**
7030 Ang Mo Kio Avenue 5
08-65 Northstar @ AMK
Singapore 569880

Printing

CTPS-China

©2010 Apa Publications GmbH & Co.
Verlag KG (Singapore branch)
All Rights Reserved

First Edition 2010

CONTACTING THE EDITORS
We would appreciate it if readers
would alert us to errors or out-
dated information by writing to:
**Insight Guides, PO Box 7910,
London SE1 1WE, England.**
insight@apaguide.co.uk

www.insightguides.com

ABOUT THIS BOOK

The first Insight Guide, to Bali, pioneered the use of creative full-colour photography in travel guides in 1970. The use of strong visual images to communicate the atmosphere of a destination and the everyday life of its inhabitants have remained a hallmark of Insight Guides ever since.

Insight Guide: Travel Photography has been published to coincide with and to celebrate the 40th Anniversary of the series. The book has been designed to provide an inspirational and practical guide for all keen travelling photographers, catering to both point-and-shoot and DSLR users and providing information that even professionals will find useful. Created by experts, the lavishly illustrated guide is built around the concept of exploring various aspects of technique and giving plenty of examples. It contains the following sections:

◆ The **Past and Present** section, indicated by a pink bar at the top of each page, explores the history of travel photography and looks at the genre in the digital age and the importance of "telling the story".
◆ The **Big Picture** section, indicated by a blue bar, looks at the key elements of Light and Composition, before describing the Camera itself.
◆ The main **Journey** section, with a green bar, provides the practical application for the technical material described in the Big Picture, covering eight main areas of travel photography including Landscapes, People and the Built Environment.
◆ A **Destination Calendar**, with tips on where to go month by month.
◆ The **At Home** section, with a yellow bar, looks at preparations before you go and what happens before you get back: organising, processing, sharing and selling.

tional magazines, as well as a large number of illustrated photographic books. Here, as well as some lovely images, he provided his expertise as consultant, on the extensive technical chapters covering Light and The Camera, the entire At Home section, as well as the chapters on Landscapes, Elements & Skyscapes, Transport and Details.

Chris Bradley has been taking photographs professionally for over 30 years. He writes and presents Travel Photography seminars, and has worked as a writer and photographer on a variety of Insight Guide projects. For this book he provided the chapters on Composition and the Built Environment.

Chris Stowers is a photographer who has travelled and worked in over 60 countries, his work appearing in major newspapers and weekly magazines. His guidebooks cover destinations as diverse as San Diego and Saigon, and for this book he penned the chapter on People photography.

Andy Belcher is an award-winning photographer known for his innovative techniques for capturing underwater, extreme sports and adventure images. He wrote the Active Pursuits chapter.

Ariadne van Zandbergen is a leading wildlife photographer based in South Africa. She wrote the Wildlife chapter, which includes her experiences photographing a leopard.

All the contributors have images in the book, as do other seasoned photographers, notably **Sylvaine Poitau, Yadid Levy, Martyn Goddard, Abe Nowitz, Richard Nowitz, Peter Stuckings, Kevin Cummins, Corrie Wingate, Anna Mockford and Nick Bonetti, Glyn Genin, Britta Jaschinski** and **Gregory Wrona.**

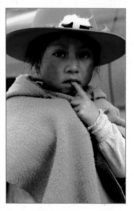

The contributors

This book was commissioned and edited by **Tony Halliday**, a senior editor at Insight Guides' London office, and a keen photographer himself. In developing the concept and pulling all the strands of the project together, he was assisted by **Roger Williams**, a long-standing guide book editor and author who has been involved in numerous Insight Guides. His written contributions here include the Past and Present section, the feature on The Family of Man, and the Destination Calendar.

Michael Freeman is an acclaimed photographer and author, who has produced more than 100 books, including a number of well-respected volumes on the practice of photography. A leading photographer for the *Smithsonian Magazine* for three decades, Freeman's work has been widely published in major interna-

ABOVE: Histogram on an LCD screen; turquoise waters off the Yucatán, Mexico; Guatemalan girl.

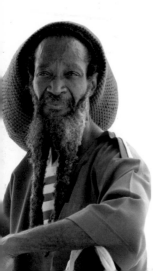

Contents

LEFT: Monument Valley, Utah.
RIGHT: Photography pioneer William Henry Fox Talbot.

Reference ▷
Our instant reference system helps you navigate the book, between technical and practical topics.

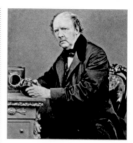

The Journey (cont'd)

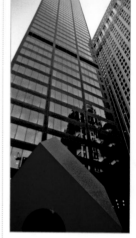

Destination Calendar

Features

Picture Stories

At Home

ABOVE: Gleaming facade in New York.
BELOW: Planting rice seedlings in Vietnam

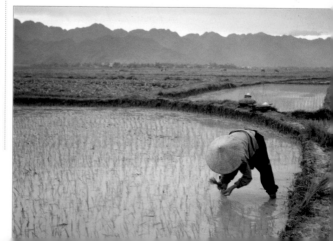

TRAVEL PHOTOGRAPHY:
TEN USEFUL TIPS

From light to composition to the workings of the camera, and on to the journey itself, this book shows you how to shoot the perfect picture. Here are some samples from the topics covered

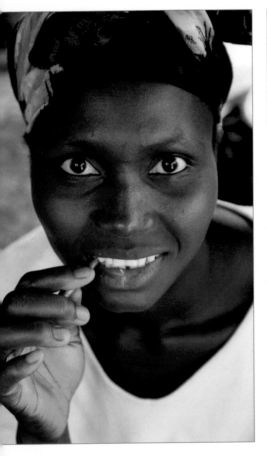

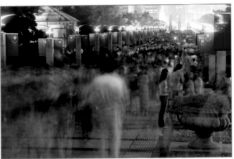

△ When photographing crowds of people it is important to retain a centre of interest. This can be aided by isolating a single figure or group of figures, something that can be achieved by a shallow depth of field or by motion blur. *See page 213*

△ Lighting is important in all portraiture. The best-lit shots are achieved with side-lighting as this emphasises depth and character in the face. The objective is to add just a little light and a glint to the eye; always focus on the eyes as they are the "Window to the Soul".*See page 209*

▷ Look out for details, whether of the everyday variety such as fish at a market, or artistic, such as tiles and calligraphy. Details help to give a sense of place and they are an important part of telling the story. *See page 241*

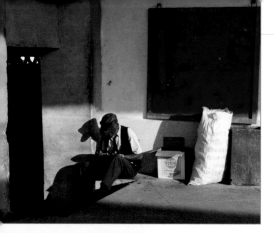

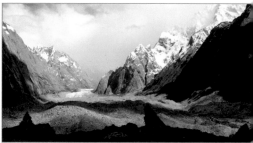

△ When taking pictures of mountains, try to find a viewpoint that conveys a sense of scale and depth, for example by having objects in the foreground. *See page 139*

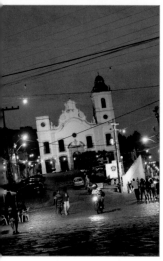

△ The best time to take pictures is in the so-called "sweet light" of the late afternoon or early morning. The warm, raking light brings out the colours, and shadows are important because they enhance texture and bring contrast of tone. *See page 57*

▷ Every photographer needs to think about composition, and varying the shooting angle is just one way of making a picture, like the one of the market traders, more interesting. Tall buildings are usually shot from below, but focus on the shapes and textures of facades to give a strong, graphic result. *See pages 222 and 183*

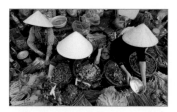

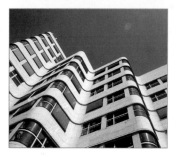

△ Dusk, when there is still some natural light as well as artificial lighting, is a good time to photograph cities. A hint of blue in the sky will communicate the night-time feel much better than when the sky is black. *See pages 153–4*

▽ When taking pictures of details such as statues, try where you can to hint at the location as well, letting the surrounding landscape be part of the picture. *See page 91*

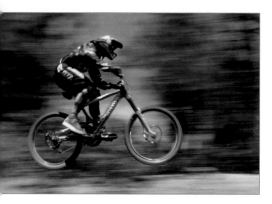

△ For action shots, blurring the background can be achieved by moving the camera at the same speed as the subject while taking the picture (panning). *See page 269*

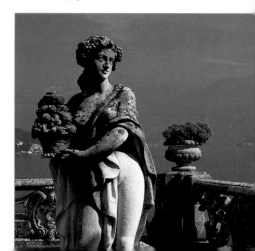

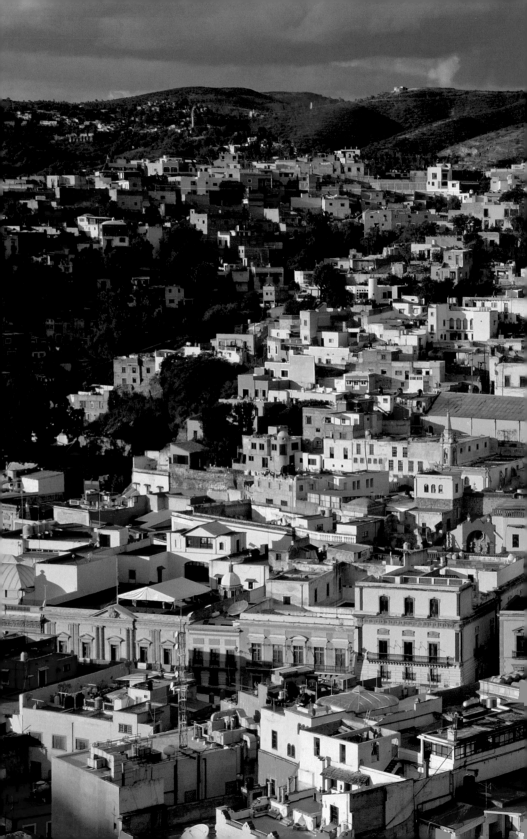

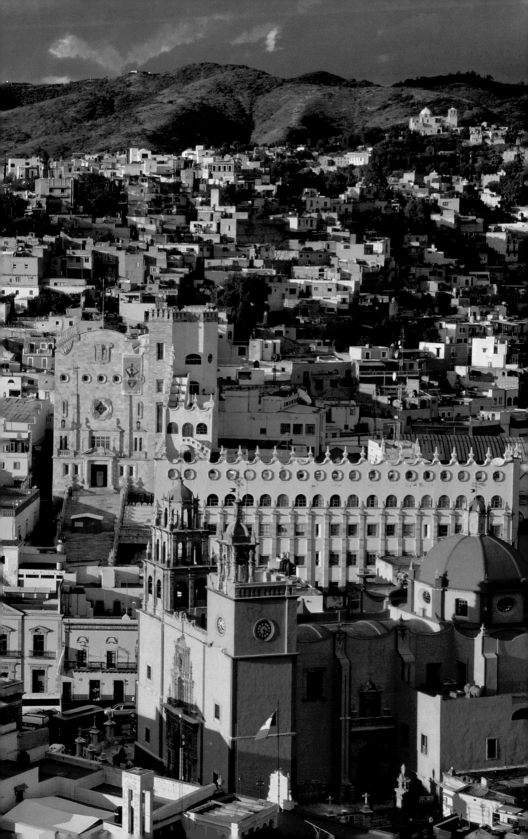

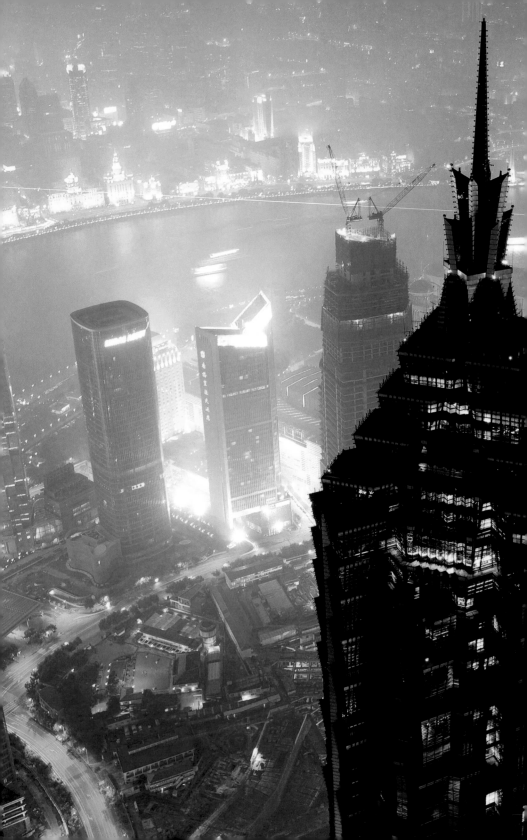

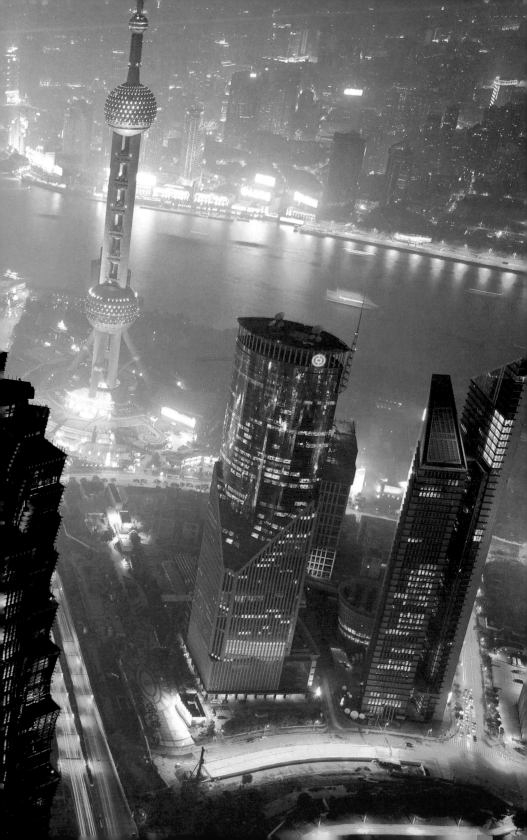

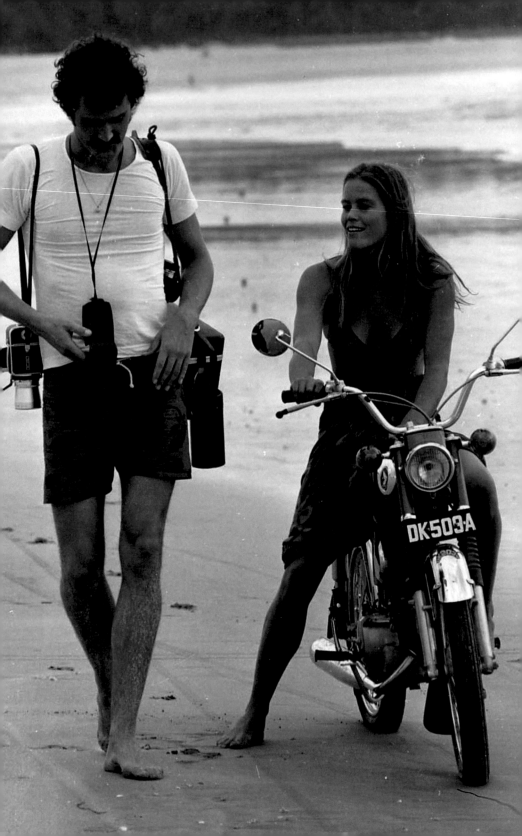

IN THE BEGINNING

**Brian Bell, a former editorial director of
Insight Guides, explains how Hans Hoefer, the
founder of the series, made a major impact
on the world of travel photography**

In April 1967, Hans Johannes Hoefer, a 23-year-old German graphic designer, set off in a Volkswagen bus with two friends from his home in Krefeld, near the Rhine. Their destination: Asia. Political turmoil has made this "hippie trail", via Turkey, Syria, Iraq and the Silk Road, almost impassable today, but in the 1960s, before the jumbo jet inaugurated the era of mass tourism, it was a cheap and enticing way for young people to explore different cultures. For Hoefer, it would be a one-way trip: Asia would become his new home, from which he would transform the staid style of travel publishing.

His trek ended in Bali, where he earned a living by selling his paintings of the little-known Indonesian island to tourists. But he was frustrated by the lack of easily available information on Bali's colourful culture and people. Where did their beliefs originate? How did their vivid paintings and expressive wood carvings develop?

The first Insight Guide

Hoefer searched for a guidebook that would explain the island's history and culture as well as describe its tourist sites. It would give an insight into its people's values and politics. It would use strong visual images to communicate directly the atmosphere of the destination and the everyday life of its inhabitants. And it would encourage readers to celebrate the essence of the place rather than fashion it to suit their preconceptions. He couldn't

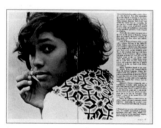

find such a book, so, drawing on his knowledge of photography, printing and graphic design, he set out to create one. The result was *Insight Guide: Bali*, published in 1970.

It wasn't an easy birth. Full-colour printing was an expensive luxury, and so most travel guides were severely utilitarian. Text-heavy cultural guides con-

PRECEDING PAGES: Guanajuato in the Central Highlands of Mexico, perfectly lit in the evening; Shanghai by night from the Shanghai World Financial Center; resident of Rufisque in Senegal. **LEFT:** Hans Hoefer on the beach in Bali. **ABOVE:** An early scheme for an Insight Guide layout and a finished page.

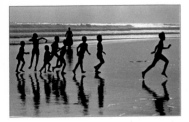

centrated on history and architecture, illustrated with a few timeless black-and-white pen drawings, while disposable self-help manuals focused on cheap transportation, hotels and restaurants. What Hoefer had in mind was very different: to distil the photographic lavishness of a coffee-table book into the portable format of a paperback. But there was a major stumbling block: he was almost penniless.

A saviour appeared in the form of the German manager of the InterContinental-owned Bali Beach Hotel, the island's first five-star hotel. Hoefer, never lacking in charisma or self-confidence, persuaded him, against the advice of his financial controller, that publishing the book would benefit Bali's nascent tourism industry in general and the hotel's reputation in particular. He got his funding, including free board while he photographed and designed the book, whose picture shapes deliberately echoed the 35mm and medium-format dimensions of photographic film.

Insight Guide: Bali won an award from America's influential *Popular Photography* magazine and a gold medal from the American Society of Travel Agents. It was the outstanding photography that caught the eye, capturing not only the island's vibrant scenery but also the everyday life of its people. The book's photojournalistic style was paired with sharp, magazine-style text to create what Hoefer called a "bookazine".

Winning formula

Over the next 10 years, he applied the same formula to other destinations in the region, such as Malaysia, Singapore, Thailand and Nepal, laying the foundations for a series that would eventually extend to more than 200 titles. Achieving good colour reproduction was a challenge in those pre-digital days when transparencies had to be colour-separated manually, and Hoefer used his printing knowledge to demand high standards. "I would come to the printing press at midnight if necessary to solve any problems," he says. "Many of the print supervisors in Singapore, which became my base, had been trained in Heidelberg and allowed me to work with them as a kind of apprentice."

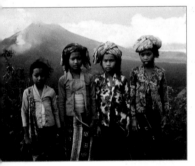

A more vexing challenge came from booksellers, most of whom would not stock the books. "They said they were too expensive," Hoefer remembers. "In their mindset, a travel guide was nothing more than a tool, it didn't need colour, and it shouldn't cost more than US$5. It took me 10 years to change that mindset."

Throughout the 1970s the books sold mainly through hotels and tourist shops. The breakthrough came when Simon & Schuster in New York took the series, followed in Germany by GeoCenter, a subsidiary of the Bertelsmann conglomerate. By this time, wide-bodied aircraft had opened up affordable long-haul travel to the mass market, and people had grown accustomed to high-quality full-colour photography in magazines.

Pictures with impact

Discerning travellers visiting an exotic destination for the first time needed basic travel information, to be sure, but they also wanted to know what made it tick: its history, culture, religion, politics, everyday life. Insight Guides' candid reporting of these topics led to some titles being banned by certain regimes – not a fate suffered by traditional travel guides. But it was the quality of the photography that really drove sales. "We weren't just showing what a country was like," says Hoefer, "we were conveying the emotion of travel, capturing the 'feel' of a destination."

Classic travel images made a powerful impact as two-page spreads: the camel market at Pushkar, the carnival at Rio de Janeiro, sunset over the Blue Ridge Mountains in North Carolina, Oxford's dreaming spires seen from Boar's Hill. But what made the Insight approach distinctive was the quality and originality of its portraits of local people living their lives.

Some essential shots were needed, of course, to avoid disappointing readers' expectations: outlandish folkloric costumes, peasants working in the rice paddies of Sichuan, a sheep shearer in Australia's Outback, a Japanese geisha. But turn the page and the unexpected would jolt you: a leather-clad Shanghai rock musician, a Sikh bus driver in Sydney, a touching shot of a doting father baiting his young daughter's fishing rod in Tokyo Bay. A bikini-clad beauty on Miami Beach would be paired with a shapely gun-toting female security guard at Coral Gables. Toll-booth workers on a Bangkok expressway, yuppies in a Lima bar, cod liver oil testers in Iceland… such photographs diluted the stereotyped images in travellers' minds and arrestingly told the workaday truths of a destination that lie behind tourism's facade. They revealed a common humanity.

The series has showcased the work of leading photographers such as Catherine Karnow, Richard Nowitz, Bill Wassman, Bob Krist and Tony Arruza. More recently it has helped young photographers kickstart their careers by running an annual travel photography competition in conjunction with a British national newspaper. The prize: a commission from Insight.

As the books were translated into more than a dozen languages, imitators sprang up, and it was not unknown for a rival travel publisher to brief its photographers by handing them an Insight Guide and telling them those were the kind of images it wanted. Hans Hoefer would have offered a more succinct approach: "There is no such thing as a travel photographer – there is only a good photographer who happens to travel." ❏

LEFT AND ABOVE: A selection of pictures from early Insight Guides, and sketching the mood by Hans Hoefer. **FOLLOWING PAGE:** Well-heeled travellers to Egypt, c.1860.

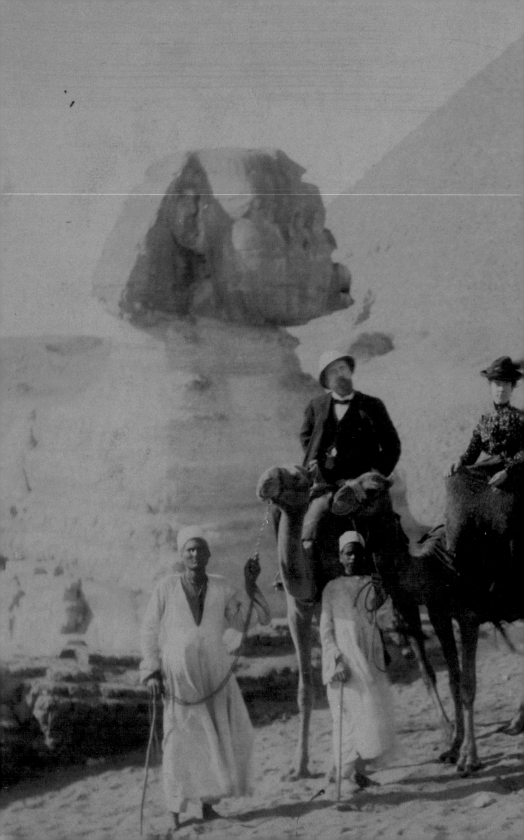

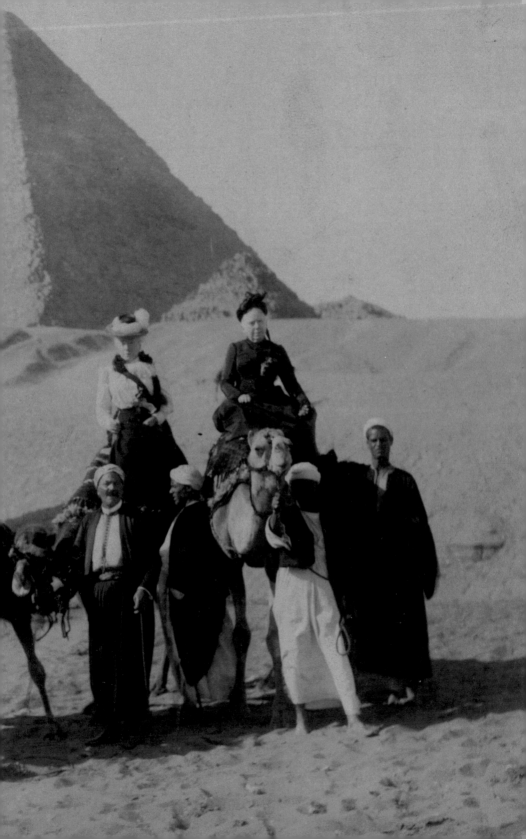

DECISIVE DATES

5th century BC
Chinese philosopher MoTi records image transfer through a pinhole into a "treasure collecting room".

16th century
Leonardo da Vinci describes *camera obscura*, which is in regular use by European artists.

1822
First photograph, made by Nicéphone Niépce after eight-hour exposure.

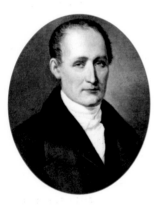

1839
Photography begins with the Daguerreotype of Louis Daguerre and Henry Fox Talbot's calotype.

1841
The first book of travel views is published in Paris. Thomas Cook organises his first tour, a short train trip in England for temperance campaigners.

1849
Maxime du Camp travels to Egypt and produces Le Nil, Egypte et Nubie, a book of 220 calotypes.

1851
First international photography show at The Great Exhibition in London's Hyde Park. Yosemite Valley, California, encountered by non-native Americans.
Wet plate collodion process invented, drastically reducing exposure times.

1861
Physician James Maxwell discovers colour photos can be made using red, green and blue (RGB) filters.

1868
John Thompson appointed photographic instructor to travellers for the Royal Geographic Society, founded 15 years earlier.

1869
Transcontinental railway across the US completed. William Henry Jackson begins 10-year project photographing America.

1879
Karl Klíc perfects photogravure process to print high quality photographs, used to great effect by Norfolk photo pioneer Peter Henry Emerson.

1888
Kodak No.1, the first mass produced hand-held camera, is produced by George Eastman, who has invented celluloid roll film.

1900
Gombojab Tsybikov and Kalmyk Ovshe Norzunov take 200 pictures of Forbidden City of Lhasa. Kodak Box Brownie, costing $1, introduced. Diaphram aperture system ("f stops" $f1$ to $f64$) established at Paris congress.

1903
Autochrfme, the first successful colour film, introduced by the Lumière brothers.

1909
35mm recognised as the international standard for film.

1910–13
Scott in the Antarctic: Herbert Ponting takes memorable images as expedition photographer.

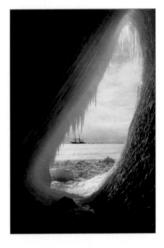

1924
Leica produces first compact camera with 35mm film.

1934
Photographic Society of America founded.

1936
Kodachrome colour reversal film becomes available. *Life* magazine launched.

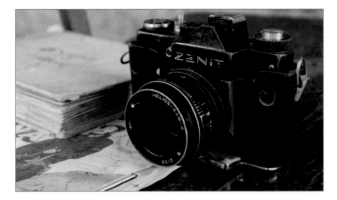

1937
Sport, the first single lens reflex camera, is produced in the Soviet Union.

1941
Ansel Adams and Fred Archer establish the "zone system" for perfect prints.

1947
Magnum photo agency set up by Robert Capa, Henri Cartier-Bresson and others. Edwin Land introduces the Polaroid camera.

1948
Nikon optical company markets its first camera.

1952
Jacques Cousteau perfects the underwater camera.

1953
Pictures of Edmund Hillary conquering Mount Everest are sent around the world.

1955
First World Press Photo awards, in Amsterdam.

1959
"System cameras" arrive; now different lenses can be attached to a body.

1962
National Geographic's first all-colour issue. Newspaper colour supplements launched.

1964
Wildlife Photographer of the Year competition started by BBC and Natural History Museum in London.

1969
First pictures of the moon, from Apollo 11.

1970
The first Insight Guide, to Bali, is published. Boeing 747 "Jumbo Jet" comes into service for long-haul flights.

1972
Texas Instruments patents a film-less electronic camera.

1976
Geo magazine launched in Germany. Today it is published in 15 different languages.

1978
The first Gap Year Expedition, Operation Drake, sails around the world. Konica markets a point-and-shoot autofocus camera.

1985
Camcorders, using VHS tapes and carried on the shoulder.

1988
JPEG and MPEG file compression methods are made standard.

1990
Adobe Photoshop released.

1991
First camera phone, in Japan.

1994
Digital cameras can now be linked to computers.

1999
Nikon D1 is first digital SLR.

2003
Tapeless videos produced by Sony.

2009
Kodachrome withdrawn. First DSLRs with video.

2010
Getty photo agency teams up with Flickr's 4 billion users to create mega picture library.

FAR LEFT: Louis Daguerre, inventor of the Daguerreotype. NEAR LEFT: a classic Herbert Ponting image of Antarctica. LEFT: 1931 Kodak advertisement. ABOVE: a veteran camera.

KODAK
1931

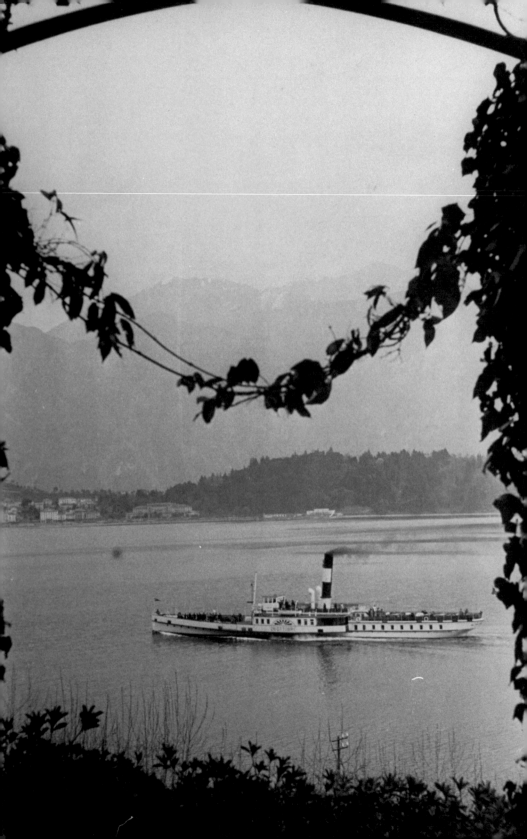

A NEW VIEW OF THE WORLD

The pioneers of travel photography were a mixed crowd of artistic scientists, dedicated archaeologists, romantic aesthetes, hardy adventurers, and fearless reporters intent on capturing new sights

The Italian Lakes have long been renowned for their tranquil beauty. Even before the days of photography, most educated Europeans had an idea of what they looked like from prints and paintings. Nevertheless, when tourists visited such scenes of delight, they wanted to capture them for themselves, to show their friends at home exactly what they had seen. A visual image was an essential souvenir; irrefutable evidence to reinforce the traveller's tales.

Henry Fox Talbot visited Lake Como in 1836. Like many men and women of his class and time, he was acquainted with the arts and had an idea of how to draw. He knew what made a good composition and could look at a view and imagine it framed. Indeed it was the Romantics of the previous century who had encouraged the first tourists in the Lake District to bring picture frames with them to hold up to view the scenery: this was the best way to appreciate the "picturesque".

Although Fox Talbot knew how to draw, the truth was that he was not very good at it. A gen-

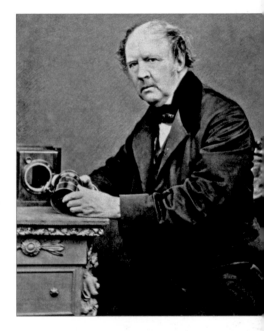

Lacock Abbey near Chippenham in Wiltshire, UK, the former home of William Henry Fox Talbot (1800–77), is now run by the National Trust, with a museum dedicated to "the Father of Photography".

tleman mathematician and scientist, he had an interest in optics, and to help him create his illustrated souvenirs, he had packed in his luggage a *camera lucida*, a recently developed mech-

LEFT: Lake Como, a century after Fox Talbot's visit.
RIGHT: William Henry Fox Talbot at home.

anism that was more portable than the artist's other drawing aid, the *camera obscura*.

The *camera obscura*, or "dark room", was simply a box of some sort with a tiny hole in one side through which light shone, converting the scene before it into an inverted image on the opposite side of the box. The device had been known for as long as anybody cared to remember. When European painting progressed beyond icons, the *camera obscura* proved a handy way of capturing scenes and tableaux, and by the 16th century it was to be found in the studio. Artists would set up their boxes and trace the image that was conveyed through the small hole. There was no other way of fixing that image.

The *camera lucida* was given its contrasting name of "light room" by a Norfolk-born scientist, William Hyde Wollaston, in 1807. Hardly worth its patent, it consisted simply of a stand in which a mirror, set at 45 degrees, would reflect the image in front of it down on to a surface on which one could draw. Far less bulky than a *camera obscura*, it proved useful for field work. During the 1830s, for example, Captain Edward Taynton of the Indian Army produced a series of watercolours of Madras using a *camera lucida* to ensure absolute accuracy of his subject: such visual surveys have always been vital to intelligence, which is why scene-sketching

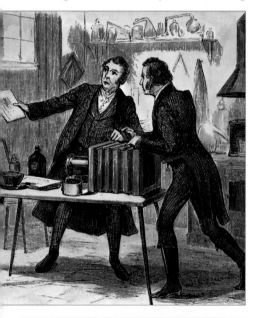

travellers, like later photographers, were often viewed with great suspicion, and on occasion even beaten up or thrown into jail.

Taynton's paintings are hyper-real, almost photographic. Fox Talbot's were not. Frustrated by his failed attempts to capture the beauty of Lake Como, the 36-year-old scientist, only child of William Davenport Talbot and Lady Elisabeth Fox Strangways, returned to the family pile of Laycock Abbey in Wiltshire. There he put all his energy and not an inconsiderable amount of money into trying to find ways of fixing images produced by the *camera obscura*. In this he succeeded, creating paper-based negatives from which multiple prints could be made. He called his process Calotype, a Greek name meaning "beautiful image". But it was not until another pioneer showed his first photographs in Paris, in 1839, that he rushed to publish his own method.

Daguerreotypes

Until it burned down, the popular Paris Diorama had been run by an inventive stage illusionist and showman, Louis Jacques Mandé Daguerre. This theatrical spectacle showed vistas painted on translucent canvases, mostly of European cities and scenes, with added special effects such as moving clouds and drifting fog. Daguerreotypes were made on copper plates coated with silver and sensitised with an iodine solution. Development required mercury vapour and, because the image could easily be rubbed off, it was immediately restrained in a glass mount, and could not be duplicated.

In spite of the complexity of making a Daguerreotype, and the fact that the image it produced was "flipped" from left to right, it was evidently a miraculous device, and immediately after the French Academy's announcement, "Daguerreomania" swept the streets of Paris. People queued at Giroux, the art suppliers selling the magic Daguerre boxes, which were eagerly taken to capture the familiar sights of the city and snap family and friends – though "snap" is not quite the right word for the many minutes' exposure time needed.

The Academy immediately ordered every monument in France to be photographed. As Daguerre's Diorama had shown, there was a huge public appetite to see what foreign places looked like, and the magic box soon set out to record the known world. In 1841, just two years after these two inventions, the first book of

travel photographs appeared. *Excursions daguer-riennes, representant les vues et les monuments les plus remarquable du globe* published by Noel Marie Paymal Lerebours in Paris, reproduced

> 66 *I have seized the light. I have arrested flight.*
> Louis Jacques Mande Daguerre 99

etchings based on Daguerreotypes, with views of Europe, the Middle East, Russia and America.

The invention of photography coincided with the coming of the steam age, and the new

again, with European industrialists and American businessmen and their wives joining the ranks of the grand tourists. It was to these same destinations that photographers first headed, just as their ideas of what to photograph had arrived fully formed from the artists who had preceded them: the Swiss Alps, the classical monuments of Italy and Greece, the splendour of Egypt, the biblical locations of the Holy Land.

Cumbersome equipment

Journeying was not easy for the photographer, whose equipment was a chemical factory of boxes, tripods, lens, dark-room tents, glass or

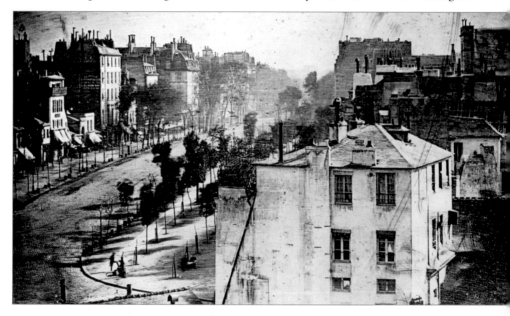

railways and now reliable ships added a considerable convenience to the travel photographer. The same year that *Excursions daguerriennes* was published, Thomas Cook started the world's first travel company with a brief railway excursion between Leicester to Loughborough. It was the start of a decade of booming travel.

Destinations were much as they had been for the Grand Tourists in the 18th century. Interrupted by the Napoleonic Wars, they now began

LEFT: Louis Daguerre discovering the Daguerreotype process. **ABOVE:** Rue du Temple, 1838, by Daguerre. The 10-minute exposure eliminated any sign of traffic. The static man having his shoes shined is perhaps the first person to be photographed in the street.

copper plates and other paraphernalia. Though photographic methods would gradually become more refined, for more than a generation they remained complicated and risky. The metal Daguerreotype was evolving into "wet plate" methods, using glass – though some travel photographers continued to use the more easily transportable calotypes, despite the inferior quality of the original paper-based negatives.

Until "dry plates" were invented, the glass had to be primed with emulsion immediately before exposure and developed straight afterwards. Plates had to be the same size as the intended print, as nothing could as yet be enlarged. They were fragile, of course, silver nitrate dripped, mercury fumes vital to Daguerreotypes were

poisonous and guncotton used in later collodion prints was explosive, with sometimes fatal results. Temperatures and conditions for the chemicals were all-important, and travelling photographers frequently had to improvise, using whatever was at hand – honey, beer, sugar, coffee and tobacco were on occasion added to the chemical mix. Also, the water for washing the plates had to be free of all impurities.

Archaeological tours

Of the many disciplines that could at once see the enormous benefits of photography, one of the first was archaeology, recording ancient sites

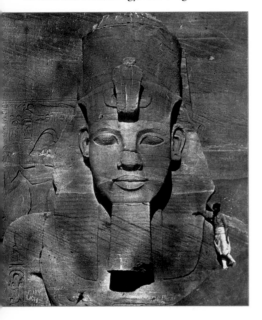

before they were plundered – and sometimes while they were being plundered. Napoleon's incursions in Egypt a generation earlier had produced a real hunger to know more about the country that had been almost lost to view since classical times. Just a few months after Daguerre's discovery, cameras were being set up in front of the Sphynx on behalf of the French Academy, to continue the research that the scholars of Napoleon's army had begun. Orientalism was in the air: Delacroix and Ingres had been painting romantic scenes, and photographers followed suit.

Gustav Flaubert wrote of his exotic – and erotic – adventures in 1849 with Maxime du Camp, travelling through the Ottoman empire from Egypt to Palestine, Syria and Turkey. Du Camp was a writer and journalist who had taken up photography because he was fed up with "wasting valuable time" while abroad try-

> Fratelli Alinari in Florence, founded in 1852, claims to be the world's oldest photo agency. It also claims to be the only photograhic company still regularly making calotypes, many of them from drawings of well-known artists.

ing to draw buildings and scenery so that he wouldn't forget them. But, he said, "Learning photography is an easy matter. Transporting the equipment by mule, camel or human porters is a serious problem."

Du Camp's book of 220 calotypes, *Le Nil, Egypte et Nubie*, came out in 1851, at the end of travel photography's first decade, which was also celebrated at the first world's fair, the Great Exhibition in London's Hyde Park. In just a few months, some six million people came to see arts and industry from around the world, which included the first-ever large scale exhibition of photographs, showing techniques and inventions and explaining what words such as "photography" meant.

Stereoscopic souvenirs

The exhibition was also the launch pad for stereoscopic pictures, which had been developing long before the start of photography. Binocular vision, putting similar images side by side to create a 3D effect, had been toyed with since the 17th century, but after Jules Dubosq presented Queen Victoria with his stereoscopic daguerreotypes at the Great Exhibition, they caught on like wildfire. The London Stereoscopic Company soon had more than 100,000 views in its catalogue, and many of the early travel photographers took stereoscopic pictures to help pay for their adventures.

Another visitor to the Great Exhibition was Roger Fenton, son of the MP for Rochdale, who had formed The Calotype Club in 1847, the first of many popular camera clubs, which was to become the Royal Photographic Society. He had been studying art in Paris under Paul Delaroche, but after visiting Hyde Park he devoted himself to photographs, taking stereoscopic calotypes, as well as single photographs, on his trip to Russia the following year.

These brought him acclaim in Britain, though today he is remembered for photographing the Crimean War in 1853.

At this stage lengthy exposure times meant that movement was still difficult to photograph. Travelling with an assistant in a converted vintner's wagon as a makeshift home and darkroom, Fenton had no easy time. By midday it was so hot that he could barely touch his chemicals, flies pestered his plates, he contracted cholera and lost friends on the battlefield. He also complained that the only way he could get army help was to photograph the officers in a flattering light. Fenton was followed into the Crimea

Another English photographer, Francis Frith, who travelled to Egypt Palestine and Syria, had an eye for composition, for showing scale to capture the colossal magnificence of his subjects, and was inspirational, and the immaculate prints remain perfect records of the times. A Quaker and self-confessed romantic, Frith admitted that he had followed "a siren call of a romantic and perfect past".

Alpine views

The classic resorts of Europe remained tourist targets. In 1861, with the help of 25 porters, Auguste Bisson managed to reach the top of Mont Blanc

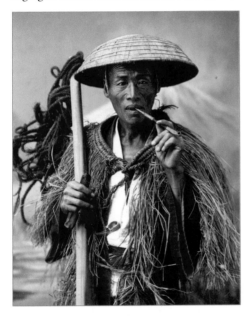

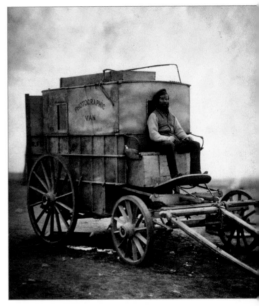

conflict by the Italian-born naturalised Briton Felice Beato. Beato was a great and energetic practitioner, working with his brother and setting up studios wherever he went. He took pictures of Tokugawa shogunate in the last days of the Edo period in Japan, where he spent many years, and in 1871, as official photographer on a US mission, took the first pictures of Korea. In Japan, he employed hand tinters to colour his photographs, a great art in itself where brushes may have consisted of one single hair.

LEFT: Colossus from the tomb of Ramses II at Abu Simbel, calotype by Maxime de Camp, 1850.
ABOVE LEFT: A tinted portrait by Felice Beato.
ABOVE RIGHT: Roger Fenton's wagon.

where he sensitised, exposed, developed, fixed and washed three plates measuring a colossal 44x54cm, for which a giant of a man with huge hands had specially been hired. Two years later Thomas Cook brought his first party of tourists to the Swiss Alps. By this time many would have seen the first photographs of the dramatic mountains taken by Vittorio Sella (1859–1943), who pieced together a dozen pictures to make an impressive 360-degree panorama from the top of the Matterhorn, a truly splendid sight.

If travel was becoming easier, it was also getting easier to spread travellers' tales. Populations were growing increasingly literate, and in the decade after the Great Exhibition a relaxation on taxes created 200 newspapers almost

overnight, while in the US the number of daily papers had quadrupled in just three decades. People in the industrialised world were becoming eager armchair travellers.

Following the empires

Dream horizons now went well beyond the Grand Tour. As the Great Powers increased their influence around the globe, more and more places were becoming destinations of wonderment and adventure, and those who could afford it sought an escape from the grimness of the burgeoning industrial cities. Britain was establishing itself in India and the East,

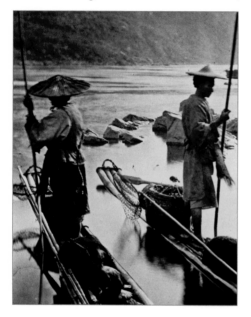

and opening up Australasia; all the European powers were in a dash for Africa where Dr Livingston was beginning his mission; Commodore Matthew Perry and the US fleet had just opened the doors of Japan to the world. And of course European settlers in America were heading West – Easterners couldn't get enough of those pioneering images and tales.

One of these first Far East photographer-adventurers was a Scottish chemistry graduate, John Thompson, who travelled extensively in China, reaching the upper Yangtze. He was generally greeted with kindness and hospitality, but his camera was regarded with suspicion, and he was "stoned and roughly handled on more than one occasion". Aggression in the cities was

> In 1851 the East India company recommended "Gentlemen cadets" to take courses in photography before going to India.

unsurprising, he said, since anti-foreign propaganda claimed that foreigners needed the eyes of Chinese children to make their photographs. People fell on their knees in front of him begging him not to take their likeness with his "fatal lens". As a harbinger of death, he found it hard to locate children to photograph, but the elderly would often be brought along by relatives for a portrait, and "for a trifling sum that would pay for a comfortable coffin" he would have a sitter who would be grateful to his or her relations for ensuring such a pleasant ending to their lives.

In 1868 his large format four-volume book on China was published. Its 100 "plates" were printed in the newly patented "Woodbury process", which produced grain-free images of startling clarity that still look beautiful today. These are not just pictures of monuments: they are of people, streets, trades, traditions and landscape, even public executions, all perfectly composed and carefully chosen to explain some aspect of Chinese life. Thompson's highly informative accompanying text describes the things he witnessed and experienced. This has led him to be called the founder of photo-reportage. But equally, *Illustrations of China and its People* can be seen as the first real photo travel guide.

"All travellers should take full advantage of photography's wonderful possibilities," he wrote in the forward to the volumes. In 1886 he was appointed Instructor of Photography at the Royal Geographical Society in London, after which "the leading explorers sought my instruction to enable them to secure excellent photographic records of their routes."

India and the Raj

Travellers' tales and news of what was happening abroad filled the pages of papers and periodicals, and in Britain especial interest was focused on the Raj. In the roll-call of known 19th-century photographers, the largest number of them were working in India, which perhaps is no surprise. Stunning landscapes, magical palaces and monuments, combined with the protection of the occupying East India men, who wanted their photos

taken for their loved ones back home, made this a photographer's honeypot. Photography clubs and competitions soon became regular events on the sub-continent, and in 1856 William Johnson and William Henderson produced the monthly *Indian Amateurs' Photographic Album*, with albumen prints stuck into its pages.

The more adventurous photographers travelled north, into the cauldron that Rudyard Kipling called "The Great Game", the jousting for position between Britain and Russia in the extraordinary landscapes of Afghanistan, Pakistan and Central Asia. In this, John Burke and William Baker were pioneers, covering the

were 1,000 photographic plates that had been strapped to the camels.

At around the same time, on the eve of its invasion by the British under the adventurous Francis Younghusband, two Russian explorers, Gombojab Tsybikov and Kalmyk Ovshe Norzunov had managed to take the first photos of the "forbidden city" of Lhasa. On returning to Moscow they shared their discovery, sending pictures to Washington's National Geographical Society. The Society's magazine, which had been going since 1888, was edited by Gilbert H. Grosvenor. Approaching the deadline for the January 1905 issue, he

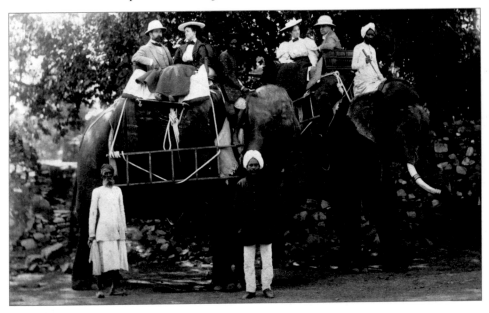

Afghan Wars and travelling extensively through the harsh mountains and deserts of central Asia.

The Great Game also precipitated a race to discover the lost cities of the Silk Road that led all the way from Europe to China. Maddest among the madmen who pitted themselves against nature's savagery on this route was a Swede, Sven Hedin. Hedin's first expedition in 1895 took him into the Taklamakan Desert where, after two weeks, only Hedin and his servant, Kasim, had survived. Others of his party, and all but one of his camels, were lost, as

LEFT: Chinese fishermen using cormorants to catch fish, by pioneering photographer-explorer John Thompson. **ABOVE:** American tourists in India, 1885.

still had a dozen pages to fill, with nothing to put in them. When he walked into his office "a large and rather bulky envelope lay on my desk. I opened the package listlessly… then stared with mounting excitement at the enclosure that tumbled out. Before me lay some 50 beautiful photographs of the mysterious city of Lhasa in Tibet." These were the first travel photographs to be published in what was to become the most influential photographic magazine of the 20th century.

The American West

Photographers in America were in the vanguard of the opening up of the West. One of the first was Solomon Nunes Carvalho, who

Capturing the Soul

Persuading people to look into the camera was no easy business, but it was one way of conjuring the spirit of a place

The belief that taking a person's photograph somehow captures their soul or reduces their physicality has always been part of the medium's mystique. In *The Golden Bough* (1922), the anthropologist James Fraser writes of photographs

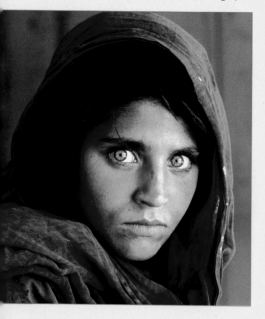

being seen as sympathetic magic, like voodoo dolls, which would capture a person's soul.

He cites incidents from Mexico to the Yukon, Thailand to Madagascar, where the 19th-century explorer Louis Catat, caught snapping souls, was obliged to "catch them, put them in a basket and return them to the owner" in compliance with the custom of the country. In the western parts of Scotland, Frazer reported, people thought having their picture taken was unlucky, saying that acquaintances had never enjoyed a day's good health after being photographed.

Even the most sophisticated people were at first sceptical. Honoré de Balzac told the famous French portrait photographer Nadar (Gaspard-Félix Tournachon) that he believed each photograph resulted in

the transfer to the picture of a "ghostly layers" of skin that was the essence of life.

Early photography came from ideals of Western painting, a European way of seeing. Not everyone looked at portraits in the same way. In Hong Kong in 1872, John Thompson, whose camera had so alarmed the Chinese (see page 28) was told by the local photographer A. Hung, "You foreigners always wish to be taken off the straight or perpendicular. It is not so with men of taste; they must look straight at the camera so as to show their friends at a distance that they have two eyes and ears. They won't have shadows about their faces because, you see, shadow forms no part of the face. It isn't one's nose or any other feature therefore it should not be there. The camera, you see, is defective. It won't recognise those laws of art."

However they were pictured, photographs of "native types" were highly collectable, and a source of revenue for early travel photographers who set up temporary studios abroad. These would be collected by enthusiasts to sit alongside pictures of local scenes in the first photo albums. And just as photography recorded monuments and ancient sites on the brink of destruction, so photographers captured dying races–the last of the Tasmanian aborigines, taken by Charles Woolley, for instance, and the subjects of Edward S. Curtis's 30-year project to photograph every Native American tribe.

Throughout much of the 20th century, peoples were so distinct in their dress and looks that a photograph of a "local" was on every travel photographer's souvenir list. By 1970, national dress was had been absorbed into general Western clothing throughout much of the world, but Insight Guides was still able to launch its main series with a portrait on the cover of each title that could show at a glance what part of the world you were in.

Fifteen years later Steve McCurry's "The Girl with the Green Eyes" appeared on the cover of *National Geographic* magazine and became its most iconic image. The girl, Sharbat Gula, had been one of many in an Afghan refugee camp. "If you wait," the American photographer said, "people will forget your camera and their soul will drift up into view."

Today there are few places in the world where the way somebody dresses and looks defines their origin. But we still want to look on a face that might contain the soul of a country – and hope that we can steal a little of it for ourselves. ❏

LEFT: Steve McCurry's "Girl With the Green Eyes", *National Geographic's* enduring 1985 cover image.

accompanied John Fremont on his fourth and final expedition to find a central route for the railroads across America. Artists' impression of the terrain had proved unreliable, and a photographic record was what was needed for the geologists and engineers. Nunes Carvalho, a trained artist, accompanied the expedition as far as the Wasatch Mountains in Utah where they survived through the winter on horsemeat and porcupine until cold and hunger brought them to a halt in the town of Parowan. Carvalho later went on to California, but fewer than two dozen of the 300 Daguerreotypes that he took on the journey survive.

these pictures and show the difficulty of taking large landscapes: either the foreground is addressed, or the distant view. Some photographers dealt with this problem by taking the view twice, once focusing on the foreground, once on the background, and then bringing the picture together in the darkroom afterwards.

Rather more successful was William Henry Jackson, a painter and photographer employed the US Geological Survey, whose first photographs of Yellowstone helped to convince Congress to turn it into a national park, just as Carleton Watkins's pictures led to Yosemite's preservation.

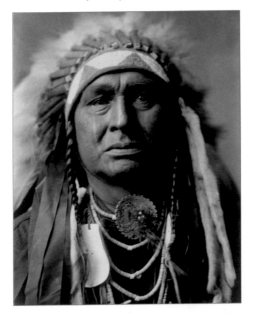

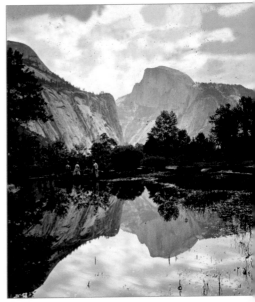

Just three years earlier, in the same year as the Great Exhibition, Yosemite had been "discovered". The Californian photographer Carleton Watkins caught the early views on a huge plate glass camera, and in stereoscope, spreading an idea of a spectacular Eden that was so much more dramatic than anything to be seen in the Old World. In 1868 the first volume of landscape photography of Yosemite was produced for the State Geological Department by J.D. Whitney, with pictures by "Mr W Harris". Distant hills and mountains are washed out in

Jackson had visited Yellowstone a year after the completion of the transcontinental railway in 1869, and was embarked on a 10-year project for Union Pacific Railway, taking 10,000 "views" of the USA. On his first assignments his portable darkroom and camera equipment, including glass plates up to 20in by 24in, were strapped on to Hypo, a mule who was "as indespensible to me as his namesake, hyposulphite of soda [*the fixing agent*]". Soon he was travelling first class in the "Jackson Special", a darkroom car drawn by a locomotive.

Nature in the raw was the theme of the age, and few captured it better than Timothy O'Sullivan, who was employed by the Geological Exploration of the Fortieth Parallel,

ABOVE LEFT: The face of a defeated people. **ABOVE RIGHT:** Mirror Lake in Yosemite Valley, with Half Dome reflected, 1870.

the first goverment survey of the West. Best known for his ealier Civil War pictures, such as *The Harvest of Death*, he spent the remainder of his life taking powerful pictures for government departments, which were used to encourage settlers. Notable among them are the Navajo pueblos of the south and some prehistoric sites.

The new century

While the adventurous were heading for the ends of the Earth, there was still much travelling to be done nearer to home, and the amateur photographer was about to be enormously

aided with the introduction of Kodak 1. George Eastman's magic box came with the celluloid film he had invented. It could take 100 pictures – at first all round in shape – and, like a modern throwaway camera, when the film was finished, you simply returned the camera for processing. "You take the pictures," the advertisement famously said, "we do the rest." Even more empowering was Eastman's Kodak Box Brownie of 1900, a handy-sized camera that sold for a dollar and took the first "snapshots" using roll film.

Subjects were no longer monumental and grand, but domestic and social. Professional

THE COMING OF COLOUR

Colour remained an expensive and secondary medium until the 1960s, a century after the discovery that colour could be built up from three monochromatic images of red, green and blue (RGB). In Russia, Sergeii Prokudin-Gorskii took pictures using a camera with three separate lenses, each with a coloured filter. The three plates were then projected simultaneously onto a screen, as a magic lantern. His pictures so impressed Tsar Nicholas II that he was given a locomotive with a darkroom carriage and from 1909 to 1915 he travelled throughout Russia taking some 6,000 photographs. He moved to the US and in 1948 the Library of Congress inherited 2,000 images, which they have been reconstructing (see www.loc.gov/exhibits/empire).

Burton Holmes, a showman in the Daguerre mould, could fill the Carnegie Hall with his travelogues of hand-painted photographs, first shown as magic lantern slides and, later, movies. For 60 years, until his death in 1952, he travelled the world in summer and lectured in winter. The *Burton Holmes Travelogues*, first published in 10 volumes in 1910, became a household name across America.

The first successful commercial film was autochrome, marketed in 1903 by the Lumière brothers in France. Early films of the world in colourful autochrome were orchestrated by French banker Albert Khan. From 1909 until 1929, he was sending film makers to capture all they saw in some 50 countries (see www.albertkhan.co.uk).

photographers such as Eugène Atget in Paris began taking city scenes, while static pictures from studios and *cartes de visites* gave way to more realistic representations. Inspiration no longer came from the old masters' views, but the real-life images that were flickering onto the screens of moving pictures.

The first world war brought a new view of the world: from the sky. Aerial photography became part of daily reconnaissance life on the Front, and when the war was over pilots went off to train airmen around the world. There was money to be made in aerial photography, too. Standing, with one leg strapped to the passenger seat of his aircraft so he could lean out holding his camera, Captain Alfred G. Buckham found a living making aerial photographs of city skylines, much of them put together in the darkroom, where cloud effects and passing planes were added.

Female pioneers

By the 1930s the well-to-do were able to fly. It was a decade of travel. National airlines took off, steam ships raced, motorcars endured. Pan-Am's Clippers overtook Atlantic cruise liners and made South America seem like the USA's back yard, while photographers like Tina Modotti in Mexico still did not have to travel far to find a disappearing world to capture.

Travel books were all the rage – in Rose Macaulay's novels, travel book writers were forever bumping into one another abroad. But there were still a hardened few, like Freya Stark, who would venture on donkey, camel and yak. Ella Maillart, Swiss Olympic sportswoman and author of the travel classic *Turkestan Solo* describing her unaccompanied journey from Mongolia to Bokhara on skis, camel and horseback, made a name travelling to the Caucasus and Kazakhstan, before conquering the Silk Road from China to the Pamir.

In 1939, with the writer Annemarie Schwarzenbach, she drove 4,000 miles from Paris to India via the Khyber Pass in a Ford Model 18 Cabriolet, an event made into a film, *Die Reise nach Kafiristan*, in 2001. Her photographs are her visual diaries, invaluable accounts of the world

LEFT: One of Sergeii Produkin-Gorskii's original RGB images, of men in Samarkand. **ABOVE:** Ella Maillart, pictured with Kaxak camel drivers in the Kizil Kum desert in Uzbekistan, 1932.

and its people at the time, taken with a Leica for her own use and not especially for publication, though several books of her photographs were published. Her pictures reside in the Musée de l'Elysée in Lausanne, Switzerland.

Ansel Adams and Group f/64

Photography was by now heading in different directions. In the US, Group f/64 was started on the West Coast by Edward Weston and Ansel Adams, who wanted to move away from both the traditional pictorial and the art movements. Creating graphic shapes out of landscapes and found objects, the group was

named after the camera's smallest aperture, one that requires the longest exposure and gives the greatest depth of field.

In their manifesto of 1932, they declared: "This signifies to a large extent the qualities of cleanliness and definition of the photographic image, which is an important element in the work of members of the group."

The clear California skies were ideal for such work as Adams's iconic *Moonrise, Hernandez, Mexico*. Though his large format cameras would burden a more restless traveller, this supreme master of landscape photography did a great deal to awaken awareness to photography's possibilities. He died in 1982, but the "zone system" he devised for optimising the

exposure of film is just as relevant for digital, and his technical books remain unsurpassed.

Classic picture magazines

Adams had perfected his craft on large format cameras, but the more portable 35mm cameras were producing increasingly good results, notable the Leica, the first to adopt separate lenses, in 1935, and Contax, with a superior Zeiss lens. They were particularly good for photo reportage and magazines were devoted to the results.

Notable photographic talent in the thirties came from Eastern Europe, particularly Hungary. Gyula Halász called himself Brassaï (he was from the town of Brasso) and his photographs of Paris by night in the 1930s was one of the first such collections, playing with light and shadow and telling visual stories of the city's demi-monde in which his own shadow sometimes played a part.

Frank Capa (born Endre Friedmann in Budapest) was principally a war photographer known for his quotation: "If your picture isn't good enough, you're not close enough". But he also took travel photos, visiting Russia with John Steinbeck in 1948, just after he had co-founded Magnum Photos, the first co-operative agency for freelance photographers.

WILFRED THESIGER

One of the greatest travellers of the 20th century was Wilfred Thesiger (1910–2003), an adventurer in the T.E. Lawrence mould. Born in Ethiopia and educated at Eton College, he lived much of his life in Africa and the Middle East, particularly among the Bedouin and the Marsh Arabs, both of whom he wrote about. In lieu of inheritance tax, he donated his extensive photographic collection of 38,000 negatives and 71 albums of pictures, most taken on his faithful Leica, to the nation. These are now in the care of the Pitt Rivers Museum in Oxford, where some are on view, and 1,300 of them can be seen on-line (www.prmprints.com).

Stefan Lorant, also from Budapest, had been a film maker in Germany, and was founding editor of *Picture Post*, a brilliant photography-based magazine that launched in 1938 and was soon selling 1.35 million copies a week. *Picture Post* was a British version of America's *Life* magazine, the first entirely photographic news magazine in the US that ran for more then 40 years after it was bought by Time Inc in 1936, reaching more than 13 million readers a week. Employing the top talents, it set levels of photography to which amateurs aspired.

Time-Life's World Library, a 30-volume set of colour and black-and-white photographs from destinations around the world, came out between 1961 and 1966 and remains a bench-

mark in travel photography. Among its contributors was another of Magnum's co-founders, Henri Cartier-Bresson, who in 1932 had been inspired to give up Surrealist ambitions by a picture by the Hungarian Martin Munkacsi. One of the great early sports photographers, Munkacsi worked for *Berliner Illustrierte Zeitung*, the best of a number of fine photo-led publications in Germany.

The image that changed Cartier-Bresson's life was of three boys dashing into the waters of Lake Tanganyika. "I couldn't believe such a thing could be caught on camera," he later recalled, "I said damn it, I took my camera and went out

in Korea. Like the second world war, which had ended five years earlier, it opened the eyes of many service personnel and their families to wider horizons. And these horizons were drawing increasingly near, thanks to the new jet engine.

Horizons were also being opened up by fresh conquests. In 1952 photographs of Sir Edmund Hillary on the top of Mount Everest were sent around the world, at the same time that the French marine biologist Jacques Cousteau had worked out how to take films under water.

An apogee of photography, reflecting the world as then seen through the lens, was The Family of Man exhibition at the Museum of

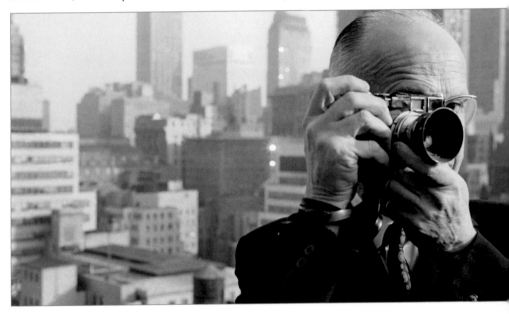

into the streets." His subsequent candid pictures of ordinary people, particularly in Spain, were complemented by lyrical landscapes.

The single lens reflex

Travel photography as reportage – taking pictures that need quick responses – was greatly aided by the arrival of single lens reflex cameras, mostly Japanese built, in the early 1950s. These headed west often via British and American servicemen who first came across them during the conflict

LEFT: Magnum image of militia training in Inner Mongolia, by Eve Arnold, 1979. **ABOVE:** Henri Cartier-Bresson, a founder member of Magnum Photos, in Manhattan, 1961.

Modern Art in New York in 1955 (*see page 206*). It was curated by the Museum's Director of the Department of Photography, Edward Steichen, who selected 503 pictures from the works of 273 photographers from 68 countries.

A new realism

The optimistic images of the American dream presented by *Life* magazine contrasted with those of the photographer Robert Frank. Born in Zurich in 1924, Frank had travelled widely in Europe and South America before embarking on a two-year road trip across America. His camera found people and communities that were isolated and lonely, and this was reflected in his haunting pictures that are sometimes

deliberately out of focus, off-centre, or disturbingly cropped. Out of 28,000 pictures, only 83 ended up in *The Americans*, published in 1958 with a contribution from Beat writer Jack Kerouac: here was a book that was truly On the Road. Most critics thought the pictures were hopelessly incompetent, but now they are considered a landmark in 20th-century photography and in 2009, Washington's National Gallery of Art put them on show.

Colour breaks through

Expensive colour printing meant that most photographers still shot in black and white.

> 66 *The sun rises in the morning and sets at night, and Kodachrome was always there to help us record those sunrises and sunsets and to brilliantly capture the ephemeral distance between light and shadow.* Photographer Eric Meola 99

All this took a while to filter down. Hippy adventurers climbing into their Volkswagen Dormobiles could drive all the way from London to India and Nepal – not something you

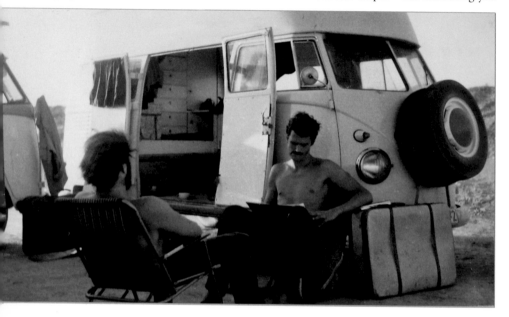

Colour finally broke through in the 1960s on several fronts, mainly thanks to improved printing techniques that would allow colour to be printed not just in sections of a magazine, but throughout. In 1962 *National Geographic* produced its first all-colour issue and newspapers began publishing colour supplements.

There was also a demand for attractive brochures to entice people to venture abroad on the new package holidays. Photographers set off in search of material to fill the full-colour pages. Nature and wildlife was particularly attractive, while scuba divers were revealing a whole new world beneath the sea. Colour television arrived in a standard form in 1967 and within ten years most households were watching it.

can do today. Their adventures were recorded in picture postcards and letters home, and if they took a camera along, it was not usually a smart SLR, but more likely a Kodak point-and-shoot, such as the 44A, named after the size of pictures it took – 44mmx44mm. Nor did they expect to make money from their snaps, which anybody could tell at a glance did not look professional.

The camera is cool

But SLRs were getting cheaper, and easier to use. They were also an attractive hobby, and schoolboys – and some schoolgirls – would set up darkrooms in their bathrooms around about the same time they started learning how to play guitar. By the late 1960s fashion had made pho-

tography sexy, while the ensuing Vietnam war – dubbed "the photographer's war" – gave it grit. Fashion shoots headed for exotic places and war photographers took a break from the conflict to travel elsewhere. Don McCullin brought a renewed interest in primitive cultures when, with the writer Norman Lewis, he brought back pictures of the genocide of Brazilian Indians. It resulted in the establishment in 1969 of Survival International.

Pioneering travel guides

By 1970, when Hans Hoefer launched Insight Guides' pioneering all-colour travel series, the haul jumbo jets would more likely take the new compact Instamatics, and use colour film sparingly. But when digital technology arrived they were in the vanguard of discovery. They appreciated the quicker communication and the more immediate ways of showing where they were and what they were doing.

Just as the invention of the camera coincided with the invention of steam, so the invention of digital technology coincided with an acceleration in travel – with gap years, high-speed trains and budget flights. After 150 years photography was leaving the darkroom and heading out into the light. ❏

declining cost of quality reproduction was creating luxury volumes. "Coffee table" books were able to do justice to the colour images produced by the colour-saturated 35mm colour reversal film, celebrated in Paul Simon's 1973 song *Kodachrome*, which also gave Nikon a plug. (*"They give you those nice bright colours…makes you think all the world's a sunny day"*).

Chasing sunny days is what students wanted to do when their education reached a break. "Gap years" came in during the 1980s and 1990s. In the early days students boarding long-

LEFT: Heading east: Hans Hoefer, creator of Insight Guides, recording his adventures. **ABOVE:** Fresh off the press – the first Insight Guide, 1970.

GOODBYE KODACHROME

In 2009, after 74 years, Kodachrome closed down. It had been professional photographers' colour film of choice, especially for 35mm transparencies, though it was available in all formats, including movie film. To mark the occasion, Kodak asked Steve McCurry to shoot the last roll of Kodachrome. The *National Geographic* photographer had taken 800,000 Kodachrome shots during his career, including the portrait of the Afghan Girl with Green Eyes *(see page 30)*. The resulting pictures can be seen at the George Eastman House Museum of Photography and Film, set up in Eastman's mansion in Rochester, New York, in 1949.

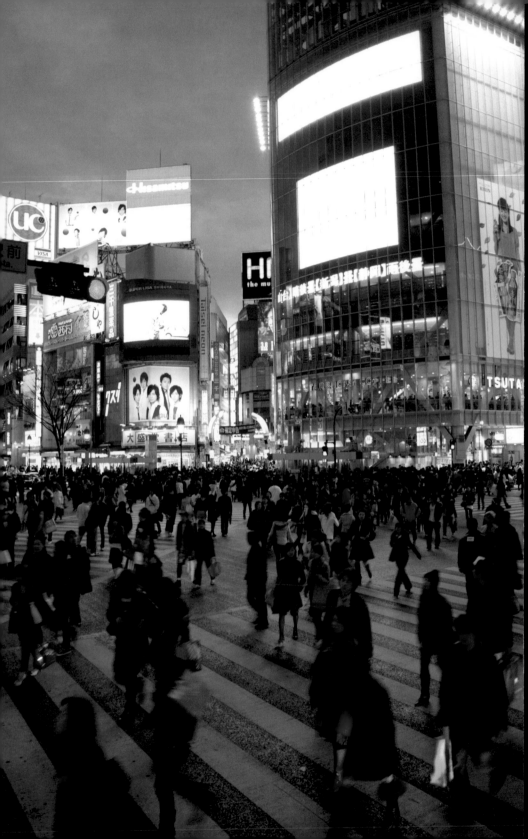

DIGITAL: THE THIRD AGE

First there was Fox Talbot, then there was Eastman Kodak.
Now photography has entered its Third Age, with technology
offering opportunities for almost limitless creativity

One of the first converts to digital was Stephen Johnson, who left film behind one day in San Francisco in 1994 when he was shown its potential. He says he immediately recognised in the medium its colour accuracy, detail and dynamic range, which he believed made images more subtle and nuanced. When Johnson subsequently joined the Digital National Parks Project, he began taking his laptop with him. A photographer who is on the road wants to travel as light as possible, but Johnson wanted to be able to view and manipulate the images *in situ*. It made him feel like the pioneering photographers who travelled with their dark rooms.

"There's an inevitable reachback through time," he says, "to remember what all the early photographers had been able to do to see their photographs on glass plates. The act of printing has moved back into the light."

Evolution

It may seem that digital photography has been a rapid revolution, but it is no more dramatic than the evolution in the first decades after Daguerre and Fox Talbot had made their discoveries. Then, as now, the hunt was on for a portable device that could produce pictures inexpensively. It took around 60 years for the first cumbersome *camera obscura* and silver halide plates to be reduced to the Box Brownie with celluloid film. That's about the same amount of time between the arrival of Kodak and Agfa's colour reversal films and the first fully digital DSLRs that made them obsolete.

LEFT: Hachiko Crossing in Shibuya, Tokyo.
RIGHT: Visitors to Tate Modern, London.

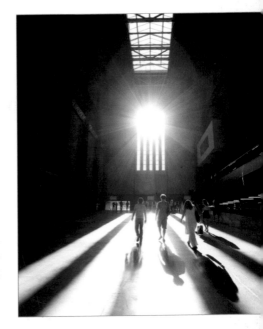

Every leap in technology is, initially, at the expense of quality. Only in time does quality catch up, and digital photography took several years to get near the results of slide film. But in the end film was buried under the mountain of advantages that digital offers. The constant search for greater speeds and reduction in size and costs follows Moore's Law of computers, which states that every 18 months the number of transistors that can be placed in an integrated circuit doubles. In photography, this translates as memory, speed and pixels, which all continue to increase at a rapid rate while the hardware shrinks in size.

Every method has its particular quality. Digital tends to flatten photos, and auto focus

keeps everything sharp. But early complaints about quality have largely disappeared, and results from the amateur photographer using inexpensive equipment can be stunning.

The Photoshop phenomenon

In 2003 Stephen Johnson became the first photographer to be elected into the Photoshop Hall of Fame, an organisation that has much to slap backs about. Adobe Photoshop and its successors have meant that post-production now has just as much a roll to play in making an image as the camera. Because the image can be practically re-shot on screen, altering the aperture

was never easy to play with, unlike black and white, on which the great photographers of the

> 66 *When we see unusual pictures, our first impression may be "how did they do it?" In other words, how was the image manipulated?* Galen Rowell 99

mid-20th century learned to dodge and burn. Ansel Adams, master of the black-and-white darkroom, who died the same year that the first digital cameras went on sale, said, "The negative

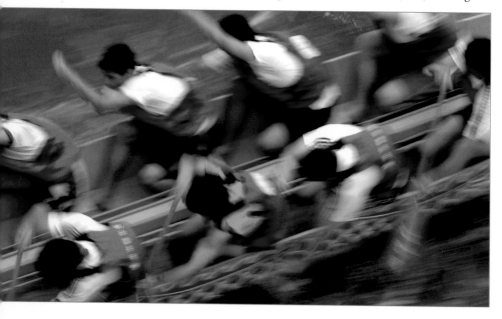

by a full four stops, sharpening the focus and changing colour balance, many of the skills of the professional film photographer are no longer necessary. Grain ("noise" in digital) has been all but eliminated and in 2005 HDR (High Dynamic Range) tonemapping (*see pages 63 and 303*) was introduced by Adobe, allowing adjustments in brightness, contrast and saturation in local areas across the image, thereby enhancing detail. Some find the results can look overprocessed; others, once they learn a picture is created using HDR, say it detracts from their appreciation of the image. Whatever anybody thinks, it is a remarkable tool.

Digital manipulation gives the photographer an extraordinary darkroom. Colour film

is the equivalent of the composer's score and the print the performance." Photoshop and its imitators provide the full orchestra.

Open shooting season

Digital photography is, for the camera-wielding traveller, a phenomenal boon, and all it takes to capture a scene is the press of a button. In the late 1990s, editors began asking travel writers to take their own pictures, never mind that the writer's picture could seldom match that of a professional. It was open shooting season. After a few decades of being able to command decent day rates and expect their archives to keep them in old age, professional photographers faced the prospect of a career change.

The travel bug infected the millennium generation because air travel became cheaper and gap years became the norm. This fed – and was fed by – a visual feast of world experiences that could not be enjoyed unless it was shared, and it wasn't long before the internet found ways of showing pictures to the whole world.

Computer-bound

Today's freewheeling photographer no longer needs to travel with a host of lenses, filters and bags of films with different ISO ratings. But there is an increasing amount of work to be done when he or she returns home. Slides,

with colour film to be supplied to photographers going to places where there was no guarantee of finding slide film stock.

By 2010 pocket cameras had memories of 12 megapixels and could shoot in Raw format, DSLRS could take high definition videos and high resolution prints could be grabbed from professional video cameras. Even mobile phones, capable of being used as projectors, were catching up.

Convergence is always anathema to tech purists, who prefer their gear to be focused on just one thing. But as quality video becomes easy to use alongside still film, using the same camera,

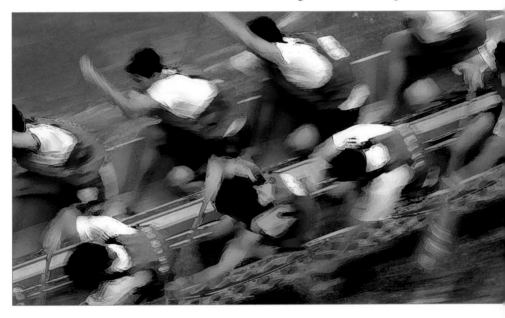

swiftly edited on a light box, took a couple of seconds to caption, with the place or event name simply written on the mount. Now, with metadata to fill in and enhancing to be done, a professional photographer will spend at least half an hour on a computer for each image.

Yet digital is just the latest element in the process of making photography the most freewheeling work in the world. "Go everywhere, meet everyone, try everything," is the travel photographer's maxim. It seems a long time ago that the fridge at Insight Guides was packed

static and moving images will increasingly be seen as partners. The continual drive for developments, set out in Moore's Law, might mean that soon all cameras will have HDR functions, 15–250mm lenses, GSPs, phones, wi-fi and a limitless ISO that will allow you to take a picture of a cat in a coal hole.

As the possibilties mount, some purists dig in. There is a demand to bring back grain and Polaroids, and there is a market for retro cameras – Kodak have revived the Box Brownie for the 2012 London Olympic Games. In the meantime, look at the picture on this page, and imagine that, by touching the dragon boat, you could see it race through the water. Well, that's what travel guide books may be doing soon. ❏

LEFT: Dragonboat race in Dajia, Taiwan, shot with motion blur. **ABOVE:** The same image given the "dry brush" treatment in Photoshop.

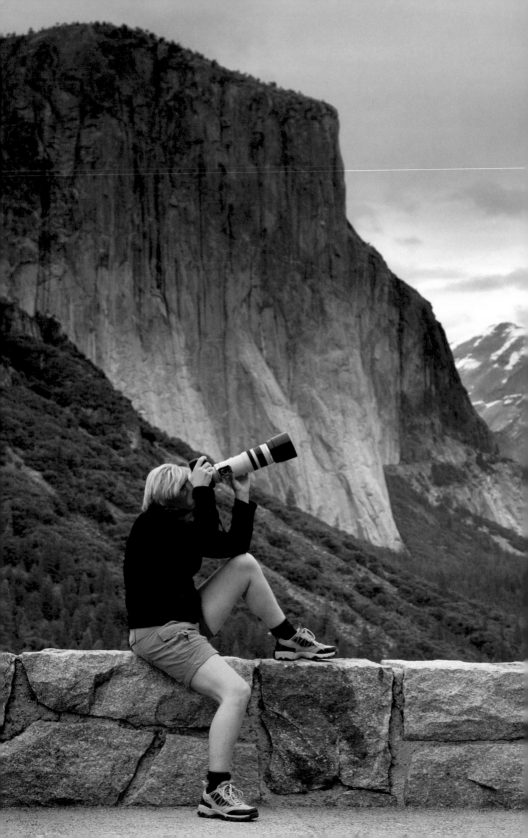

TELLING THE STORY

A photograph has something to say – one person's point of view interpreted through the lens. And as photographers travel, so their stories build into a library of memories that are as much about the person as the subjects they choose

We are all photographers now. It is almost impossible to travel without taking a camera, even if it's an addendum to a mobile phone. Sales from Japanese manufacturers, which make up more than 90 percent of the world market, are running at around 100 million cameras a year, and every month three billion photos are uploaded onto Facebook, videos reach YouTube at the rate of more than 20 hours a minute, and more words and pictures are added to the 200 million existing travel blogs. Nobody thinks of travelling far without a camera, and when presented with new sights, we want to view them through a viewfinder or LCD.

Recent research by a former Latin America tour guide at the anthropology department of London University concluded that, when presented with a sight, tourists always take three photographs: (1) the sight, (2) their travelling companion(s) in front of the sight, and (3) themselves in front of the sight, taken by a com-

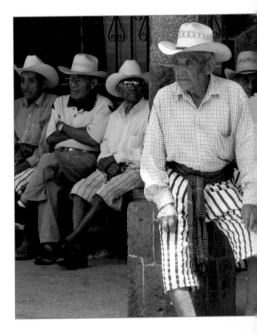

For Europeans, travel and landscapes are the most popular photo subjects, accounting for around 70 percent of pictures taken, according to a Nikon poll, which also revealed that more than half of all pictures end up on-line.

panion. What they are doing, the writer concluded, is behaving like consumers: they had bought the travel experience, and they wanted

LEFT: Lining up a shot at Tunnel View, Yosemite National Park, California. **RIGHT:** Locals at Santiago de Atitlan, Guatemala.

to have the goods to show for it, the pictures of them with the items, material entitlement for the money spent.

But a travel photographer will want much more than this. With enthusiasm and some knowledge of photography, of the way that light and shadows work, and of how a picture is composed, he or she will want to take a photograph that not only has a "wow" factor, but also one that reveals their personal interpretation of a view, that shows a place in a particular circumstance or light.

Each image will carry the weight of the photographer's own integrity. These pictures will be part of a chapter in their lives that

other people can look at and share and even, sometimes, admire.

Our ability to take an inexhaustible number of pictures means that we can chart our experiences and adventures in detail, which build, episode by episode, into the tale of our whole life. This is photography as immortality, evidence that we have been not just to particular places, but that we have had an existence on the planet at all. Our lives can be visually documented from family occasions to the times that we were perhaps at our happiest: unknown, unencumbered, experiencing newness, just being out in the world, travelling.

Many travel photographers hope for lasting images of a dying world – of landscapes transmuting under climate change, of diminishing wildlife, changing cityscapes, anything that may not be here tomorrow. This is the traveller as witness, one of the photographer's most important roles.

The story of a place

Ari Ghuler, a great travel photographer, has also spent his life capturing his own city, Istanbul, in a journey through time. "Life has changed," he says. "Because they never knew the former city and cannot imagine it, the new generation today thinks that this is Istanbul, that Istanbul was always like this. When they look at one of

my old photographs, they are astounded. 'Where is that?' they ask, because hardly anywhere still looks the same."

> 66 *Photographers deal in things that are continually vanishing, and when they have vanished there is no contrivance on earth that can make them come back again.* Henri Cartier-Bresson 99

Many photographers have pet themes: road signs, architectural styles, shop windows, particular fauna or flora. Some have taken pictures of the same spot every day for a year, others mark the changes in a single day. There have been books of photographs dedicated solely to dovecotes, front doors, letterboxes, garden sheds. Whatever the theme, a focused body of work can help to develop your particular style or language. And "collecting" images can prove as addictive as collecting anything else. German travel photographer Hans Silvester is known for his stunning pictures of the highly decorated Omo people in a remote region of remote Ethiopia, but he also produced the best selling *Cats of Greek Islands*, followed by *Kittens of the Greek Islands* and *Sleeping in the Sun: Carefree Cats of the Greek Islands*.

LIFE: A Journey Through Time, which can be seen on-line (www.lifethroughtime.com) is an inspirational volume of photographs that interpret the history of the world through 86 wonderful nature images. Taken by Dutch-born Frans Lanting, the pictures have been presented in performance, with music composed by Philip Glass, and are a reminder that an image can go beyond print or screen into projects that involve other media.

Making memories

Photographs are a way of sharing a point of view, and of providing an aid to our physical and emotional past. We need these reminders, and have done since ancient times when a young woman from Corinth named Dibutade supposedly invented the art of drawing when her lover was about to embark on a long journey. The memory she would carry of him in her head would not be enough, so she traced his shadow on a wall so that she could look at him every day in his absence.

"Photo albums are for people without memories," says Ryan Bingham (George Clooney), the material-free jet-setter in the 2009 movie *Up in the Air*. But our memories cannot be trusted, and one of the many things that Bingham is missing out on is the undoubted pleasure of being able to look at tangible evidence of a place once visited.

As picture editors will attest, we recall photographs imprecisely. Often we are convinced we have seen certain things in a picture, perhaps even one that is familiar, and yet when we look at it again, it is not exactly as we remembered it. So a photograph can be an important corrective, even to the memory of a photograph itself.

Photography and computers offer endless stimulation for retirement, and some believe that older people may achieve better results than youngsters, as they might more easily win their subjects' confidence.

Visual stimulation

Most of all, however, a travel photographer really loves a great picture, and an appreciation of what is great is the starting point for taking good pictures. Four-fifths of the information going into our brains is visual: this is a high profile input, and when our visual senses are stimulated, the rewards are enormous. The

The great adventurers – Darwin, Humboldt, Hedin, and most early travel photographers – made their important journeys while they were young, and they used the memories of these adventures in later life, perhaps to write memoirs or entertain their friends, or to return to the darkroom to reprint favourite negatives. Today, there is still a good deal of adventuring in early life, and inexpensive air travel can keep us regularly on the move. But there is also a rapidly increasing band of pension-age seniors on the road with cameras.

LEFT: Snapping details in the Royal apartments at Versailles. **ABOVE:** Framing a shot at the Piazza del Campidoglio in Rome.

intelligence to know what to look for, when to press the shutter and how to use the technology, is not necessarily learned at school. A surprisingly high number of photographers (Ansel Adams, David Bailey) are dyslexic, compensating a lack of ability in one form of communication by excelling in another.

The same sense of curiosity, adventure, escape and liberation that makes us travel, also makes us travel photographers. Recording, witnessing, heightening awareness, a camera is an indispensible aid to a journey. And for lone travellers with a little time on their hands, unrestrained by the demands of companions or the press of a deadline, taking pictures can be a hugely rewarding experience. ❑

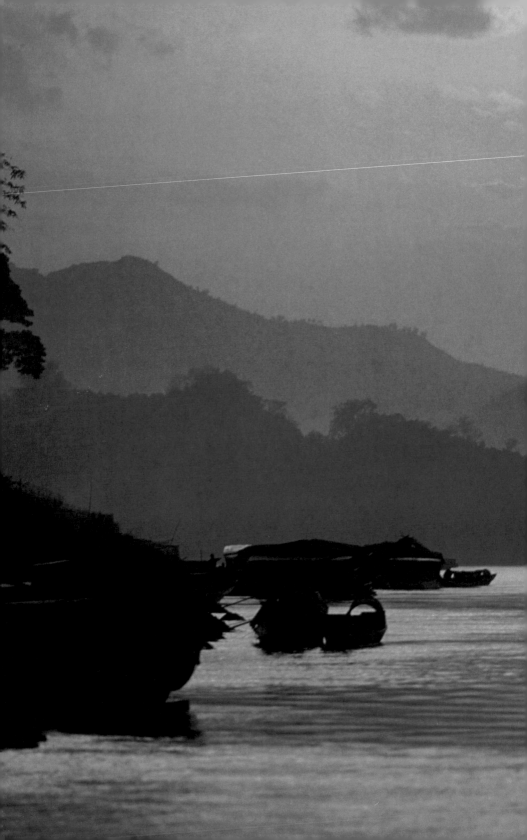

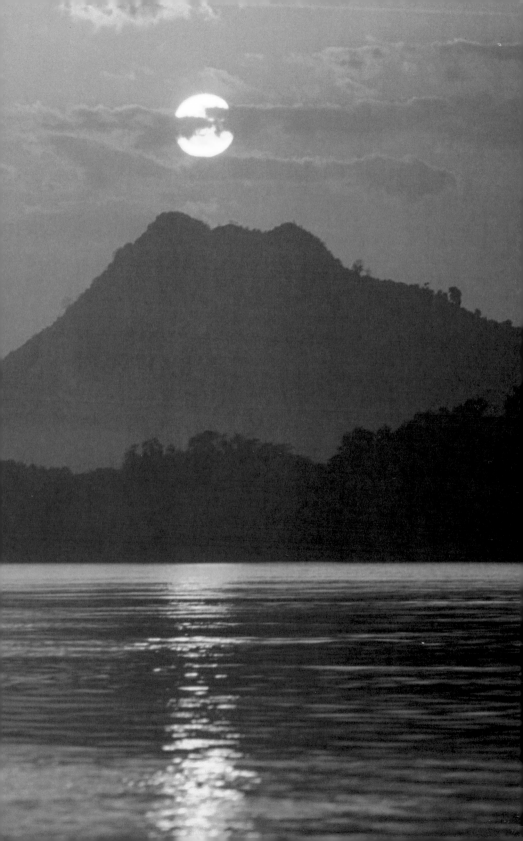

THE BIG PICTURE

Light, composition and, of course, the camera are the three essential ingredients of photography. Before you set out on your journey, spend time getting to know some of the basics

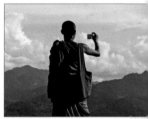

Photography is a way of looking at the world, and everybody looks at the world differently. Each of us has a visual and emotional point of view, just as we have an intellectual point of view. These are responses to the world before us, and photography is one of the best ways in which we can express them.

In the beginning, of course, there was light. Without light there is no tone, no hue, no shadows, no differentiation between skin, hair or eye colour. Light depends on the time of day, geographical location and the weather. It is transient, illusive, magical, and to chase it and capture it is one of the pleasures of the travelling hunter-photographer. How light affects photography is described in the chapter on Light starting on page 53.

Light also reveals shape and form, the relationship between man and nature, how the world falls into place. Our eyes are astonishingly complex. For a start, there are two of them, so we never see the world from a single viewpoint. We can take in a whole scenes at a glance, or we can focus on a single object or person. We have learned from nature to understand what is beautiful – nature invariably gets it right, compos-

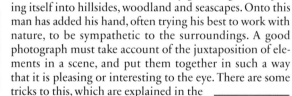

ing itself into hillsides, woodland and seascapes. Onto this man has added his hand, often trying his best to work with nature, to be sympathetic to the surroundings. A good photograph must take account of the juxtaposition of elements in a scene, and put them together in such a way that it is pleasing or interesting to the eye. There are some tricks to this, which are explained in the chapter on Composition, starting on page 75.

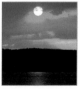

A camera may not see in exactly the same way that we do, but it gets pretty close. A photographer needs to know its possibilities and its limitations, and how it can serve his or her point of view. The chapter on the Camera starts on page 97. ❑

PRECEDING PAGES: An atmospheric view of the Mekong River; shafts of sunlight penetrating a smoky back street in the Old Town of Lijiang, China, home to the Naxi culture. **LEFT:** A monk emerges from the exquisite Wat Xieng Thong temple in Luang Prabang, Laos.

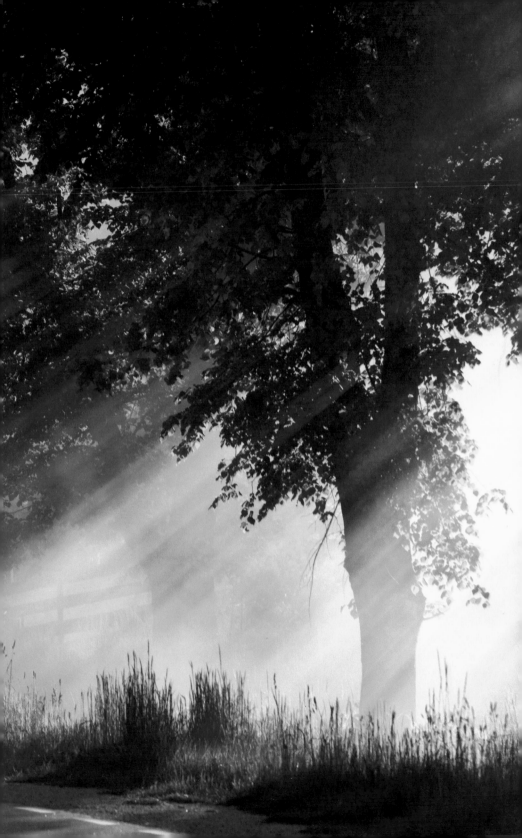

A FEELING FOR LIGHT

Light is what makes pictures happen, and most of the time it lies beyond a travel photographer's control. That's why it is important to understand its effects and how it is such an essential element in taking a good picture

Four ingredients go into making a successful travel photograph: location, timing, composition and lighting. Of these, the last is the real variable and the least predictable. It also makes a powerful difference to an image. You can research and choose the location, improve on your photographer's skills at timing and composing, but the lighting is just how you find it. For all travel photography other than night-time and interiors, it is completely weather dependent.

Certainly, you can make weather predictions, and choose to visit destinations at the times of year that should deliver the kind of lighting you would prefer, and in the pages that follow we show how to set about this. But ultimately, for most of the time, you will be dealing with a variety of light that is not of your choosing. The only control available is to wait. And for travellers who need to move on to the next destination, this choice is limited.

If you have two or three days in one place, then for an important picture you can and should consider the time of day that would show the subject to its best effect. This works only when the weather is predictable, but you should also consider working with a variety of climatic conditions, rather than struggling against them.

To get the most from any situation, you need to be able to realise the potential of any type of lighting, be it a misty morning, stark midday tropical sunlight, the soft glow of dusk, or even the unpromising, shadowless light from a heavy overcast sky.

Of course a flash and various kinds of reflectors can help, but it is always best to work with natural light. All light can be put to good use, and knowing how to make the best of any given condition will greatly improve the flow of your photography on the journey. ❑

Main topics
LIGHT & GEOGRAPHY
LIGHT & TIME
LIGHT & WEATHER
EXPOSURE CONSIDERATIONS
LIGHT EFFECTS
ARTIFICIAL LIGHT

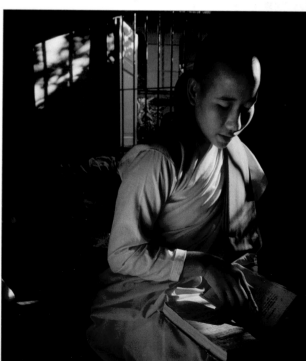

LEFT: An impressionistic image of sunlight through trees. **RIGHT:** Making the best of natural light in a dark environment.

LIGHT AND GEOGRAPHY

NATURAL LIGHT is affected by a host of conditions and variables: where on the planet you are, what latitude and height above sea level, distance from the sea or from mountains.

Geography affects the weather, and weather affects the light. Nothing is settled and the variables are infinite. There are even micro-climates that make the light in a short stretch of coastline and other confined areas different from the surroundings, such as in northern California and Oregon, for example. But the broad geographical picture, drawn by a mixture of the latitude, moisture, and altitude, is covered by the following eight divisions.

Temperate

Lying in the middle latitudes between the tropics and the poles, and referring to most of Europe and North America, this region's climate is extreme only in the centre of large continents. It has the lighting condi-

tions for which cameras and their sensors are designed. That means a variety of cloud cover, often daily, a range of seasons with summer days up to twice as long as winter days, but with the sun never really low or high.

Normal sunny days give rise to an old exposure rule in photography called the "sunny 16" rule. It means that typically, at $f16$ the usual exposure for a scene is a shutter speed the same as the ISO (the film speed, or a digital camera's sensitivity to light). So, at a sensitivity of ISO 200 you can expect to shoot at around 1/200 sec at $f16$, or equivalent.

Changing weather, particularly near coasts, such as in Western Europe, is characteristic, so expect frequent uncertainty.

Mediterranean

Within the Temperate region, this includes the Mediterranean region itself, central and southern California,

BELOW: Classic view of Wasdale in the English Lake District, where a variety of cloud cover is almost guaranteed.

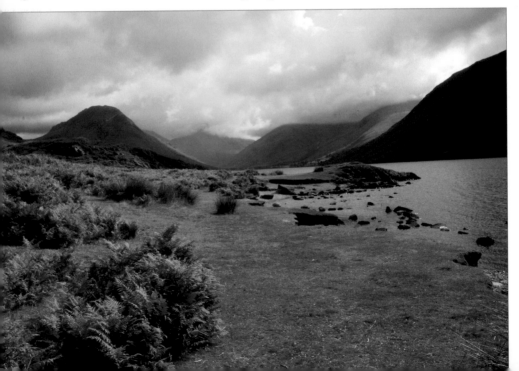

southern Australia, South Africa and central Chile.

You can generally plan shooting for different times of day quite reliably in these regions. This is ideal for travel photography because the very comfortable weather, generally warm, dry and with predictable clear skies, makes it one of the world's most popular tourist destinations.

Dry climates

Dry climates occur in a number of different kinds of locations, from sub-tropical inland (Sahara, Arizona, central Australia), to coastal (Atacama and Namib deserts), and cold and high (Gobi desert, Qinghai plateau). *Desert* light is generally strong, hard, utterly predictable, and the most attractive times of day for shooting are early and late, when the sun is low. Endless and featureless blue skies can, however, become boring after a while and offer little challenge to the photographer.

Dry also means little vegetation to hold down sand and dust; sand storms and dust storms are occasional but a real issue for *equipment*, as well as creating strange, hazy light.

Wet and monsoon climates

The discomfort of being soaking wet and keeping your camera dry apart, monsoon climates have a particular effect on light. Wet climates, whether tropical or temperate maritime, and prolonged wet periods, such as during the monsoon in, say, India, mean little chance of sun, an overcast sky, lower light levels, and the soft, definition-reducing effect of falling rain.

None of these is necessarily a problem, but be prepared for three things: muted colours, the need to raise the ISO sensitivity to overcome slow shutter speeds, and the surprisingly high contrast between a typical overcast sky and relatively dark landscape, if you decide to have both in view.

Sea and snow

These both have high reflectivity, so you need to be light and bright. Light levels tend to be high, which is no problem, but if most of the landscape *ought* to be bright (such as snow or a

Reference ▷

Desert, p.151
Equipment, p.294
Light & Weather, p.60
Exposure, p.63, 108
Elements, p.167

BELOW:
The harsh, strong light of the Sahara desert in Libya.

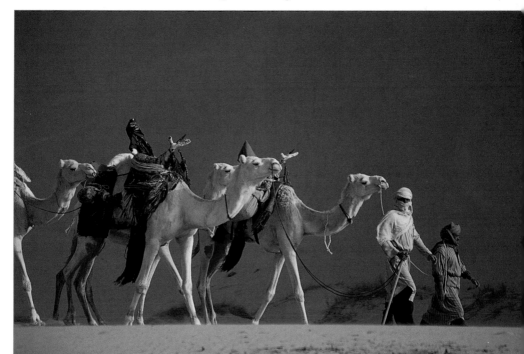

white beach), look at *Exposure considerations*. Snow in particular, tends to be very sensitive to colour temperature, so watch the neutrals when you process the images later.

While there is a clear difference between tropical wet (such as the Amazon, much of West Africa, Singapore and Malaysia) and tropical dry (parts of India, summers in mainland Southeast Asia), two conditions to watch out for are a high sun for much of the day (overhead around midday), with shadows directly *under* subjects, and no seasonal changes. Sunrise and sunset, therefore, are rapid, much more so than in the mid-latitudes.

Mountains and plateaux

Altitude affects light because of the thinner atmosphere. This means much more ultraviolet light, increasing the blueness of shadows and distant mountains – a good reason for fitting a UV filter to your lenses. A polarising filter, perhaps a rotating one, has a strong effect in these conditions, and apart from deepening skies (possibly too much), it can cut through the UV haze

effectively, particularly with a telephoto lens. Clear skies can be an intense deep blue, especially above a few thousand metres, and contrast on sunny days can be higher than the camera's sensor can cope with. In particular, watch for the whites of clouds blowing out, which can be prevented if you reduce the exposure.

Arctic and sub-arctic

The overwhelming lighting issue as you get closer to the poles is the huge difference between short and long days. The Arctic and Antarctic circles are the line at which, on midsummer's day, the sun only just touches the horizon at midnight, so summer in these regions offers a very long shooting day, and if the weather is clear, some of the most striking, *low-angled lighting* is likely to be well after a late dinner, though the sun never gets high.

In winter, there may be only an hour or two of useful daylight for photography. This can also be mixed with some of the above conditions, including the high reflectivity of *snow* and variations between dry and wet. ❑

BELOW: High up in the Karakoram and Himalayas, the skies are an intense blue.

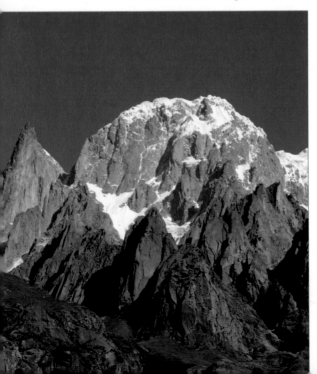

Upside Down

Most of the land mass and 90 percent of the population are in the northern hemisphere, which accounts for our one-sided view of how the sun appears to move in the sky – that is, left to right and mainly from the south. Not so, however, in Australasia, southern Africa and the south of South America, where everything, including the seasons, is reversed. Photographing sunrises trains you to anticipate where the disc will appear, but in the southern hemisphere it will rise to the left of the pre-dawn glow, not the right. For anyone planning where the sun will be at a particular time of day, this is crucial. The sun's path is from right to left, and in the northern part of the sky.

The same applies, of course, if you are shooting the stars at night, and the constellations are different.

LIGHT AND TIME

WITH THE co-operation of weather (by no means guaranteed), the time of day has an extraordinary effect on light and images. Provided that you are not rushing at breakneck speed through one destination after another, this is the lighting variable that can offer you the greatest measure of control.

Being patient is a kind of passive control, but by learning to anticipate the angle and colour of light that will best suit a scene, you are able to plan a day's shooting during which you extract the maximum creative effect for your landscapes and shots of people, buildings and monuments.

Angle and shadows

The sun's passage through the sky has a major effect on the quality of light, in particular the angle at which the light falls on a scene, and the resulting shadows it casts. All this assumes that there is sufficient sunlight to cast

those all-important shadows. Shadows are important in so much travel photography because they enhance texture, bring contrast of tone and even colour. Under a clear sky, they will be more blue than the sunlit areas, and this can be particularly pleasing early and late in the day.

Sweet light

Let's start with everyone's favourite, the warm, raking light from a low sun, either within the first two hours of morning daylight or the last two of the afternoon (the period of time is shorter in the tropics where the sun rises and sets almost vertically, longer in higher latitudes where its angle of ascent and descent is more gradual).

Some photographers call it "golden" light. It's great for landscapes because its raking angle heightens texture and throws longer shadows, and it's good for tallish subjects like *people* and *buildings* because it lights one side

BELOW:
A corner of Trinidad, Cuba, in the late afternoon.

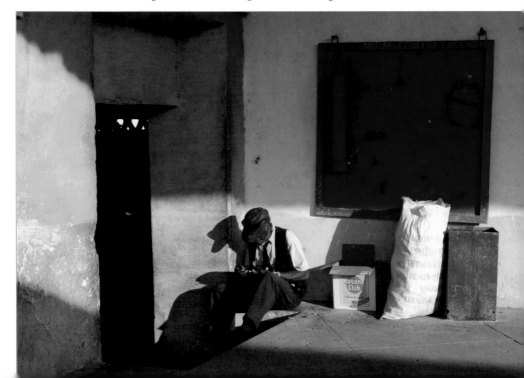

fully. The deep warmth of the light is also attractive, although this is something you can enhance or moderate easily during *processing*.

A further advantage is that the sun is located well into one part of the sky, so you have a choice of shooting angles that vary from away from the sun, into the light, or at right angles. The feeling and character of each of these is different. Shooting into the light in particular has the potential for strong atmosphere and mood. But beyond these logical and photographic reasons, most of us simply like the lighting at these times of day, and enjoy it just as tourists.

So, if you respond to the conventionally attractive, this period of the day early and late is prime photography time, good and useful for almost all subjects. In fact is it is often hard not to take a good picture in this light, provided the composition is right, of course.

Nevertheless, exercise caution in always relying on or wanting this kind of daylight, because you will often simply not have it available. This is where making the most of other kinds of light becomes important, as we'll now see.

High sun

As the sun rises higher, its colour becomes more neutral (white) and the shadows it casts become smaller and usually denser, falling underneath objects and people rather than to one side. This is especially true of the tropics, and if you are new to tropical travel, the effect may be harsher and less pleasant than you expected.

A portrait with the sun high overhead, for example, will have hard-edged shadows under the eyebrows, nose and chin, which is quite the opposite of conventionally attractive lighting. If the person is wearing a hat, then the entire face will be locked into deep shadow, and the contrast range will be high – probably too high for the camera sensor if they are wearing a light-coloured hat, which is more than likely in tropical heat.

The effect on most landscapes is, perhaps surprisingly, the opposite, making it seem flat. So what is good about a high sun for photography?

BELOW:
Atmospheric picture of a cheroot smoker, taking full advantage of shooting into late-afternoon light.

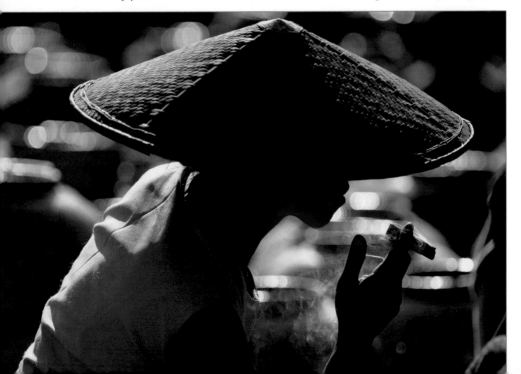

Well, you can use the high contrast of light and shade to advantage by making strongly *graphic compositions*, as in the picture below left, always remembering to underexpose sufficiently to retain highlights and keep the shadow shapes as deep silhouettes. And if a portrait with those unfamiliar shadows isn't conventional, does it even matter? It can be striking and unusual. Look also for bounced lighting from bright streets into the shadows.

Sunrise and sunset

There is no exact point at which the sweet "golden" light of a low sun turns into the classic sunrise or sunset shot, but everyone recognises these standard images of travel photography. Technical matters of exposure and focal length apart, the issue for serious photographers is how to avoid the image looking like a postcard cliché.

Sunrises can be more peaceful than sunsets, but judging the exact spot (for instance, exactly behind Bear and Rabbit Rocks in Arizona's Monument Valley) means knowing the exact time of sunrise and realising that the sun will rise to the right of its pre-dawn horizon glow (but to the left in the southern hemisphere: see panel on page 56).

Dusk and darker

While you'll see many sunset photographers packing up as the sun disappears, skies can often get more interesting a little later – not necessarily immediately, but after many minutes. The dusk glow in a clear sky, and the sudden flash as high *clouds* light up red, are bonus events that justify waiting in case they happen.

Shading of tone and colour are made all the more intense by using a wide-angle lens that takes in more of the sky. If the sky is good, consider making it the main area of your composition, keeping the skyline low in the frame.

Turning away from the sunset or sunrise, dusk can have a dark softness that can be atmospheric, provided that you keep the exposure dark (dusk ought to be dark). The colour temperature rises (see *white balance*), giving a natural blue cast that you do not necessarily need to correct and neutralise. ❏

Reference ▷

Processing, p.300
Exposure, p.63, 108
Light effects, p.64
Sunsets, p.70-1
Clouds, p.172
White balance, p.106

BELOW:
A blue cast starts to appear at dusk; here a silhouette of Sultan Qaboos Grand Mosque in Oman.

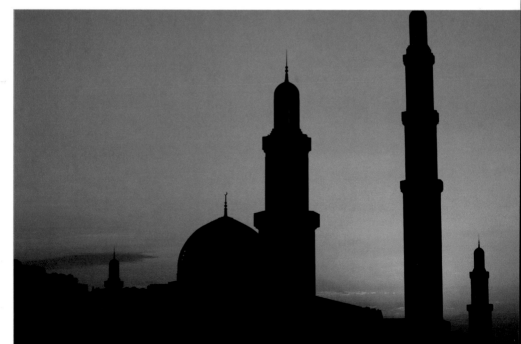

LIGHT AND WEATHER

WEATHER IS climate on a local, day-to-day scale, and while it may not always suit your idea of perfection, it is always possible to make something photographically from just about any condition, be it cloud, sun, rain, mist or whatever. Travel photographers learn not to fight the weather but to go with the flow. All weather conditions modify the light, among other things, and that is our concern here.

In a completely separate way, pronounced weather, such as dramatic stormclouds, can become an important element of the composition, even the main subject, especially when it comes to *landscapes*.

Diffuse light

From haze through thin, high cirrostratus clouds to the thick heavy overcast of nimbostratus, there is a whole range of weather conditions that diffuse sunlight. While we seem to be conditioned to want bright sunshine and blue skies, particularly on holiday, light diffused by weather has all sorts of attractive qualities and uses in photography.

Diffusion is, after all, something that studio photographers go to great lengths to create when they are photographing people or products, from pack shots to cars. Haze or light cloud provides this for free. What diffusion does is both to fill shadows and to soften their edges, while keeping the light directional for good modelling. This makes diffuse lighting, in which you are still able to see a little of the sun, highly efficient for most subjects; not dramatic, but pleasant, and without contrast problems.

Even more diffuse light

As cloud thickens into an overcast (one kind of stratus or another), shadows disappear altogether, and the light source for everything, from landscapes to people, becomes simply the full expanse of the sky.

BELOW: Misty conditions here at at Top Station, Kerala, produce well saturated colours because of the absence of shadows.

Normally we think of this as dull, grey weather and wish for something brighter and clearer, but the totally diffuse light from a white or light grey sky is excellent for complex and colourful subjects.

Overall, colours under an overcast sky are actually better saturated than in sunlight, contrary to what many would expect, because bright sunlight creates highlights and shadows. This is never more obvious than with trees, forests, thick vegetation and gardens. Remember that *raw processing* gives you huge control over contrast and saturation, and as grey-lit scenes minus their skies have low contrast, there is always a wide processing choice.

Lighting problems begin to surface when you include an overcast sky in the composition, particularly if it is bright (meaning not obviously dark rainclouds or thunderclouds). Paradoxical though it may seem, the diffuse lighting conditions that lower contrast and remove shadows on the ground also make for a high contrast between land and sky.

The choices here are either to re-compose to avoid a white, blocked-out sky, or to recover exposure during processing. A traditional solution, still available, is a neutral graduated filter over the lens. This darkens part of the image along a straight line, which can be aligned with the horizon in a rotating and sliding filter mount, and is normally available in strengths of one or two *f*stops. However, digitally, if you shoot Raw, you should be able to recover at least one *f*stop during processing (Photoshop even has a digital equivalent Graduated Filter which allows any amount of sky darkening). Moreover, if you are using a tripod, you can bracket exposures and combine them.

Heavy weather

Rain, snow, mist, fog, a heavy build-up of deep clouds, and dust storms all offer special lighting opportunities that experienced travel photographers seize on in order to bring variety to their journey's photographic take. Most of these conditions also bring some measure of discomfort and potential harm to equipment, so that most peo-

Reference ▷

Landscapes, p.135
Processing, p.300
Exposure, p.63, 108
Rain, mist & fog, p.168

BELOW: Waiting for the right light in overcast conditions can take time. Here a chink of sunlight brushes Mt Tryfan in Snowdonia, North Wales, boosting the texture and drama of the scene.

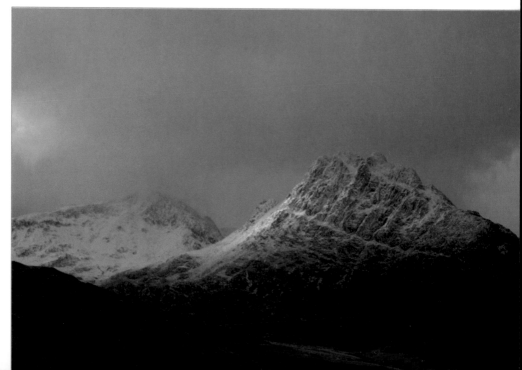

BELOW: Drama unfolds in the Langdale Valley, Lake District, as the brightly-lit building is contrasted against dark, brooding summits.

ple's natural reaction to rain, snow and dust is simply to run for cover and stay under shelter.

There are a number of ways in which you can can *protect cameras* from these risks, and provided that you take sensible precautions, you should probably be thinking of running in the opposite direction to everybody else – towards the bad weather!

Usually, but not always, the effect on lighting tends to be twofold: lowering contrast while diffusing the light, and reducing light levels. Diffused, shadowless lighting actually benefits many scenes, such as vegetation. Mist and fog, of course, are the ultimate diffusing condition, softening the light so that it appears to come from everywhere, with no shadows.

Lowered light levels can often be dealt with simply by upping the *ISO setting*, but consider first whether the scene should actually look darker than average. As rain begins to pelt down from dark-grey clouds, you can best preserve the sensation by making sure that the clouds and everything else are indeed dark in the image, and not try to brighten them to make it look as if it's not such a bad day.

Dark sky, bright foreground

Quite the opposite happens if the sun breaks through to light up the foreground or middle ground, and the contrast shoots up between lit landscape and dark sky.

This combination is always dramatic, and order to capture it you should avoid over-exposure at all costs. Dark skies can radically alter the lighting of a picture, not just in landscape photography. A facade of a building suddenly illuminated by the sun against a dark sky can look very dramatic indeed, as can a mountain ridge suddenly highlighted in otherwise gloomy conditions, or a field of rice glowing bright green against a dark grey backdrop.

You might encounter these conditions spontaneously, but you may also have to wait. You may also have to run so that you are in the right place at the right time – before the sun goes in again. And again you might consider bracketing so as not to lose the moment. ❑

EXPOSURE CONSIDERATIONS

ALL CAMERAS use automatic exposure by default, and the simpler ones offer few possibilities to override this. Nevertheless, automatic exposure systems are not yet content-aware, and any unfamiliar lighting conditions call for judgment. The saving grace with digital photography is that you have some latitude when processing the image, with the possibilities for recovering mistakes, as we show in the *At Home* section. Nevertheless, three basic considerations will get you through most exposure issues to do with lighting.

First, how bright or dark *should* the scene be? This may not seem obvious until you come across certain conditions, like snow, a bright sandy beach or a village nestled in a valley at dusk, as the lights begin to come on. Just remember that the camera's exposure system will always try to give you an average mid-tone. While this perfectly suits most scenes, it would render a snowscape a dirty grey, a bright tropical beach too dark, and fading dusk unnaturally light. With experience, you can learn to judge by how much to compensate – do familiarise yourself with your camera's specific exposure-compensation method. But you will lose little time by simply adjusting a stop up or down and looking at the result on the camera's screen – then adjust again if necessary.

Second, is there a big contrast between major parts of the scene? Small shadow areas hardly matter, but an overcast sky may be so much brighter than the landscape underneath it that you may have to re-compose the shot or consider bracketing exposures (*see below*).

Third, try hard to avoid clipped, blown-out highlights that are any bigger than a pinpoint. Bright small reflections hardly matter, but a prominent white wall, hat or cloud that is featureless white may ruin the shot. It is easier to recover dark shadows in processing than lost highlights. ❑

BELOW:
A bright beach in Thailand. This type of subject is perfect for bracketing exposures and combining them later.

Catch Extremes of Brightness with any Camera

Many outdoor scenes in bright sunshine, such as bright mountains and tropical beaches, have a much wider range of brightness than even the best digital cameras can capture. It also applies to scenes that combine dark interiors and bright exteriors. These have a high dynamic range, which photographers used to call "contrasty". Then, there were three solutions: go for a silhouette, let highlights blow out to white, or forget the whole thing. Now, digitally, it's possible to have it all in one shot. The solution is to take a bracketed sequence of exposures, from dark to light, spaced about one or two *f* stops apart. These can later be combined in your computer software. These tips should ensure success.

First, the camera should be steady so that all the pictures are framed the same; a tripod is ideal, but software can cope with small differences if you photograph handheld. Second, keep the aperture the same so that there are no differences in depth of field, and vary the shutter speed so the gap between exposures is one or two *f* stops; many cameras will let you set an automatic bracketing sequence, but most have a maximum step between frames of one *f* stop. Third, start with an exposure dark enough so there is no highlight clipping (use the clipping warning if your camera has one) and continue until the darkest tones are mid-tone. The importance of this last point is so that there will be no noise in the shadows.

LIGHT EFFECTS

LIGHT CAN be more than just the factor governing how your travel scene is illuminated. Under some conditions it can also be striking enough to become the subject of the photograph. Although it's always good to have interesting subjects, under strong light conditions the elements in the scene may be able to take a back seat.

Silhouettes

Because our eyes are so efficient at accommodating different light levels in a single scene, we rarely see silhouettes, but they are a time-honoured photographic solution to high contrast between (usually) foreground and background, which the camera had difficulty handling. They work as strong graphic compositions under the following conditions:

• First, when the outline of whatever is silhouetted is recognisable – thus, faces in profile are more effective than frontal – or make interesting graphic shapes without any need for texture or tone. In this kind of silhouette, the picture begins to approach the qualities of a black-and-white picture.

• Second, when the exposure is kept dark enough in order to favour the lighter background with rich tonality and colour.

• Third, when the proportions between silhouetted shape and background are similar. Strong, distinct silhouette shapes make striking images that stand out well, and all you need is to shoot against the light or the lit area with a much darker foreground subject.

Sun stars

Shooting into the sunlight, as we saw earlier with "sweet light" and sunsets (*Light and Time*), is often strongly atmospheric, and the glow of light flooding the scene can hardly help but become part of the subject. And though avoiding shooting into the sun is one of the first lessons of photography, the

BELOW LEFT: Monk silhouetted against the Shwedagon Pagoda in Yangon, Myanmar. **BELOW RIGHT:** Sun on the water, Jamaica.

sun itself, with some technique, can be made to have an attractive star-like appearance, surrounded by short rays – natural ones, not the cheesy, cliché effect that you get from front-of-lens diffraction filters.

First, the lens should be wide-angle and stopped down.

Second, the exposure for the sun needs to be dark enough to show the sun star effect. The trick here is to partially obscure the sun with some part of the scene, just cutting into it. The hard edge of almost anything will work, from a rock arch in Utah to the tip of an Egyptian pyramid, but particularly effective are leaves and branches when you are shooting through a tree's foliage. This is dealt with further in "Reflections and refractions" below.

Rays of light

A shaft of light reaching down to the earth through a dramatic break in the clouds is one of the prizes of landscape photography that is impossible to resist. It is, of course, a rare event, as it needs a special combination of conditions: an isolated gap in a heavy cloud cover,

a tangible atmosphere (hazy, dusty or rain), and a dark background. These same conditions can also be found a little more predictably in cavernous *interiors*, such as at St Peter's in Rome, shown below, and even more spectacularly in Rome's Parthenon, where the oculus in the dome acts like a camera lens letting in a bean of light.

Shafts of light like this appear strongest with a darker exposure, and it's a wise precaution to bracket for safety – and also possibly for late exposure blending.

Reflections and refractions

The sparkle of sunlight in water, on slick wetted surfaces, or on ice and snow can make a subject all on its own because of the glittering high-contrast patterns and shapes that lend themselves to semi-abstract imagery.

This often works best graphically in close-up detail, and so cropping in with a longer lens is a standard technique for composition. It is wise to bracket exposures because you may change your mind later about which works best, and do not worry about

Reference ▷

Light & Time, p.57
Exposure, p.108
Blending, p.303
Interiors, p.194

BELOW: A shaft of light kisses the statue in St Peter's, Rome.

BELOW: Shooting through the leaves towards the light results in over-exposure of the background, here creating an ethereal image of this lake in China.

accompanying flare. This can simply enhance the abstract atmosphere of the image.

Refractions such as those wavy, shifting bright lines and shapes at the bottom of a swimming pool, or from sun streaming through a cocktail glass on the hotel verandah, can also be given the same treatment.

Into the light

The reflections and refractions that we have just looked at are one by-product of shooting into the sun – or indeed, into any light source. And there are others, beginning with what many people would count as mistakes, such as the different kinds of flare.

Yet what may be a technical error can also become, according to your taste and some luck, a happy accident. Basically, lens flare is non-image-forming light, and it can take several forms.

One is an overall washed-out look, called "veiling" flare, as light from just outside the picture frame bounces around inside the lens barrel. It can also create streaks, flare polygons (a string of roundish shapes related to the

lens aperture) and rainbow-coloured diffraction effects.

The good thing that flare can do is to enhance the feeling of looking towards bright light, adding atmosphere to a shot, while streaks and lines of polygons can sometimes add graphic diagonals to a photograph. You can reduce or cut flare by shading the lens, either with a lens shade fitted or, if shooting very close to the sun, with your hand in front, just out of sight, as if shading your eyes – though this will leave you only one hand to hold the camera. But it's always worth experimenting by seeing how flare might make the picture look more spontaneous and atmospheric.

Flare aside, shooting into the light tends on the whole to reduce detail and colour but strengthen contrast and mood. Effects can vary depending on the time of day and amount of ambient light. If *early or late in the day*, this can often silhouette the subject. With more ambient light, placing the subject directly between the sun and the camera can create a dramatic halo effect. ❑

ARTIFICIAL LIGHT

TRAVEL PHOTOGRAPHY does not have to end with the setting sun, even less so now that digital photography helps solve the old difficulties faced by film in taking pictures by artificial light. The potential problems are the much lower light levels and the often wild variation in the colour of light.

Digital overcomes these two first, by allowing you to dial up the ISO sensitivity on demand to match the lower light levels, and second, by allowing you to neutralise colour casts using the *white balance* setting. Even when there are two or more differently coloured light sources, you can selectively alter them in any good image processing software, such as Photoshop or Lightroom.

Increased noise, as we have seen, is the downside of increasing the ISO sensitivity, but there are constant improvements in camera sensors and in processing software, so that unless you are tackling extreme darkness, it is no longer a major issue. The different colours of artificial light can be surprisingly marked, and the reason for this is that our eyes are just so efficient at compensating.

Tungsten lighting is actually much more orange than daylight, but after a few minutes in a room lit by ordinary incandescent lamps, we simply see it as normal. Fluorescent striplights and compact fluorescent lamps (CFLs) that are replacing tungsten for ecological reasons, work better for the eyes than they do for the camera; unfortunately they have broken spectra which make it difficult to restore a feeling of full colour. Digital processing can help in this, but be warned that the results can never be perfect.

Indoors

To get a normal sense of an interior, the standard approach is to use a wide-angle lens and a corner viewpoint, and

BELOW: All the artificial colours of the rainbow at Copacabana metro station, Rio de Janeiro.

BELOW: This restaurant in historic Krakow is lit by natural as well as artificial light, where the opposing colour temperatures of blue and orange are complementary.

in order to have good depth of field from a small aperture (the standard expectation from an interior photograph), a tripod or some way of fixing the camera for a time exposure. Contrast levels tend to be high in most interiors because the lights are usually in view, so *bracketing* exposures is recommended.

One common situation with indoor photography during the day is to have a mixture of artificial light indoors and daylight from a window. There will inevitably be a colour contrast, but that is not necessarily a bad thing, as the opposing colour temperatures of blue and orange are actually complementary. If nevertheless you prefer a more neutral colour, this is easy to achieve in processing later, particularly with *Raw processors,* such as Adobe and Camera Raw, that allow local changes.

If you want to balance the exposure between interior and the view out through a window or door, the simplest on-the-spot way is to wait until dusk when the light levels will match each other inside and out;

otherwise, you can go the *exposure-bracketing, HDR* route.

Collapsible reflector

A standby for professional still photographers and television cameramen alike is a collapsible silver-coated fabric disc. This makes almost no difference to the baggage, and yet is supremely useful in two kinds of photo situation: for *portraits* and for pouring reflected sunlight into shadow areas.

As portrait supplementary lighting, the disc, which folds compactly by means of twisting the surrounding metal hoop, gently fills in the shadowed side of a face for a more rounded, flattering effect, and does not need to be in sunlight to have this effect.

More dramatically, as long as there is sunlight somewhere, it can be used to re-direct strong light into an interior or any shadow, such as a carving inside an ancient temple, or simply to balance shadows in strong, harsh daylight.

There are several varieties, with one side usually coated silver, the reverse white for a gentler effect.

Night-time outdoors

Cities and towns at night are a rich source of travel imagery, whether neon displays, traffic tail lights, shop windows, street lamps or foodstalls lit by hanging bulbs. Contrast levels will be high, so expect to have parts of the scene silhouetted or fading to blackness, but blown-out clipped light sources like street lamps are generally acceptable.

There are two styles of night-time photography: handheld with the *ISO sensitivity* turned way up (a wide-angle lens will reduce the visible effects of camera shake and *motion blur* with slow shutter speeds), and tripod-mounted long exposures. For telephoto views, choose the latter.

A final tip: if you photograph during late twilight, when there is still a hint of blue in the sky, this will give definition to the outline of buildings, and communicate the night-time feel much better than when the sky is pitch-black. ❏

Flash Photography

There are a number of ways that flash can help to illuminate a picture and prevent the full-on glare of a simple flash

The role of flash in photography has changed radically since cameras went digital, and in particular since digital cameras began to perform so well at high ISO sensitivity settings that it often makes flash less necessary.

The kind of small flash unit that will fit on a camera (as opposed to large, usually mains-powered flash units of the kind used in studios, which are a different proposition altogether) was designed originally to make some kind of picture possible low-light situations, but no manufacturer ever pretended that the result would be attractive or flattering. The reason is that on-camera flash bathes the subject in a hard light because the the lamp is small, and as it comes straight from the front there is no gentle modelling. However well the camera-flash combination measures the flash output for the best possible exposure, the background will always be darker (black if it is at a distance), and anything in the foreground will be too bright.

Other ills of on-camera flash are the chance of reflections back into the lens, the solution for which is to shoot at an angle to reflective surfaces like glass windows. Red-eye is another kind of reflection from the subject's retina. Here a solution is to use the red-eye mode on a camera, which triggers a small pre-flash that makes the subject's pupil contract.

Flash units that fit onto a camera's hot shoe can improve this state of affairs with various diffusing attachments. Another aid is a swivelling head that can be aimed to bounce off a nearby light surface, such as a wall or ceiling, so the light does not his the subject full on, and instead comes from a kinder angle.

All in all, however, a flash used at full power like this will give an efficiently-exposed image, but the lighting will not win you any creative awards. This makes it worth considering whether dialling up the ISO in a low-light situation might not be a better option – it will certainly preserve the atmosphere of the scene. However, with cameras and flash units that allow you to adjust the strength of the flash output, there is a genuinely useful technique, called fill-flash, in which a relatively small dose of frontal flash is added to the otherwise ambiently-lit scene. In a backlighting situation, this can open up the shadow areas, and in lighting conditions that are simply dull, adding just the right amount of flash can give a colourful fillip to the shot. Judging the right amount (assuming your camera-flash combination allows you to choose, which is by no means always the case) takes some skill and practice, but settings that give 1/8, or 1/4, or 1/2 the normal amount are the most generally useful.

Another, related way of making good and interesting use of flash is, with a DSLR, to set the camera to what is known as "rear-curtain" flash while reducing the flash output as just mentioned and using a slow shutter speed (say, half a second or longer). This setting delays the timing of the flash until the *end* of the slow exposure, and the result, if you are shooting at night with various ambient lights, can be dynamic and attractive. The slow shutter speed records the ambient-lit moving subjects as swirling, streaking movement, while the final dose of flash adds a crisp, recognisable image. To make best use of this technique, set the camera and flash controls to manual, and experiment with the combinations. ❑

RIGHT: A full-on flash can create disappointing results; a sync chord with hand-held flash is often better, enabling you to light the scene from the side.

SUNSETS

For dramatic colour in nature, nothing beats a sunset, which is why it is so popular with photographers. But to avoid your picture looking like a cliché, you need some forethought

The first thing you have to realise when photographing a sunset is that you don't have to shoot directly at the sun each time. If the light is exceptionally clear and bright, face away from it to see its reddish glow illuminating the scene stunningly.

But if you do choose to shoot the sun itself, the two keys to success will be composing the sun against an interesting part of the horizon, and getting the exposure right. As the examples here show, it's what else is in the shot that makes all the difference, whether an ancient temple, or outstanding rocks on which the sun is putting on a departing show. The sun alone is never enough. When shooting into the sun, remove all filters to avoid ghost images. Polaroid filters are effective only if the sun is off to one side.

Overexposure is the worst mistake; this kind of shot wants colour richness. And if you want more landscape detail than a deep silhouette can provide, consider shooting a bracketed sequence for later exposure blending *(see page 303)*.

A telephoto will make the sun's disc larger in the frame, and a really long lens (500mm equivalent focal length or more) can be spectacular, with the disc large enough to be a backdrop for a flock of geese, for example, in silhouette. Wide-angle compositions can also work well, with the sun a pinpoint and the horizon a wide sweep of silhouette. A cloud passing in front of the sun in this wide-angle scenario can be useful for the composition as well as lowering the contrast.

BELOW: The sun diffuses its light over the Golden Temple in Amritsar. Devoid of figures, it has a timeless quality.

ABOVE: The sun by itself is never enough: it's the rays penetrating the atmospehere and cloud cover that create the picture here. The red clouds produce a velvet texture, while the sea darkens to black.

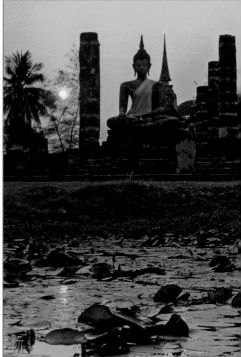

ABOVE: It is often the foreground that creates the interest in a sunset shot. The pool of water in front of the ancient ruins of Sukhothai in Thailand gives the picture an added dimension.

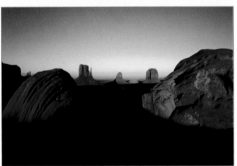

ABOVE: Turning your back on the setting sun, you will see the other side of the silhouettes, and how the sun lights up the landscape. Here, at the Mittens in Monument Valley, Arizona, it brings out the deepest colours in the rocks.

SUNRISE

Sunrises are more difficult to photograph than sunsets, not in any technical sense, but because you don't have daylight in which to anticipate where the sun will be on the horizon, and to see what mist or cloud cover there is. Ask around to find the best spots to watch the sun come up, and find out when it arrives - sometimes the time is listed in local papers. The rewards for getting up early can be great. At this time of day there is often a different kind of light, a beautifully quiet and soft quality with none of the flame and fire associated with sunsets. This morning light can also invade city and harbourside streets – the sea will be calmer than in the evenings – when everyone is asleep, bringing picture opportunities.

The rules for sunsets apply similarly to sunrises, but if you are on any elevated spot, or in a wide open space, such as a desert or steppes, a wide angle will show the full extent of the flooding colour and light. A long lens, on the other hand, will show the shimmering outlines of the sun, which emerges like a living being, changing it colours and shape by the second. The action will happen quickly: and you will need to fire off rapid numbers of shots to get the best reults.

There are many famous high spots to visit to witness the sun's arrival, casting the shadow of the hill or mountain and exploding like a rainbow ripple around the horizon. Some, like Mount Fuji, can be crowded. Since ancient times the rising sun has been celebrated, making places such as Machu Picchu and Adam's Peak particularly magical at this time of day.

LEFT: At sunset the sun simply pours its colour over everything before it. Here, over the Charles River in Boston, Massachusetts, the water turns to a silvery gold, while landscape features disappear into a deep palette, and the sailing boats provide a touch of idle animation.

ABOVE: The magical morning shadow from Adam's Peak in Sri Lanka.
LEFT: This welcoming silhouette reinforces the idea that dawn is a time of rebirth.

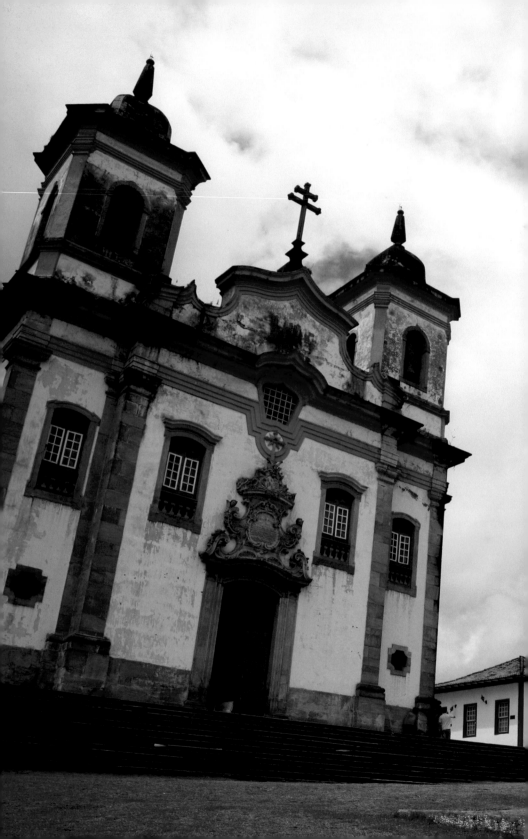

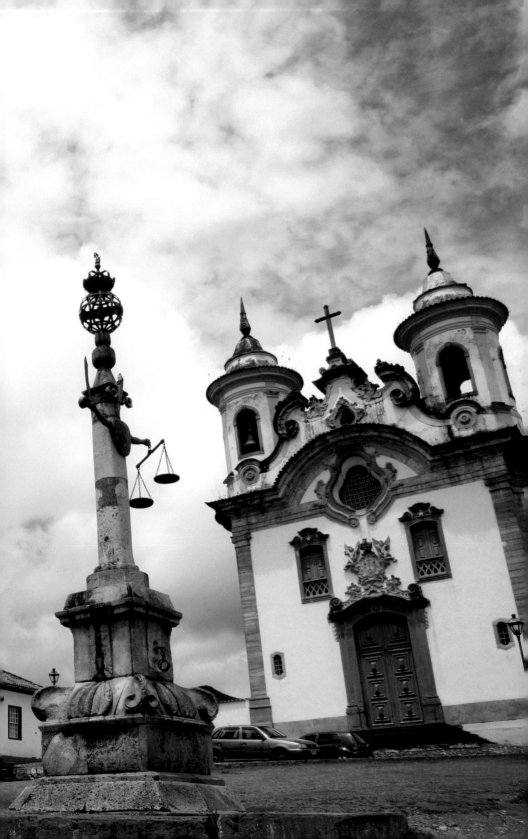

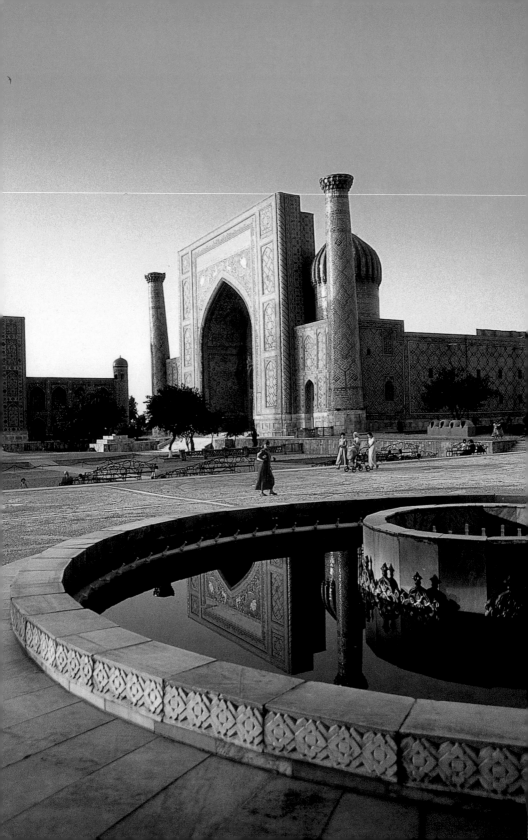

COMPOSITION

Good pictures don't just present themselves, they have to be composed, and even though some aspects of composition may be instinctive, there are still a number or rules worth considering

The American photographer Edward Weston once declared: "To consult the rules of composition before making a picture is a little like consulting the law of gravitation before going for a walk. Such rules and laws are deduced from the accomplished fact; they are the products of reflection."

It is true that instinct is a photographer's guiding force, but instinct can be trained, and a little reflection on what makes a good photograph can go a long way towards achieving a striking image. We all have our own favourite travel photographs, and even though these may be completely different for each person, they will obey certain rules.

Crucial to creating an unforgettable shot is the positioning of the subject within both the frame and general layout of the image. The photographer must be aware of what elements are within their control (elevation, point of view, distance from subject, and so on) and what is not (the amount of sea to the horizon, a dense group of trees on one side). Working within these parameters, every photographer will find a way of getting their best photograph.

One of the main failings of photographers is to simply accept what is in front of them, making no attempt to reposi-

tion subjects, correct any problems or create a better shot. Almost every photograph is taken from a standing position regardless of what is being captured.

Look at your favourite photographs and apply the rules in this chapter. Many will obey them precisely, but some of the most striking will not follow the rules at all – and in some cases disregard them totally. Like a well-schooled painter such as Picasso, only by understanding the basic rules of composition can you go further and know when and how to break them.❏

Main attractions
CENTRE OF INTEREST
RULE OF THIRDS
POSITIVE AND NEGATIVE SPACE
ANGLES AND VIEWPOINTS
SCALE AND DEPTH
GEOMETRY
FRAMING
VERTICAL OR HORIZONTAL
CHOOSING THE MOMENT

PRECEDING PAGES: Sao Francisco de Assis and Nossa Senhora do Carmo churches at Mariana, Brazil. **LEFT:** Registan Square, Samarkand, Uzbekistan. **RIGHT:** Roman remains at Leptis Magna, Libya.

CENTRE OF INTEREST

ONE OF THE key questions to be considered when setting up a picture is "What will people be looking at in this photograph?" It's not just a matter of taking pictures of mountains, buildings or people, but the eyes of the viewer must have something to focus on, a point or centre of interest to which they are guided. Looking at a photograph, it is easy to see how the eye is led towards this point. But, as the photographer, you need to make this analysis before releasing the shutter.

The centre of interest can be created by colour, shape, position, action, detail, highlight or contrast. It may not be one single object, but could be a number of objects so arranged to direct attention to a specific area.

Picking out people

As a traveller, you can easily find yourself in busy, chaotic scenes. Your eyes may be very good at homing in on important detail, but the lens of your camera will capture everything.

Imagine taking a shot looking down onto a railway station concourse or a busy shopping mall. How do you avoid creating an image with an undefined mass of people rushing about, with nothing to focus on? Isolating a figure or group will tell the viewer what they should be looking at. So take the time to size up the scene: a single figure briskly walking across a shiny marble floor will have greater impact than a random group. Even within a mass of people, say all dressed in dark colours, then a single person in a bright colour will become the centre of interest, especially if placed at one of the "strong points" determined by the *Rule of Thirds*. Of course, a mass of people need not necessarily be randomly scattered; they could all be walking along a busy station platform in one direction, in which case they and their movement become centre of attention.

BELOW: Musicians in Parati, Brazil. But the guitarist's gaze makes the centre of interest the street rather than the music.

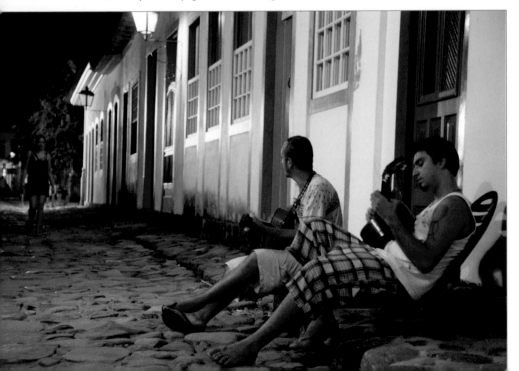

In addition to positioning a person correctly in the frame, an excellent way to isolate a figure or figures in a crowd is by using *depth of field*, focusing on a narrow plane with the background and foreground out of focus, much as when we see things with our own eyes.

Leading the eye

Some of the most successful images are very simple – an autumn leaf beside a blurred stream of water, or a person looking across a great *landscape*. One of the reasons these images are so effective is because there is no confusion about the main point interest – the eye is taken straight there. Paths, tracks, railway lines, roads rows of buildings, trees, fences, telegraph poles and wires can all be used to guide the viewer. If a path leads to a gate, then the gate should be open, inviting the viewer into the photograph. An open gate, door or window is always more positive than a closed one.

A flow of water can take the eye towards the leaf. *Vanishing points* can lead the eye to various parts of the image. Strong diagonals are a dynamic element to use, and can be created in almost every situation. Viewed from below, a modern bridge can dramatically launch itself into a photograph from an upper corner and lead the eye towards a town or city.

You should avoid including misleading guidelines that reduce the impact of a shot or confuse the viewer. This could be a meandering pathway that disappears out of the frame, rather than ending at a building, or the main branch of a tree that takes the eye off to the side rather than upwards. This also applies to people in a photograph.

Imagine a picture of a *market*, for example, where the centre of interest is a fruit seller and a particular pile of exotic fruit. People may be gathered around the stall, as subordinate elements, and it would be best to picture them looking at the fruit. The people's gaze leads the eye in the same way that a line of fence posts do.

Experiment with this rule about the centre of interest in mind. Think, too, of people looking away; their gaze could lead to another part of the image that may be just as interesting. ❑

Reference ▷

Rule of thirds, p. 78
Depth of field, p.100,114
Vanishing points p.85
Landscapes p.135
Markets, p.222

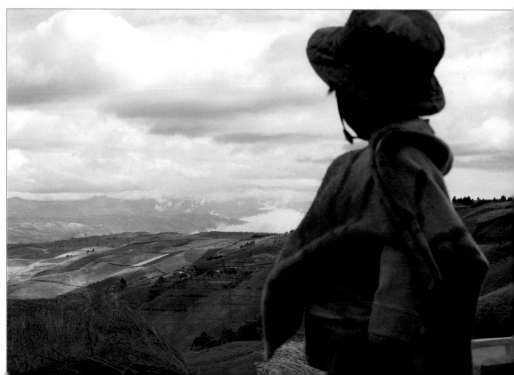

BELOW: Landscape surrounding the town of Guamote, along the Avenue of Volcanos in Ecuador.

RULE OF THIRDS

THE RULE OF THIRDS is one of the most important compositional factors for any photographer to recognise and learn. It divides the image into three sections, both horizontally (the horizon and seashore, for example, as pictured here, or row of buildings) and vertically, to obtain the best balance, harmony and overall feel.

Horizontals and verticals

A common mistake is to place the horizon in the centre of the frame, giving both foreground and sky the same space. This creates too much symmetry and hence a dull, static image. Instead, while looking through the viewfinder, try mentally to split the frame into "thirds" using two horizontal lines. Tilt the camera up or down and place the horizon on one of these two imaginary horizontal lines. This will give more priority to the ground or sky depending on which is the most interesting, or the mood

you are trying to convey. A dramatic sunset or threatening sky may deserve to have more of the frame, as might a field of colourful flowers or shining cobblestones. By adjusting in this way, the image will immediately start to look better.

Now do the same with the verticals and imagine two equally spaced lines running from the top to the bottom of the frame. Pan the camera right or left to place any vertical subject (standing person, tree, building, for instance) on one of the vertical lines either to the left or right of centre.

Strong points

The whole frame is now split into a grid of nine sections, like a game of noughts and crosses, or tic tac toe. Any subject placed along these lines will enhance the composition of the shot. The four points at which these imaginary horizontal and vertical lines intersect are known as "strong points", each

BELOW: The Rule of Thirds dictates the position of the horizon as well as strong points within the image.

of which is roughly a third of the way from the centre of the frame to the corner. People's eyes tend to veer towards these points rather than the middle of an image, so placing the highlights of the horizontal and vertical subjects here further enhances the impact of the photograph.

Positioning

For any given framing situation there will be an optimum positioning of points of interest at the strong points or along the horizontal and vertical "thirds". It is not necessary for all the strong points to be occupied; it can just be one or two, and generally the ones on the left have a stronger impact than the ones on the right (studies show that we scan pictures as we read a book – from left to right).

One of the strong points will usually be occupied by the main *centre of interest* such as a boat on a river, a farmer in a paddy field or camel in the desert. Shots such as these rely on the deliberate placing of large objects within the frame or perhaps waiting for them to move into a strong point

position. However there are also more static, close-up situations where the camera framing can be adjusted by zooming in and out or physically moving the camera nearer or further from the subject.

When taking pictures of people it is common to line the body up with a vertical line, and have the eyes level with the top horizontal line. The shoulders might then run along the lower horizontal line, or an even tighter shot could place the lips and mouth there, rather than too low down near the lower edge.

For a more complex creation, try using the rule in a dynamic, three-dimensional way. Imagine, for example, two slender white minarets soaring into a blue sky. Your first thought should be to manoeuvre yourself into a position where each minaret is on one of the vertical lines. Then reposition yourself to allow the top of one of the minarets to end at the higher strong point, and the other to end at the lower strong point.

Sometimes it is not possible to make it all happen, but as long as you know

Reference ▷

Centre of interest, p.76
Portraits, p.206

BELOW: The most dominant feature of this image, the girl's right eye, is positioned on a strong point.

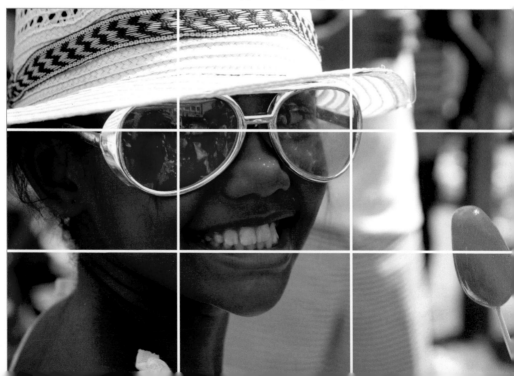

Reference ▷

Rule of thirds, p.78
Panning, p.102

what you are trying to achieve the quality of your photographs should improve. Get it right and the resulting image can be stunning.

The Golden Section

The Rule of Thirds is an approximation of a much more precise mathematical ratio called The Golden Ratio or Golden Section. This "Divine Proportion" ratio, thought to have been deduced by the mathematician Pythagoras, has been used for more than 2,000 years to produce eye-pleasing paintings, structures and images. An oblong shape with this width/length ratio of 1:1.618 (or 0.618:1) is aesthetically more pleasing than any other, and can be observed in the proportions of the Parthenon in Athens, as well as countless famous paintings. The artist Leonardo da Vinci employed the Golden Ratio in many of his works, including the Mona Lisa, as did the architect Le Corbusier in his buildings.

BELOW: The Golden Section overlays an image from nature.

Not only should the external dimensions of the image be in this ratio (roughly the same as a 35mm film)

but so should points of interest within the photograph. The laws of mathematics and nature dictate that the overall shape and position of objects within that shape look more pleasing when they follow these "rules". This ratio also appears naturally in crystal growth and human body dimensions, in plants and in seashells, and it has a connection with the Fibonacci number sequence. The term "Golden Spiral" covers a range of mathematical approximations that turn this ratio into a pleasing spiral, which twists towards one of the strong points (or very close to it).

As a photographer, you might be wondering what use this can be when taking a photograph, but as long as you recognise that some ratios have a natural balance, you can start to create more eye-pleasing shots.

Some SLRs now have grid line options on their visual displays that can show where these natural strong points are. Some software, such as Photoshop, has this too, as well as a Golden Spiral overlay that rotates into one of the strong points. ❑

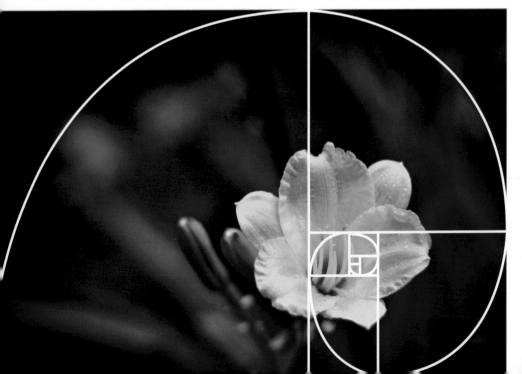

POSITIVE & NEGATIVE SPACE

THE MAIN SUBJECT of a photograph is said to occupy "positive space", while all the area around is classified as "negative space". The amount of negative space might thus seem arbitrary, but is actually extremely important when balancing out the look and feel of any image.

A portrait of someone looking directly at the camera looks natural and balanced when positioned in the centre of the frame. However, this does not apply for a person photographed in profile, where a more natural and satisfying position is to have less space behind the head and more in front of the face.

Moving subjects

When taking photographs of people, animals, vehicles or anything else that moves, it is important to allocate the negative space around them. In the *Rule of Thirds* the subject should ideally be placed on one of the imaginary vertical lines splitting the frame into thirds. At this point, the subject will now split the frame into 1/3rd and 2/3rds. A moving subject should be allowed to move into the larger 2/3rds of the frame rather than the smaller 1/3rd of the frame.

By keeping this in mind, it should be easier to anticipate the framing of fast-moving subjects such as running animals or speeding cars. Simply *panning* the camera slightly to left or right should help you release the shutter just at the right moment.

Cropping

One of the great benefits of a digital image is that you can immediately see the results, and if you get it wrong first time, or it could be better, then you can try again. In a case where a photo cannot be repeated, if the subject looks awkward moving into negative space, all might not be lost. In the same way that a landscape can become

BELOW: Youngsters playing football in Brazil, with the girl moving into the larger 2/3rds of the frame.

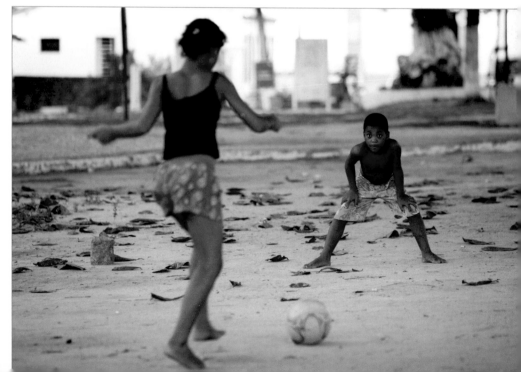

a portrait or vice versa by severe cropping, a large negative space can be reduced in size and cropped. Your good travel photo could still become a great travel photo, though the image may be reduced in size.

Think positive

Static people and animals should be looking into positive space as well. The classic image of somebody pointing or looking should always be into this larger area ahead of them, if only because it looks strange for people to be pointing out of the frame, away from the great space that we, the viewer, can see behind them. We see examples of this all the time on television, when an out-of-shot interviewer is talking to a guest. The person will be talking directly to the interviewer, but from left or right of the frame (again the *Rule of Thirds*), and looking into the larger space.

Of course all rules can be broken and powerful stories or scenarios can be told by having a subject leaving the frame (moving into negative space). For example, if there is a person walking out of frame, while behind them in the larger space is a sign saying "Beware of Landmines". Or perhaps two people who have had an argument are shown with their backs to each other, both looking out of frame, one to the left and one to the right, can create an atmosphere of tension. And having a *portrait* of one person looking out of the frame rather than into it may help to create a certain mystique, with the viewer wondering what the person is looking at – a shepherd gazing up at the sky, for example.

Vertical view

As most things tend to move along the ground, we are generally referring to landscape formats. However the same principle applies for portraits of people gazing upwards, looking through telescopes, space rockets on launch pads and so on.

Even a photograph of a tree should allow some space at the top for it to grow into. Likewise ancient columns at an archaeological site or even skyscrapers in New York. ❑

BELOW: Many photographers will go to great lengths to to get a better angle on their subject.

Fill the Frame

There is nothing worse than having a wonderful subject that is too small in the frame. Telephoto lenses can help with distance shots, but when it comes to photographing people, nothing can beat a good fixed lens – traditionally around 100mm – and getting in tight. The mantra that "you can never get too close" is a good rule to follow for the travel photographer. Travellers often have a great subject in front of them, but miss out on getting the detail by standing too far back. You may feel inhibited getting too close to people, but as long as they are happy, blast away getting full frame head shots, and even face details. Four or five shots is about as many attempts as you get, and your intrusiveness will seem less threatening if you share your shots, showing your subject a digital image each time.

ANGLES AND VIEWPOINTS

EVEN THE MOST famous locations in the world can be given new life when seen from an unusual angle. Far too many photographs are taken from a standing position right in front of the sight, so try to change your viewpoint. Look around for better positions, roof access, high or low elevations. People can be captured in a different way, too.

High and low

Standing on a chair to photograph a group of people immediately gives a different viewpoint. The rise in height will allow the lens to include everyone in a group shot, and chances are they will all be smiling because you are doing something unusual.

Conversely, a low position has the advantage of getting more into the picture vertically, and despite everything that is said about the benefits of realistic size and *scale*, striking shots can be gained by using this trick to make humans seems the same size as a skyscraper or tower. In New York's Times Square, for example, just placing the camera on or near the ground and taking a shot looking up from sidewalk level will produce a more unusual image, with passers by looking taller than buildings.

Taking a picture of a tall building from below may produce the distortion known as "keystoning", the result of the camera's sensor not being perfectly parallel to the subject. This can add to the graphic quality of the image (see *Skyscrapers*). However, there is software to correct it, or the option of investing in an expensive shift lens. The effect can be more irksome when taking pictures of more close-up subjects such as tiles with geometric patterns, in which case the advice is to stand back and use a telephoto lens to limit the distortion.

Don't be afraid of tilting the camera off the horizontal. World famous sites such as London's Tower Bridge can be given new life when seen on the slant

BELOW:
Carnival parade performer at the Sambodrome, Rio de Janeiro, shot from a low angle.

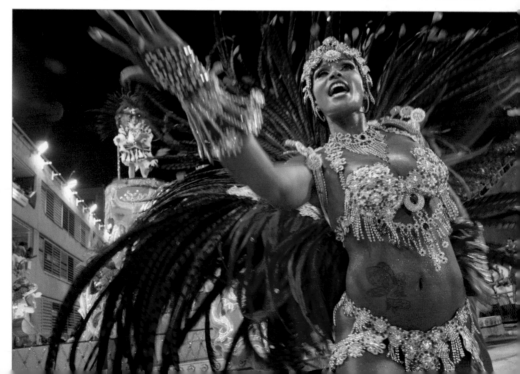

from below. The roadway can be made horizontal so that the vertical towers tilt ludicrously away to one side and yet the bridge is still instantly recognisable.

Whatever the location, try to create as many different *viewpoints* as possible. Everyone takes shots of London's Tower Bridge, but how many people shoot the river from the bridge while including a small recognisable part of the building? Or shoot upwards while standing on the bridge – it will still be clear where you are.

Vantage points

Views of villages from surrounding high ground, or towns from high points looking down on their main streets, give invaluable overviews for any narrative of a journey. Views from the rooftops of *tall buildings* such as the Top of the Rock in New York or towers like the CN Tower in Toronto can produce great *cityscapes*. Other high-vantage points can give unusual versions of standard sights. A local fisherman casting a hand net into a river looks completely different when viewed from the top of a

nearby building. Many public buildings, including hotels, have lofty views that are open to the public.

Something different

Be on the lookout for the unusual. Try holding the camera at arm's length, upwards or sideways. It can provoke a humorous reaction to people unused to having their photographs taken this way. Get used to turning around and looking behind you. What does the Sistine chapel floor look like? What do you see when you turn your back on the Taj Mahal? What are the elevators like in the Empire State Building? The astonishment of visitors' faces when they come across a sight can be a telling moment to explain its awesome power.

Descending stairways into a dark tomb or subterranean cavern might not offer great images, but turn around and photograph someone behind you silhouetted against the glaring doorway. Strange angles, unusual size comparisons, weird viewpoints, unobvious framing and unexpected reflections can all produce striking and thought-provoking images. ❑

BELOW: The Egyptian Spice Bazaar in Istanbul viewed from above.

SCALE AND DEPTH

IT IS OFTEN difficult to convey the size of some objects, both large and small, and a well-placed comparison of something of a known height, such as a human figure, can help. A landscape of fields or *desert* can be meaningless unless there is something nearby and relevant to give it scale. A photograph of a sand dune on its own means very little, as it could be a few metres or hundreds of metres in height. A person sat on top of a dune in Oman will show that it is relatively small, whereas a tiny figure struggling up a sand ridge in Namibia will explain its enormity. A single tree will have the same effect.

Depth of field

A sense of scale can be achieved by using *depth of field*. If everything in the frame is in focus, it can be difficult to identify both the main subject and the relationship between objects. By using a reduced depth of field, distant objects can be thrown out of focus, not only highlighting the main subject, but also giving an idea of foreground and background. Having a "soft" foreground, reducing the focus to a single point in the background, can be very effective in producing a sense of scale. A vast field of flowers, for example, could have the closer ones unfocused, leading the eye to an in-focus subject, such as a scarecrow or barn.

Vanishing point

One of the most effective ways of showing depth is to include a "vanishing point". We have all seen photographs of parallel railway lines, avenues of trees or rows of houses heading off into a single convergent point – the vanishing point – in the distance.

The position of the vanishing point in the frame will greatly affect the look of the shot. Most vanishing points are placed in the centre of the frame for

BELOW LEFT: Tiny figures in the foreground help to convey the scale of the giant Buddha at the Beopjusa Temple in Korea.
BELOW: Reduced depth of field can help to define foreground and background, as here at Kynance Cove, Cornwall.

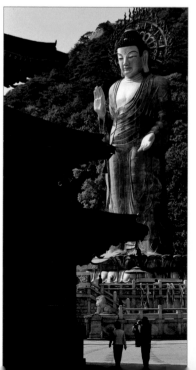

symmetry's sake, but placing them at one of the four *strong points* can give a more dynamic look.

Another way to enhance the main subject is to focus on the foreground. A rich mosaic in front of a ruined building can add information, colour, interest and scale. Too much emphasis on the foreground, however, might deflect attention from the main subject.

Tones and shadows

The tones that make up your photograph can help to give perspective. A brightly lit farmhouse can seem to burst out of the frame when placed in front of a series of indistinct mountain ridges growing fainter in the distance, a useful natural atmospheric effect.

Shadows are also vitally important to give rounded depth to 3D objects, such as a statue. When viewed in even light, objects can appear flat and lifeless, but by increasing the contrast and having a shadow along one edge, the object can suddenly come to life. This highlighting can be created by direct sunlight, artificial light or by closing down your aperture by one or two stops. ❑

GEOMETRY

ONE OF THE FUN aspects of photography is playing around with shapes, patterns and colours, especially if it makes the viewer think and analyse the photograph. The objective here is to view the overall effect that shapes make within a photograph, rather than the individual items themselves. A well-composed, tight image of common objects such as leaves, bottles, pipes, bricks and rooftops can force the viewer into really noticing the composition and layout. Moving in from a wider view will create angles and patterns, which eventually become *abstract* images, sometimes making the object indiscernible.

Repetitive patterns

Repeated patterns always make interesting images, even something as simple as a series of terracotta roof tiles. Instantly recognisable from around the Mediterranean region, no other part of the building is needed, just a

BELOW: Casting shadows at the Yad Vashem Holocaust Museum, Jerusalem.

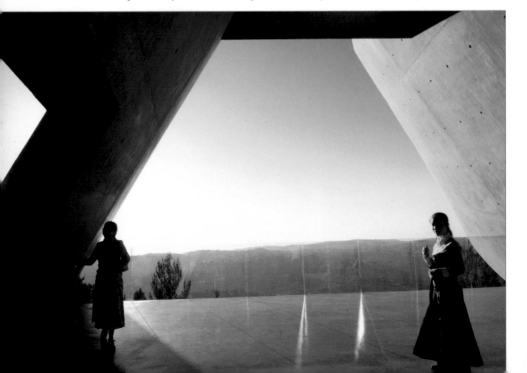

series of curved tiles, especially if the lines are placed along the diagonal. Rows of trees in a misty plantation; a line of products on a busy market stall; a series of prayer wheels at a remote Buddhist temple, are all suitable subjects for creating converging lines, diagonals and patterns.

The play of light and shade on any geometrical man-made or natural pattern – railing, fencing, flooring, trees – can lift an otherwise simple image into a stunning photograph. The shadows cast by the slats of window blinds are powerful repeated images within a room.

When dealing with patterns, your framing needs to be tight enough so that the shapes fill the entire image, without peripheral distractions. But a balance needs to be struck by not getting too close, so that any one element becomes a dominant feature. A row of identical bicycles in China or shopping trolleys in the USA looks great filling the frame, but is even better if it is in contrasting colours and placed at one of the *strong points*. People, such as the dancers below, can also make striking images.

Light conditions can also help to create amazing patterns, such as a series of alternate light hills and dark valleys receding into the distance.

Symmetry

Symmetrical images are harmonious and attractive. Two graceful swans facing each other can seem a perfect sight. An upside down river *reflection* of a city skyline, or a mountain in a lake, has the same pleasing effect. However, complete symmetry can become boring and it is sometimes awkward having one or even two mirror images, as this generally offers halves and quarters of a frame. Thirds, as suggested in the *Rule of Thirds*, can offer alternatives, and groups of three and five generally give greater scope for creating shapes of triangles and diagonals.

When creating photographs of shapes, eliminate any unwanted objects that reduce the impact of the shot. In most cases, the simpler the better. The main thing is to be observant enough to see the geometry of shapes and patterns, on both a macro and a micro level. ❑

BELOW: Repetitive patterns can be found in people, such as dancers, as well as objects.

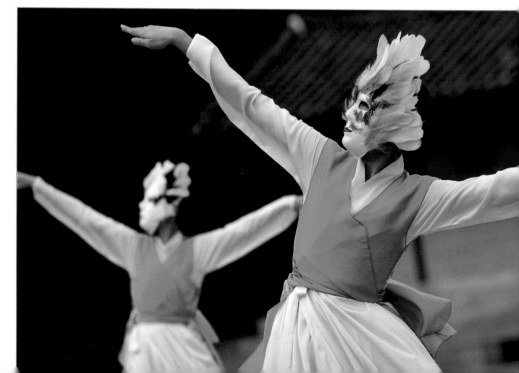

FRAMING

ALTHOUGH IT is possible to lead the eye towards the *centre of interest*, one of the most effective ways of focusing attention is to frame the main subject. Taking a photograph through a window is an obvious way to do this, especially if the texture or construction adds information – a distressed wooden window frame with peeling paint while looking out towards an old farmyard with rusting equipment, a face at the window of a city block. Some frames appear naturally – a church neatly framed by overhanging trees viewed from a road – but at other times they have to be searched for and even invented.

Natural frames

A traveller on the road will find that the most effective and flexible frames are trees, branches, leaves and bushes. An uninteresting view of open countryside can be improved by framing within a tree and its branches. This also adds depth, since the tree is nearer the camera than the view.

Such framing can clean up an otherwise untidy shot, perhaps blocking out an unwanted distraction or intrusion. If there are no convenient boughs to frame your shot, find a branch of leaves to hold at the side of the frame.

Imagine a perfect rural scene but with an unwanted object such as a telegraph pole and unsightly wires or an electricity pylon in the distance – a common problem at historical sites in developing countries. By the carveful use of more natural objects such as a tree and branches, especially in leaf, it is possible to hide such distractions. Even a pylon sprouting from the top of an ancient building can be hidden by a branch of leaves.

Doorways and arches

Doorways and arches offer great framing possibilities and are available if you look around. Because they are usually

BELOW: Trees used to frame the Byodo-In Temple, Oahu, Hawaii.

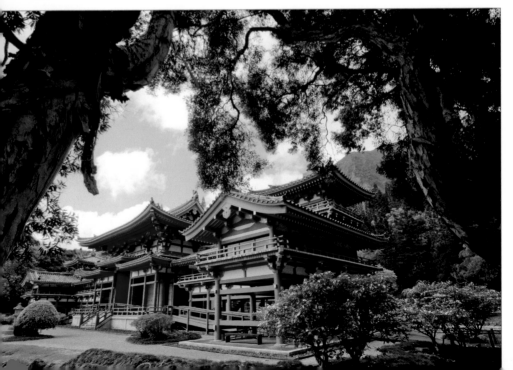

solid frames in shadow, they can completely alter the dynamic of an image, akin to using a mask or cropping template. Make sure you know where your camera is getting its light reading from, as there are great contrasts between the bright centres and dark edges in these situations. Some frames can naturally echo the subject – a semicircular arch fits wonderfully around a church dome for example.

Be careful about positioning subjects too tight inside this smaller "framed" space. A tighter *Rule of Thirds* will now apply within the new framing, so reposition those as well.

Preparation needed

There are many innovative ways to use frames to create striking images, some of which will need a little thought and preparation. Go through any series of travel shots and see where the basic idea of framing is used. It might be shooting through another person's hands where the fingertips are touching to create a square frame. A surrounding ornate metal fence might not be such a hindrance to a great shot. Try to create

a frame of metalwork while looking through at the main subject. Depth of field is usually a problem here, as it is hard to get both the close-up framing and the distant object in focus, unless using a tripod and longer exposure (1/8–5 seconds).

Bookends

Framing does not have to encircle the entire image and can be used more like "bookends". A photograph showing a new church construction might be highlighted by placing it between two closer domes. This kind of framing has the desired effect of creating a more interesting image than the incomplete church on its own, and also hides some unattractive construction equipment.

Once you get used to the possibilities of framing it can become a useful technique and quite a bit of fun to see what you can achieve. Tired shots of *iconic sights* can be given new life and repackaged by framing. Even the Taj Mahal at Agra takes on a new aspect when framed through the archway of one of its surrounding buildings. ❏

Reference ▷
Centre of interest, p.76
Rule of thirds, p.78
Tripod, p.295
Iconic sights, p.180

BELOW:
The Eunjin Mireuk statue framed in an opening in the Gwanchoksa Temple, Korea.

VERTICAL OR HORIZONTAL

ALMOST ALL cameras are set up to take shots in a landscape (horizontal) format, which is the nearest configuration to replicate the view of two human eyes. But unlike our eyes, which are incredibly versatile at focusing and absorbing images, we must place a single circular lens on the camera in order to record what we see. The viewfinder then gives us an image of our intended subject in a horizontal, rectangular shape.

Because our eyes are also horizontally placed, a scene shot in "landscape" format looks more appealing than one on a vertical, "portrait" format. We don't place our heads on one side with one eye on top of the other to look up at a tall building. Yet this is essentially what we do when we rotate the camera through 90 degrees to get a vertical shot.

Sideways look

Horizons, seascapes, houses, vehicles and general scenes are much more suited to a landscape format. Despite this, there are many occasions when the subject will fit more suitably into a portrait format. Anything to do with the human body – the standing human figure, head and shoulders shot, and close-up of a face – all naturally fit into this vertical view. Get used to turning the camera on its side when the situation dictates.

There are, however, some problems with taking portrait formats. The vertical lines of a tall building will converge at a vanishing point somewhere in the heavens. This natural angle is even more exaggerated by the parallel edges of the frame, especially as you get close to the edge, where the building appears to bend inwards. This can sometimes be compensated for using special sofware, but it is always a balancing act between an aesthetically pleasing shot and reality.

Although *seascapes* and landscapes look more natural in a landscape for-

BELOW: This image, of a dirt track in Senegal, could only be taken horizontally.

mat, there are often compromises to be made. By taking a portrait of the sea horizon it might be easier apply the *Rule of Thirds*, especially if a setting sun or cloud formation is on the other third, something that could be difficult to achieve in the landscape format without a telephoto lens.

Shooting "landscape" or "portrait" should give you enough options in any situation, but don't be afraid to find a halfway house as it doesn't have to be "one or the other". Some monuments and other large structures might not fit easily into either format, so try holding the camera at an angle in between, using the longer diagonal, which can often provide strong images from one corner towards the other.

Video tilts

For the best quality shots a tripod should be used. But before purchasing a tripod, ensure that it can easily be rotated into a vertical position. Many cheaper tripods and those designed for video cameras (a video camera does not need to be turned onto its side, it just needs to tilt up and down)

do not have the facility to move through 90 degrees. Even tripods with this option can be awkward and frustrating to swing into position, so test fully before buying.

Internet compatability

We are all used to looking at television and computer screens as a 4:3 landscape format and 16:9 widescreen. Portrait images do not fit particularly well into this space giving severely reduced image size with large areas of blank screen either side (*see Negative Space*). This is important if your photographs are to be regularly viewed on the internet or on digital albums, where landscape shots naturally fit better. Portraits can be cropped to become landscapes but with a severe loss of size and quality.

However, portrait formats suit the print media, which is still mainly set up around the vertical image of book, magazines and newspaper pages. If possible, therefore, if you are hoping to distribute or market your pictures, try to take both landscape and portrait shots. ❑

Reference ▷

Portraits, p.206
Seascapes, p.145
Rule of thirds, p.78
Tripod, p.295
Space, p.81

BELOW LEFT: This image, in Kerala, most naturally fits into the vertical format. **BELOW:** Some subjects, like this example in Boston, lend themselves to being tilted.

CHOOSING THE MOMENT

HAVING MADE all the compositional preparations, there is still the decision as to when to actually release the shutter and take the picture. This may sound an obvious thing to do, but it is not always as simple as it would appear. Although digital cameras allow instant reviewing, there are plenty of other gremlins ready to ruin your perfect shot. Many a photograph has been well planned and set up, only to be let down by the actual "moment" – the subject looking away, closing their eyes, another person walking in front, etc.

One of the most important "moments" to wait for is eye contact with the subject. In a one-to-one situation this should not be a problem, but in crowded and noisy travel situations there are sometimes too many distractions for the subject to look only into your lens, including other photographers taking the same shot. Patience will eventually reap rewards.

BELOW: A Guatemalan butcher shares a happy moment with one of her customers.

If everything is under the control of the photographer, such as in a studio or still-life scenario, there is no excuse for not getting everything exactly right. But with travel photography, few things are under your control, and situations are often conspiring against you. Choosing your correct moment will require quick decisions on *viewpoint*, composition and *focusing*. Anticipation and spatial awareness are probably the greatest assets for this.

Shutter delay

Depending upon the speed of your memory card, type of camera or flash recharge time, there might be a delay in the shutter releasing, making it difficult to judge the split-second moment that the camera will capture. Familiarity with a particular camera set-up will allow you to build such delays into your calculations.

We have all taken shots when the subject closes their eyes just at the

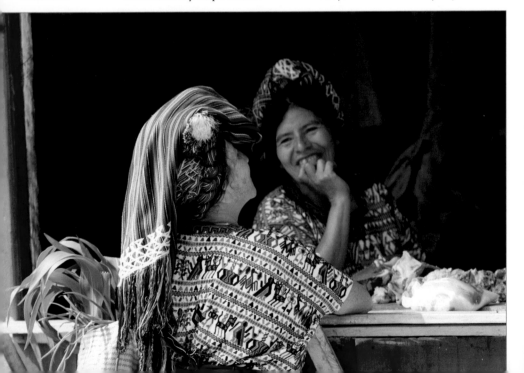

wrong moment, especially if they have been waiting around for some time. In this case it is a good idea to keep talking to them and indicate when you are about to take the shot. Often it is simply a case of luck.

Pizza action

A popular shot for travel photography is a chef spinning dough or whirling pizza bases around as he prepares them, but the exact location of the flying pizza is impossible to predict at the moment the shutter opens. The resulting disc might obscure the chef's face, move half out of frame or even look like a small model of the moon if highlighted by flash. Take several shots and at least one should turn out fine.

No matter how much preparation you put into a shot, there is always something else to think about. Sometimes it's the one thing that you forget or miss that becomes the main point of discussion afterwards. It could be a distant tree sticking out of the top of somebody's head; a bridge that looks as though it runs into the side of a building; or someone in the background messing around.

Playing back the moment

When you choose "the moment", you are concentrating so much on all the topics in these chapters that other things might not be noticed. But once it's viewed and pointed out, it will always be an unsatisfactory element within that shot. Digital review should give the opportunity to check the shot immediately afterwards, but having not seen the problem originally, it might not get picked up a few seconds later when viewed through a small screen.

The only sure way is to play back immediately on a larger screen (such as a laptop or TV) and thoroughly inspect the image, which is how the professionals ensure that they've got the shot.

Technical improvements can be made retrospectively using software, but the composition of a photograph, the capture of the action and the eye contact with the subject might only last a fraction of a second. That is when you need to be ready to choose "the moment". ❑

Reference ▷
Viewpoint, p.83
Focus, p.104
Portraits, p.206

BELOW: Missed the moment, as the elder sister is suddenly distracted.

Compose Yourself

If you ticked off a checklist of all the advice given in this book, it would take hours to create just one shot. Even these rules on composition would take a few minutes to go through. But with travel photography you seldom have the time. Everything tends to be done on the fly, usually in chaotic, noisy environments and often with people who are unsure about having their photograph taken. In order to get great shots quickly, most of the above should be well rehearsed, coming as second nature without really thinking. Practise how to use your camera, be familiar with all the settings and know which techniques work and which don't. When you're in the middle of a crowded market in Timbuktu or Taipei, you won't have time to look at this book, so try it all out before leaving home. Practice really does make perfect.

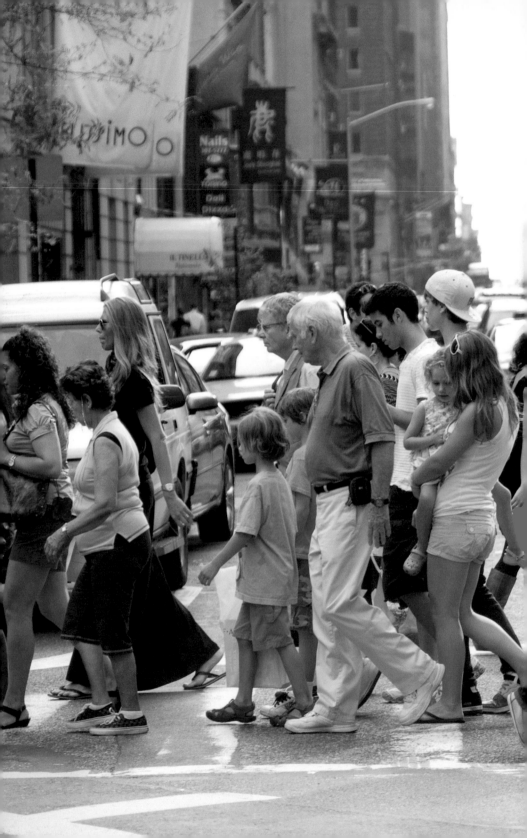

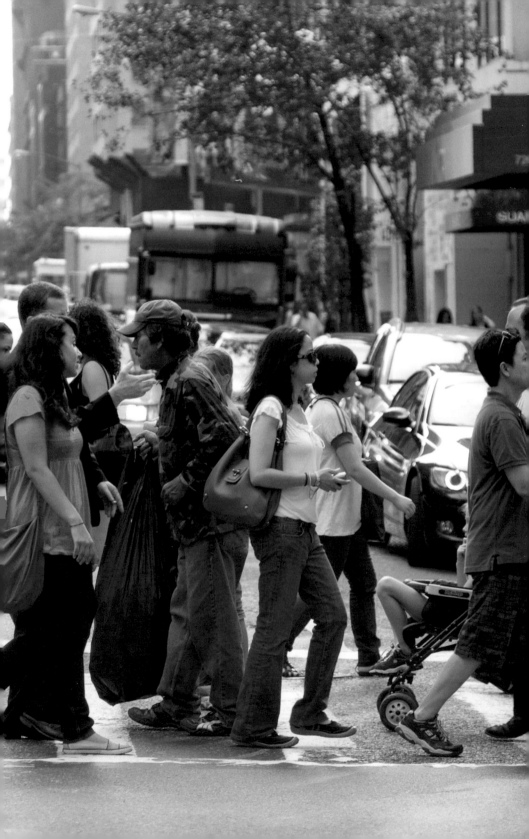

THE CAMERA

From light and composition we move on to the camera and how to get the best out of it. Here are the basics about compacts and DSLRs, settings, exposures and lenses. Plus tips on video performance

Digital, apart from everything else it has done to photography, has complicated hugely the choice of camera – but in the nicest way. From small compacts that will slip into a shirt pocket to high-end SLRs, there is variety to suit most budgets and every need that manufacturers can anticipate, plus a few more features that they hope will become needed.

The ground rules for camera design are open and the nature of digital technology means constant innovation. A year is a generation in the camera world. A large part of the choice of what to buy and what to take when travelling depends on how serious a part of your trip the photography will occupy. But more basic than this is the variety of sensor, of image format, and what still remains the big divide among digital cameras: compact or DSLR.

Digital cameras come in all kinds of sizes and flavours, touting this feature or that, but the two major classes are compacts and DSLR (digital single-lens reflex) cameras. The major difference lies in what the DSLRs have and the others don't: through-the-lens viewing by means of a prism and a mirror that flips up at the moment of shooting, and interchangeable lenses. Some mirrorless cameras also offer a range of lenses, but by and large, compacts do a simpler job with less fuss and less weight, while DSLRs are the choice of professionals and serious amateurs. This does not mean that DSLR image quality is necessarily better, just that there are more features.

Manufacturers are constantly blurring the lines by launching models designed to "bridge the gap". The shape of the image (which comes from the shape of the sensor), otherwise known as aspect ratio, tends to divide along the same lines. Most compacts produce

Main Topics
SETTINGS
EXPOSURE
LENSES
VIDEO

PRECEDING PAGE: Crossing the street in Manhattan. **LEFT:** A monk taking in the sights from Phu Si hill in Luang Prabang, Laos. **RIGHT:** Zooming in.

images in the proportion 4:3, known as "four-thirds", while DSLRs tend to follow the old 35mm film standard of 3:2. Creeping up behind is the newer 16:9, which fits HD television, and will probably grow in popularity.

The importance of sensors

Before buying a camera, it is important to know about the variety of sensor. The heart of a digital camera is the product of intense miniaturisation. The front surface is packed with small photosites, one per pixel, which collect photons that are then stored briefly as an electrical charge. The more pixels there are, the higher the resolution of the final image, and so the bigger it can be printed or displayed. For this, sensors and their cameras are rated by megapixels (one million pixels). All digital cameras have sensors that will produce a good-sized print, and will fill a computer or television screen.

To work out how large a digital image you need for a screen or a print, you have to know the resolution, which for a screen is between 72 and 96 pixels per inch, and for most high-quality printing is generally accepted to be 300 pixels per inch.

For instance, a compact camera with a 12-megapixel sensor delivers an image that measures 4000 pixels across by 3000 pixels deep. That will make a good print measuring 13 inches by 10 inches. For a computer display, all you would need to fill, say, a typical 15-inch screen is between 1000 x 600 and 1200 x 800, while even HD television needs just 1920 x 1080. In other words, for almost all needs other than large gallery prints, most camera sensors do the job perfectly well.

The photosites on a sensor collect just light, and do not discriminate colour, so to create a colour image, the sensor is faced with a grid-like transparent filter called the Bayer array in a pattern of red, green and blue. One colour covers one pixel, so the colour resolution is lower than the bright-to-dark resolution, and the "colouring" of the final image is estimated in the camera. However, as our eyes don't require as much detail in colour as they do in brightness, it all works out well.

Calculating colour is just one of the

BELOW: An image taken with a Holga recalls the early days of photography *(see also page 32).*

Retro Revival

Perverse though it may seem to many, the super-technology of digital cameras has bred a reaction – a new-found love among some photographers for the imperfections and distressed-image qualities that came from cheap, throwaway plastic cameras. Models like the Holga and the Diana make a virtue out of low fidelity, utter simplicity, and the effects of using a cheap plastic lens, which include softness, colour fringing, flare and vignetting (darkening towards the corners). This cult is, of course, a part of the constant search among photographers and the people who use photography for new and different styles of imagery. If you are on the road, one extra advantage of toy cameras, if you like their results, is that they are unlikely to get stolen!

tasks that the camera's internal processing has to do. The others are converting the electrical charge from the sensor into digital values, and making the image look "right" to the human eye by brightening part of the range. Digital capture is "linear" in that it doesn't vary from bright to dark, whereas the human eye, and film incidentally, registers more information in the highlights and shadows.

Processing images inside the camera is a complicated business, which is why sensor and processing unit are inseparable. Sensor sizes and performance vary between cameras, and the best are found in high-end DSLRs, which generally have what are called full-frame sensors (meaning the same size as former 35mm film: 24x36mm). Even modest compacts have 10MP, but while squeezing more and more pixels onto a sensor improves the amount of detail that can be captured, it does not help noise, which is why DSLRs that perform well at high *ISO sensitivity* settings make more careful use of their larger sensors. Larger pixels capture more light and so are less prone to noise. If you are choosing between cameras, make sure that you check megapixels, colour fidelity and noise performance on one of the many comparative websites.

Still with film

Digital may have taken over photography almost completely, but it's a confident prediction that film will never disappear. Some photographers still prefer film for being less complex and for being more forgiving of harsh lighting and less-than-perfect exposure. Film cameras are much more mechanical than are digital models, which makes them more long-lasting, and there are countless available secondhand. Taking a film camera on your travels can be a less expensive and more robust option, and if you are in remote places without the necessary supply of electricity, a film camera remains useful. But remember that there is no instant review to show you got the exposure and framing right, so accuracy is important. Film cassettes or rolls need care, in particularly keeping them out of heat and bright sunlight and avoiding too many passes through an airport x-ray scanner. ❑

Reference ▷

ISO sensitivity, p.103

BELOW: Film has not disappeared altogether.

SETTINGS

ALL CAMERAS offer a choice of settings in order to try and satisfy different tastes and ways of working, and the choice can be daunting. Moreover, manufacturers often cloud the issue by offering proprietary extras with fancy names that in reality are just ways of processing the image that you already captured.

To cut through all of this, just remember that there are three key camera controls – aperture, shutter speed and ISO sensitivity – and then there are the digital settings that affect image appearance and quality. First, let's look at the three key controls, all of which control the amount of light that goes to make the image, but do other things as well.

Aperture

The lens aperture is a diaphragm that closes down (called stopping down) to restrict the amount of light from the scene that will strike the sensor and make the image. The aperture is measured in ƒ stops; these are for convenience, so that each stop smaller than the one before lets through half the amount of light.

Because they are on a log scale, the actual numbers don't immediately suggest this, and the sequence goes like this, from wide to small: ƒ2 ƒ2.8 ƒ4 ƒ5.6 ƒ8 ƒ11 ƒ16 ƒ22. When the diaphragm is completely open, the aperture of the lens is at its maximum, and many lenses go no wider than ƒ4 or ƒ5.6. Lenses that are wider than this at their maximum, such as ƒ2 or even wider like ƒ1.4, are considerably more expensive to make, and are called fast lenses. At the other end of the scale, some lenses, like long telephotos and macro *lenses*, stop down to ƒ32 or even more.

Older lenses had a mechanical aperture ring on the barrel that could be turned manually, but nowadays aperture can be altered from controls on the camera body. Stopping down

RIGHT: The pictures here demonstrate the use of the aperture. Those at top left and bottom left were taken with a large aperture, which lets more light into the camera and enables faster shutter speeds – important for taking pictures in low lighting or freeze framing. A small aperture, as used in the picture on the right, increases the depth of field, but in low light conditions you may need a tripod.

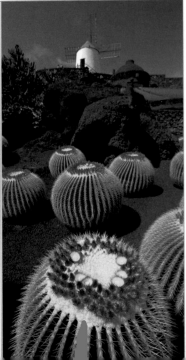

has another important effect apart from reducing the amount of light: it increases the front-to-back sharpness in a scene, known as the depth of field. We'll look at this in more detail later on, but the more you stop down, the more of the scene will be sharply focused. For many, perhaps most situations, this is ideal, but there are others that we'll look at later when you might want to concentrate attention on just one sharp subject within the scene.

With any picture you are about to take, it helps to decide from the start whether you want clear detail throughout, or to make one part of the scene stand out by being sharper than its background and/or foreground. In the first case, the aperture you need will depend on how deep the scene is. *Landscapes* and *cityscapes* where you have middle-distance to distance but no foreground – overall views, in other words – will usually be sharp with a middle aperture setting – $f8$ or $f11$, for example.

Close-ups with foreground and background both in frame will definitely need a small aperture (eg $f22$), although at such small apertures the lens sharpness suffers a little. To throw all but one subject out of focus, make sure that it is clearly separated in distance from anything else, and use the widest aperture possible.

Shutter speed

The shutter speed also controls the amount of light that reaches the sensor, so that stopping down the aperture by one f stop at the same time as slowing down the shutter speed by one level leaves the exposure unchanged.

The reason for this choice is so that you can decide whether you would rather have good *depth of field* from a small aperture, or sharply caught movement from a shorter shutter speed. As with depth of field, most people in most situations would prefer to have any movement in the frame, such as someone running or a bird flying, sharp rather than blurred.

But photography allows for all kinds of creative imagination, and some motion blur – a kind of streaking that happens when the shutter

Reference ▷

Depth of field, p.114
Lenses, p.113
Landscapes, p.135
Cityscapes, p.180

BELOW: This image is a compromise between speed (1/250 sec) and light (aperture wide open at $f2.8$), so the Takraw player appears a little blurred. Compare with the picture of the Thai boxers on page 217, taken at 1/500 sec.

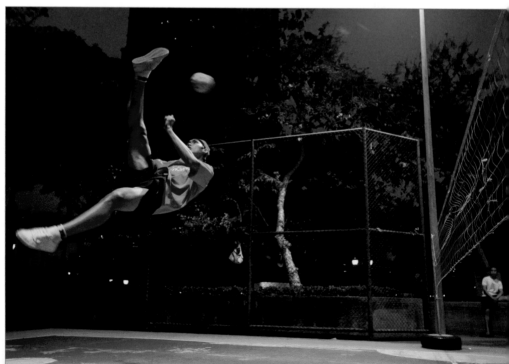

speed is slower than the movement – can give a better feeling for action (*see panel below*).

It is useful to be aware of two things: the slowest shutter speed at which you can hold the camera without introducing shake into the image, and the shutter speeds needed to freeze different movements of subjects. Your best hand-holding shutter speed can be improved by a few simple techniques, including keeping your hands tucked into your sides, squeezing not jabbing the shutter release, and using a solid grip by letting the camera sit firmly in the palm of one cupped hand.

It will also depend on the focal length of the *lens*, as the longer the focal length, the more magnified will be any twitches and shakes. As a rule of thumb, 1/125 sec is generally safe (though you would need faster with a long telephoto of more than, say, 300mm), while it's possible to train yourself to shoot at 1/30 sec or even slower with a wide-angle lens. However, the subject itself may show blur at these lower speeds.

BELOW RIGHT:
Some examples of motion blur, with the disappearing lights of a car and some twirling dancers.

When choosing the right shutter speed for a moving subject, remember that it's how fast the movement looks through the viewfinder – someone running at a distance, with a wide-angle lens does not need as fast a shutter speed as they would if filling the frame and zipping across it in a second. A rule of thumb is:
• 1/60 second when there is only gentle movement
• 1/125 for a person moving normally
• 1/500 (at least) for any action that you would generally consider fast, such as *action sports*.

If a subject is running or moving across your field of vision, the natural reaction is to swing the camera to keep it in the frame; this is known as panning, and of course helps to keep the subject appearing to move slower in the frame. Finally, some cameras now feature tiny micromotors to "stabilise" the view and compensate for shaking hands and other involuntary movements. This vibration reduction, if your camera has it, can help you to photograph at up to two levels of shutter speed slower than you would

Motion Blur and Panning

When the shutter speed is too slow to freeze movement (either the subject or the camera), the result is streaking in the image – in the direction of the movement. This is motion blur, and whether it's a good thing or a bad thing depends on the kind of result you have in mind. A perfectly frozen moment at 1/500sec or faster, such as of a horse in mid-gallop with all legs in the air and dust flying, everything crisply captured, is one kind of technical perfection, but controlled motion blur can often convey an impression of speed better than anything else. The blur of spokes on a bicycle shows that the otherwise-sharp cyclist is actually in motion, and if in addition you were to follow the bicycle with the camera, and used a moderate-to-slow shutter speed, such as 1/30sec or 1/60sec, then the background would streak in motion blur while most of the bicycle would stay sharp, which will give an even more impressionistic image of movement.

Following a moving subject like this is called panning, and is a very useful technique for helping the moving subject to stand out, in much the same way as a wide aperture helps to keep a subject distinct from its blurry, out-of-focus background.

Practise this at different shutter speeds to become familiar with the degree of blur you like best.

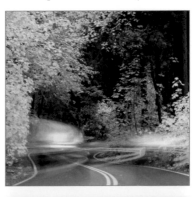

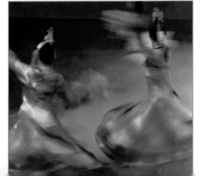

otherwise be able – such as from 1/60 unaided to 1/15 with.

ISO sensitivity and noise

This is the third way of controlling the exposure. Sensors work at their best when they have plenty of light, and the sensitivity of a sensor is measured in units called ISO (which stands for International Organization for Standardization).

ISO 100 to ISO 200 is typical. However, the sensitivity can be boosted from the camera menu by selecting from the choice of higher ISO settings, which is useful if the light levels are low, such as at dusk or indoors, or if you want to keep the shutter speeds fast or the aperture small, or both together. There is, however, a price to pay, and that is the image quality, because the higher the ISO, the more noise there will be in the image. Noise has a grainy, speckled appearance, and detracts from the appearance of a digital photograph.

But how much is acceptable? This depends on personal taste, what compromises you are prepared to make (a noisy image may well be better than

no image at all), and how large the image is displayed.

Also, noise is most glaring in featureless parts of a picture that are mid- to dark in tone, like a dusk sky, while if there is a lot of detail in the image, this will make the noise much less noticeable. And all sensors are not equal when it comes to noise. High-end cameras designed for low light or fast action (invaluable in *sports* and *wildlife* photography) deliver much less noise at high ISO settings than others – but expensively.

Auto or manual

When it comes to choosing these settings – aperture, shutter speed and ISO – the first consideration is almost always the *exposure*. In the next section we'll look at this in more depth. Most cameras will do this either completely automatically, or partially, and in most lighting situations this works perfectly well.

Simple compacts give you little or no choice, but more advanced models allow you to choose between the depth of field from the aperture, the

Reference ▷

Sports, p.216

Active pursuits, p.261

On safari, p.229

Performance art, p.214

Lenses, p.113

BELOW:
A noisy picture of the New Zealand coast at Christchurch.

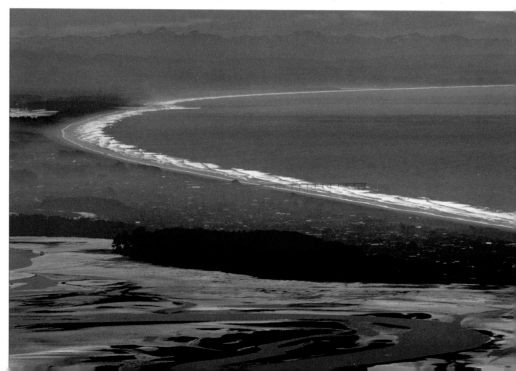

motion-stopping power of the shutter speed, and the image quality from the ISO setting.

Automatic modes that cameras offer therefore tend to be Aperture Priority (you choose the ƒstop and the camera sets the shutter speed), Shutter Priority (you choose the shutter speed and the camera sets the aperture) or a Programmed Mode, which is more sophisticated.

Programmed Modes make assumptions about minimum useful shutter speeds and juggle the aperture shutter and ISO to give a kind of best compromise. On more advanced cameras you can tailor the Programmed Mode to your own preference. But also on advanced cameras, strangely enough, you can opt to make all the adjustments manually.

But why would anyone want to do this, given that auto exposure works so seamlessly? One reason is that it is not always easy to remember exactly what the camera is doing with it s particular auto mode, and it might be increasing the depth of field when you might not want it. Another, more basic reason,

is that shooting manually helps you think about the camera controls, and they are, in truth, not that complicated. It's why some people prefer a car with manual gear change.

Focus

Automatic focus is standard on cameras, although some will allow you to focus manually if you want. What continues to change, however, are the different ways in which a camera's focusing system will decide what to focus on.

The simplest method remains whatever appears in a small central rectangle in the frame, and this suits many subjects. Yet as more people learn to compose photographs in a more interesting way, such as offsetting the main *centre of interest*, this does not always work.

However, most cameras will lock the focus if you press the shutter release just halfway, so a time-honoured technique is to aim at the subject you want sharp, half-press the release and hold it while quickly re-composing the scene.

But automated focusing gets cleverer, and some cameras make a selling point

BELOW: Focusing on a worshipper at the Niujie Mosque in Beijing.

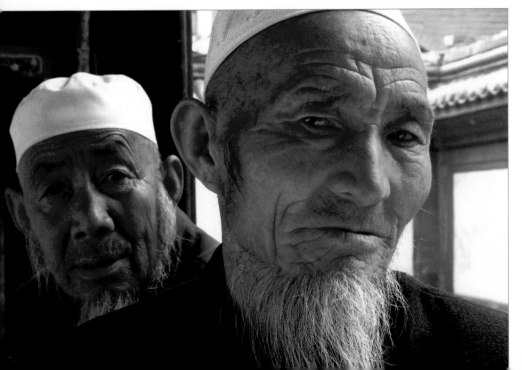

of recognising faces and then focusing on them. Others let you choose to have the focus continually re-adjust as the subject moves. Some high-end cameras have a setting that, once having focused on a subject, will actually track it wherever it moves in the frame, keeping it sharp – useful for sports and wildlife photography.

This kind of sophistication is useful, as long as you know how it works, but can be a problem if it does what you don't expect. The only solution is to find out from the manual exactly how your camera handles focus, and if you can choose between methods, decide which is most convenient for you. Often, the old-fashioned ways are the most certain.

Image size, quality, format

Usually, these are settings that you will not often want to change, once you have decided on what suits you best. As we saw under *Sensor*, the number of megapixels determines the final image size. Large is always good, except for the amount of space it takes up on your memory card, and that

is one of the things to think about when choosing which image format to shoot and save in.

Not all cameras offer all three choices, but they are JPEG, TIFF and Raw. JPEG is the most widely used format in the world because it is universally recognised and compresses the image file so that it takes up much less space. It also saves faster to the memory card, which can be useful if you are shooting a lot of images rapidly. There is some theoretical loss of image quality because of the compression, but in practice impossible to see when looking at the image.

TIFF is another format, used especially when working on digital photographs on computers, and is as high quality (uncompressed) as is possible. But it takes up much more space on the memory card than a JPEG, and lacks the processing advantages of Raw. This third format, Raw (not an acronym; it really does mean "raw", *see below*), keeps the full image data captured by the sensor, and because of this is the professional choice. It takes up more space than a JPEG, and is slower

Reference ▷

Centre of interest, p.76
Sensor, p.98
Processing, p.300

Formats and the advantages of Raw

Images can be saved in several sizes and qualities, but an image saved in Raw is much easier to manipulate.

As explained above, the industry standard format is a JPEG, which is compressed so that it takes up little space on the memory card. Rather less common (it depends on the camera model) is a TIFF, which is not compressed. In addition, mid-range to high-end cameras allow you to save the raw data captured from the sensor so that you can process it yourself later on a computer; this format is called, not surprisingly, Raw, and most serious photographers save their images this way, because, as we'll see on page 300, it retains more brightness and colour information.

Choosing Raw format in the camera's menu rather than JPEG or TIFF has advantages that make it the choice of most professionals. It preserves the "raw" unprocessed data that the sensor captures, and this includes extra latitude in the exposure. When you take a picture and then review it on the camera's LCD screen, what you are seeing is just a quick JPEG interpretation. Hidden beneath this is more data with the potential for better quality, because cameras that have

the Raw option capture in a greater bit-depth (12 bit or 14 bit) than the 8 bits used in JPEGs. If you save just in JPEG, you lose this, but in Raw you can often actually recover some exposure when you open the image in software such as Photoshop and Lightroom. Also, any settings that you might have applied, like white balance, sharpening, contrast and so on are kept separate from the Raw data, so that later on the computer you can change these at will and with no quality loss at all. As mentioned, the only disadvantage with Raw is that it is slower for some cameras to save, and takes up more space than a JPEG. Cameras that save in Raw usually offer an extra option of saving a JPEG as well, and if you don't mind using the small amount of extra space that this needs, it is a useful insurance to have the two versions of the same shot. Because Raw formats are taken directly from the sensor, and because each camera manufacturer has its own way of doing things, they are not standardised. Nikon's is quite different from Canon, for example. Nevertheless, good processing software can deal with all of them, because shooting in Raw is so popular.

to save, and each camera manufacturer has its own proprietary formula for creating it, but the quality advantages are considerable *(see panel on page 105)*.

Memory cards

Images are saved onto whatever memory card you choose to put in the camera. There are different shapes and sizes, such as CompactFlash, SD, miniSD and Memory Stick, but of course any one camera takes just one kind. Where you have a choice is in the size–the storage capacity in other words.

Cards are classified by the number of megabytes (MB) or gigabytes (GB), and because high-capacity cards cost more, it's worth estimating how much you will be shooting on a trip. Don't think of storing all your images from the entire trip on the memory card, because this is a more expensive way of storing images than a hard drive, and because you should always make *backups* of your images, but do think of how many images you will want to capture on, say, a day's shooting.

As we have seen, the size of the photographs measured in megabytes can vary. But once you have chosen these, you will know from the camera manual how much space they will take on the card. For example, if you elect to shoot and save Raw images with a 10 to 12 megapixel camera, and use the camera's compression setting, it's likely that each image will need about 15 MB. So around 60 of these will fit in one GB of a memory card. And memory cards are available in several-to-many GB.

White balance

Humans consider white to be the normal colour of light, but in practice it comes in a range, from the orange of a good sunset to blue in the shade under a clear blue sky. *Artificial lighting* produce other, sometimes odder, colours, such as greenish from some strip lighting, yellow from sodium streetlights, and a sort of creamy light that seems to drain colours from compact fluorescents (CFLs).

Yet the eye and brain are very good at ignoring these colour shifts because we get used to them after several minutes. Not so the camera sensor, which simply

BELOW: Different colours come from different light sources, as in this French street.

records the exact light and its colour. For this reason, camera menus offer a choice of White Balance settings, generally in a list that contains Sunlight, Cloudy, Shade, Fluorescent, Incandescent, or similar descriptions. The idea is that you choose whichever suits the occasion, so that if, for example, you move into the blue-tinted shade of a building to take a portrait on a bright, clear day, using the same Sunlight setting you had for the previous shot, you will end up with a blueish image. Change to Shade, however, and the camera will add a warmer overall tone.

If you choose Auto, the camera will just do the best it can to give an overall neutral cast. Even if you forget to change this when you should, or simply make a mistake, the result can be corrected later on the computer. And if you shoot Raw, it doesn't matter at all what White Balance setting you choose, as the Raw box explains.

Style settings

Beyond the really important settings just described, there are others which vary from one camera manufacturer

to another. These make processing changes to the image to give it more or less contrast, to sharpen it, make it more or less colourful, even pull out details from shadows.

These are all settings that affect the style of the image, and are specific to each camera model. This may seem on the face of it an excellent idea, to give more oomph to one image or more pastel subtlety to another at the time you shoot them, but it is as well to know what is really going on inside the camera.

All of these special style settings are ways of *processing* the image after capture, and if you have chosen to save the image as a JPEG or TIFF, it really means that the camera's processor is throwing away image information. If you shoot Raw you are protected from this, but in any case, everything than a camera's built-in processor can do, a computer running an image program can do better. Unless you really cannot be bothered with tweaking your images when you get home, think twice about accepting the camera's kind offer to process your images on the spot. ❑

Reference ▷
Processing, p.300
Backup, p.296
Artificial light, p.67

BELOW: Style settings include isolating just one colour from the image – a common feature of compact digital cameras. This is a hydrant in Hong Kong.

EXPOSURE

THE NUMBER ONE concern among all photographers is getting the exposure right. In principle, it could hardly be simpler: all cameras have built-in meters to judge the brightness and then, usually automated, the *aperture* and *shutter speed* are set to allow just the right quantity of light to strike the sensor. Raising the *ISO sensitivity* is a third option if the light levels are too low.

And yet, with all this help, exposures still sometimes go wrong – some part of the picture is too bright or too dark. There are three reasons. One is that digital *sensors* capture light in a way different from our own eyes (or film, for that matter), and this can cause special problems in the highlights.

A second reason is that certain lighting conditions are challenging, particularly shooting into the light and when there is very high contrast. The third reason is more personal – only you can decide which part of the scene is the most important and needs the exposure to be right for it. Cameras are good at measuring light, but not at deciding priorities.

Dynamic range

This is the range of brightness, from deepest shadow to brightest highlight, and can be measured in different ways, but the easiest for photography is in *f*stops. An average landscape scene in normal sunlight – not harsh and not into the sun – has a dynamic range of about 9–10 stops. A landscape on a cloudy day that does not include the sky could a range of about 4–6 stops.

These conditions are fine for a digital camera, because the dynamic range of sensors varies from about 10 stops (cheaper cameras) to about 12–13 stops (high-end DSLRs). Exposure problems set in, however, with very contrasty sunlit scenes (crisp air without haze) and when you photograph into the light, when the dynamic range can be

BELOW: High sun (and challenging exposure conditions) on the way to the carnival in Sao Vicente, Cape Verde Islands.

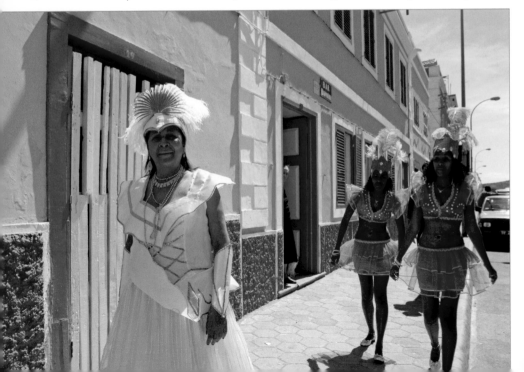

in the order of 14 stops to 16 stops. In these conditions, an average exposure will give too-dark shadows or over-exposed highlights, or both together. This doesn't mean that the image is "wrong", just that you have to give up detail in the shadows, highlights or both.

Take care of the hIghlights

Our eyes are remarkably good at seeing a wide range of brightness, and one reason is that we are not as sensitive to really bright tones as we are to mid-range tones.

A camera *sensor* has no such built-in compensation; its photosites, like miniature wells, just fill up with photons at the same rate, and when each one is full the result is pure white. So when an area of the view is recorded on the sensor as white, it has no detail whatsoever. Moreover, instead of gently shading to white, an over-exposed digital image just goes to white with a sharp break.

Imagine photographing a scene which has the sun in view. With a normal exposure, the sun will of course go white, which is expected, but in the

area of sky close to it there is likely to be a sharp break.

Modern *processing* software is quite good at repairing this kind of defect, but it is always best to protect the highlights, and this means adjusting the exposure a little darker than usual. *Processing* software is better at recovering shadow detail than it is at restoring highlights.

Exposure compensation

When the camera's metering doesn't get the exposure quite right (and for the kinds of lighting situation when this may happen *see page 110*), almost all cameras allow you to raise or lower the exposure by up to 2 ƒstops, and usually in steps of a third or a half a stop. The actual control varies from camera to camera, but use it if the preview of the shot you just took appears too dark or too light.

When to change the ISO

Changing the sensitivity of the sensor is a very digital solution to exposure, vastly more convenient than changing to a faster film. But as we saw above,

Reference ▷
Shutter speed, p.101
Aperture, p.100
ISO sensitivity, p.103
Sensors, p.98
Processing, p.300
Light & Time, p.57

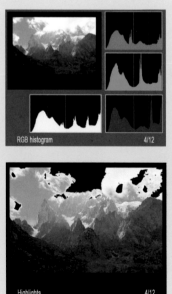

RGB histogram 4/12

Highlights 4/12

Histogram and clipping warning

Better models of digital camera offer two valuable aids when they play back a photograph that you just took on their LCD screen.

One is a histogram, the other is a warning about any over-exposed areas in the picture. A histogram is a solid graph that shows how the tones in an image are distributed, from dark to light. If the image is well-exposed, without loss of shadow or highlight detail, the histogram will look like a peak or set of peaks centred in the graph, as in the picture on the left. If the picture is a little under-exposed, the peak will be shifted to the left, and if a little over-exposed, as in this example, it will be shifted to the right. If the over-exposure is serious and the highlights are blown out to white, the histogram will be squashed up against the right edge (and the opposite way if greatly under-exposed). If you have the option to turn this histogram on in the camera menu, it is a good, quick check – and with experience you quickly become familiar with the way it should look.

The second aid is a "highlight clipping" warning, as shown in the bottom picture. There may be areas of an image that fall outside the maximum intensity that can be represented. These over-exposed areas will turn to white, and typically flash when the mode is selected. A glance will tell you when you have a problem, and give you the chance to adjust the exposure to compensate, and shoot again.

Some Exposure Situations

1. Average contrast (eg most normal scenes, neither dull nor harsh in the way they are lit). No special precautions to take; just let the camera's metering get on with it.

2. Average contrast but bright (eg snow scenes). You will probably need to make an exposure compensation, of up to 2 *f*stops in the case of a bright, white snow scene.

3. Average contrast but dark (eg things that you expect to be dark, like a black cat!). Think first how dark a scene should be, and adjust the exposure compensation downwards as necessary. This is very much a matter of personal judgement.

4. Low contrast (eg foggy, misty scenes). No special precautions to take. In fact, as long as the histogram (*see page 109*) sits comfortably somewhere inside the graph, the brightness or darkness of the image can be altered later on the computer.

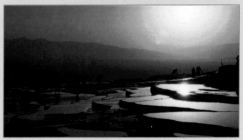

5. High contrast –important part darker (eg shooting into the light when the main subject is in shadow and you want to see plenty of detail in it, whether a person or a building). The choice of exposure is not easy, and you will probably have to sacrifice loss of highlights. If the scene is static, consider a bracketed range of exposures and later exposure blending (*page 303*).

6. High contrast – important part lighter (eg silhouette against a colourful sky when you want to keep the light tones rich and not over-exposed). In this case, expose to hold the highlights, which means making it darker than you usually would.

the penalty is a more noisy image, so as a general rule it's better to adjust exposure as much as possible with the aperture and shutter speed before turning to the ISO.

Nevertheless, as there are no rules about how much noise is noticeable or acceptable, and as the noise performance of cameras varies from model to model, a sensible approach is to make a test at home. Take any scene that contains some large, smooth and not too bright areas (such as a room with some plain wall space), and photograph the same view at different ISO settings.

Look at the pictures on a computer screen at the size you would normally use them and decide what your tolerance for the noise is, and under what conditions you would compromise. If you usually make prints, have two or three printed the same size. You need do this only once, ideally before a trip.

Bracketing exposures

When in doubt, shoot the same scene at different exposures, from darker to lighter. This is called bracketing, and

some cameras have a bracketing mode that you can set, then the camera shoots a burst as you hold down the shutter release.

This is extremely convenient, and it means that you can later delete whatever you don't want. And there is a new digital reason for doing this, which is different from simply later choosing the exposure you like best. This is the possibility of combining all of these different exposures into a single image that takes the best exposure from each of them.

There are two kinds of ways to do this during processing. The first is *exposure blending* in which several exposures are turned into a single ordinary image that combines the highlights from the darker exposures and the shadow detail from the lighter exposures. The second is HDR (high dynamic range), which is an un-viewable image file that contains a massive dynamic range, and which then has to be converted into a normal, viewable image.

It's useful to know about these at the time of shooting, because bracket-

Reference ▷

Blending/HDR, p.303
ISO sensitivity, p.103

BELOW: The same scene (Canada Place in Vancouver) bracketed at increments of 1 *f*stop.

ing exposures is a way of archiving the light – capturing all the details which you can later retrieve on the computer. It takes time and effort, but some views may be worth the trouble.

Although a *tripod* is ideal, the software is smart enough these days to be able to align hand-held images provided that they are fairly similar. Noticeable movement, such as people walking about, is less easy to deal with, and this technique is really best for static scenes such as buildings or landscapes.

Time exposures

Even when you reach the lowest limit of *shutter speed* at which you can hold the camera steady, and when you cannot freeze the subject movement, there are still some exciting images to be made, as long as you can fix the camera steady for a few seconds or longer.

A tripod is more or less essential for this. Think of setting up a shot looking into crashing waves, or a waterfall, or with clouds scudding fast across the sky. If you set the shut-

ter speed to several seconds (and the lens aperture smaller to compensate), the result can be quite ethereal (*see Motion Blur and Panning*).

Dusk and semi-darkness are ideal times, because they will allow the shutter to stay open for minutes, or even hours in the case of a night-sky exposure that reveals the constellations circling around the sky. You would definitely want to save in Raw format for this kind of shot, in order to make adjustment to brightness and colour later.

Fill flash

Some cameras not only have built-in flash, but are programmed to use it whenever the scene is judged to need it. A common case is when shooting against the light and when you want to see detail in the subject, such as a *portrait*, rather than let it become a silhouette.

A touch of flash fills these shadows without drowning the natural lighting effects. Decide whether you actually like this effect – some photographers prefer to keep the images natural.

BELOW: Fiesta time on the island of Taquile on Lake Titicaca, Peru, using fill flash.

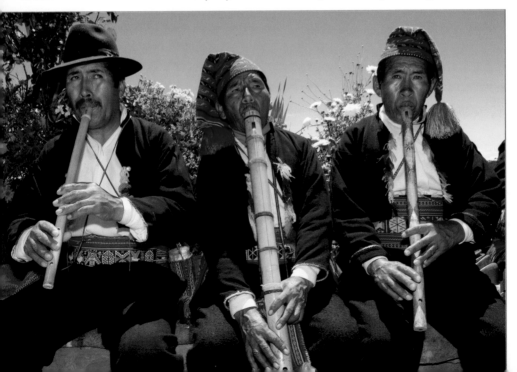

LENSES

WHILE MANY people struggle to get to grips with the plethora of digital features in a camera, and investigate megapixels and formats, the real work in any camera is done by the lens. Compact cameras mainly come with lens attached, DSLRs have interchangeable lenses, but in either case, your initial choice should consider lens quality, performance and focal length.

What focal length means

The defining characteristic of a lens is its focal length, because this is what determines its magnification and the angle of view that it covers.

A "standard" or "normal" focal length is the one at which the view through the camera is more or less similar to the eye's view, and one very easy way to compare the two is to keep both eyes open when you look through the viewfinder (for those digital cameras). If the subject appears about the same size in each eye, then

you have a standard focal length. As most lenses these days are zooms, this is one way of finding out which zoom setting gives the most normal view.

Focal length is measured in millimetres, and in the days when most cameras were 35mm, lenses were easy to compare in this respect. However, what counts as "standard" actually depends on the sensor size, and there is a variety of sizes. The better DSLRs have full-frame, which means the same as old 35mm, but others are smaller. The general rule is that when the focal length of the lens is the same as the diagonal measurement across the image, it looks "standard".

So, with full-frame cameras, and like the old 35mm ones, standard is between 35mm and 50mm; anything shorter is wide-angle and anything longer is telephoto. Two things make this important. One is how much of the scene in front of you will be captured, from wide at one end of the zoom range, for

BELOW:
As series of shots showing different focal lengths, starting with wide-angles on the left. The picture at top left was shot with a 24mm lens; the one at top right with a 200mm telephoto – when used close to people wide-angle gives a more involved, in-your-face feeling.

example, to narrow at the other end. The other is less easy to quantify but possibly even more important – the character of the image.

Wide-angle photographs have an expansive feeling when used to take in a sweeping view, and an involved, in-your-face feeling when used close to events and people *(see picture on page 104)*, with a characteristic distortion of shapes at the edges of the frame. Telephoto images magnify and compress the sense of perspective, which can be graphically strong in an opposite way from wide-angle distortion, and they also can give a somewhat cooler, more objective feeling, "across-the-street" rather than close and personal.

Depth of field

As we saw under *Aperture*, stopping down not only lets less light through the lens, it also increases the depth of field, so that front-to-back more of the scene appears sharp. A wide aperture focuses on just a narrow plane, leaving the background and foreground out of focus, and this, often called selective focus, is good for making some subjects stand out from cluttered surroundings.

With a fast lens *(see below)*, the depth of field is even shallower. Telephoto lenses appear to give a shallower *depth of field* than wide-angles simply because they magnify a smaller part of the scene. This is splitting hairs, but generally and in practice, wide-angle images tend to show more front-to-back sharpness than do telephotos.

Lens speed

Speed in this sense, when talking about lenses, means how much light the lens can capture when it is at full aperture – wide open, in other words.

For photographers who don't want to compromise on either *shutter speed* or *ISO sensitivity* (that is, shoot at as fast a speed as possible and without noise), a fast lens is worth the considerably extra cost.

Lenses are designated by their maximum aperture. Thus, an *f*2.8 lens is reasonably fast, whereas an *f*5.6 lens is quite slow – and that is one way that manufacturers can offer relatively inexpensive lenses. Truly fast lenses are spe-

BELOW: Waiting for the train in Seoul, a shallow depth of field used to focus attention on the passenger.

cialised and very expensive, and have maximum apertures of ƒ1.4 or ƒ1.2. Longer focal lengths are especially difficult to make fast, and need a lot of glass, which is why the lenses that wildlife photographers prefer, such as an ƒ4 600mm, weighing several kilos, are the most expensive of all.

Choosing the right lens

Most lenses these days are zoom lenses, but the range covered varies. They vary in how wide a range they cover, and in whether that range is concentrated around the standard focal length, or in the wide range, or in the telephoto range. In the last two cases, the lenses are usually called wide-angle zooms and telephoto zooms respectively.

With a fixed-lens camera, the choice is just as it comes, but if you are buying a new camera, it is important to compare. With DSLRs, lenses are interchangeable, so the choice is greater, and there is every reason to consider two or three lenses, depending on your budget and how much weight you are prepared to carry. Also,

the range of lenses for the principal makes of DSLR include fixed-focal length lenses (known as primes), and specialist lenses such as macro and shift. The argument for prime lenses is that they deliver better optical quality, although good zoom lenses these days are very good and the difference in result not so easy to see. In any case, whether or not your choice is limited, the criteria to think about are first, focal length, and second, quality and lens speed.

Standard lens

The majority of zoom lenses have their range organised round the standard focal length described above. This is the focal length to use when the scene in front of you looks fine just as it is, and needs no assistance from a wider coverage or a greater magnification.

Now obviously the human eye images differently from a camera lens, not least because there is no rectangular frame. Our field of view, if you think about how far to the side you can make things out, just shaded from sharp in the middle to indistinct at the edges.

Reference ▷

Aperture, p.100
Depth of field, p.100
ISO sensitivity, p.103
Equipment, p.294

BELOW:
Wide-angle immerses the viewer in the scene: here a 24mm shot of Lake Wanaka, New Zealand.

Nevertheless, what you see in front of you, a standard lens will reproduce fairly well, just adding a rectangular crop around it, and its field of view is around 40°.

The character of a standard focal length image is best defined by what it is not: it lacks the distortion and drama from a wide-angle, and it lacks the compression of a telephoto. Some photographers consider it more "pure" in this respect. The viewer is not distracted by any of the strong graphic optical qualities that are possible with the far ends of the range of focal length, and events in the frame can better speak for themselves.

Wide-angle for immersion

Having said that about the standard focal length, visual excitement is addictive, and one way to help this along is to use a short focal length with a wide field of view. "Wide" means between about 50° and 70°, while up to 100° is ultra-wide.

The most basic use for a wide angle is to cover more of the scene in front of you, especially useful if you can't or

don't have time to move further back. So, good for sweeping landscapes and good for interiors.

In order to get this wide field of view, these focal lengths distort the shapes of subjects away from the centre, and while this might look awkward with something recogniseable like a face, it is by no means always a bad thing. Geometrical distortion adds graphic drama by stretching things near the corners.

Telephotos for distance

Go to the other end of the zoom range, or fit a real telephoto lens, and the angle of view narrows. Medium telephotos cover typically between about 10° and 25°, the really long ones that are ideal for much wildlife photography less than about 6°. However, whereas the angle of view is what tends to be most important for wide-angles, in the case of telephotos it is the degree of magnification that gets most attention.

This is easy to work out: simply divide the focal length of the telephoto by whatever is standard. So, assum-

BELOW: A 17mm wide-angle shot takes in most of Piazza Navona in Rome.

ing 50mm as normal for a full-frame DSLR, a 300mm lens will magnify the view by 6x. This is the basic task for a telephoto – getting closer without moving closer. But in addition, there is a graphically powerful effect of appearing to compress the scene.

Subjects get to be a little closer to their real size in relation to one another. If you stand close to a house with a mountain range as a backdrop and use a wide-angle lens, the house will loom much larger than the mountains, but if instead you walk back and use a telephoto, the mountains will appear more like their impressive size behind the house. This compressing effect can be compelling with the right choice of subject, such as the succession of cliffs and buttes along the Grand Canyon stacked into planes, or pagoda behind pagoda at Bagan, Myanmar.

Close-up and macro

A specialist kind of lens, or sometimes a function built in to regular lenses, is one that will focus very closely to give strongly magnified views of such small subjects as flowers and insects, and in wilderness travel photography they can add to your coverage of the trip.

True macro lenses have their optics optimised for close distances, and will stop down very small, such as to ƒ32, to keep the depth of field deep. Technically speaking, macro means that the image is close to the actual size of the object.

Depth of field is shallow at such distances, but there are digital ways of dealing with this, as described in *focus blending*.

Panoramas

There have always been specialist cameras to take such wide views, including disposable cameras. But now, with digital, they are hardly necessary, as one of the simplest and most effective tricks in photography, particularly travel photography, is to create a panorama from a sequence of overlapping images *(see page 160)*.

This is so popular that manufacturers have perfected software to make this happen, and even camera features that aid the process. ❏

Reference ▷

Panoramas, p.160
Macro, p.236
Depth of field, p.100
Focus blending, p.304

BELOW:
A telephoto shot (160mm) of the beach at Crescent City in northern California, the scene compressed from front to back.

VIDEO

EVEN THOUGH the technologies of video and still digital are converging, particularly in DSLRs that are video-capable, as ways of expression they are poles apart.

Still photography is about skillfully catching slices from the motion of life –telling moments that encapsulate a situation in a single shot. Video is about the flow of movement and events, and tells a story in a narrative way. You can, if you are lucky and adroit, catch an evocative still moment from an otherwise unpromising situation, but video more realistically records the entire event.

Nevertheless, one of the exciting possibilities is to mix still and video in a slideshow or movie, and they can fit well together, moving from video to well-caught single moments in stills. For this reason, adding video to your armoury of story-telling can be effective in recording the experiences of travel.

If you're going to be shooting video, the first thing to decide is what to use.

BELOW: Sizing up a sequence at Death Valley. Camcorders are designed to be ergonomically held in the hand.

The technological development that allows a still digital camera to record video is hugely popular, but if this is an extra incentive for choosing this kind of camera, you should still consider the conventional alternative of buying a camcorder.

Camera or camcorder

There are pros and cons to either route. The arguments in favour of a video-capable still camera are: it sticks to one system; there is less to carry around and no extra cost; with a DSLR you can take full advantage of its range of *lenses*, especially wide-angle which camcorders often lack; camcorders have a hard time in low light.

The arguments in favour of a camcorder are: at the moment camcorders generally have better video quality, better audio quality, longer telephoto capability and are ergonomically better for filming; they are also tiny and not particularly expensive. That said,

technology moves fast in all these areas, and video-capable still cameras will improve. But then so will camcorders.

Controlling movement

Camcorders are designed ergonomically to be held in the hand. This, plus the fact that it's fun to walk around with one while filming, suggests that moving the camera is a good idea. Sometimes it is, but more often the result is jerky and incoherent.

The baseline for professional video is the same as for film: slow, smooth movements that are easy on the eye and plenty of footage where the camera is not moving at all. After all, most of the time you will have moving subjects, and this will often be quite sufficient.

Camera movements have their place, but on television and in the cinema they are usually with a purpose. Movements that are obviously handheld are used professionally to give a sense of urgency, and so not at all frequently.

First, practise moving the camera gently and steadily. The easiest and smoothest way of doing this is to use a tripod. Simply loosen the head and

grasp the camera with both hands, making sure that any image stabiliser is switched off (otherwise it will actually introduce small movements at the beginning and end of the move).

Start a panning move as slowly as possible, speeding up gently, and at the end, slow down. Leave a few seconds footage at the start and at the end.

Another tip is to plan the move whenever possible, possibly even making a quick dry run first, because to be really successful, a camera move should start with a good composition and end with the same. Use your still photography skills to find these good framings *(see Composition)*.

Also, be sparing with the zoom. Many people believe that because a camcorder has a motorised zoom, it ought to be used a lot during filming. In fact, unless performed very slowly, and very, very occasionally, zoom shots can be tiresome to watch. Use the zoom in the way you would with a still camera: just to select the focal length.

One kind of camera movement that does work well much of the time is from most kinds of vehicle, especially

Reference ▷

Composition, p.75
Lenses, p.113

BELOW:

Video is perfect for catching the movement of dancers, such as these dervishes in Istanbul. Hold the camera still as they drift in and out of the frame.

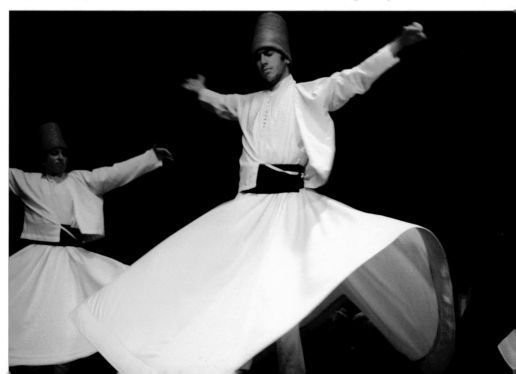

looking forward. The trick is to keep the camera as steady as possible on the vehicle, and here again, a *tripod* can be invaluable. Imagine being on the Keralan backwaters or on the Mekong River in Vietnam being rowed or poled along by a boatman: simply fix the camera on the tripod at the front of the boat and let the boat's motion do the rest – or aim it back to the boatman to give some action as well.

Static shots

One of the things that video does best is to capture the movement in the scene. While it may not sound exciting, locking the camera so that it does not move at all is a guaranteed formula for professional-looking results.

Spend time instead on making an effective composition, ideally one that includes moving subjects. A telephoto view down the length of a busy street might not work as a still shot – too many obstructions, the field of view out of focus – but as a minute of video you could be surprised as to how watchable it is.

BELOW: Boating down the Mekong – a perfect subject for a video, but it helps to have a tripod!

Movement across the wide HD frame works particularly well, and if this movement starts outside the frame, entering it while the camera is running, so much the better. For instance, imagine a horse-drawn carriage in an old city centre turning the corner. You can see where it is going, so if you frame the shot ahead of it and hold the camera steady, the result will be professional anticipation; the audience will be pleasantly surprised as the horse clops into the frame.

Or another example might be street dancers performing in a town square: fix the camera so that the shot begins empty and a dancer twirls into frame. The possibilities are endless, but the principle is to make full use of whatever movement is going on.

Thinking in sequence

Video automatically tells a tale. Things happen, have a sequence, start somewhere and end somewhere. Very similar to travel, in a way.

To make the most of this, it helps to think like a scriptwriter, but on the spot, imagining how shots will fit

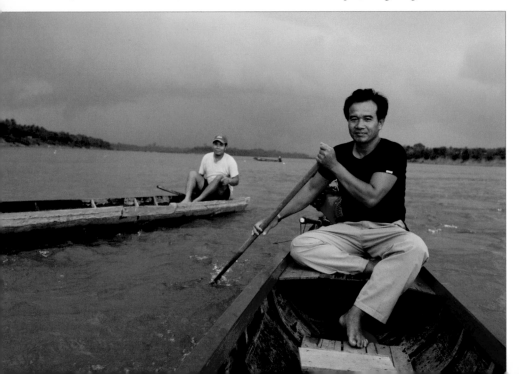

together. In still photography, the aim is often simply to find great shots, in whatever order they come, but video needs sequence.

This means, even as you film a compelling scene, think ahead to what should accompany it. This includes setting the scene, which makes establishing shots of the location, even if not particularly exciting, valuable.

Also, think about filming the same scene from different angles and with different focal lengths, so that you can later cut them together. A close portrait of a trader in a market will make more sense if you have a starting shot of the overall market, then possibly a medium shot of the trader's stall. You can shoot this backwards, in the sense that once you have a great shot, step back and sideways to fill in the gaps.

Talking movies

And as this is likely to be a travelogue, you can have linking dialogue. Some of this can be recorded later as a voice-over, but think how useful it would be to have you in shot talking to camera: "*Here I am in…*" To do this,

consider buying a small microphone that clips onto your shirt, blouse or jacket, with a long lead. And this is yet another argument for a tripod, because "talking-head" shots usually look best when the camera is still, and you can also film yourself without help from a companion.

Easy on the special effects

Just as still digital cameras are increasingly loaded with style settings that process the image to look as you think you want it straight out of the camera (see *Settings*), so camcorders come with such special video effects as fades and wipes.

For the same reasons that you should think twice about taking this option with a still camera – such effects are irreversible – it may be better to film in a straight and uncomplicated way and leave the transitions and so on until you edit the footage later at home on the computer. More work, yes, but using video at all involves a commitment to doing extensive post-production later. There is a variety of excellent software available for this.❑

Reference ▷

Tripod, p.295
Settings, p.100

Software Solutions

When it comes to editing your captured video, a number of software options are available. Most computer operating systems come with video editors preinstalled, notably Movie Maker for Windows and iMovie for Mac. These are perfectly adequate for basic video editing. Both feature a large choice of video transitions as well as captioning and audio tools. They are simple to use and you will be able to create great videos in minutes. Both of the aforementioned also include tools for sharing video with families and friends. For a bit more control over your video there is a lot of mid- to high-end software available, including Adobe Premier and Final Cut Studio. These are used by professionals and have a huge range of features which can be incredibly rewarding – if you have the time to learn how to use them.

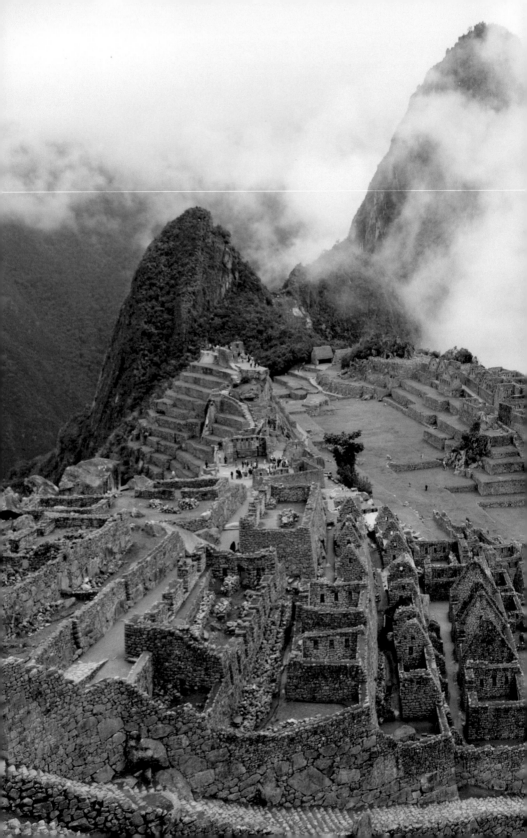

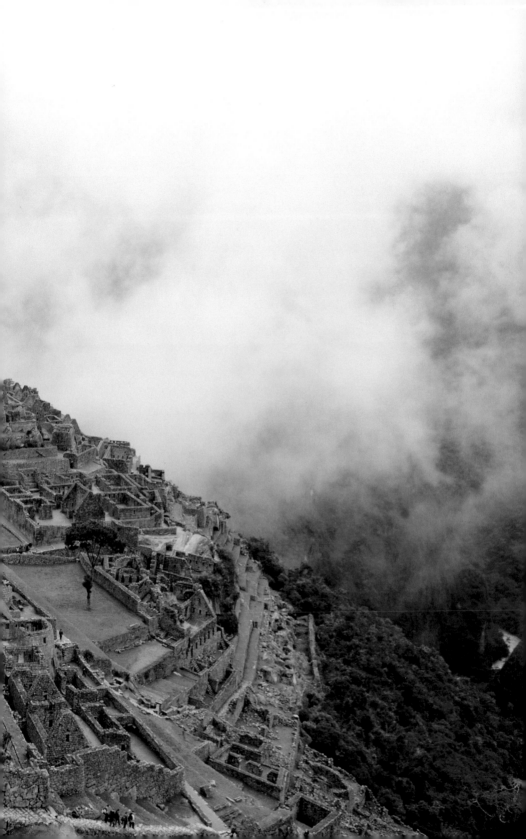

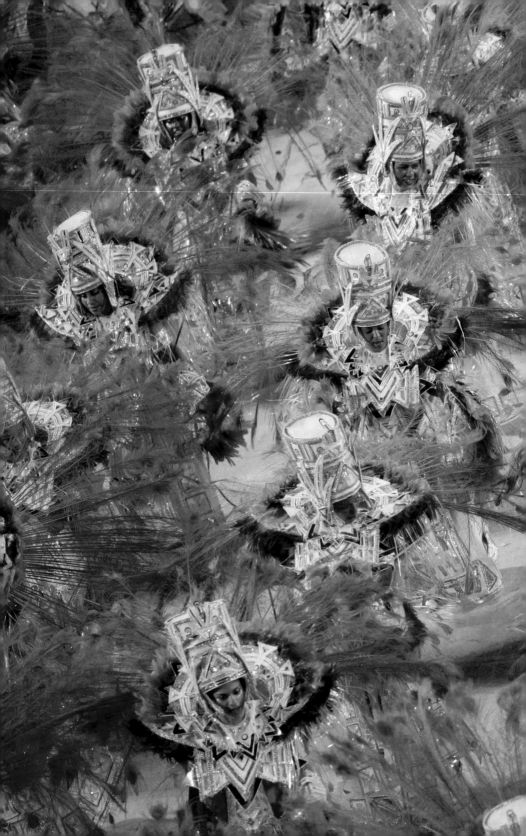

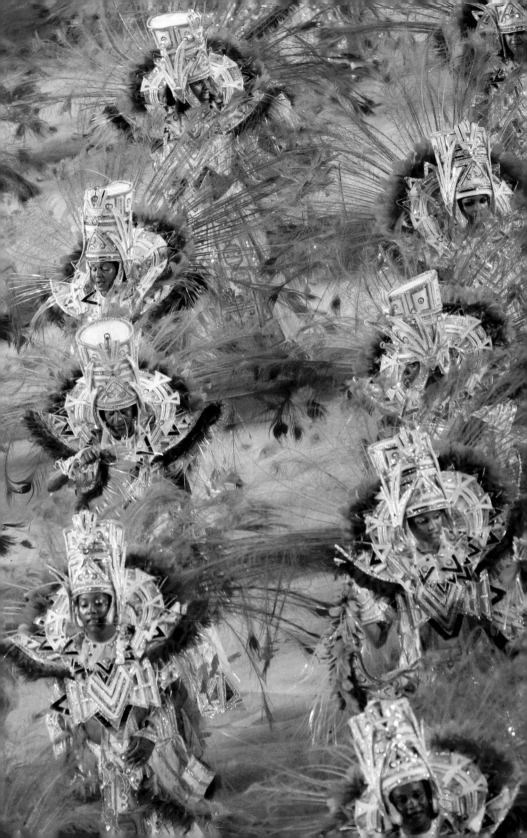

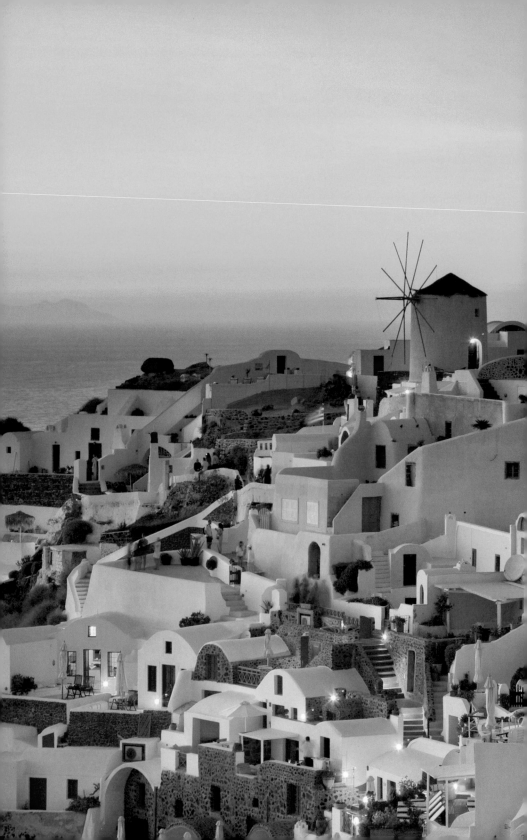

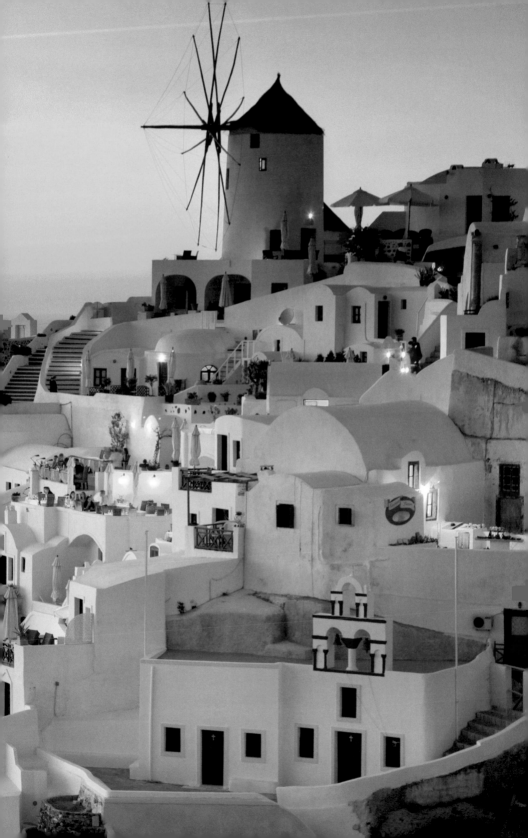

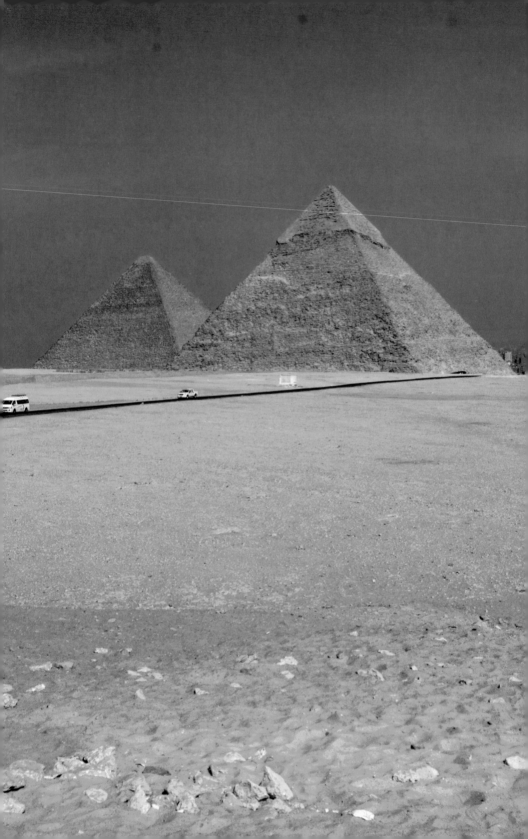

SETTING OUT

Once you've mastered the camera and its possibilities, it's time to set out. Along the road a million and one unexpected things can happen, which is the joy of travelling

When it's time to pack for the journey, the travel photographer should have some idea of the kind of pictures he or she wants to take. This might depend of the destination, whether it's Paris or the Panatal, Lapland or Lourdes. Few photographers are good all-rounders. Most soon find out what they are good at or what they like doing best, and they should play to these strengths. But there also may be areas they have not tried before: portraits of local characters, night shots in Times Square, skyscrapers in Shanghai or birdlife in Belize.

"Travel light" is the maxim from most hardened travel photographers and everyone will have their own version of what this means. You might want a compact or camcorder as well as an SLR, and ponder the pros and cons of a tripod. What bags and pockets will everything fit into? Whether going on safari, to the seaside, or taking a city break, whether you decide to travel in a Rambo-style jacket, or if you just want to slip a discrete compact into your pocket, this section covers all the situations a travel photographer is likely to face on the road.

Landscapes

Photographers love landscapes, and though nature is so generous in providing such photogenic vistas, not everybody is an Ansel Adams. There is a lot we can learn from other photographers, too. Whether it's Yosemite Park, the English Lakes, or the wilds of Karakoram, there are certain lessons to take into account. There's also advice on photographing the desert and the red dunes of the Namib desert, and the white light of the poles, the wetlands from Florida to Kerala, and the flatlands from the Steppes to the Great Plains. There is black-and-white and infrared photography to experiment with, or you might think about stitching images together to make a magnificent panorama. The rhythms of nature, both untended, as in deserts or grasslands, or tended in cultivated fields, create many interesting patterns and shapes that can be abstracted into intriguing pictures. *See page 135*

PRECEDING PAGES: the ruins of Machu Picchu in Peru, with the mist adding to the drama; Carnival parade in Rio, from an interesting angle; a classic shot of the Greek island of Santorini. **LEFT:** The pyramids at Giza with Cairo behind and the road and vehicles giving a sense of scale and depth.

Elements and skyscapes

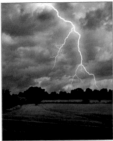

The weather is the most unpredictable part of travel photography. Some of it, like lightning, needs both forethought and snap judgment to capture, while dust storms can be a particular hazard. Often, poor weather can ruin a shoot, but sometimes it improves it, as you will see if you ever stand in a Japanese garden in the rain. A major visual part of the world's weather patterns are cloudscapes, seen from aircraft windows when we fly over them, but they are more complex than they appear, creating interesting patterns and sudden shafts of light. *See page 167*

The built environment

The urban landscape offers many possibilities – from ancient ruins and sites, so favoured by pioneer travel photographers, to the edgy streets of the modern metropolis. Here man-made colours and straight lines suggest graphic images that can be monumental or fragile, ambitiously grand or on a human scale. Ancient sites may be familiar even before we actually see them, which gives the opportunity to photograph them in a completely new way. City lights always have the possibility of good pictures, as do traditional buildings such as churches and great houses. Vernacular architecture can quickly convey a sense of place, and local architecture, both inside and out, can result in personal encounters on your journey. *See page 179*

People

The most rewarding area of photography is also the most difficult. Photographing friends is one thing, but getting among strangers is quite different. Here are some tips about how to get shy sitters to pose, though in some places, such as Bollywood-influenced India, you might find it hard to get children not to pose. Festival time, whether it's the big Rio carnival or Nevada's Burning Man, is a great opportu-

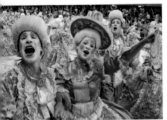

nity for good pictures. Crowds have their own demands, particularly in confined spaces, such as markets and bazaars, which are some the most difficult subjects; but they make an interesting vision if they are all headed one way, such as on Howrah Bridge in Calcutta, the busiest commuting bridge in the world, just one aspect of the world of work. The famous Family of Man project made an ambitious attempt to tell the story of human life at work, rest and play. *See page 205*

Wildlife

Whether you are after the Big Five in Botswana, the great migrations of the Serengeti, the elusive Indian tiger or the flight of a condor in the Andes, wildlife photography is for the patient travel photographer. It's not just a question of waiting by the waterholes at dawn and dusk – you have to know about animal behaviour to anticipate the perfect shot. Wildlife photographer Ariadne van Zandbergen describes how she caught a

leopard leaping to give her a picture of a lifetime. There is also a big story to be made from nature's smallest creatures and most delicate plants, which opens up a whole new world in macro photography, from curious insects to the most delicate flowers. But it is often the habitat, rather than the animal, that determines the approach to bird photography. *See page 227*

Details and close-ups

Sometimes it's the little picture that gives the big picture. It can be the everyday – items in small shops and busy markets, colourful, isolated or piled up to make pleasing patterns. People can be expressive by the way they grip a cup of tea or a bus rail – you don't have to go for the whole portrait. Even a subject as big as an elephant at an Indian festival can be brought down to size with a judicious shot. Go for graphics, too, posters and lettering, street signs and scripts in different languages. *See page 241*

Transport

Your journey starts and ends on transport – and there will be a lot of travelling in between. Whether it's a city bus, a steam train in Darjeeling

or Machu Picchu, an inter-island ferry in the Philippines or a horse-drawn carriage in Seville, your mode of transport and its passengers are key elements in your journey. Transport hubs are often extremely lively places and offer photo opportunities, though often it's the vehicles themselves – Pakistani trucks, Cuba's 1950s American cars – that are the centre of attention. If you are ambitious, you could try aerial photography. There are tips on cycling, a popular and green way to see the world, and on being a cruise ship photographer. *See page 249*

Active pursuits

You don't have to be sporty to enjoy photographing outdoor activities – but it definitely helps. Watersports, mountain pursuits and aerial activities all require special considerations about personal safety, and the safety of the people you are photographing – you don't want a surfer crashing into you just as you get the shot. Your equipment needs protection, too, from water, snow and dust. A head for heights helps when you are snapping mountaineers, paragliders or bungee jumpers, and you need good friends to reenact their best ski-jump or bike feat over again when you missed the shot first time. *See page 261*

Calendar

The travel photographer's calendar shows the best time to visit sites around the world, from January in Antarctica to Yosemite National Park in June and Agra in December. *See page 279* ❑

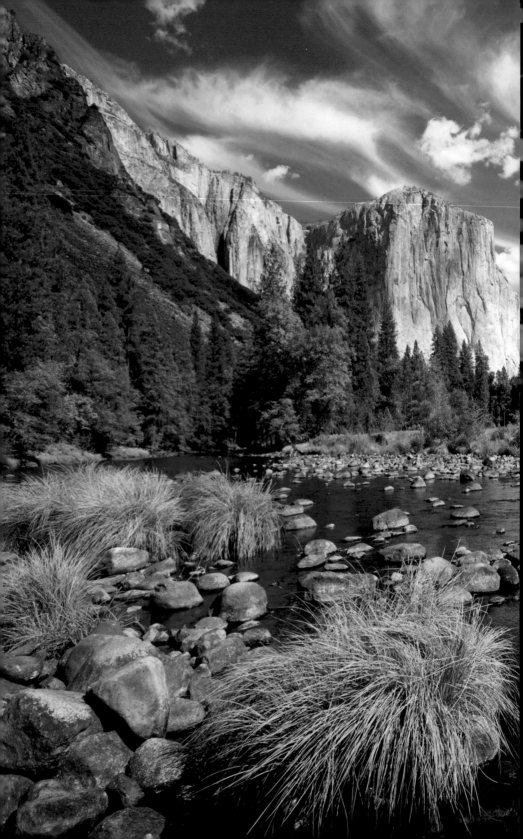

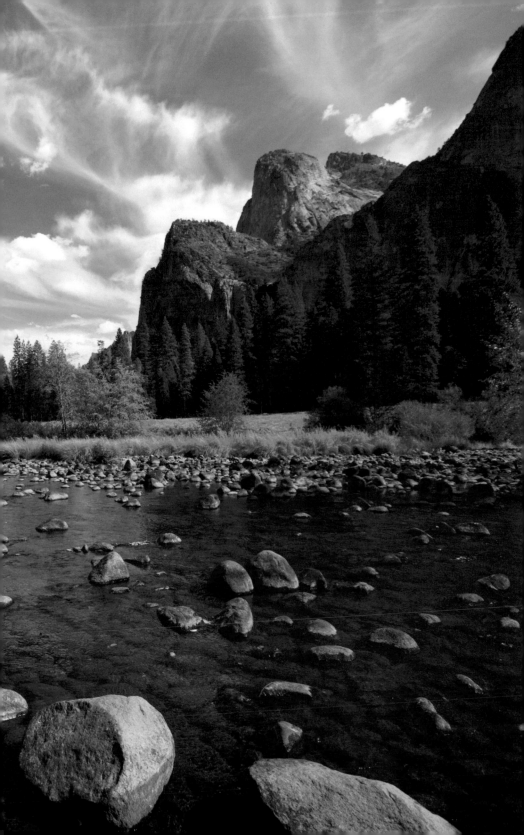

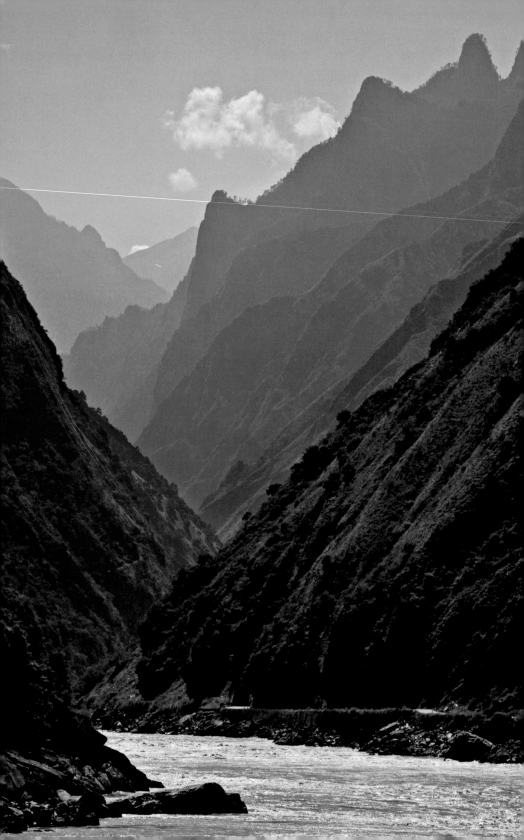

LANDSCAPE

Every travel photographer knows that the world is a wonderful place, of mountains, deserts, forests, waterways and man-made lands. The problem is, how to picture them with the traveller's eye

Landscape is one of the great classic themes of photography, and for the whole of its history it has been married to travel photography. Nineteenth century pioneers such as John Thompson, Carleton Watkins and Timothy O'Sullivan set out to show those at home what distant and unknown places looked like.

Landscape photography still contains an element of discovery, but as often as not it is a personal discovery. It is a human invention, and is the visual artist's way of interpreting geography as an image. When the writer Virginia Woolf was in Italy attempting to convey a sense of place, she concluded, "What one really records is the state of one's mind." In other words, when trying to capture a scene, keep it personal and try to show what appeals to you rather than slavishly follow the accepted "ideal" viewpoints and subjects. There is no such thing as a single, perfect view, only views that have, through laziness, simply become accepted as the obvious.

Wide-angle or telephoto

Most landscapes are, by definition, broad views of a place, and for the camera they tend to group themselves into one of two camps: wide-angle and tele-

photo. These two treatments both feel different and call for different technique and vision. Wide-angle landscapes are excellent at showing the full sweep of a large view, including the sky (which therefore needs to have some interest in it for the image to work at its best).

They are also capable of expanding the sense of depth in a scene by including a strong foreground – what Ansel Adams referred to as a "near-far" approach. For this, finding the exact viewpoint is important, one that pitches a close element, such as sun-

Main topics
MOUNTAINS
FLAT LANDSCAPES
RIVERS & LAKES
SEASCAPES
FOREST & FOLIAGE
DESERT
ICE & SNOW
CULTIVATION
BLACK & WHITE
PANORAMAS

PRECEDING PAGE: El Capitan and the Merced River, Yosemite, California. **LEFT:** a telephoto shot (200mm) of the Yalong River Gorge in Sichuan, China. **RIGHT:** Poppies in a field.

flowers in a Tuscan field or pebbles on a beach, with a distant element that is also strong.

Such camera positions often tend to be low, and this style of wide-angle landscape calls for good depth of field, which in turns means a very small aperture and so probably a slow shutter speed. A low tripod will come in very useful for this kind of shot.

The opposite optical treatment is the telephoto landscape view. Long focal lengths are good at picking out unexpected scenes within the overall view, and so a way of injecting your own vision into a view from a well-known and heavily-photographed overlook. In other words, one good viewpoint might offer you a single wide-angle landscape, but several different telephoto ones.

Long focal lengths are also good at giving a compressed view of a scene, and if the conditions are right – such as a series of cliffs, some haze and shooting into the light, as in the Grand Canyon – the classic "stacked planes" image as shown in the picture of the Yalong Gorge on page 134.

Depth of field becomes an issue only if you have foreground elements in the view, such as the branch of a nearby tree; then you will need to stop down the lens, or alternatively shoot at a few different focus points and *blend* these later (*see Processing*).

The horizon line

Where to place the horizon line is one of the constant decisions for landscape composition, as it is almost always visible. Take each scene on its own merits, and decide where the main interest lies.

The two most common positions are approximately a third of the way down from the top of the frame, or a third of the way up from the bottom. Without getting obsessed about *Rules of Thirds* and the golden section, the idea is simply to favour, definitely, either land or sky. Extreme positions – very high, very low or right in the middle – have their occasional uses, again depending on the elements that interest you in the scene. And of course mountainscapes dictate their own rules, as you can see opposite. ❑

BELOW: A sense of scale – enjoying the view in the Eravikulam National Park, Kerala.

Figures for Scale and Life

The question often crops up in the mind of the landscape photographer: to include or do without the human figure? Figures in a landscape are almost inevitably small, and they have two main purposes photographically. One is to help the viewer understand the sense of scale, something that particularly affects mountain landscapes. The other is simply to populate the landscape – to give it life and action. Including or excluding is very much a matter of personal taste and style. Many people might want to keep a desert dune landscape "pure" and abstract, for example, while others might see it enhanced by a train of camels crossing in the distance. This example highlights the importance of what kind of figure – one that looks in dress and actions as if it belongs to the scene will suit it best.

MOUNTAINS

WHETHER AMONG the low peaks and fells of the English Lake District or among the giants of the Himalayas and Karakoram, mountain landscapes show nature at its most dramatic and inspirational. For photographers, they have a *vertical* component that gives much more freedom to compose than usual. Their unpredictable weather and uncertain, sometimes risky paths add to the excitement that should be conveyed in photographs.

Ever-changing scenery

Whether you are down in the valley looking up at the face of a mountain bathed in early morning light, or hiking round precipitous paths where jagged peaks or thundering glaciers come into view, mountain scenery is endlessly changing. For the camera these are complex creations made up of landscape, time of day, season and weather.

Yet to capture the drama and majesty in an image that you felt at the time, you face the landscape photographer's quintessential dilemma of having to translate a complex experience into a two-dimensional image, without the help of sound, wind and the sense of scale that are so obvious at the time.

Viewpoints

This sense of scale is the first thing to tackle, and there are certain guidelines that will help. These involve viewpoint, familiar reference features and the choice of focal length.

There are three broad groups of viewpoint: from a distance, from the valley below, and from ridges or passes as you climb.

Where roads cater for tourists, such as in Yosemite or Switzerland, the signposted overlooks that you will regularly come across in scenic areas are not to be despised or ignored: these undoubtedly offer some of the best views. Those marked on the tourist

BELOW:
Evening time in the Pyrenees, France. The mist has just cleared to reveal the summit of Mt Valier (2,800m) reflected in a lake.

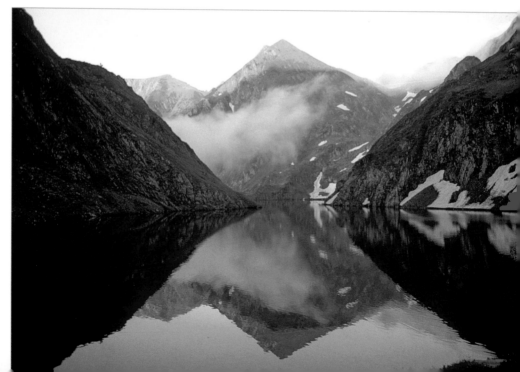

Ansel Adams

Using the Zone System for his black-and-white images, the great American photographer visualised landscapes in a wholly new way

Ansel Adams (1902–84) remains one of the best-loved and most admired photographers of landscapes. He worked mainly in the American West and Southwest and his photographs were notable for their grand natural themes, their rich black-and-white tonality and precision printmaking. Although modern landscapes photography has evolved in different directions, towards colour spectacles in the work of David Muench and Galen Rowell, and towards a more environmentally conscious imagery of damages landscapes, as in the work of Robert Adams, Ansel Adams's style is distinctive and has never been bettered.

There is much to learn for travel photographers from studying an Adams print, in particular his intuitive sense of mood and the excellence of his processing and printing. He delved deeper into the experience of landscape than most people, describing some of his images as having "a certain trans-

parent feeling of light" and as being "a romantic/emotional moment in time."

His practical contribution to landscape photography included two "inventions". One was "visualisation", the term he used for imagining the outcome of the image at the moment he pressed the shutter. *Monolith*, a photograph of the face of Half Dome in Yosemite National Park that appeared in his first portfolio, published in 1927, is a dramatic image with a black sky and striking rockface that bears his hallmark engraving-like clean lines. Describing his approach to the picture, he wrote, "I had been able to realise a desired image: not the way the subject appeared in reality but how it *felt* to me and how it must appear in the finished print."

Visualization as practised by Adams was particularly important for three reasons. One was that he worked in *black-and-white*, which is quite different from the colour we are now used to. A second was that he habitually photographed with large-format view cameras, using individual sheets of film that could not be squandered on bracketing exposures. Thirdly, he was fond of using strongly coloured filters over the lens to control what shade of grey individual colours turned into, with a marked preference for red and orange filters to blacken clear skies and accentuate drama. All of this meant that knowledge of success or failure had to wait until the end of the trip and days in the darkroom. While digital photography has removed all such doubts and difficulties at a stroke, the principle of deciding what *you* can see as the potential in a landscape rather than depending on what the view offers you, remains just as valid now as in Adams's time, and is one of the secrets of success in landscape photography.

The second "invention" was the Zone System, which he developed with Fred Archer, a method of assigning tonal values to black-and-white images that was particularly suited to large-format camera work. It meant that 8x10-inch films could be given special processing to adjust their contrast.

The Zone System divided the tonal range into 10 zones, written in Roman numerals (0 is black, X is white), each one equivalent to one stop. By using this reference, Adams could decide which were the most important tones and which needed adjusting. One digital processing software, LightZone, uses this method successfully today and the system remains valuable as a way of thinking about and analysing the tonal range of a scene. ❑

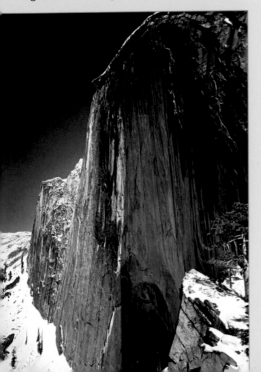

LEFT: Ansel Adams' *Monolith*, from his first portfolio (1927).

maps, however, are not the only ones, and it usually repays exploration to find your own alternatives.

Daunting height

Let's take a specific example. Dominating the Hunza Valley in the north of Pakistan is a stupendous mountain called Rakaposhi, or "Shining Wall" locally. The north face rises almost 6,000m (20,000ft) straight from the Hunza river to the summit at 7,788m (25,550ft), making this the highest uninterrupted mountain face on the planet. The awesome scale of the mountain becomes fully evident if you stand just below the main ridge, but almost too much to comprehend.

You would expect the camera to capture at least some of this, but photographed from its base, Rakaposhi is invariably a disappointment. You need to find the correct viewpoint to set the mountain in the context of the surrounding landscape, bearing in mind some of the rules we learnt about in the Composition chapter. A wide-angle lens may well be necessary, though no wider than absolutely necessary or the mountain will appear to be little more than a bump.

In the composition, try to include some foreground or middle ground detail such as figures, buildings, trees, boulders or cairns to emphasise the *scale* and help give *depth* and added interest to the image. Human figures may also help; if no-one is conveniently walking or climbing through your frame, ask a companion to go ahead into view.

The right lens

The size relationship between mountain and such foreground elements is controllable by your choice of focal length. *Telephoto lenses*, or the long end of a zoom lens, compress the perspective, and so make a distant mountain loom much larger over middle ground and foreground.

In fact, from very close, looking upwards and being compelled to use a wide-angle lens or zoom setting, you risk losing the imposing sense that the mountain has from a distance. A 200mm equivalent focal length or longer counts as telephoto in this respect. Moreover,

Reference ▷
Shooting angles, p.83
Lenses, p.113
Scale & Depth, p.85
Black & White, p.158

BELOW:
The Charakusa Valley in Baltistan, Pakistan, where clouds shroud the main peaks but add to the drama. The boulders and trees in the foreground help provide a sense of scale and frame the glacier which leads to a vanishing point.

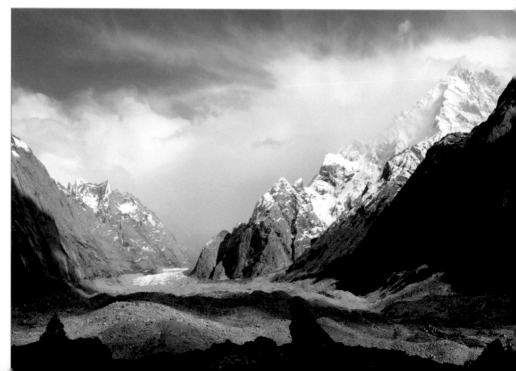

telephoto lenses can also let you home in on details such as pinnacles and summits, and if there is a series of ridges or other features one behind the other, the foreshortening can help create a graphic "stacking" effect.

Mountain light

In mountains the light has a particularly transforming effect. Around midday, the sun's high angle can make even the strong three-dimensional quality of the mountains look flat and undramatic.

During the early morning or late afternoon, however, it's a different story, as the angled rays throw rock faces into relief, ridges into deep shadow, and generally etch the landscape with contrasting tone and colour. The first and last hour of sunlight, when mountain tops can glow orange, pink or red, depending on the weather, are even more special.

If you are staying in the area for any length of time, you should be able to work out by simple observation where the light falls at different times of day, what the best viewpoints are and

whether a given mountain face is best shot in the morning or the evening – or indeed both.

Micro-climates

This all assumes sunlight, of course, but that is not a guaranteed commodity in mountains, because they tend to create their own micro-climates. Intruding into the atmosphere, they create clouds in specific ways, unique to each mountain range.

Local knowledge is therefore worth seeking out. You might find that at certain seasons, for instance, low valley fog is common in the very early mornings, rising and dispersing later.

Season is indeed very important for mountain trekking and climbing. In the Himalaya, for example, certain months of the year are hazier than others due to the monsoon or the heat from the valleys.

For some mountains, such as Kailash (Kangrinpoche) in the west of Tibet, the gap between cloudy summer and the physically difficult winter results in two fairly short windows, late spring and early autumn. ❑

BELOW: Morning light throws the giant (4,500-m) south face of Batura in the Karakoram into sharp relief.

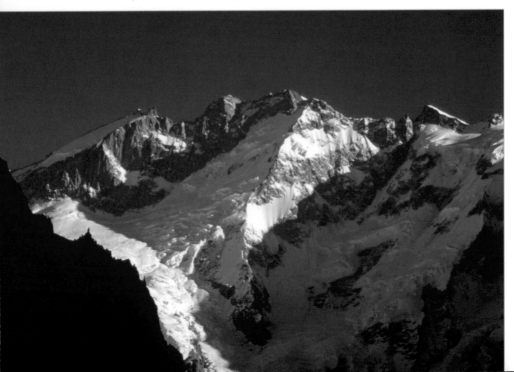

FLAT LANDSCAPES

AFTER THE EXCITEMENT of valleys and mountains, with their vertical drama and wide choice of viewpoint, a natural reaction to flat landscapes might be that they lack possibilities for good photographs, and are even visually boring.

That would be to miss the point that the very flatness and open expanse of these places, whether the Steppes, the Great Plains west of the Mississippi or England's Norfolk Broads, has its own special character. The feeling is vast and endless, and the sky dominates. With this in mind, a minimalist approach can work well, stressing less rather than more.

Vision of emptiness

Try to convey this vast emptiness by finding viewpoints that show as little as possible – say, endless fields of grain – but perhaps with one key small *centre of interest*, such as a granary or a lonely farmstead, or a small flock of birds. Even a straight, empty highway or a line of telegraph poles can help put the scale of such landscapes into perspective, especially if they are viewed stretching away to a *vanishing point* the horizon, which will give a strong diminishing perspective. In such an empty landscape a single figure can create a feeling of loneliness.

Here also is one situation where a central position for the horizon, normally advised against in the *Rule of Thirds*, can best capture the character of a territory that sometimes seems suspended between land and sky.

In flat country, even a slight elevation for the camera can make a useful difference, but you may have to search for somewhere suitable – a bridge, perhaps, or the upper floor of a building, or even a tree. If you are driving, the roof of the vehicle (if it is strong enough to take the weight) is always a possibility. ❏

BELOW:
Rustic charm in Tasmania, suspended between land and sky.

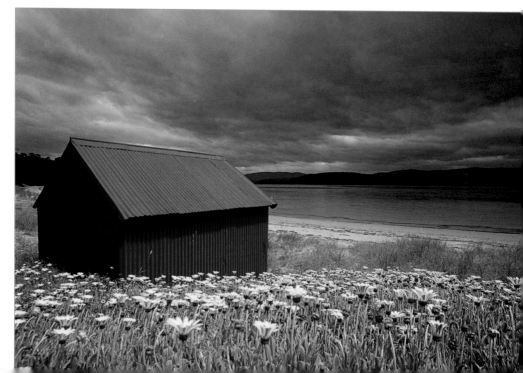

RIVERS AND LAKES

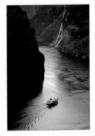

RIVERS, CANALS, locks, lakes and ponds – any inland waterway provides rich material for the camera. They are distinct forms that make a strong centre of interest, with the creative potential for reflections of the sky and surrounding land or townscape.

If you are aiming for a "portrait" of a river – in effect saying this is what the Mississippi, or the Thames or Yangtze looks like – one of the main issues is trying to organise it within the frame so that it has some shape. This is not always easy, and usually calls for some kind of overlook.

The upper reaches

BELOW: A shutter speed of just over half a second is enough to give the Jeriau Waterfall at Fraser's Hill in Malaysia a silky smooth texture.

Scout for high positions that give an understandable view of a river. In rural areas, in the upper reaches of the river, where the topography is likely to be steeper and more varied, there will often be *viewpoints* on bluffs and near bends. If the area is in any way conventionally scenic and developed,

these will be probably be signposted from the road.

For relatively straight sections of a river, or indeed for a canal, look for end-on views, and again, these will generally make more sense visually if you are higher. A bridge or lock is ideal. In steep-sided valleys and gorges such as the Yangtse, the Indus or the upper Mekong there is often a river road running high above the water that will have its own vantage points. In hilly country, look for pronounced bends in rivers which can look spectacular with a wide-angle lens.

Tumbling small rivers and streams in steep sections and in woodland make a distinctive kind of subject exploited by European landscape painters since the 18th century. The steep descent and the smaller dimensions make it much easier to find head-on views with the water snaking down towards the camera.

As with waterfalls *(see below)*, fast-flowing water lends itself wonderfully

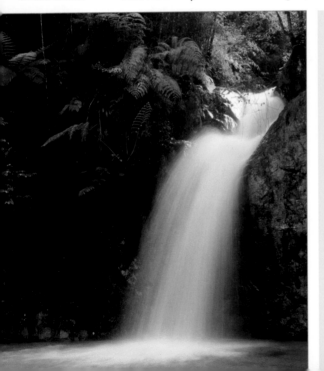

Waterfalls

Waterfalls are natural subjects for photography. Because they are universally popular, they are generally easily located. Season is important; you want a full flow of water, not a trickle at the end of the dry season. Automatic exposure is not always reliable, because it will be affected by how much of the picture frame a fall takes up. If only a sliver, overexposure is likely, so pay attention to the highlight clipping warning on the camera's screen. You don't want to lose the fine texture in the white water and spray. Also look for different vantage points, not necessarily head-on. Another approach to small falls is to look for view from very close, to one side or even behind the falling water. With sunlight glinting on it, and a high shutter spread to catch the sparkle, you can attempt a backlit image.

to a slow treatment. Set the aperture as small as possible and the ISO setting low, use shutter priority or manual and choose a *shutter speed* of a second or more – you will need to keep the camera steady. The result will be of a misty, silky smooth flow of water, contrasting marvellously with the solidity of the rocks. This is a guaranteed crowd-pleaser.

River estuaries

In the lower reaches of rivers it is a different world, particularly around estuaries. These are tidal – by how much depends on the location – and the ebb and flow twice a day can alter the appearance completely, giving a wonderful variety of imagery.

Look for glistening mud banks and ripples as the tide goes down, which can make graphic and almost abstract images if you shoot into the light, and of course early morning and evening are good times for *lighting* atmosphere. Because of the water, dawn and early morning is a time to expect low-lying mist hovering over the river, and while this is never predictable, it is one of the

rewards of getting up early for photographs. Dawn and dusk are also good times for waders and other birds.

At any time of the day, look for activity along the river and banks: fishermen, herons, people boating or sculling. They can give a sense of *scale* and a *centre of interest*.

Lakes and reflections

For stunning landscape images you can't beat a good lake or pond. In contrast to the sea, shallow lakes are often as calm as the proverbial millpond and so present the possibility of some stunning reflections, depending on the surroundings of course. The permutations for reflections are endless, but most will feature some dramatic sky and quite possibly mountains and forest or fields too. There is no point in having a refection of sky unless there are some interesting clouds to go with it. Try varying the proportion of landscape/sky and lake. If symmetry is what you're after, the *Rule of Thirds* will not be an issue – go ahead and split the image clean in two. Some pictures work with just

Reference ▷

Viewpoint, p.83
Shutter speed, p.101
Light effects, p.64
Centre of interest, p.76

BELOW:
A few ripples add a graphic element to this reflection of a canoe.

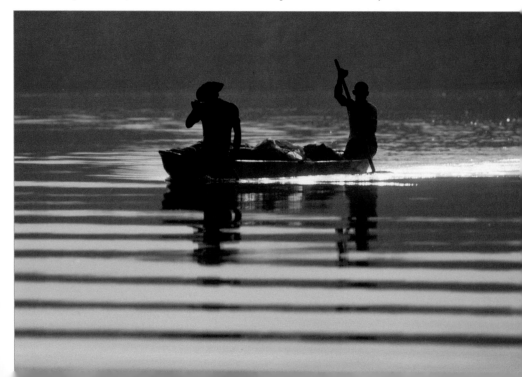

a little sky and landscape and mostly reflection, some the other way round. It just depends on what you want to emphasise, and experimenting is very much the name of the game. Whatever the proportions, it's worth having everything as sharp as possible by using a small *aperture*, and for the perfect result it's best to focus on the reflection rather than the scene above. You might want to try a boat or a jetty in the middle distance to add a *centre of interest*.

Alternatively, do away with the scene altogether and just have the reflection, say of foliage in a pond or people on a jetty. Reflections in water are more intense under a direct sun, and can give well-defined graphic silhouettes. Ripples on the water create their own special effects *(see pictures on previous page and opposite)*.

Wetlands

Wetlands are found typically around coastal estuaries and broad river plains and they have a particular isolated feel. Some of the largest and most well-known are the Everglades in Florida,

the Pantanal in Brazil, and the almost impenetrable Sudd in the central, Sudanese reaches of the Nile.

Largely flat and open, there is little in the way of relief in the landscape, nothing to block out the attractive light that moves steadily across it from dawn through midday to dusk.

One important visual advantage of wetlands is the water itself, which can have a variety of interesting reflections, particularly when mixed with clumps of reeds and other aquatic plants.

By comparison, the light on an overcast day or under a high sun is more difficult, and wetlands can have a very flat and ordinary appearance in such conditions. The *lighting conditions* in clumps of trees such as the "hammocks" of the Everglades and in mangrove swamps are essentially those of *broad-leaved forests*. Low direct sunlight is particularly appealing in wetlands as it gives a texture to the reeds, grasses and water ripples. Side-lighting is also generally good for close photographs of birds, and *birdlife* is one of the great attractions of this kind of habitat. ❑

BELOW: Low direct sunlight and shallow depth of field highlight these reeds in front of a lake and forest in Finland.

SEASCAPES

ALTHOUGH THE sea may seem to be lacking the wealth of features that we are used to in landscapes, it offers a surprisingly rich variety of imagery. The secret of varied seascapes is twofold: what else you add to the photograph, and the ways in which you can make the sky and sea interact.

Most views of the sea are from coastlines, and from here there is incredible variety. There are rocky coasts with headlands, cliffs, coves, arches and stacks (collapsed arches), sandy shores, mudflats, pebble beaches, mangrove swamps, salt flats, and more. There is also a great variety of vegetation, from windswept Monterey pines on the California coast to sheep-grazed green headlands and fringes of coconut palms.

A strong feature

These elements can be added to the seascape by choosing a viewpoint that makes use of at least one strong feature,

ideally off-centred. Even flat shorelines can be worked into a composition. For example, if all you have is a pebble beach, experiment by placing the camera very low, even resting it on the pebbles, using a wide-angle lens or zoom setting, and a very small aperture for strong *depth of field*.

Boat life

The other perfect complement to an expanse of sea is, of course, a boat, and if you are close to a port or fishing harbour you can expect to make use of a passing vessel to key the composition. In fact, a boat at sea is one of the simplest, classic situations for placing a subject and dividing the frame – refer to our Composition section for ways of doing this harmoniously.

Other coastal activity to look out for are fishermen hauling nets into shore. The Chinese nets used in Kerala, for instance, make wonderful, sail-sized shapes, while in Chile the

BELOW: Cape Town, South Africa, where a slow shutter speed helps capture the spray and the resulting small aperture gives great depth of field.

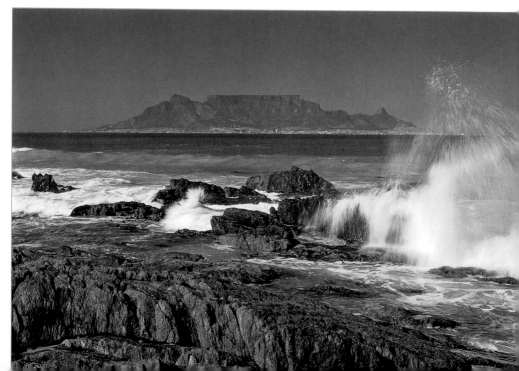

horses that pull fishing boats ashore amid hungry pelicans are a sight that just has to be recorded.

Boats in a harbour can make graphic images, either when they are brightly painted, or when their paint is peeling, and there is nothing more like a Turner prize winner than a rusting hulk on the shore. All the paraphernalia of boats – tarred ropes, patched nets, lobster pots and marker buoys – make ideal subjects, while returning fishing boats and their trail of scavenging gulls are images to match an autumn tractor ploughing the fields.

Cliffs and birdlife

Rocky coasts, particularly those with sheer cliffs, are favoured by colonies of *seabirds*, who choose this kind of site for protection. Be sensitive when birds are nesting, for your own sake as well as theirs – get too close to fulmars and they will bombard you with bile. Check local tourist information to see if there are any nearby. You will probably need a telephoto lens.

The second key to seascape photography is playing with the ways in which sea and sky interact, because for anything other than close-ups, the flat horizon line will usually be prominent, and the sky also. The sea's surface, which if calm will reflect the sky, is an important variable, and can create totally different impressions, from, say, a grey and ominous rough sea flecked with white crashing onto an Atlantic shore in bad weather, to the turquoise of a gently sloping white-sand beach in the tropics.

In the tropics

Tropical beaches are a subject in themselves. It is often easy to idealise them as a perfect mixture of white sand, clear blue sea and sky, with a palm tree leaning conveniently to frame the scene. Obviously, not all tropical coastlines are like this, but the best are firmly on the tourist map, whether the Seychelles, in the Caribbean, the South Pacific or one of the thousands of small islands in the Philippines.

The spectacular colouring from deep blue to turquoise that everyone expects to see, comes from three essential conditions: clear calm water, deep cloud-

BELOW: An ebbing tide at Galle in Sri Lanka.

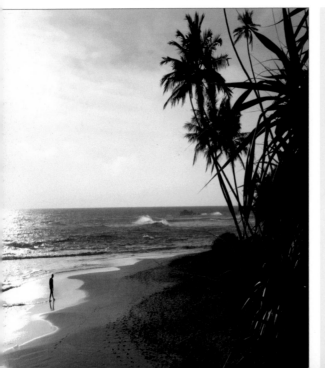

Rock Pools

The receding tide on rocky coasts leaves behind rock pools that are likely to contain intertidal life, from sea-wrack to crabs and molluscs. Make use of the close-up techniques described on pages 236–7 for photographing the small-scale life in these pools, keeping as much depth of field as possible. Unless you are deliberately photographing towards the sunlight in order to capture the sparkling reflections and highlights, you will need to take special precautions to prevent reflections of the sky from obscuring your view of what is inside the pool. Try to position the camera so that the light comes from one side. A polarising filter cuts reflections and can be a useful solution. Another alternative is to shade the water above and in front of the camera with something dark, such as a black card or even a piece of clothing.

less sky that the sea's surface can reflect, and shallow beaches and lagoons with coral and white coral sand.

The intense blue-greens in shallow water come from the way in which water selectively absorbs light. In such ideal and colourful conditions, underexposing slightly can be very effective by intensifying colours and exaggerating the already slightly surreal appearance. A polarising filter can add to this even more.

High light levels

Light levels tend to be high for all seascapes, partly because the water and beaches reflect light. But pay attention also to the overall *sense* of brightness. A deep blue sea and grey rocks will have the same kind of average reflectance as a regular landscape, but if most of your frame is taken up with white foam, the exposure will be more like a *snowscape* and you will need to compensate by increasing the exposure, possibly by one to one-and-a-half stops.

This need for compensation is likely to be even greater if you are photo-graphing towards the sunlight in a scene where the sea is reflecting the sky strongly. This kind of backlit shot can make use of silhouettes from, say, an offshore island or a passing ship, and also the sparkle and glint of specular reflections of the sun.

Capturing the waves

Rocky coasts usually have heavy wave activity, and when the sea is crashing onshore there is likely to be plenty of fine spray. Apart from its effect on cameras and lenses, coating them with a fine deposit of salt, if you spend time shooting, it brings a haze to the scene, particularly visible in telephoto images. Use an ultra-violet filter or a rotating polarising filter.

The movement of waves, whether gentle or violent, also suggests a possible slow-motion treatment in low light, such as evening or dawn. For this, use a tripod and keep the ISO setting low and the aperture small to allow an *exposure* of at least several seconds. The effect can be ethereal, with the water seeming to flow around rocks like mist. ❑

Reference ▷
Bird photography, p.234
Details, p.241
Light & Geography, p.54
Shutter speed, p.101

BELOW: The blue-greens of the waters off the Yucatán Peninsula in Mexico are intensified by underexposing slightly.

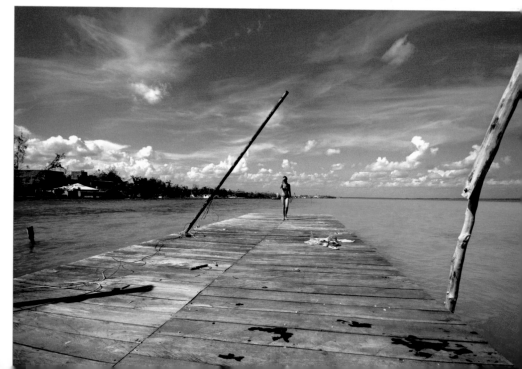

FOREST AND FOLIAGE

FROM EVERGREEN needleleaf forests in northern latitudes, through deciduous broadleaf woodland in temperate regions, to the tropical rainforests of the Amazon and Congo, forest is in decline, yet surprisingly it still covers almost a third of land on the planet, with Europe accounting for a quarter of the forested area.

The leaf canopy of most forests is continuous or nearly so, which makes them not only an enclosed world, but a challenge for photography because visually they are busy, even cluttered.

Two choices

This leaves you with two basic choices: photographing from outside at a distance, or entering for an immersed view. The former is a simpler option, provided that there are suitable viewpoints. These include, for example, photographing from one hillside to another in forest country that has strong relief, such as in the picture of

forested ridge lines *(below)* or looking across open space like a river or lake for a view of the woodland edges, or looking down from a high overlook (aerial shots can be even stronger). A telephoto lens is often useful for its ability to be selective and close in on patches of forest for this kind of shot.

One problem in photographing forests from a distance like this is the mass of trees may look formless and uninteresting, unless you can find some element such as a river, stream, lake or rocks to introduce a break in the pattern, or use light and shadow to do the same. Even better is when one or two species are in flower, or are turning colour in the autumn.

Temperate woodland

Spring and autumn in temperate deciduous woodland are often the best times for colourful imagery, particularly in Canada and the northern United States, Scandinavia, the Caucasus and east

BELOW: Early morning view from Nuwara Eliya, Sri Lanka. The 180mm telephoto gives a compressed view of the forested ridges.

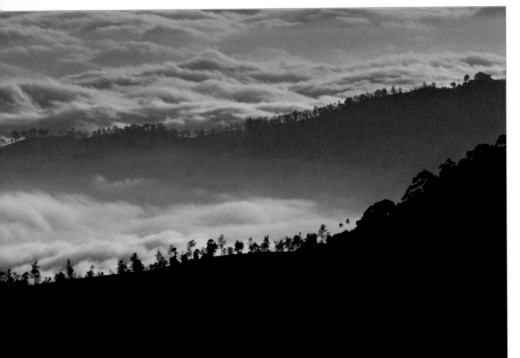

Asia. These are the regions that have most pronounced fall colours.

In North America, Vermont has long been well-known for these, as has the main island, Honshu, in Japan. Autumn foliage is important enough where it happens to the local tourist industry that the predicted timings tend to be well-publicised, but the regions are underpopulated and visitors won't interfere with your shots. In Japan, the seasons are sufficiently definite that the precise dates are published well in advance. These progress from southwest to northeast – the abundance of maple trees make "maple viewing" or *momijigari* a phenomenon, matched in spring by *hanami*, or "cherry blossom viewing" *(see Calendar)*.

Finding a viewpoint

Creating an effective composition that makes sense of the mass of tree trunks and foliage and conveys a sense of being there usually means that you have to find a clear *viewpoint*, and glades and small clearings are ideal.

To cope with the depth of view inside woodland, you will usually need to keep the aperture small for good depth of field. A wide-angle focal length helps overcome this, but usually means tilting the lens upwards, and you may need to correct the perspective distortion later when processing – unless you go for a shot pointing vertically upwards as in the picture below, which can make a refreshing change to the usual composition, and is good when canopy leaf colours are interesting, such as for fall foliage.

Difficult lighting

Lighting can be tricky, not only because the light levels are low (yet you generally want a small aperture), but because of high contrast on a bright day.

Sunlight breaking through the canopy creates visible *shafts of light* and can produce intense pools of light many times brighter than the forest shade. Either change your viewpoint and composition to keep bright patches to a minimum, or else, as with the picture below, make them a more important and larger part of the image by getting closer, and expose for them rather than the shade. An alternative is to make a

Reference ▷

Calendar, p.279

Exposure, p.108

Viewpoint, p.83

Light effects, p.64

LEFT:
Shafts of sunlight
penetrate a forest
canopy.

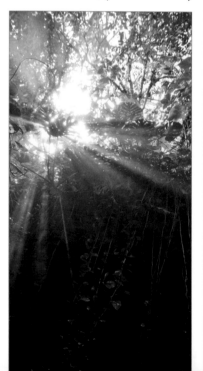

Individual Trees

The complex shape of many trees and the fact they are often surrounded by others make it a challenge to photograph single specimens. For a clear, isolated view of a single tree, consider the following:

• Some species, like elm and acacia, often grow singly or scattered over open ground.

• A steep hillside viewed from the opposite side, presents trees arranged more vertically.

• Skyline views, on the tops of hills and low rises, silhouette trees (as in the picture opposite).

• Water, from a high viewpoint, provides a simple background. Use a telephoto lens looking down on trees near the edge of lakes, river, or the sea.

• Mist and fog can isolate trees, even in a forest, by muting tones and separating a scene into distinct planes. Mid-level clouds shifting across mountains have a similar effect.

• Low-angled sunlight will pick out some individual trees. Early morning and late afternoon are good times.

• More often than not a long focus lens, with its ability to make the background appear larger in proportion to the tree, helps simplify the image.

series of exposures and blend these later in *processing*.

Deciduous forests in winter are a different matter, much more open without their leaf cover. Conventionally they may seem bleak and barren, but the shapes of trunks and branches can sometimes take on an architectural appearance.

Rainforest and redwoods

Rainforest is among the most impressive and atmospheric environments for photography. Most of it is in the tropics – the Amazon, Congo, Borneo and New Guinea are the major locations. A few temperate rainforests are more accessible, and the best-known of these include the Hoh Rainforest on the Olympic Peninsula, Washington State, the Tasmanian Rainforest, eastern Taiwan and Japan's Taiheiyo forests on the islands of Shikoku and Kyushu.

High rainfall and almost completely closed canopy cover help to make a rich, green and moist, silent world, with impressive trees and around half of the known species of flora and fauna. Because of the near-solid canopy,

which restricts sunlight, the forest floor is typically quite open. This makes composition a little easier but keeps light levels low. A tripod is a good idea. Forest giants, in the 50-metre range, often have buttressing at the base, and these make good subjects, particularly if you can give them a sense of scale by including a figure.

A figure (or figures) will definitely come in handy when photographing the California Redwoods. And here, among the tallest trees in the world, light is not such an issue as the canopy is nowhere near as dense.

Infrared option

A specialised but exciting treatment for any forest is to photograph it in infrared. The chlorophyll in green leaves fluoresces strongly in the near infrared wavelengths that a converted digital sensor responds to – and infrared film, of course, if you use a film camera.

The result is that green and healthy foliage appears white, like snow. In a mixed deciduous forest, it also gives a special clarity that visually separates different species. ❏

BELOW: Low light levels in the thick of the Hoh Rainforest on the Olympic Peninsula in Washington State.

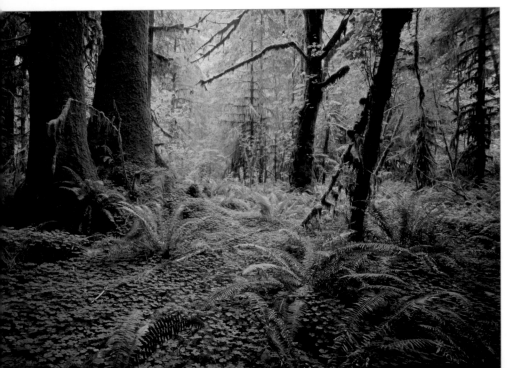

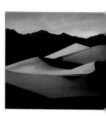

DESERT

DESERTS ARE defined by their aridity – no more than a few inches of annual precipitation, and in some years no rainfall at all. This simple climatic fact makes them at the same time the most inhospitable and the most impressive landscapes on the planet.

To begin with, they are sparsely populated if at all, which gives them a high ranking among the world's wild places, but also makes travelling through them a specialised affair. The aridity means that continuous sunlight and predictable clear skies are the norm, which makes it possible to plan shooting for key times of day (*see following page*).

The lack of rainfall means little or no vegetation, so that desert landforms are pure and uncovered – rock formations and dunes have clean, graphic lines and shapes found nowhere else. For photography, such starkness of form is a wonderful opportunity for creating stylised, even *abstract* imagery, though sometimes you might find yourself looking for some kind of prop to give the dunes a sense of scale.

If you are making a desert trip, make sure that you are in the hands of a driver and guide who really know what they are doing. Deserts are dangerous places to get stuck in, and the landscape can also be disorienting.

Dune fields

In the popular imagination, the classic desert landscape is of dunes, with or without camels. In reality, dune fields, or *erg* as they are known (most desert terminology comes from the Arabic) are much less common than, say, the stone and gravel desert plains, known as *reg*.

For the desert photographer, dunes are the *premier cru*, and include such marvels as the red dunes of Sossusvlei in Namibia (the oldest in the world), the 100-to-300 metre (330–985ft) Mingsha Shan dunes of the Gobi

BELOW:
The ridges of the Moreeb dunes in Abu Dhabi, UAE, create subtle, almost abstract patterns with the assistance of a telephoto lens.

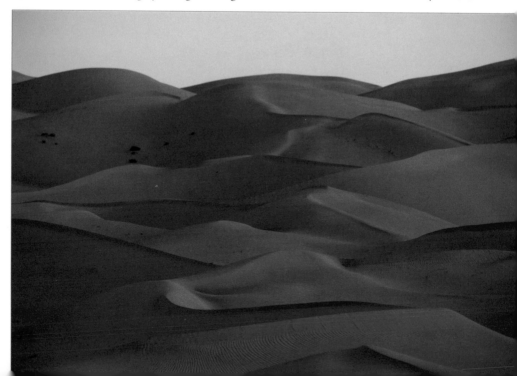

Desert near Dunhuang in China, the white gypsum dunes of White Sands, New Mexico, and the Erg Chebbi of the Western Sahara in Morocco.

The sinuous lines, ridges and ripples create shapes and patterns that provide endless opportunity for experimenting with composition. Dunes alter their appearance radically with changing light, and are at their most striking when the sun is low. The classic shot is end-on to a dune ridge that is aligned roughly north to south, with a sharp S-curve separating the lit from shadowed sides.

Look also for dune slopes in various directions, and for the effect that raking sunlight has on creating patterns from ripples.

Type of lens

When it comes to lens focal length decisions, there are again two classic treatments: telephoto and wide-angle. The telephoto approach is useful for *compressing perspective*, giving a single dune a more vertical appearance. With its compressing effect and natural selectivity a telephoto lens makes a dune field fill the frame more satisfactorily than a standard focal length.

The wide-angle approach is quite different, and takes advantage of the continuous texture of sand. Stand on or close to the ridge itself and angle the camera downwards so that the dune's horizon is close to the top of the frame; the lower part of the image will be filled with close sand. Provided that the sun's angle throws patterns into relief, this can be very striking, especially if sand particles glint (as they do spectacularly in White Sands, New Mexico).

Avoid signs of life

All this emphasis on pristine surface texture in sand makes it important, wherever possible, to avoid the footprints – yours and anyone else's. If you are fortunate enough to be alone in an area of dune, try to plan your walk so that you do not suddenly find that the best view is back towards your own trail.

In well-known and constantly visited locations, such as Crescent Lake oasis, near Dunhuang, China, the view

BELOW: The extraordinary White Sands dunes backed by the San Andres mountains in New Mexico, with no sign of life at all.

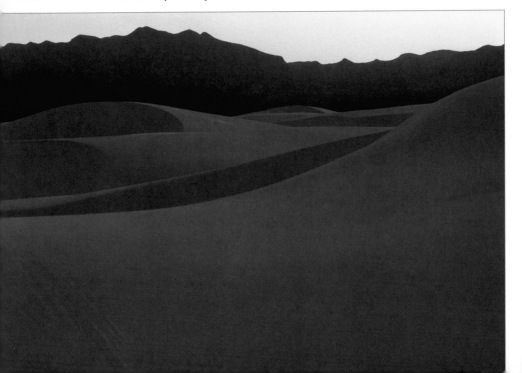

will always be marred by footprints. The only possibilities then are to time the shot so that most footprints are in shadow, and crop the frame accordingly. Or, if you are lucky, you will arrive after a windy period when they will have been briefly obliterated.

Formations

Other than dunes, the really strong appeal of deserts is the bare topography, uncluttered by vegetation, that creates wind-and-sand-eroded rock formations.

The southwest of the United States, in New Mexico, Arizona and parts of Utah have a fantastic collection of mesas, buttes, needles and arches. The superb organisation of the US National Park Service and good roads make these easily accessible.

Elsewhere, Saudi Arabia has Mada'In Saleh, made even more dramatic by the pre-Islamic buildings carved into the rock faces, Jordan has Petra, similar but much better-known, Australia has Uluru (Ayers Rock), which dramaticaly changes colour throughout the day, and Turkey Pasabagi in Cappadoccia, where the caves and fairy chimneys create a unique landscape that is popularly overflown by *balloon*.

Deserts also contain rock formations in reverse, in the form of slot canyons, narrow, deep and winding. Arizona's Antelope Canyon is one of the most famous and beautiful, almost invisible from the surface but containing an exquisite variety of swirling sandstone forms eroded mainly by flash floods.

These, in any canyon, are a rare but real danger – more than 100 people have been killed in Arizona flash floods, 11 in a single one in Antelope Canyon in 1997. So heed local advice and weather reports if you are venturing into one.

The dynamic range of light inside any narrow canyon, such as the Siq at Petra, Jordan, leading to The Treasury, is extremely high, particularly when a shaft of light enters close to midday. If you have a tripod, which is recommended in this case, take a series of exposures that vary by at least one ƒstop for later combination (*see Exposure blending/HDR*). ❑

Reference ▷

Lenses, p.113
Blending/HDR, p.303
Hot-air balloons, p.256

BELOW:

Sunrise behind Thor's Hammer in Bryce Canyon, Utah

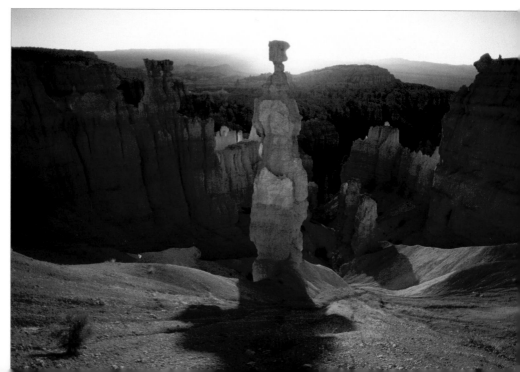

ICE AND SNOW

WHEN SNOW coats the landscape, it simplifies everything, at the same time reversing the usual tonal relationships. As a result, there are many more opportunities for clean, graphic compositions, which you can exploit as semi-abstract images, or take the minimalist approach by selecting just one relatively small recognisable subject to set against a white backdrop – a house, perhaps, a figure, or an isolated tree.

If possible, go out immediately after a fresh snowfall, before other people have had a chance to trample on it. Early morning is particularly good, while there is still some fresh frost and before the sun has melted icicles.

Don't restrict yourself to overall snowscape views. Take time to look closely at details, where you may find abstract patterns, such as a lining of frost on leaves and spiders' webs, and cracked patterns and trapped bubbles as the surface of water begins to freeze.

BELOW: Exposure compensation is necessary when taking pictures of snow.

If snow is falling, this too can make for otherworldly scenes, but avoid flash, as this will reflect from falling flakes close to the camera, and look like white blobs and blemishes.

Exposure compensation

Exposure is an obvious concern. You want snow to look white rather than grey in the final image, so exposure compensation of typically one-and-a-half to two stops will be necessary. Use either your camera's exposure compensation control, or use manual and adjust the settings accordingly.

Rather than waste time estimating the exposure, simply adjust by an extra one stop for the first shot and assess the result on your camera's screen. In fact, the "correct" exposure for snow has quite a narrow range, because brighter patches in the scene can quite easily be clipped as you increase the exposure.

Always check the results using the camera's highlight clipping warning.

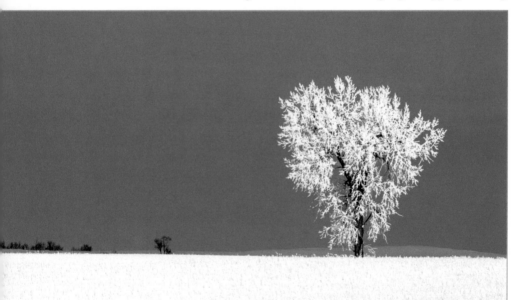

There should be no clipping other than a few sparkling point reflections in sunlight. On a 0–255 level digital histogram, the ideal exposure for white snow and ice should be in the region of 230–245.

Polar trips

Polar ice can be even more spectacular, with blue to blue-green colours, icebergs and ice cliffs. The logistics of a trip to Antarctica is beyond the resources of personal travel. If this is your goal you will be on a cruise, and almost certainly in the hands of experts. Most polar cruise ships have at least one resident professional photographer on board, which will help with any problems. Technically, all the advice here on snow and ice in general applies with more rigour.

Temperature extremes

Conditions that are likely to affect you are dealt with on page 298, but to summarise, the two main equipment problems are that batteries fade faster at lower temperatures, and condensation occurs when you move between temperature extremes. For the first, make sure your battery is fully charged at the beginning of the day, and ideally take a spare. If the battery appears to have run out of charge, remove it and warm it under your clothing – you may get a few extra shots out of it. Some DSLRs have external battery packs that you can also keep warm under clothing. For condensation, keep the lens cap on when you move out into the cold, and remove it later. Returning to the warmth, try to let the camera warm up slowly – say in a cool part of the building for a quarter of an hour or so – before entering full heating. Also avoid breathing unnecessarily on the camera; that too will cause condensation.

Silk glove approach

Exposing fingers to extreme cold (minus 15–20°C and below) needs mittens or gloves that can unzip at the side to expose your fingers just for shooting, as well as a pair of thin inner gloves (silk is best). Avoid touching metal. Tape over tripod legs and metal parts on the camera back that your face may touch. ❏

Reference ▷

Light & Geography, p.54
Exposure, p63
Difficult locations, p.298

BELOW: The colour of the ice makes Antarctica a photographer's dream.

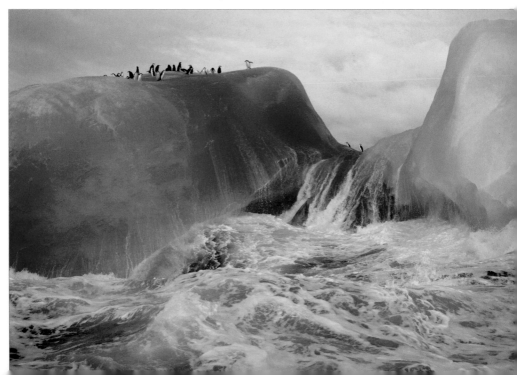

CULTIVATION

LANDSCAPES UNDER cultivation, whether ancient farmland with hedgerows in France, rice terraces in southern China, tea bushes in Japan, or an oil palm plantation in Malaysia, are a source of imagery that can be at the same time graphic, because of the patterns of planting, and a reflection of local culture and way of life.

Although we tend to be conditioned to think of wild nature as good and the hand of man bad, agricultural land can be beautiful, too. French *bocage* or stone-walled fields in the Yorkshire Dales, for example, carry the imprint of tradition, toil and history.

Monoculture

The most graphic of all cultivated landscapes tend to be those under monoculture. Look for the pattern of planting and follow its structure. Oil palm and rubber plantations, for example, are generally in straight rows, which can give impressively deep views

from certain angles. In such conditions it often helps to have a figure for scale and compositional interest, such as a worker tapping rubber in the early morning. Human interest is a matter of taste, but is always worth considering, such as a rice farmer replanting young rice in a wet paddy. Labourers created these fields: they are part of the landscape.

Finding an overview

Viewpoint matters, and as with so many landscape features, anything approaching a plan view is likely to be effective in revealing patterns. This usually means either looking down from an overlook or across a valley to a facing hillside.

This is particularly true of photographing terraced agriculture – rice and tea are the two best known cases – because this ancient and labour-intensive method of using land evolved to cope with hilly areas, where such

BELOW: Tea pickers at Darjeeling, India.

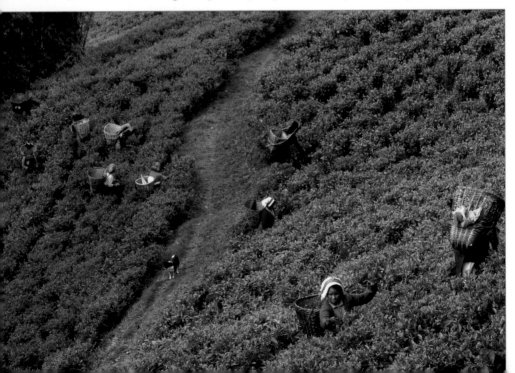

viewpoints are common. The mosaic patterns created by terrace partitions can have a particularly artistic effect.

Patterns on a landscape

If the pattern is extensive, such as the famous examples of rice terraces in southeast Yunnan and in northern Luzon in the Philippines, you can make use of a wide-angle lens focal length. One tip here is to try composing and cropping so that the frame is filled with the terracing pattern and nothing else. Otherwise, use a telephoto to crop in on details.

Rice terraces are in many ways a special case, because seasonally they are filled with water; their appearance at this time of year and in the right light, especially very early and late in the day in sunshine, can be outstanding. Shooting with the sunlight or with cross light tends to bring out colours, while shooting into the light emphasises contrast and pattern.

The changing year

It is worth researching the crop cycle for the places that you are planning to visit, to discover the planting and harvesting cycle. Remember that with irrigated landscapes, the condition of crops can vary from place to place locally – there may be two crops in the year, for example, rather than just one, and different parts of a rice terrace complex may be at different stages.

Seasonal variations

In all cases, seasons make a difference to the look of a landscape as crops grow, ripen and are harvested. Harvest is always the busiest time, and in societies that are not well mechanised, this is a great opportunity to photograph groups of people at work, though even mechanised labour, with gleaming or rusty machinery, can produce interesting images.

Few people will object to photographing at this time of the agricultural cycle, and photography can segue into pictures of lively celebrations, which accompany most harvests.

Even mechanised agriculture offers unexpected moments of beauty, such as wrapped hay bales dotting a harvested field. ❏

Reference ▷

Light & Time, p.57
Viewpoint, p.83
Geometry p.86

BELOW: Small terraces cling to slopes in an autumnal Hunza Valley, Pakistan.

BLACK AND WHITE

THERE IS A long and honourable tradition of black-and-white imagery in landscape photography, not simply because 19th-century emulsions were monochrome by necessity, but through a line of masters that includes Edward Curtis, Carleton Watkins, Peter Henry Emerson, Edward and Brett Weston, Ansel Adams, Robert Adams and Don McCullin.

Because serious landscape photography is all about personal interpretation, black-and-white has always been able to offer more opportunities than colour for producing an image that's different. This is mainly through processing choices, which include selective dodging and burning (Ansel Adams's photographs are prime examples of this, particularly when they create drama in the sky), and choice of contrast.

Black-and-white images can be processed successfully to greater extremes than can colour, simply because the monochrome palette is already a distance removed from natural "reality". This is as true of digital processing as it ever was for film and wet prints, and the procedures are easier.

You could, for instance, interpret an Icelandic mountain landscape of black lava and white snow in extreme graphic contrast as black and white, whereas the same treatment to a colour image would look crudely over-processed.

Using coloured filters

Perhaps the greatest control in black-and-white landscape work, however, is over the way in which colours are converted to shades of grey. We deal with the technical aspects of this in the *Processing* section in At Home, but the principle is the same for both film and digital – a strongly coloured filter will make opposite colours translate into monochrome as much darker, because their wavelengths are blocked, while it passes the same

BELOW: Upper Yosemite Falls in Yosemite National Park, California.

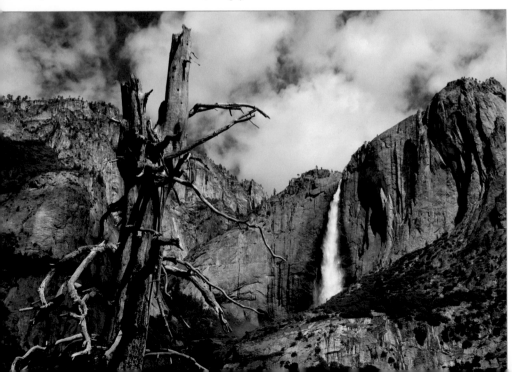

colours unrestricted, so they reproduce light in monochrome. Thus, a red filter over the lens will turn a strong blue sky almost black in monochrome, while a green filter will lighten vegetation.

Digital photography no longer needs a set of coloured lens filters (which were, incidentally, used extensively by Ansel Adams), because processing software can achieve the same effects by manipulating the colour channels red, green and blue.

Digital equivalents

The examples here use Photoshop's "Black & White" adjustment, but all good processing software can do the same thing. The digital equivalent of using a coloured filter over the lens is to move that colour slider higher. But you can also choose the slider corresponding to the colour you want to change and tweak that. In landscape photography, the classic uses of filters (or sliders) is as follows:
• Darken blue sky and shadows, for stronger contrast: blue slider down or red slider up.

• Lighten green vegetation: green and/or yellow slider up (much of what we see as green for vegetation is actually more yellow).
• Increase the aerial perspective and sense of depth: blue and/or cyan slider up, particularly when there is bluish distant haze, as in mountain landscapes.

As the sliders are usually very precisely calibrated to specific colours (the equivalent of a sharp-cut filter), you can often, depending on the original colour scheme of the scene, adjust selectively.

For example, if you have a blue sky and green fields, try working the blue and green filters together, such as to darken the sky and lighten the grass or cultivated crop. This can be even subtler. For instance, a blue sky down to the horizon will often have a higher cyan component close to the horizon, so you could lower the blue while raising the cyan to give a more marked gradation. With green fields in raking sunlight, you might find that sunlit areas have more yellow, so that raising the yellow more than the green increases the local contrast. ❑

Reference ▷

Ansel Adams, p.138
History, p.31
Black & White, p.303
Motion blur, p.102

BELOW: The Merced River in Yosemite, complete with motion blur.

Digital Infrared

Several small companies offer an exciting option for a striking landscape interpretation by altering the camera sensor's wavelength response so it records infrared rather than ordinary visible light. Digital sensors are already sensitive to infrared – too much so for normal use, so the manufacturer fits them with an infrared cut, or hot mirror filter, at the front. Step one in customising a camera is to remove this filter and replace it with a filter that blocks visible light. This can be either a partial block to add visible light to the image (the standard procedure), or a total block for a more dramatic effect. The focus is also re-calibrated, as infrared waves focus at a different point. You can then shoot infrared "false" colour, or convert to black and white, for a typically black sky and snow-like vegetation.

PANORAMIC LANDSCAPES

IF ANY SUBJECT is tailor-made for a panoramic, widescreen treatment in a photograph, it is landscape, and in particular a landscape seen from a high viewpoint that takes in the broad sweep of the horizon.

From an overlook, whether it be the summit of a mountain or a viewpoint at the side of the road, this is how most people take in the scene anyway, looking from side to side, their attention located a short distance above and below from the horizon line. Indeed, many landscape scenes lack interest high (in the sky) and low (in the foreground) so this is a great way of dealing with them.

As almost all of the potential interest is around the horizon, this makes the ideal framing to be long and wide.

Stitching a scene

"Seeing" a panorama in a view is the key first step. Now you can, of course, simply crop into a regular frame later,

during or after processing, but this reduces the size of the image. The alternative is to pan the camera left to right between frames, photographing an overlapping series that can then be stitched together.

The advantage of this *stitching* method is that the image can be much larger than a single frame alone – and panoramas look best from a creative point of view when they are printed large. This is especially convenient for desktop printers that will accept a roll of paper. If you do not own one, it is anyway likely to be cheaper if you give the image file to a local printing service.

There is also no limit to the length of the sequence. You can just keep shooting and panning until you run out of interesting elements in the scene. In any case, you can decide where to crop it later.

One way to increase the size of the final image file is to rotate the camera

RIGHT: The individual shots, each one overlapping by about half.

to shoot vertically, and adjust the zoom to a more telephoto setting.

Ignore the rules

The ordinary "rules" of composition do not apply here, not least because you have to imagine the result at the time of shooting, and it is difficult to keep a sense of how the image frame will be. As the image is long and thin, mimicking the way that we would normally scan a scene, the viewer is simply less conscious of the frame. The position of the horizon is rarely an issue, because in this long frame there is little choice in raising or lowering it. Also, with a long panorama, the image reveals itself as a sequence from side to side.

In any case, try experimenting not just with a view that has everything in the distance, but with, say, a foreground element like a close tree or rocks on one side of the frame to anchor it. And with stitching software so efficient these days (Photoshop's "Photomerge" is powerful and simple to use), you have little need to worry about any movement in the scene, such as branches in the wind or a person walking through it – the software can automatically sense any difference between frames and favour one, eliminating the kind of doubled image known as ghosting.

Movie show

If you later intend to make a *slideshow* of your journey's images, or even a video, there is one more interesting thing that you can do with a long panorama. Many slideshow and video programmes, such as Keynote and iMovie, have a slide transition option that has the image moving from left to right or in reverse. The effect is like a movie pan as if you had been using a camcorder to survey the scene. It can add movement and an appealing break to the show.

Panoramic optics

A panoramic optic, which attach to the lens, will do the same job, taking a 360° picture in one shot without the need for any stitching. The camera needs to be mounted on a tripod, pointing vertically. Shutter release is set at around 10 seconds, and accompanying software unbundles the image. ❑

Reference ▷

Stitching, p.304
Slideshow, p.306
Rainbows p.170

BELOW:
The finished panorama after stitching: storm clouds and rainbow obscure the Daxue Shan range, Sichuan, China.

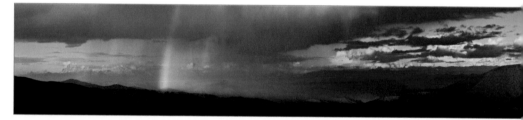

Some tips for panoramas

To create any kind of panorama, all you need to do is to shoot a set of images from exactly the same position, swinging the camera slightly from one shot to the next so that the images overlap. Overlapping by half is safe, but even by a third is acceptable for most of the software that will later put the images together in a process that is known as "stitching". Ideally the camera should be on a level tripod when you take the panoramas, but most stitching software will make a good job of assembling your hand-held sequence.

The choice of lens focal length is important, because a wider lens will take in more of the scene and so needs fewer overlapping frames to make up the panorama. It will also cover more of the foreground and the sky.

If you make your panorama a full 360° circle, you can create an interactive image format called a QuickTime VR panorama. VR stands for virtual reality, because the results can be "played" on screen so that the viewer can swing the view around as if actually standing there. If in addition to a complete horizontal sequence of overlapping images you shoot higher and lower sequences, all overlapping, then the QuickTime VR experience is even more remarkable, using the cursor to look up and down as well as from side to side.

ABSTRACTS

There is no such thing as a straight line in nature. Shaped by wind and water, landscapes already possess an abstract quality. It just takes a good eye to discern its possibilities

Photography is not always about getting an exact likeness of what you see. Consider the possibility of making the image less documentary and more abstract or graphic. Abstracting means taking out the realism from a scene. The more stark the landscape (such as a desert or an Arctic ice floe) or the more unusual (strange rock formations such as rock arches in Utah and the colourful, dramatic shapes found in Arizona), the easier it is to abstract.

In many cases you might consider the following techniques:

• Crop into the scene to remove the obvious, such as the horizon, signs of human habitation and anything that detracts from the central idea of the picture.

• Select subjects with clear graphic lines, such as rocks, sand dunes and ripples, snowdrifts.

• Close in on details with lines, shapes, textures, such as patterns in ice, raking light over a textured rock.

• Emphasise the bright light and deep shadows in orchards or olive groves.

• Use reflections in lakes or rivers, or even puddles, as a starting points for abstraction.

• Go for high, stark contrast by shooting into the light, and by processing for contrast.

• Alternatively, go for soft, hazy, misty scenes treated in a low-contrast, minimal way (telephotos are better at this than wide-angles).

• Use bad weather to your advantage: rain or poor visibility can have a distorting effect.

Though you should look out for these ideas, they may not occur until you are processing your pictures. Cropping, exaggerating hues and colours, are just some techniques that can suggest ways to turn regular pictures into something that looks "creative".

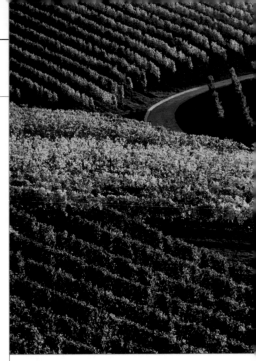

ABOVE: Vineyards in Tuscany. With no sign of people or buildings, and with no horizon, these rows of vines on the hillsides create a pleasing pattern.

ABOVE: These golden fronds are reflections in a rushing stream, taken with the shutter left open for a second to blur the movement, which fuses the image into molten colours of sky and foliage.

LEFT: Rock formations in Antelope slot canyon in Arizona are an ideal subject. Here they have look more like soft furnishing than solid rock.

LEFT: Water can have an abstractive effect, turning the recognisable into the unrecognisable, though it is not too difficult to guess that these random stripes might be trees.

THE HAND OF MAN

Nature does not have a monopoly on abstract shapes. There are many man-made things that can be reduced to an abstraction, too. Perhaps the best known way of doing this is through micro-photography – making everyday objects look strange by taking them from an odd angle and blowing them up. But by keeping a look out for angles, the travel photographer should be able to come up with unusual pictures that are pleasing to look at while being difficult to pin down.

Man-made materials tend to be brighter than nature, with harder edges and a huge variety of textures, all of which lend themsleves to visual exploration. Into this category could come street furniture. There are also possibilities in multiples: rows of bikes, lines of bollards, stacks of any kinds of stuff. And of course, nothing has to be the right way up: turning things on their heads or setting them sideways are just a couple of ways of getting a different perspective on the world.

There is only one rule to abstract photography, and that is there are no rules: in focus, out of focus, over or under exposed. You are on your own. This is where you get creative – and either it works, or it doesn't.

ABOVE: This slice of the Libyan desert looks more like something that has come out of the oven. The rippling effect of wind on sand makes some terrific abstract images.

BELOW: This light show in blue and green is unenhanced during processing. It is in fact a bluebell wood, and during exposures the camera has panned in a vertical plane.

ABOVE: This is a water pipeline under construction in Libya – what it is and where it is from would be impossible to guess.

RIGHT: City clutter – high-end apartments at the Dizengoff Center in Tel Aviv look like a small stack of electronic hardware.

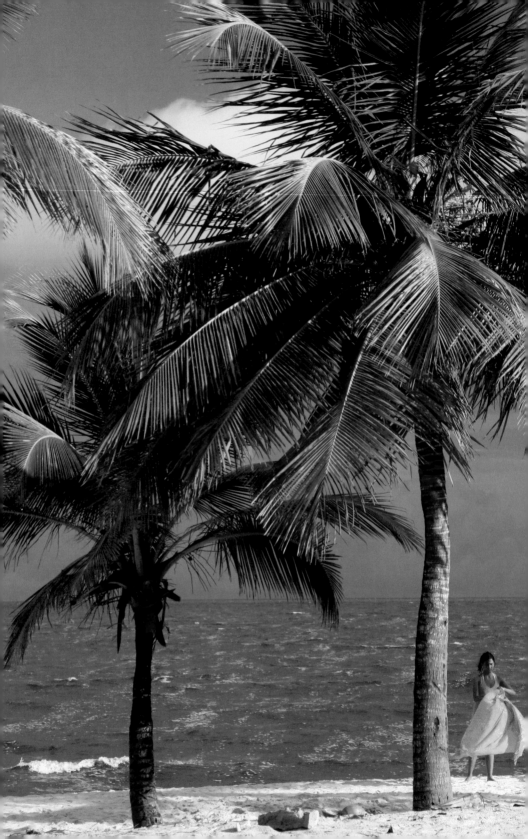

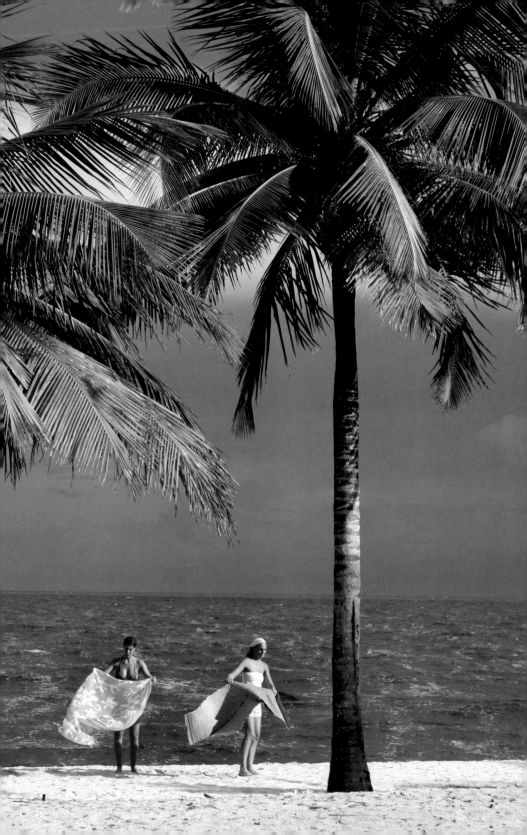

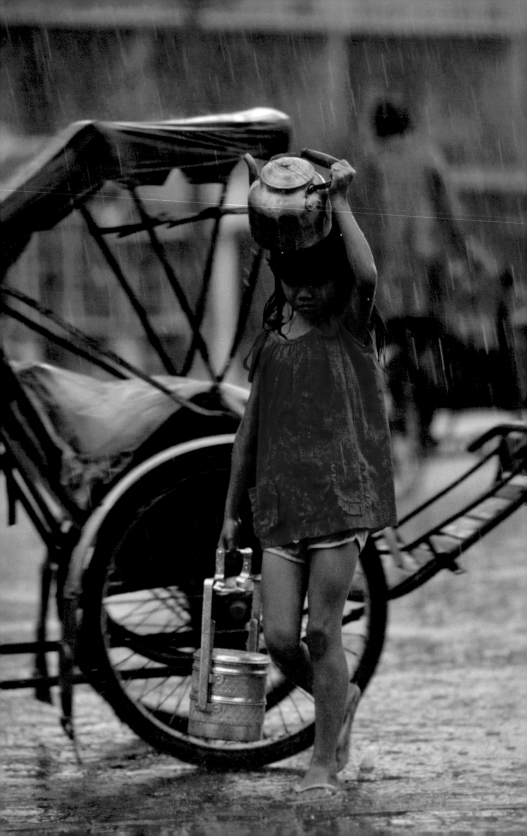

ELEMENTS AND SKYSCAPES

Whatever the weather, it's a good time for taking pictures. Instead of wishing for sunshine, photographers should make the most of what they find, and be prepared for nature's little surprises

The fact that there is no certainty in life is no more obvious than when contemplating the weather. The planet is so tireless in playing around the elements, that most of the time we have no idea what to expect.

In much of the world, all predictions are suspect, and any attempts to analyse, quantify or categorise the elements are hopeless. The artist John Constable spent a liftime trying to dream up a system of classifying clouds. He never achieved it. Isaac Newton decided there were seven colours in a rainbow but he made the number up to coincide with a music scale. The Beaufort Scale may describe the wind force, but there are no words for every kind of sea. We have no idea when lightning is going to strike, when volcanoes will erupt or how hurricanes or tornadoes will behave.

All this is enormously exciting for travel photographers, who daily may face half a dozen different changes in the weather. Keeping a good lookout, they may find themselves racing to capture the sun's rays, scurrying to see the steaming pavements after a tropical downpour, or running to catch a sun that's setting like a biblical revelation. And fleeting elements, such as rainbows and lightning, require an instant response.

To say that every cloud has a silver lining should be self-evident to a photographer. Look at this great picture of a little girl in the rain, in front of a rickshaw. It's not cute. She isn't smiling. In fact she's fed up that it's raining. A perfect shot.

A fog or mist can act like a soft focus lens, in which foreground colours and silhouettes can dramatically stand out. And if you don't want to be out in wet weather trying to keep your camera dry, that's okay: you can still take pictures from the shelter of a hotel room, a car or a cafe awning. ❏

Main topics
RAIN, FOG AND MIST
FLEETING ELEMENTS
CLOUDSCAPES
NIGHT SKY

PRECEDING PAGES: Stormy weather on the Bahia coast of Brazil. **LEFT:** Caught in the rain. **RIGHT:** a wintry Forbidden City, Beijing.

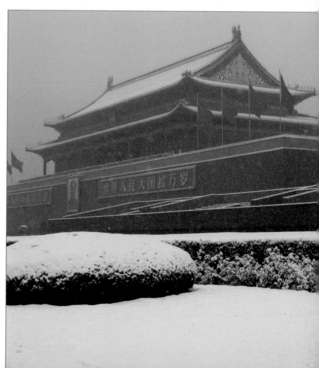

RAIN, FOG AND MIST

MANY OF US are conditioned to want, even expect, bright sunlight and clear weather, partly through sheer animal comfort and partly because most holiday and tourist destinations thrive on an output of fine weather picture promotion, in which beaches are empty, squalor is hidden and skies are relentlessly blue.

This is fine and pleasant, but like life itself, photography thrives instead on variety of imagery, and part of this variety in travel can come from weather conditions that you wouldn't choose to sunbathe in.

Rain, mist and fog all have the potential for ladling atmosphere and mood into a scene, provided that you learn their special characters.

Rain and snow

BELOW: Umbrellas out on a wintry city street.

In rain, things glisten and drip (green vegetation and Japanese gardens in particular are never better than like this), people carry umbrellas or run for cover, the air fills with atmosphere. A crowd of people carrying umbrellas – often in a variety of colours – has much more image potential than just people. If you are lucky enough and sun breaks through, look for images *towards* the light, with the sun backlighting the falling drops.

Rain, in short, gives photo opportunities, but whether you're shooting pedestrians and cars reflected in city streets or rain bouncing off rooftops and pavements during tropical downpours, always try to ensure that you keep water from landing on the lens.

Falling *snow* is even more atmospheric, and can turn an ordinary scene into a very special one; remember that you will probably need to compensate by opening up the exposure to keep the scene white rather than grey. The falling snowflakes will show up as either white dots or white streaks depending on the shutter speed, and will appear most clearly

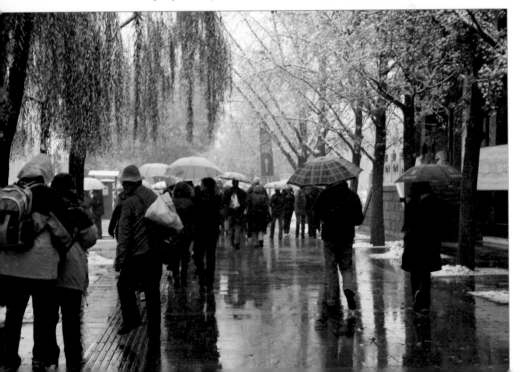

when falling against anything dark. If the resulting image looks uncomfortable, then so much the better.

Mist and fog

Mist, fog and enveloping cloud in the mountains offer some of the best photographic opportunities of all, bringing a subtle and gentle white or light grey minimalism to any scene. If you use a wide-angle lens and shoot close to a foreground, you can usually make use of a strong three-dimensional depth. As with snow, keep an eye on the exposure to make sure the camera's auto system is not making the images too dark.

The *weather* and landscape conditions that tend to give rise to mist and fog, with early winter mornings near low-lying water at the head of the list, are worth getting up early for.

They can provide almost magical atmosphere, and by experimenting with your camera position you can exploit the way that fog and mist can separate parts of a scene into distinct, almost cut-out planes. This effect is at its strongest if you shoot towards the source of light (one side of a misty

scene is often brighter), while shooting with the brighter part behind you tends to reduce contrast and render the scene with greater subtlety.

Above all, this kind of weather condition allows you to isolate subjects from their surroundings, and this is a frequent goal in photography. Swirling mist from a distance, as happens in humid weather in mountains as it drifts across hillsides, can provide a constantly changing picture, exposing a single tree or outcrop for a moment, then hiding them. In this situation, from a vantage point across the valley, for instance, use a telephoto focal length and spend some time waiting to see how the scene changes *(see picture of Machu Picchu on page 171)*.

Dust and sand

A variant on mist, fog and cloud is dust and sand. Swirling in a storm, such as in one of the rare haboob of Arabia and Sudan, when a wall of sand rushes across the desert, they can provide the most exciting weather lighting of all *(see picture on page 171)*, but camera safety really does come first. ❏

Reference ▷

Light & Weather, p.60
Light effects, p.64

BELOW: The sun starts to burn through morning mist at Staithes, Yorkshire, UK.

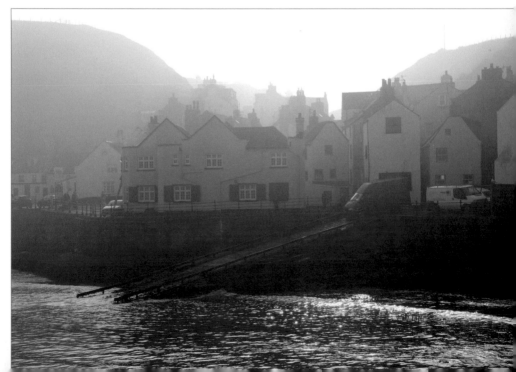

FLEETING ELEMENTS

SOME SKY elements are particularly fickle and short-lived. This is where knowledge of favourable conditions, plus luck and fast reactions, come in handy. Always try to compose these into an interesting landscape rather than make them the sole subject.

Rainbows

Rainbows, unpredictable and short-lived though they are, can transform a landscape. Caused by water droplets diffracting direct sunlight, the conditions they need are rain and sunshine from a low angle, and ideally you would want dark stormclouds behind to intensify the colours. Bear in mind that when you process the image, you can selectively adjust the saturation of the rainbow.

Rainbows appear directly opposite the sun from your camera position, and so their position is not fixed, but relative to yours. If you move, the rainbow appears to move. Bear this in mind because, while a rainbow alone may be an attractive sight, a rainbow that fits into a good landscape composition with other elements such as trees, hills, a farm, can make a special photograph.

You have no guarantee of how long one will persist, but immediately look at the landscape below and decide if moving your *viewpoint* would improve the shot. Be prepared to alter the zoom setting on your lens to accommodate the size of the bow, which can vary; the alternative is to use a telephoto focal length to concentrate on one of the ends; if you do this, the composition will definitely call for some other, ground-based element to be *part of the composition*. Galen Rowell's famous photograph of a rainbow over Lhasa's Potala palace is a fine example of this.

Lightning

Lightning flashes last a fraction of a second, so catching them means having some expectation of where and when the next one will be. This is

BELOW: Capturing the moment while kayaking off Kadavu, Fiji.

not at all easy to predict, although it is likely that there will be more than one in the same general area. Forget "lightning never strikes twice in the same place" – the actual point of contact may well be different, but from a distance this hardly matters (and you should certainly be at a distance).

If lightning begins, the best thing is to assume there will be more strikes in the same direction and set up the camera, ideally on a tripod. If you use a wide-angle lens, the angle of coverage will be wider and give you a better chance of catching a strike within the frame. There are both cloud-to-cloud and cloud-to-ground types, and the former tends to light up the clouds more.

There is no point in attempting to trip the shutter as you see a strike – by then it will be too late – so the technique is to open the shutter first, using the B setting so that it remains open until you close it manually. The timing problem is that in daytime there is too much light to allow a long exposure (unless you are phenomenally lucky), so lightning photog-raphy has a higher chance of success in low evening light or at night. You need luck anyway to be able to catch a strike during the exposure, but just keep on shooting – you can delete the wasted shots afterwards.

Aperture controls the exposure, and although it is hard to estimate, a range of exposures is perfectly acceptable. Try ISO 200 and *f*5.6 as a starting point, then check the first result and adjust as necessary. As lightning is an arc, just like in a flash unit, it will of course be blown out. Watch for the effect on surrounding clouds.

Wind

Strong wind can be a powerful element when you are standing in a landscape, but to convey its force you will need to show it moving something. Telltale indicators include trees and plants bending and shaking, smoke for a chimney stack, people leaning into the wind as they walk, flags and clothes flapping, white tops on waves, and so on. Unless you want to show motion blur, you will need a *speed* of 250 or 500, or set to "sport'" mode. ❏

Reference ▷

Viewpoint, p.83
Centre of interest, p.76
Lenses, p.111
Shutter speed, p.101
The moment, p.92

BELOW: The ultimate sandstorm – confronting a haboob in the Sudan.

CLOUDSCAPES

THE AMERICAN painter Georgia O'Keefe called sky "the best part of any place" and moved to New Mexico partly for this reason. She was perceptive; while mostly we see the sky as just part of a landscape photograph's composition, it is often worth shifting your point of view completely and treating the sky alone as the subject. Places with flat horizons and few obstructions – plains, steppes and high plateaux, for example, in contrast to the restricting views from cities – naturally encourage us to look upward, particularly when striking weather approaches.

Unlike regular landscapes, skyscapes are almost completely unpredictable, beyond a general idea from the weather forecast. They are more like reportage photography of people in street situations, and call for reaction instead. In fact, those skyscapes that *are* moderately predictable, such as a grey overcast behind a warm front in an Atlantic depression or a flawless Mediterranean blue sky, are the least interesting. Dramatic skyscapes are always sudden appearances. They also make sudden exits, and you should be prepared to photograph quickly. This may mean a rapid change of location to get clear of buildings, power lines and other obstructions.

Compositional choices

The compositional choices are limited and simple, as skies lack the normal foreground and background. The most common way is to place the horizon low in the frame, almost at the bottom edge, to give an anchor to the composition and to orient the viewer. If you are heading towards abstraction, you could abandon the ground altogether and simply frame within the sky. Two of the old American masters of photography, Alfred Stieglitz and Minor White, both made cloud studies in this way, calling them

BELOW: Sun rays through the clouds on the way to Ko Phangan, Thailand.

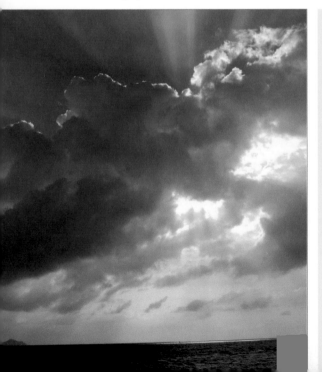

Special Clouds

In the same way that special landforms attract, such as sheer-sided mesas, rock arches, elegantly peaked mountains, and deep river meanders, the shifting landscape of the sky also furnishes a catalogue of varied and fascinating cloud formations. Beyond the basic dramatic appeal of a big-sky view, some of these cloud sets are worth capturing for their own sakes. Shape is the key, and the more distinct, or pattern-like, and unusual, the better. Among the most spectacular are iridescent clouds (the iridescence comes from tiny ice crystals or super-cooled water droplets), fallstreak holes, 'angels on horseback' (a variety of cirrus), roll clouds and mammatus. Possibly the most amazing and rare are lenticular clouds, which might easily be mistaken as cover for flying saucers.

"Equivalents" because they were supposed to symbolise a sentiment or emotion. Stieglitz wrote that these were the "equivalents of my most profound life experience, my basic philosophy of life."

While the extent of interesting elements in the sky will determine the focal length (experiment with different positions of the zoom control for framing), the usual lens choice for skyscapes is wide angle. With normal, ground-based scenes, tilting a wide-angle lens strongly upwards, as you need to in these situations, introduces strong vertical convergence (things appear to lean inwards from the lower corners of the frame), but skies are immune to these expectations, and this is hardly ever an issue. Convergeance can anyway be corrected later in Photoshop or the equivalent.

Exposure demands

Exposure for skyscapes is not complicated, but it does demand that you judge the scene and how you think it ought to look. As the ground plays an insignificant role, you have little need to worry about a high contrast range, although this can still be quite high in, for example, rainclouds partly lit by sunlight. We "see" most skies as being light in tone, which suggests compensating with an increase over the automatic exposure, but an evening storm, or a mountain sky dominated by a rich dark blue ought to be *darker* than average. For these you would need to under-expose.

Learn to judge a sky in terms of how much brighter or darker it should look as an image, and as always, avoid clipped highlights. Dense cumulus clouds, and towering cumulonimbus, that are sunlit on one side, have a wide dynamic range, and to capture the rich three-dimensional modelling it is certainly worth attempting a bracketed exposure sequence which you later combine either through HDR tonemapping or simple *exposure blending*. However, tall cloud systems actually change shape very quickly, even though you may not notice it at the time, and capturing an exposure sequence that will fit together needs to be shot in a couple of seconds.

Reference ▷
Blending/HDR, p.303
Exposure, p.63, 108

BELOW:
Altocumulus glowing red at Anna Maria Pier, Florida.

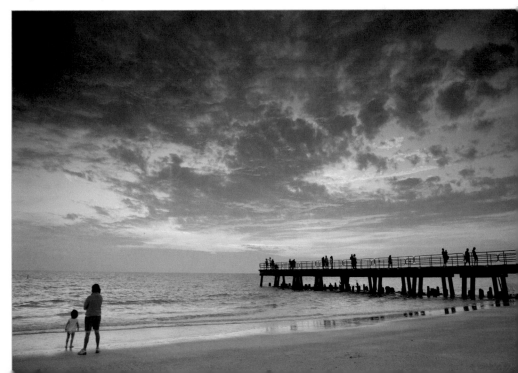

NIGHT SKY

THE NIGHT SKY has always held a fascination for travellers, not least because travel to a different part of the globe reveals different portions of the sky, and in many types of travel destination – mountains, deserts, oceans – the sky is likely to be much clearer than back home.

Most cameras can deal with photographing the night sky, but you will need to experiment to get the right exposure. And if you are serious about it, at least two lenses are worth considering: a telephoto of at least 300mm and a wide-angle, perhaps 28mm, with as big an aperture as you can afford: ideally f1.8.

Rotation

A tripod is essential, because exposure times can be long, generally at around 15 seconds with a long lens, after which the heavenly bodies will appear to move, as the earth rotation becomes evident. For the moon, movement will

BELOW: The magic of the Aurora Borealis.

be evident in less than half that time. A wide-angle lens will not capture this movement so quickly, and you can keep the shutter open longer.

Star trails

This is an area you need to work on to get right. Use manual settings. Longer exposures result in "trails" – points of light streaking across the sky in circular fashion. A 30-minute exposure could be considered for this. Equatorial Tracking Mounts are designed to counteract the earth's rotation, but these are for the serious astronomical traveller. Not all cameras offer a 30-minute exposure, and for trails you might consider taking separate photographs and putting them together on your computer later.

Such long exposure times are a drain on your battery, so ensure it is fully charged before setting out. Consider, too, a wireless or remote shutter trigger to prevent any possible movement

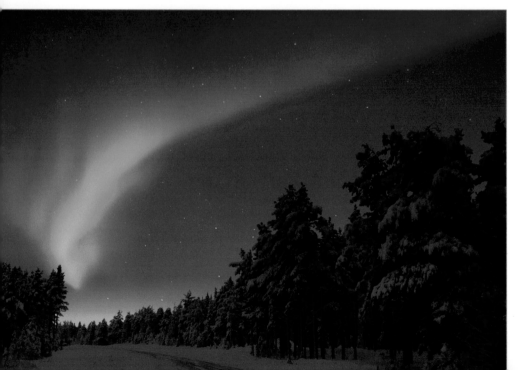

of the camera. Use a manual exposure and set the aperture as wide as possible, at least ƒ4.5, ideally 2.8, with an ISO of around 800.

It can be effective to get some objects in the foreground – a building or trees, but the length of time needed for the exposure means that windy nights will put foliage out of bounds.

The moon and moonlight

Lit by the sun, the moon is very bright, and a common mistake is to underestimate its brilliance, resulting in overexposure. An ISO of 100 at ƒ11 and at 1/25 sec could be all that is needed if photographing a full moon high in the sky. Note that its features are clearer when it is less than full, and the sun lights it from the side. And the higher in the sky it is, the clearer it will be. Bracketing is a wise move.

If it is a moonlit shot you are after – over a romantic building such as the Taj Mahal or across a wide landscape – speeding up the ISO and opening the aperture will result in losing the detail of the moon itself. One solution here would be to take two pictures and put them together later – this is what Ansel Adams used to do.

If you are photographing something in moonlight, using manual focus, the flash will help you focus. A high ISO, up to 1600, will bring clearest results, but there will obviously be some noise, so use your camera's noise reduction feature. In some cameras this involves an automatic second, "dark" exposure when you expose the image for any length of time: this takes a blank black picture to replace all the white dots of noise with black ones.

Auroras

The Northern or Southern Lights are where digital cameras can show off – they were always difficult to capture on film. You need a tripod. The need for a fast lens precludes most long lenses. Fast wide-angle primes are expensive but if you have a fast standard (35–50mm) lens you should get acceptable results from it. One reason for a wide aperture is that you need to keep exposure time down, because even slow moving auroras lose their sharpness as they continually change and move around.

Reference ▷
Lenses, p.111
ISO sensitivity, p.103
Shutter speed, p. 101
Aperture, p. 100

BELOW: Star trails streaking across the sky.

THE BUILT ENVIRONMENT

The beating hearts of nations are the places where people gather to live and work. Here their buildings, past and present, vernacular and pioneering, can be seen in so many different lights

The areas where we live and the buildings we inhabit define our civilisations. While simple homes in some parts of the world have changed little in thousands of years, great empires and their centres have risen and fallen, and much of what we see around us is just the latest in a long line of continual renewal and decline.

Thousands of sites offer glimpses into our past, present and future, from simple Stone Age burial sites to the inspiring Burj Khalifa Tower in Dubai, the world's tallest building. Most towns and cities have a core containing the main places of worship, commerce and administration. The solid, brick- or stone-built centre, often with narrow streets unsuited to motor traffic, will cover a relatively small area. This is the part of town the travel photographer heads for first: it's where the picture postcards come from.

The approach to photographing a city will be different to a sleepy village, not least with respect to vertical scale. Longer (300mm+) and wider (18–35mm) lenses are needed to view a metropolis, while more intimate standard lenses (80mm–120mm) will suffice in a more homely environment.

But it is the human presence in both that will define its character. Human activity and achievements are important aspects when recording the look and feel of any place, regardless of its size. People created these communities and it's only their presence that keeps them alive. Any place can seem "dead" without people, which is just as true for your photographs.

Many buildings, even the grandest, will have elements of the vernacular architecture. Communities grow organically, villages becoming towns, towns cities. Their style has been shaped by local materials, landscape and beliefs. Try to get to the roots of that style, and reduce them to single images. ❏

Main topics
CITYSCAPES
SKYSCRAPERS
CITY LIGHTS
PARKS & GARDENS
STATUES & MONUMENTS
PLACES OF WORSHIP
INTERIORS
ANCIENT SITES
HOUSE AND HOME
VERNACULAR

PRECEDING PAGE: View of downtown Perth.
LEFT: Florence from the Duomo. **RIGHT:** Fire escapes in New York City.

CITYSCAPES

A CITY is often defined by great works of architecture, prominently placed to reflect cultural, political or economic significance. These are the icons that people will be familiar with and aim to capture for themselves, from the best possible angle and in the most favourable light.

Classic views

Settings are paramount, and whether it is the Taj Mahal viewed across the Yamuna River, the Sydney Opera House from Luna Park on the other side of the harbour or Hong Kong viewed from the Peak, the best vantage points will be obvious and possibly tourist attractions in their own right.

Some places are more inscrutable, however. For example, because of the hills, there are countless *viewpoints* from which to get a great shot of St Peter's in Rome, not just from straight on but from the other side of the Tiber, from the Gianocolo Hill

or even from the distant Piazza del Quirinale. Then there's the intriguing shot through the keyhole of the gate to the headquarters of the Knights of Malta on the Aventine Hill. The fun for photographers is finding a place to suit their style, taste and mood.

Iconic sights

One of the advantages of capital cities for the photographer is that, due to their size and importance, many aspects of a whole country can be found concentrated within them. Always take the classic shots – yellow taxi cabs in New York, Christ the Redeemer statue in Rio, Pyramids in Cairo, but also check to see if there is a newly opened attraction. With so much going on, cities are great places to be inventive.

Bear in mind that some cities are synonymous with certain architects – Antoni Gaudí in Barcelona, Charles Rennie Mackintosh in Glasgow, Frank Lloyd Wright in Chicago. Try to see how

BELOW: In the frame: London's Tower Bridge and City landmarks. Dusk is a perfect time for wide city shots, with a mixture of ambient and artificial lighting *(see also picture on page 186).*

The Trouble with Tripods

Tripods seem to be considered by the authorities as a type of WMD launch device; it seems there's a conspiracy out there to stop you from getting stable, long exposure shots. If you use one in the City of London you are liable to be stopped, while the Faro tower in Madrid won't let you take a tripod up, and you'll need a press card and letter of permission from the Archeological Survey of India before putting one up at any of the famed Moghul-era monuments in Delhi. Ditto for long lenses at certain locations. At Panmunjum, the truce camp in the Korean Demilitarised Zone, cameras with focal lengths exceeding 100mm are not allowed. A telephoto lens is instantly singled out, but pocket cameras with effective zooms of 300mm or more are not, simply because they look less threatening.

the architects envisaged the final structures. What did they see in their grand designs, and how do the surrounding buildings now affect this vision? Analyse the textures: the cold brightness of glass against the warmth of stone is like acrylic paint versus oils, while iron can add a charcoal drawer's touch.

If you want to capture iconic sights effectively it's worth organising your schedule carefully and doing a bit of research. Would you prefer to take the subject in the afternoon or in the morning? At what time does the light catch the attraction best? When is the best time for the ferry to the Statue of Liberty? What time does the Sagrada Família in Barcelona close and will it be very busy at that time? If time is short you need to assess your priorities.

Off the beaten track

Beyond their famous sights, older cities such as Marrakesh, Cairo or Beijing can appear to be a series of inner city villages where lifestyle has changed little for perhaps hundreds of years, around which the metropolis has developed. Look out for contrasting shots of a rag-ged donkey cart passing the high-tech gloss of an international conglomerate, or a street dweller on a mobile phone.

Don't just follow the well-trodden routes described in the guidebooks, try creating your own itinerary. An interest in art, history, religion or a particular building style can help formulate a route that is specific to you.

Never mind the weather

We know famous buildings and cities from around the world, captured in the perfect lighting and weather conditions. But how often is our visit likely to coincide with this? If it's pouring with rain in Kuala Lumpur, foggy in San Francisco or snowing in Milan, you will be hard pressed to get that classic shot, but try to turn it to your advantage. Some unforgettable images have been produced in difficult conditions, and if this is your only day, capture the spirit of the place as it presents itself, warts and all. You are not likely to see your photograph of the Taj Mahal being lashed by driving rain in a holiday brochure, but it will certainly be different for a competition.

Reference ▷
Viewpoint, p.83
Light & Time, p.57
Rain, Fog & Mist p.168

BELOW: City life is best found in the back streets – here in the souks of Marrakesh.

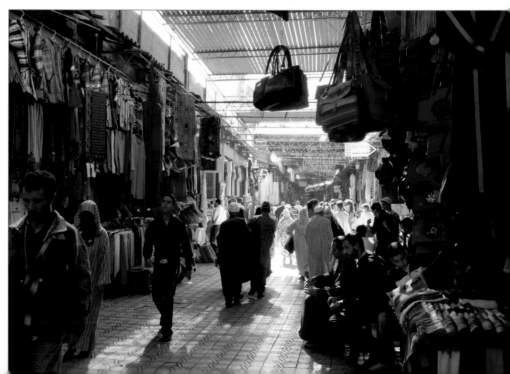

Urban streets

Architectural students are always urged to "Look up! Look up!" as they walk along urban streets – and for those with a graphic eye, looking up will certainly bring great rewards and inspiration, with roof detail, and facade ornamentation often otherwise missed.

Down at street level there's plenty to observe as well – painted doorways, porticoed arches, grand entranceways. *Detail* is important. Be on the lookout for the different types of signage and typography, as well as a vast range of street furniture – fountains, seating, lighting, litter bins and post boxes are all elements that define a place. Door furniture – bells, letterboxes and knockers – can be singled out.

On a busy city street, such as Fifth Avenue in New York, it's worth trying out a variety of *lenses* or focal lengths on your zoom. A wide angle lens (18–22mm) will place the people and traffic in context with the surrounding buildings, invariably all in focus. A standard lens will select groups of people along the street with a more limited depth of field, while a telephoto will pick out individuals and anything outside its shallow *depth of field* will be nicely out of focus, helping to attract the eye. Getting more into focus for a given focal length will require a good depth of field and hence a small aperture, which in turn (if you are working with a low ISO to get best quality) will need a longer exposure – a good reason to carry a tripod to avoid handheld camera shake.

Leading the eye

Use long streets, rows of buildings or bridges to lead the eye towards the main *centre of interest*. When the sun is low, tram lines can become streams of bright light, ideal for leading the eye through dark city canyons.

In London, the Millennium Bridge can be used to lead the eye across the Thames to St Paul's Cathedral. This can work from on the bridge itself, when a wider lens (28mm) will exaggerate the bridge but reduce the size of the distant cathedral. Always look for ways to get higher: in this case there is a better elevation from the viewing platforms high up in Tate

BELOW: A telephoto shot of street lights in Amsterdam. Note the shallow depth of field and the out-of-focus background.
BELOW RIGHT: A wide-angle view over the rooftops of San Gimignano in Tuscany.

Modern. From here, there are more options for using the bridge as a strong diagonal, or using a longer lens to increase the size of St Paul's, but still having the bridge as a lead-in.

The old towns

One of the main problems in the built environment is that it is hemmed in, preventing space in which an image can breathe. This is true in towns as well as cities, especially their ancient centres.

Get an overview of the street patterns and swirling rooftops. The terracotta roofs of the ancient towns of southern Europe are particularly attractive seen in this way, and even though they often sit on a hilltop there may be a church tower that can be climbed for a view. All your lenses are valuable up here, so put each one on in turn and pan around to see what they can capture. The eye is not so selective, so it really is worthwhile looking through each lens in every direction.

Framing

Within the structural confines of the city you need to be inventive with framing. Before going into the Taj Mahal garden, try taking an image of the Taj framed in the entrance archway. With a larger depth of field (using *f* 8–22), the edges of the frame can also be just about in focus. *Framing* helps to concentrate the mind on a particular scene, without any other distractions from around the edges.

Interesting motifs

If the building lends itself to it, exaggerate the *symmetry* between edges, walls or components by adopting a viewpoint that shows it off best.

Art deco period buildings typically have great symmetry in their designs. Identify the particular features and then concentrate and even exaggerate these. If there are sharp angles in the construction, use a wide-angle lens to accentuate it further. Curved surfaces can also "bend" even more if taken from the right position.

Don't be afraid to push this too far, as whatever the result, we can still recognise them as buildings and you might get a stunning shot that people will react to. ❑

Reference ▷
Detail, p.241
Lenses, p.111
Depth of field, p.100, 114
Centre of interest, p.76
Framing, p.88
Symmetry, p.86

BELOW:
The flowing facade of Emil Fahrenkamp's modernist Shell-Haus (now GASAG Building) in Berlin, perfect for experimenting with angles.

SKYSCRAPERS

MODERN SKYSCRAPERS provide the photographer with endless possibilities for exploiting dynamic lines and shapes. The streets of vertical cities are the perfect playground for creative photographic minds, balancing the compositional possibilities with endless plays of light on the facades.

A sleek modern straight-sided tower of gleaming glass can be great for reflections and colour tones, whereas an older-style tiered skyscraper offers ways to break up the skyline. A well-lit skyscraper photographed from the dark shadowy canyons of the city streets always looks dramatic.

Try out the angles

Experimenting with angles is what it's all about. Stand opposite the entrance to the Empire State Building on West 33rd Street, for example, and almost regardless of the lens that you're using, you will find that the facade is too big for the frame. The light might also not

BELOW: The Trump Building in Lower Manhattan, shot when neighbouring Wall Street and its famous Stock Exchange were in shadow.

BELOW RIGHT: The HSBC Building in Lower Manhattan, with its sleek International Style lines, was built in 1967.

be in the right place either. So take a look around and see what views you can capture from neighbouring streets. Try the views from along East 34th Street, for example, where the building will appear from a more interesting angle.

Modernist and Art deco buildings, particularly the behemoths in New York and Chicago, look good at any time of day, provided the light is decent and there's enough contrast. But shot in the morning or late afternoon light they can look very special indeed, with extra intensity of subtle colour streaming from the facades.

In terms of composition, the vertical lines in a skyscraper can replace horizontal lines on the ground, helping to add depth, or in this case height, to the building. There will be some *keystoning*, but it's the graphic effect that really counts. Holding the camera vertically, position the *vanishing point* either dead centre or on one of the *thirds*, depending on the detail and interest in each of

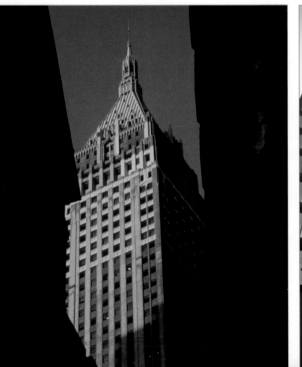

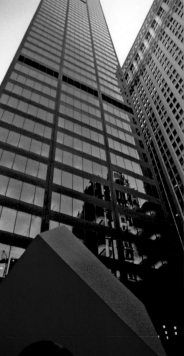

the building's facades. Looking directly upwards with a 360° view of skyscrapers all around should place one side in sunlight while the other is in deep shadow. A dramatic sky above and beyond the tower tops is an added bonus.

Reflections

Great fun can be had working with the reflections and unbroken tinted glass facades of skyscrapers. Further contrast can be achieved by looking for reflections of older buildings that inhabit the lower levels. Look too for the abstract patterns of vertical ribs, horizontal floors and strong shadows cast by other buildings. Use a long lens to get in tight to fill the whole of the frame, and tilt the camera to help put any strong lines on a diagonal.

With a few clouds in the sky, look for opportunities to isolate one skyscraper in dramatic sunlight whilst others languish in the shade behind.

Group shot

From a distance using a longer lens (200–300mm), any group of skyscrapers should be treated as compositional shapes – put ground level and the jagged tower tops along the *thirds* while placing the tallest tower along one of the vertical thirds. All of the tops should be included, otherwise the eye is led up and out of the frame. Also, think of some creative ways to frame the skyscrapers – perhaps a distant shot from below an angled bridge *(see picture on page 180)*.

Views from the top

Standing between skyscrapers with a wide-angle lens, the converging lines and outlines can create vertigo-inducing images, not to mention a stiff neck. So you may want to escape the confines of the streets and have a look from another angle. Whether in Chicago or Hong Kong, Sydney or Shanghai, there's no better place to view a cityscape than from high up. But you might have to do some research about the best vantage point and make sure that you are allowed access. And while the highest building in the world is currently Dubai's gleaming Burj Khalifa, the views of Manhattan from the Top of the Rock or the Empire State, or of Hong Kong from The Peak, are still hard to beat. ❏

Reference ▷
Rule of thirds, p.78
Keystoning, p.83
Vanishing point, p.85
Shooting angles, p.83
Framing, p.88
Light & Time p.57

BELOW: Classic view of the Empire State Building and Lower Manhattan from the "Top of the Rock". A fairly wide angle and good depth of field render foreground and background in focus.

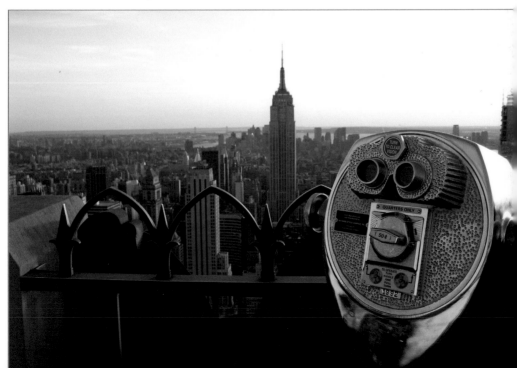

CITY LIGHTS

DRAMATIC IMAGES of towns and cities can be taken when places are illuminated in a blaze of lights. This is true not only for skylines, but also of individual buildings and areas. The Las Vegas strip is invariably shown as a night shot for two reasons – it doesn't look that great in the daytime and there's plenty of neon to blast it into prominence at night.

Long exposures

Being able to take a good night shot is a real art, with many aspects needed to get it right. A tripod is usually essential due to the length of exposure (1–30 seconds). The other option is to up the ISO to 800 or 1600, then keep the *shutter speed* as fast as possible. However, depending on your camera, the quality of the night shot may be grainy or noisy, so you need to find out in advance the limits of your camera. A further option is to rest the camera on something like a beanbag or *mono-*

BELOW: Evening street scene in the historic city of Olinda, Pernambuco, Brazil.

pod, or even a wall with a guidebook or some small item of clothing underneath for padding.

With DSLRs use shutter priority and let the camera work out how much light to let in through the lens to give a good exposure.

Bracketing can help

A good, fast fixed-length lens ($f1.4$ or $f2$) is needed to get the best quality in low light. There is no set shutter speed to suit every situation, but experiment with different timings of, say, 10, 20 and 30 seconds. Areas of bright light naturally dominate darker sections of a photograph, creating harsh contrasts that are hard to compensate for. Judging the correct exposure in low light conditions can be difficult and this is where *bracketing* comes into play.

Take a shot at the "correct" *exposure* the camera is indicating, and then take more shots incrementally at 1/3 or 1/2 of a stop higher and lower.

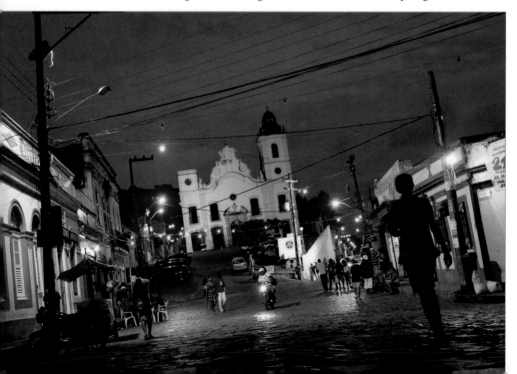

One of these shots should be the best balance for highlights and lowlights, from which you can then use software to adjust as necessary.

Dusk is best

The ideal time for a wide city shot is just after sunset. Lights start to come on, but there is still enough ambient light to pick out shapes of buildings. This dusk time can be even more stunning with a dramatically lit sky.

Reflections of lit buildings in rivers and lakes can work really well, the stillness or movement of the water determining how much blur is created. The skyline of Manhattan reflected in the East River with the Brooklyn Bridge, Hong Kong in Victoria Harbour, Sydney in its harbour and Toronto in Lake Ontario all offer splendid possibilities. Also, after rain, look out for reflections in puddles in the streets.

Illuminations

Night-time shots in almost complete darkness usually work better where a specific area is illuminated with *artificial light*. Think of shop windows in downtown areas, or neon signs in a clubland district. On their own, illuminated signs can generate striking images especially in the bright, gaudy colours of neon.

Sometimes the strength of this artificial light can be so great that exposures are short enough (1/30–1/60 seconds) to freeze human movement without any blur, for example people moving in and out of a brightly lit theatre foyer or cinema. A remote shutter release can also be helpful to avoid camera shake, otherwise use the self-timing device to trip the shutter.

Trails of light

One fun aspect of night photography is capturing moving trails of light. The headlights and tail lights of cars and buses will be traced across your image if you shoot them whilst they are moving with a slow shutter speed (anything from 2–20 seconds). Release the shutter just before cars enter your frame and use their trail of lights to lead the eye in the correct direction, such as into the heart of Times Square in New York. ❏

Reference ▷

Shutter speed, p.101
Monopod, p.295
Exposure p.63, 108
Bracketing, p.111
Light & Time, p.57
Artificial light, p.67

BELOW:
Bright lights in Shanghai.

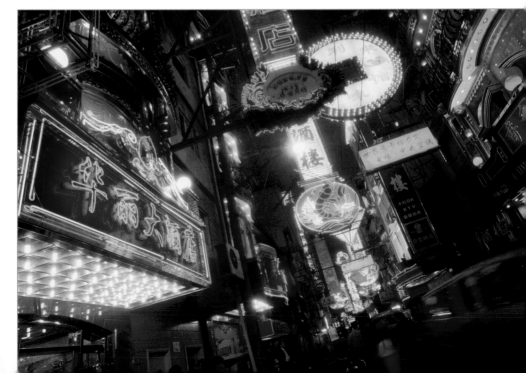

PARKS AND GARDENS

WITHIN GREAT cities full of noise and chaos, there are often areas of peace and quiet, such as the Retiro Park in Madrid or the Jardins de Luxembourg in Paris, where photography can be conducted in a more tranquil atmosphere.

Tranquillity in the parks

Apart from the weather and direction of sunlight, everything else should be under your control, so there are few excuses for not getting it spot on. Aim to get top-quality images of floral displays, with great composition and stunning colours. In more formal gardens, lines of immaculate topiary work can create strong diagonals and act as vertical interruptions within a horizontal flow of colour and texture.

Parks are places of escape for city dwellers, and offer unique photographic opportunities when people come out to enjoy themselves, often as families. Many gardens are designed around the effect of lakes, bridges and trees, from Stourhead Gardens in Wiltshire, England, to the Humble Administrator's Garden in Suzhou, China. The water can provide great *reflections* of seasonal colours, while bridges will naturally act as centres of interest from a distance and for framing.

Elsewhere, look for dominant paths or rows of colourful flowerbeds that can lead the eye to a main point of interest. At all these public places, gates and doorways should ideally be open, inviting the viewer further inside.

Seasonal shots

Photographic interest will vary considerably according to the seasons. The coming of spring offers the vivid bright colours of new flowering plants whilst summer is good for lively human interaction. Autumnal hues are more subtle, perhaps appearing as a blaze of leaf colours, with winter visits always interesting for monochromatic moody lighting and

BELOW LEFT: Lakes are great for reflections, here in the Villa Borghese Park, Rome.
BELOW RIGHT: This shot of an arbour at Schönbrunn Palace in Vienna leads the eye beyond the people walking through.

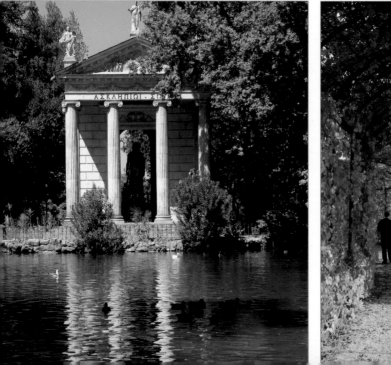

misty conditions that need higher ISO and slightly longer exposures.

Macro lenses can be used to full effect by getting tight to fill the frame with swirls of colour, shape and texture within flower petals and leaf formations, ideally using a tripod.

In summer avoid midday when sunlight is directly overhead, unless you are creating images from low down shooting up at silhouettes into the sun.

Shapes and patterns created by the various colours and layers can be worked on within the overall composition. Any highlights, verticals or horizontals should be placed according to the Rule of Thirds.

Mansions and palaces

Famous gardens are often associated with their mansions or palaces like Versailles, near Paris. Some of these gardens have been created with precise symmetry, patterns and geometric designs, often using naturally eye-pleasing dimensions, ratios and sizes.

A higher *viewpoint* can capture the overall layout, while down at ground level, look along lines of flower beds and low hedges for wonderful patterns that can lead the eye, perhaps to the palace or stately home.

Often the building will complement the garden, acting as a grand backdrop, intentionally reinforcing the period or style. Sometimes the vibrant colours don't just come from the flowers. The Jardin Majorelle in Marrakesh, Morocco, for example, was rejuvenated after being purchased by the late Yves Saint Laurent in 1980. He brightened it with red flooring, blue buildings, green columns and yellow pots, making for great photos year-round. Gaudí's Park Güell in Barcelona is also a riot of colour and fun with great shots to be taken of the snaking colourful mosaic seating as well as fabulous views over the city.

Use a shallow *depth of field* to highlight an item within the garden such as a statue or ornamental feature, while leaving trails of unfocused colourful flowers streaming away into the background. Taken later in the day, low angled sunlight on statues, water features and fountains can add interest and depth.

Reference ▷

Reflections, p.143
Macro, p.236
Viewpoint, p.83
Depth of field, p.100, 114
Leading the eye, p.77

BELOW:
Scale, depth and geometry used to maximum effect at Versailles, near Paris.

Reference ▷

Rule of thirds, p.78
Details, p.241
Shooting angles p.83
Framing p.88
Light effects, p.64

Small hedges such as those found in box gardens are designed with sharp angles and interwoven designs that can stimulate the idea of developing patterns and shapes within the photographic frame. Larger hedges are best viewed from above, and there are wonderful shots to be had of mazes, with hemmed-in people placed at the *strong points*. Even an unkempt garden can have great attractions with overgrown shrubs and plants impinging on a weedy pathway leading to a derelict château.

There are usually plenty of trees and gates around to help frame statues or features like pavilions, follies and pagodas.

Oriental gardens

Unlike the West, which has a love of colourful floral displays, the emphasis of Japanese and Chinese Gardens is towards a more simplified layout of shapes, natural elements and foliage. Within these stricter formal codes are expressions of high art through complementing shades and textures, sharp edging and angles that produce great close-up shots.

Traditional gardens are a reflection of the society that created them, so analyse the designs and look for the main elements and themes. In Zen gardens, the patterns of stone, sand and moss can create stunning semi-abstract compositions. Persian paradise gardens are like a vision of heaven in arid locations and will always have streams of trickling water.

For blending architecture with garden design, there are few places more impressive than the Alhambra Palace in Granada, Spain, with interlinking courtyards and pools and endless framing possibilities through the exquisite columns and arches.

Botanical gardens such as Kew in London attract photographers for unusual and rare flora, but when going inside glasshouses and hothouses, beware of high humidity, which can severely affect sensitive workings of cameras and lenses. Neatly framed exotic shots can transport you straight into the tropics, otherwise you might have to travel to see them in their natural habitat, somewhere like Cinchona Gardens in Jamaica. ❑

BELOW: Crossing a bridge on Hangzhou Lake, China, with the reflection of the sun framed in the arch.

STATUES AND MONUMENTS

THE TIME OF day and consequently the light are crucial to get the best shots of statues or monuments as your camera will typically be tilted upwards towards the sky. Know where your camera is taking its light reading from, as an average reading taken from too much sky can give under-exposed shots of the statue, resulting in a silhouette. If you are unsure, then bracket in small increments up to two stops higher.

There is nothing to be done if the light is not falling in the right way, except to revisit when sunlight is striking them from a better angle. If sunlight is at completely the wrong angle, you could use a reflector to shine light onto the front, or use fill-in flash.

Background information

If the background is distracting, you might want a "clean" image just of the statue itself. But sometimes a little extra information can be gleaned by including some background.

In the picture below, not only is the light hitting the statue of the damsel perfectly but it is also complemented by the eyecatching central red flowers to which her gaze seems directed. Including part of the shore behind her helps to locate her recognisably in the Italian Lakes.

Frame the subject

Look for anything that will help to *frame* the subject, such as nearby trees or ornamental gates, especially if it helps to identify the location.

Wide-angle lenses (18–22mm) will fit everything into the frame, but can unnaturally distort the shape. To avoid the bases of monuments appearing too wide and bulky when shot with a wide-angle, take a few steps back to make them look more realistic. Play with the *angles* by putting slants on horizontals and verticals, or conversely, take a vertical such as the Space Needle in Seattle and lay it diagonally across the frame from corner to corner for dramatic effect. ❑

BELOW:
Sumptuous style at Villa Balbinello on Lake Como.

PLACES OF WORSHIP

SOMETIMES IT IS HARD to separate religious sites from historical, cultural and artistic attractions as they often overlap, and the underpinning religion is obscured by modern tourism – the Duomo in Milan, the stave churches of Norway, the Basilica of Guadalupe in Mexico.

Within these buildings are hundreds of images just waiting to be captured – vast interiors, vaulted roofing, decorative walls, stained-glass windows, mosaics and domes. Look out for geometrical patterns created by arches, columns, windows, beams and seating. Many of these buildings were created before the invention of electric light, and they incorporated windows and lanterns that would add a radiating light to reflect the aura of the deity. Nowhere is this more effective than in the Pantheon in Rome, where light floods in through the dome like a mystic revelation. The *effects* created by the rose windows of great European cathedrals can be equally dramatic. Whichever building you are visiting, the conditions outside and the time of day can be important.

Taking good photos of a large dome usually results in either a stiff neck or a picture that's off-centre. One method is to place your camera centrally on the floor facing up to the dome. Estimate the framing and focus by looking through the camera before putting it down and then try to keep the camera level, as few are designed to lie on their backs. Then ensure that you are out of shot when releasing the shutter.

Look for the unusual – access to an upper gallery or an incidental shaft of light. For moody results, try *underexposing* by one or two stops which will highlight the lightbeam even more.

Observe sensitivities

In some faiths the sanctity of places is preserved by allowing only the faithful inside. Even if given permision, the

BELOW: Patterns of light and shadow created by church windows and the afternoon sun.

Stained-Glass Windows

Stained-glass windows can provide colourful images of high impact, but they need to be well lit and are best captured from inside when illuminated by the sun. Shooting at a slight angle to the sun will give a consistent light across the window. If the windows are a few metres from the ground, isolate individual figures, images, designs or texts to get details of bright colour. If the window is high up, use a long lens to get as close as possible, or include some of the dark surrounding wall to frame your shot. If photographing from a low angle the window and figures will appear larger at the base than at the top. This can be corrected with software but always try to get positioned as high up and "straight-on" as possible. Look, too, at the patterns made by stained glass on walls and floors.

photographer must observe all instructions and sensitivities. For instance, around the world, Islamic buildings and churches of the many Christian faiths differ greatly in their openness and tolerance of visitors. Even if the majority of Islamic buildings in a particularly country might be out-of-bounds, there could be a particular Koranic school (the Attarine Madrassah in Fez) or grand centrepiece mosque (Hassan II in Casablanca, Sheikh Zayed in Abu Dhabi) that is open to all.

Climb to the top of any spires, towers or minarets for great views down onto the building. This will also give interesting close-ups of statues and architectural features high off the ground. Climbing inside the Giralda Tower of Seville Cathedral, for example, also affords wide-angle views of the city and countryside.

Tricky temples

Hindu and Buddhist temples are always full of noise and colour, usually with lots of activity. Rows of spinning prayer wheels, geometric painted designs and statues, all interwoven by mingling devotees, priests and pilgrims. Low light and smoke are just some of the problems to be overcome, with longer exposures (1/15–1 sec) requiring a tripod or solid standpoint.

The burning of offerings, oil lamps and incense all create smoke that can obscure a view or reflect the light from a flash, and certainly won't relay the moody atmosphere inside. These are some of the most difficult photography conditions, with seemingly everything working against you – limited access, crowded spaces, unwilling subjects and dull light conditions.

In these situations you never get the luxury of too much time, so identify shots quickly and use your camera even quicker. Make use of windows both inside and out to frame an image – perhaps a monk reading texts in a darkened room, or a bright Himalayan mountainside outside.

Monasteries of every faith often chose remote and beautiful mountain settings, such as the Tiger's Nest in Bhutan, or Greece's Mount Athos, making them good stock images for the travel photographer. ❑

Reference ▷

Light effects, p.64
Exposure, p.63, 108
Tripod, p.295
Viewpoint, p.83
Local customs, p.297

BELOW: Shafts of light inside the Jade Emperor Pagoda in Ho Chi Minh City, Vietnam.

Interiors

Varying light conditions can make interiors difficult to shoot, especially when you want to use only natural light

Interiors of buildings present the photographer with a number of different problems. Private houses, public buildings, museums, churches, mosques, temples and restaurants all require special attention. If there is any situation where you can never have enough photographic equipment, then it is shooting internally in a wide variety of lighting conditions, often with restricted space.

The main concern is usually the amount and type of *light* that is available. Digital photography gives immediate choices for white balance, a great advantage over film, which has to be planned in advance. Daylight streaming through a window, battling with a fluorescent strip light, table lamp or spotlight can create havoc with any light meter. Sometimes there's just too much variable lighting, so try to reduce (or even eliminate) anything that causes problems.

Also watch out for too much contrast. Digital software can later isolate areas of inconsistent light

and re-correct the exposure and type of light, but you should always aim to get the best result initially, as this gives you more flexibility when you come to adjust the image.

The simplest way to override competing light sources is to use *flash*. Many flash units built into cameras are simply not good enough for the best result, so make sure you have a fully charged external flash unit and know how to use it.

There are, however, certain situations where flash does not work so well. If taken "head on", highly reflective surfaces such as glass cabinets, polished tables, marble statues or shiny mosaics will bounce the flash back at the camera, giving unsatisfactory results of overexposure and uneven light. Try shooting from a different angle which might solve the problem. In small rooms and tight situations a wide-angle lens is invaluable, but this might cover a wider view than your flash unit, resulting in areas of gloom and shadow. Check on this compatibility before leaving home.

Use of flash might not be permitted at all. Museum artworks and fragile tomb paintings can be damaged by flashlight. One method is to use a *reflector* or bright surface to bounce light onto the dim subject. Another solution is to use a longer exposure (longer than 1/8 sec), when a tripod is indispensible. Without a tripod, the camera can sometimes be held against a wall or placed on a cabinet, but take care not to cause damage. Ultimately you might just have to wedge yourself as solid as possible into a corner and hope for the best.

Most cameras have good anti-shake systems that allow handheld photos to be taken in low light to some degree. Try raising the ISO setting to cope with poor light, but make sure you know what resolution and quality you are forfeiting for your particular camera.

Using a small *f*stop in lower light, the *depth of field* will also be reduced so check that your main item is as pin-sharp as possible.

If featuring a particular type of building such as a palace or mansion, the interior period decoration is usually as interesting as the exterior. Try to capture the essence of the style from lamps, ornaments, statues and staircases.

Note down any information or description of an object. An unknown statue or painting, of indeterminate period is difficult to sell, or to explain or describe if you plan giving a talk or lecture. ❑

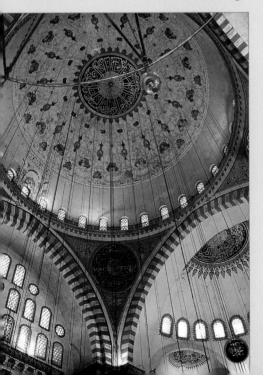

LEFT: Natural light infuses the dome of the Blue Mosque in Istanbul.

ANCIENT SITES

THERE ARE few places better for combining your skills as a photographer than a worthy archaeological site. Whether it's the temples of Angkor Wat in Cambodia or the extensive classical ruins of Libya's Leptis Magna, the wealth of features provide countless possibilities. Some places are naturally stunning because of their location or their construction (Machu Picchu in Peru, Petra in Jordan) while others might need a photographer's inventiveness. A low angled light in early morning or late afternoon brings out natural stone colours best.

Vantage points

Look immediately to climb up to any vantage point, where you will see a useful layout of the site and be able to take high elevation photos. Use the vestiges of ancient streets as diagonals, bringing them to life by including people, and use them to lead the eye towards important buildings such as theatres and temples. Even from the barest of foundations, the outline of a city or building complex can be traced. If a site has been rebuilt by archaeologists, such as Ephesus in Turkey, for photographic purposes treat it like any large modern city, using people to give the buildings scale.

Getting rid of people

You may feel that the atmosphere of an archaeological site can be enhanced if no people are around. Visiting a site early in the morning before the other tourists arrive or in the evening before it closes can be a solution, but at places like Angkor Wat sunrise and sunset are the busiest times of day. One solution is to *combine different exposures* taken at the same spot and use software to eradicate the people *(see page 304)*.

Framing options

Identify the many *framing* options around you – arches, windows, columns and beams, doorways. Contrasts

BELOW: Audience at the theatre at the Roman city of Sabratha in Libya, shot in the late afternoon to bring out the natural stone colours.

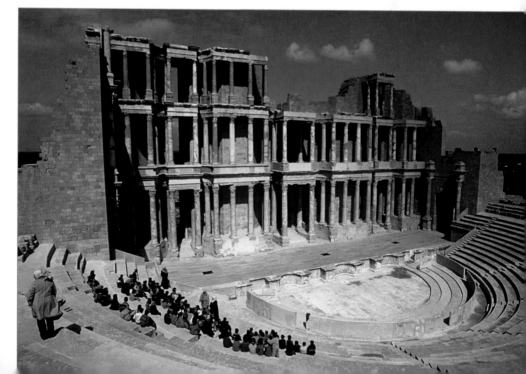

in light can work well, such as a bright subject framed by a dark doorway or arch in shade. Viewpoint, framing and centre of interest are all vital.

Depth and repetition

Getting that upright column in the most aesthetic position along a third, and positioning a wild flower at one of the strong points immediately boosts the image. Rows of columns, such as those seen at Roman and Greek sites right across the Mediterranean and into the Middle East give depth and repeated patterns. Despite all capitals being the same height from the ground, your viewpoint can see them as a strong diagonal across the frame. When added to the diagonal created by the column bases, these are powerful *vanishing lines* appearing to meet in the far distance.

With repeated motifs, such as the row of seated Buddhas at Ayutthaya in Thailand, it's fun to experiment with depth of field. With a small aperture they will all be in focus. Alternatively, create a different effect by using a narrow *depth of field* to highlight one statue, throwing the ones in the fore-

ground and background out of focus, such as in the picture opposite.

Portrait format

Moving from landscape to portrait format, get close and look up the side of a column for interesting effects.

If decorated with inscriptions or carvings, try to get it all in with a wide-angle lens. This might mean lying on the ground to get the lower carvings in and shooting upwards at a steep angle in order to also keep the very top in view. As a rule of thumb, focus about 1/3 of the way up the column, and most of it should be within the depth of field.

Alternatively, select a single carving or text and get the best shot with a standard lens (50–120mm) so there is little or no distortion (keystoning). Spiral fluted columns are great – with the lens almost touching the column, look up at the lines as they twist out of view.

Tales from the road

All these techniques can be repeated with fallen columns, especially if adding depth and leading the eye to a centre of interest, such as a triumphal arch.

BELOW: Shot from ground level, with blades of grass in the foreground, it is difficult in this image to gauge the size of Stonehenge.

Old roads can also tell stories of the traffic they carried for hundreds of years. Look closely to see if there are any ruts made by cartwheels in the stone blocks. Holding the camera about 30cm off the ground will accentuate the rut, ideally with one side in shadow. *Focus* on a point in the rut about one metre away and make sure that you can see the rest of the road disappearing into the distance, gradually going out of focus.

Where streets intersect at right angles, a really wide-angle lens (15mm) can view simultaneously down two streets at 90 degrees. Such a view would be typical for a modern city, but quite a revelation when applied to a historic site.

Try to insert further interest into your photography, even to some of the most photographed places on earth. A camel placed in front of the pyramids adds colour, scale and depth. The camel must be in focus, so with a handheld shot, don't get too close or it will throw the distant pyramids even more out of focus.

Life in old stones

Unreconstructed archaeological sites can be hard to interpret and diffi-cult to photograph. Ugarit in Syria and Troy in Turkey might be incredibly important, but without plenty of imagination they can look distinctly underwhelming. Avoid midday when there is no shadow to define shallow building foundations, low walls and the few piles of stones. When everything is near to the ground, a *sense of scale* is even more important, as a human figure can define the size of a wall or broken column. Take every opportunity of getting a higher view, where the outlines of buildings and streets become more apparent. A small column might look insignificant when shot from normal height, but lay the camera on the ground to shoot up its full length and it becomes a towering piece of ancient architecture.

On reflection

A popular way for guardians to illuminate Ancient Egyptian tombs for tourists was to reflect sunlight coming through the doorway. Silver paper stiffened onto a piece of cardboard acts as a wonderful *reflector* and accurately redirects light into dark places. ❑

Reference ▷

Vanishing point, p.85
Depth of field, p.100, 114
Vertical/horizontal, p.90
Focus, p.104
Scale, p.85
Reflector, p.68

BELOW: Statues in the Temple of the Emerald Buddha, Bangkok. Only one statue is sharp on account of the shallow depth of field.

Museums

Each museum has its own terms and conditions for entry and photography, so don't be disappointed at not getting the gold face mask of King Tutankhamun in the Egyptian Museum in Cairo where photography is forbidden. Other museums forbid flash, though smaller museums can be more tolerant.

The main difficulties in photographing inside museums is the conflicting amounts and temperatures of light *(see Interiors, page 194)*. Objects are often displayed in subdued lighting, so use a tripod if permitted, otherwise you need to stand rock steady. Flash might be useless if the objects are inside glass cabinets, which reflect the light. Important objects always attract the most people: getting an uncrowded view of the Mona Lisa at the Louvre in Paris is almost impossible.

HOUSE AND HOME

THE ROOT OF all community life, be it in a metropolis or a hamlet, is the family home, a building that can range from a Scottish crofter's bothy or a Kenyan dung hut to a designer's Miami mansion. Whatever it looks like, to be invited into somebody's house is, for the traveller, the ultimate privilege.

Here one's social skills are put to the test but here also is a chance to see the minutiae of daily life. The furniture and fabrics, the knick-knacks and necessities – a vase of flowers at a window, grandmother's needlework, a clock on the mantleshelf, drinks on a patio table – are images of daily life and customs on an intimate scale.

Hidden delights

In some cultures, such as Spain and Latin America, it is seen as rather crude to make the outside of your house look too grand, and it is only when you step into the cool of the interior, perhaps with a hidden courtyard, that the full richness of life is revealed.

Natural light can cast interesting deep shadows on *interiors* and you should use it where you can. Otherwise you might employ a flash unit, a *reflector* or even a piece of newspaper, white sheet or T-shirt by angling the reflector to bounce whatever daylight is available into the dark.

A choice of wide-angle lenses will also ease the problems of how to fit things into the picture. Working with limited light, the lens will be wide open at $f1.4–2$.

Ornamentation

Even if you don't receive an invitation to visit somebody's house, the view from the outside – for the travel photographer as a passer-by – still offers great opportunities to capture the style of a place.

Decoration and ornamentation of facades can be remarkable works of local art. The recording of the Hajj

BELOW: Use for a roof in Kerala, India

pilgrimage to Mecca can completely cover the external walls of houses in Upper Egypt, with colourful depictions of aeroplanes, ships, camels and cars, all in a wonderful naïve style.

Decorative painting of mud houses with colourful geometric designs is popular throughout Africa. The best shots will be in sunlight, ideally with some human interaction.

Village art on walls and floors can put much-needed vibrancy into mud, earth and stone-coloured buildings, such as rangoli floor paintings at New Year in India. Ask permission and you should be rewarded with smiling faces.

Groups of buildings can form patterns, from suburban blocks and painted terrace housefronts, deliberate attempts by the owners at a local aesthetic.

Seasonal traditions

Look out for signs of local traditions, such as good luck symbols on doors to drive away evil spirits – ibex horns on desert houses, carlin thistles in the Pyrenees, wind chimes in Asia. Show the time of year of your pictures by photographing mushrooms drying on doorsteps, corn dollies or palm fronds.

Human activity – sweeping a doorstep, painting a windowframe, hanging out a line of washing – can add interest. And a building with a door that is open or ajar looks far more welcoming than one where doors and windows are firmly closed.

Poverty tourism

In a desire to capture the harsh real world, the travel photographer may be attracted towards images of life in makeshift homes in the poorest parts of the developing world where there is little privacy and not much dignity.

Photography is usually discouraged on the guided tours that exist of the slums of India, the shanty towns of South Africa and favelas of Brazil. An independent traveller should consider the same respect and restraint. But that does not preclude the overview, the shot from the roadside, or from a vantage point where the clutter of housing creates patterns and shapes. And many people, like the children below, are proud to show off where they live. ❑

Reference ▷

Indoors, p.67
Reflector, p.68
Detail, p.241
Local customs, p.297
Vernacular, p.200

BELOW:
Kids at home,
Hushe, Pakistan.

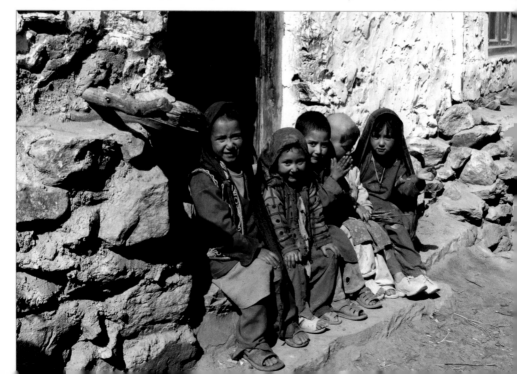

VERNACULAR

Traditional homes around the world are built with local materials, in styles and colours that fit their climate and landscapes. A photograph of one can sum up the essence of a place

Communities grow organically, adjusting to their landscapes, climates and daily needs. Their building styles may in time be subsumed in cities, but even modern architecture will have influences from the past. Finding the vernacular, both original and borrowed, is a key to depicting a place.

Weather plays a large part in how buildings develop – steep pitched roofs for snow, flat roofs for acres of sunshine, cool courtyards in sunny spots, south-facing balconies where people want more sun. Vernacular architecture is also governed by the availability of suitable materials – mud, clay, reeds, timber, stone, marble, slate and handy man-made materials such as corrugated iron. Some villages have an area set aside for the production of building materials – brick kilns in India, sun-dried mud blocks in Arabia, saw mills in coniferous forests, reed beds in marshlands. Photos of activity here can be helped with fill-in flash if there is a lot of contrast between a bright exterior and a face or body in shadow. Artisan builders, such as thatchers, are usually happy to pose for a shot, knowing that more exposure through photographs will help to keep their tradition alive.

Look for details in bricks and stone, which make graphic patterns: knapped flint, ashlar masonry, herringbone and checkerboard. Roof tiles produce good patterns, too. An old stone building comes alive as a golden centre of interest when shot in late afternoon sunlight. An added sleeping dog or cat will help create a contented picture.

ABOVE: No building material is as natural as mud, which can make a building seem part of the land, as in this Arizona adobe. The cactus sets off the picture, giving it extra colour and design, while the shuttered door and empty basket make the picture seem posed.

ABOVE: Never mind form and function, the vernacular style in Korean temples, like Woljeongsa, calls for elaborate decoration. Note the colours, which are as particular to the local architecture as the shapes and patterns. For the photographer here, detail is the key.

LEFT: As English as – well, as English as a West Country thatched cottage: trim, clipped and whitewashed. Look out for the local thatcher: he may well pose for you to publicise his dying trade.

COLOUR, LIGHT AND PAINT

It is not just the figure in the picture above that tells you this is the Caribbean. It is the colour and the light. Beneath a deep blue sky, painted green and blue, the colours of these buildings could not be found in a northern climate. Heading away from the equator, the earth's atmosphere, through which the sun's rays have to travel, increases, causing a more limpid light and lowering the intensity of the colour. Nearer home, like wine that does not travel, the attractive lavendar blue of window shutters in Provence can look dull in a northern European country, even when the paint is taken from the same paint pot. Paints evolve locally, and the vernacular architecture in many countries for decades relied on – and was defined by – a limited range of proprietary paints: a house in a southern Portuguese town will have woodwork of a specific kind of green, available in every local shop. Greece is famous for its deep blue, which sets off its whitewashed buildings in the same way as a deep azure sea or sky. Cities like Jaipur in India are distinctly pink. Pastel paints, rooted in earth colours, warm facades in towns such as Cuba's Trinidad.

It is important that photographers get the colours right. Returning home, there is often only memory to rely on to ensure a good match.

ABOVE: Colourful huts in the Dominican Republic.
BELOW: Roof tiles at the Alsace Open-Air Museum, Ungersheim, are like colour swatches in a haberdasher's.

ABOVE: A traditional hut in Bekal, India. Without glass and no plaster on the colourful laths, it is immediately clear that this is not located in a cold climate. At the same time the reed roof gives it a cheerful, mop-haired look.

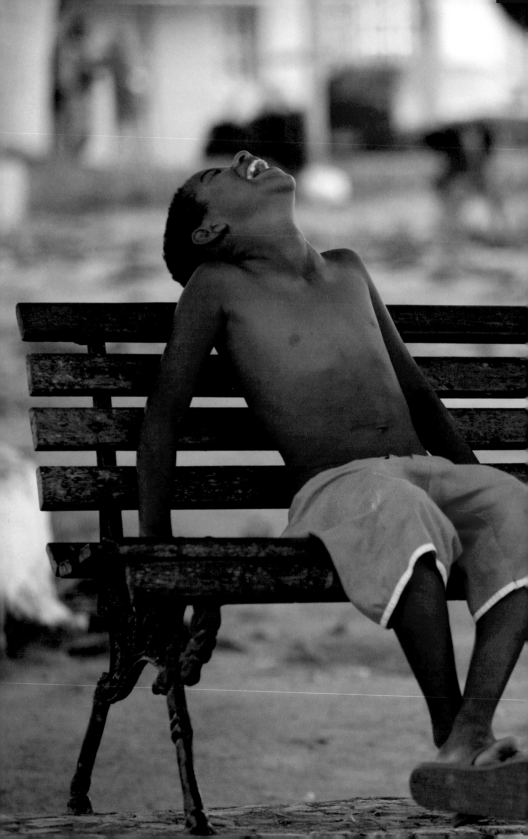

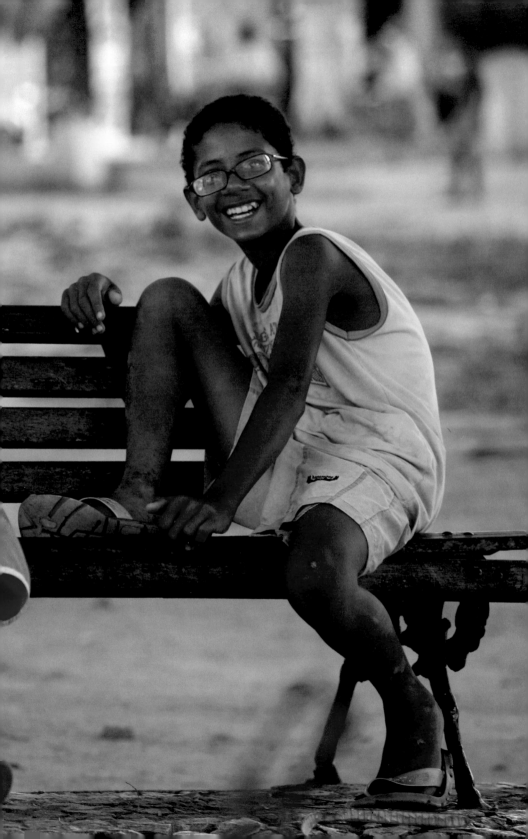

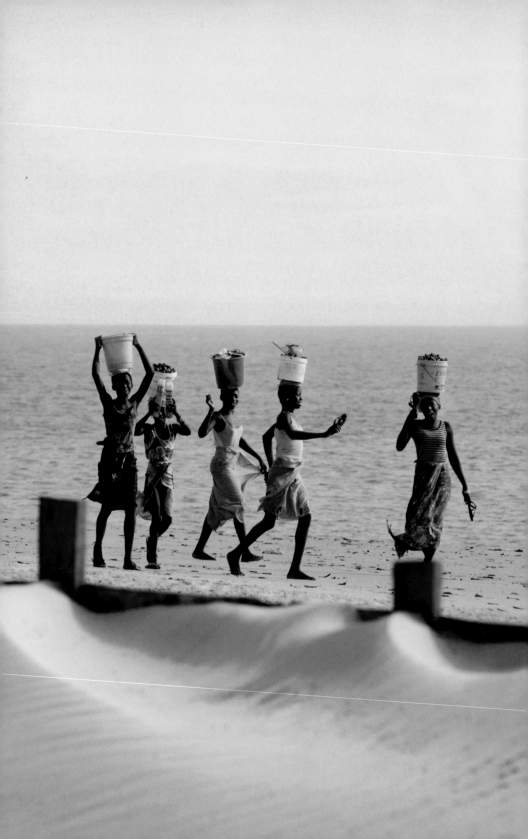

PEOPLE

Diverse and taxing, people are the most rewarding area of photography. Sensitivity is key; to spot a subject, make your approach, choose your moment

Photographing people is as much about psychology as technical ability. Even the terminology used is predatory: we "capture" images and "shoot" people. The action of raising a camera instantly alerts the intended subject to the presence of the photographer. And although the advent of digital cameras with flip screens – allowing the camera to be held innocently at waist height – goes some way toward helping you to remain a fly on the wall, nothing beats patiently waiting for your subject either to acquiesce to your request, or to ignore you altogether.

There are more than 7 billion humans to choose from; each face a landscape of individual hope or happiness, history and histrionics. People give scale and purpose to an otherwise empty scene. Very often they are the composition and the visual narrative of an image. In a world where an increasing number of us are seeking to record rather than to participate, the challenge, more than ever, is to capture moments of pure, undiluted human emotion.

Crowded environments, be they city streets, railway stations, ports, construction sites or markets, offer the best hunting ground for photographs of people in action. Celebrations, festivals, family gatherings and weddings offer glimpses of people dressed up in their finery, often only too happy to show off for your camera. But when the playing field is levelled, photographer and subject facing-off in a quiet or intimate environment – a boulevard café, perhaps – the mere click of the shutter can seem an intrusion. Unless the subject is totally engrossed in his dog-eared copy of Sartre (in which case he is existentially fair game) establishing eye contact is not only polite, but will instantly tell you whether it is safe to take the shot, or go back to your caffè latte. ❏

Main Topics
PORTRAITS/GROUPS
FESTIVE OCCASIONS
PERFORMANCE ART
SPORTS AND PASTIMES
PEOPLE AT WORK
MARKETS AND BAZAARS

PRECEDING PAGES: Sharing a joke at Arraial d'Ajuda, Brazil. **LEFT:** Gathering shells in the Saloum delta, Senegal. **RIGHT:** Theyyam dancer, Kerala.

PORTRAITS/GROUPS

THE PHOTOGRAPHER is born with the habit of analysing people's faces. And where better to begin experimenting with shooting portraits than with the faces you know most intimately, at home? Grandparents, the newly born, arguing siblings... the material in the average household is enough to fill a *Life* magazine photo essay. It's when one ventures out into the wide world that the challenge of attaining access to members of the public obliging enough to let you take their photo begins.

Stealth or request

Generally there are two ways of approaching strangers: by stealth or by request. If you are confident in yourself and of your camera, comfortable with the lens and know how to handle natural light, then stealth is definitely preferable. After all, what draws you to a particular character can be something as fleeting as a look in their eye, or the crease of a face when it smiles;

nothing beats the ability to recognise and capture the spontaneous.

Portraits fall into two main categories. The first are close-ups, where the person, or a part of them (a calloused hand can tell more about a person's life than their face), fills the entire frame. The second are environmental, where the subject is part of the landscape and may take up a quarter of the frame.

Close-up shots look more natural and are less distorted when shot with a longer *lens*, something from 50mm up to 135mm. Environmental shots are captured best on wider lenses, the classic being 35mm, but consider 24mm or 50mm options if you want to include more, or less, surrounding landscape into your image.

Sign language

Candid shots leave a lot to chance, and it is often best to come clean and ask if they don't mind you taking a picture. If language is a problem, sign lan-

BELOW: Choosing the moment – school's out in Trinidad, Cuba.

guage is pretty universal – a quizzical raised eyebrow, pointing at the camera, a thumb's up. Surprisingly often, people are relaxed enough to allow you to take their picture, especially if you engage them with the process by showing them the results on your LCD monitor. It is a good policy to try to ascertain an email address for the subject so you can later send them small JPEG pictures.

The problem might be to stop them from acting up for your lens. In India, Bollywood has a lot to answer for, as most young men adopt the heroic poses of their favourite action stars; in Taiwan and Japan it is the ubiquitous out-turned v-sign.

Take a few icebreakers

In poorer countries particularly, you will be faced with the dilemma of whether to pay to photograph someone. There's no hard and fast rule about it. Generally one should try to avoid the issue of actual cash. In many countries (Vietnam, Indonesia, China and large parts of Russia, for example) people smoke a lot, and an excellent alternative to cash is cigarettes. Get into the habit of carrying these icebreakers, even if you yourself are a non-smoker.

Sometimes you are confronted by a person so obviously poor and down on their luck that it would be inhuman not to try to help them with spare change. But most of the best travel photos of people are taken for free of willing or blissfully unaware subjects.

Dealing with small crowds

Wherever you take a camera in the developing world, small crowds will form. In Bangladesh, for instance, it's not unusual for hundreds to gather around, curious to see what it is you are shooting, often obscuring or scaring off your subject in the process. In such a ready-made group, you'll need to initiate crowd control. Empower a few teenagers with the task of keeping the masses back.

A disadvantage of digital photography is now everyone wants to see how they turned out in your shot and pester you to retake it if they think they've turned out a few shades too

Reference ▷
Lenses, p.113
Local customs, p.297
Model release, p.307

BELOW:
Young trainee monks in Laos. Note again the limited depth of field, isolating the main subject in the foreground.

Model Release Forms

In these increasingly litigious times, some publications will not risk using photos that feature a clear and prominent individual, unless accompanied by a Model Release Form signed by that person. The problem is that waving an official-looking piece of paper in front of people can scare them off, especially when the MRF is printed in a language that is not understood. Presently only publications in the US and a few other developed nations are bothered about these forms, and in many countries people are happy at the thought of being featured in a magazine. But agencies usually need the forms because the picture could be used in a commercial context. A number of bodies, such as Professional Photographer, have sample Model Release Forms to download. (www. professionalphotographer.co.uk)

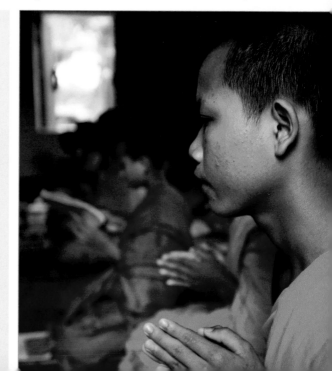

The Family of Man

Travelling helps you see differences among nations. It also reveals common bonds. It is the things we share that inspired the greatest photographic exhibition

A wish to find out about the way people live is one of the reasons that we travel. For example, do the people of Lao laugh as much as the people of Peru? Are the Slovenians as concerned about the way they dress and educate their children as the Japanese?

Travelling from country to country, a photographer can only discover a small amount about the world and its daily concerns. One solution might be to try to bring the people of the world to us. This was the thinking of the great American photographer and curator Edward Steichen (1895–1973) when he organised *The Family of Man*.

As the first Director of Photography at New York's Museum of Modern Art, Steichen set himself the daunting task of selecting from thousands of amateur and professional photographers the world over a collection of photographs that would sum up the shared human experiences of life.

Born in Luxembourg and raised in America's midwest, Steichen was a trained painter and initially he followed the pictorial school of photography, taking pictures that came close to capturing artists' canvases. One of his earliest photographs, "The Pond – Moonlight", taken in 1904 and hand printed in a way that gave it some hint of colour, set a record price of $2.9m at auction in 2006.

His photographs were frequently published in *The Camera*, edited by Alfred Stieglitz, and in 1905, the two of them opened 291, which was to become one of the city's leading art and photo galleries. But in 1923, convinced that photography was the future, Steichen burned all his canvases and spent his energies on photography. Soon he was America's highest paid practitioner, working for advertising agencies and fashion magazines. He also served in photographic units for the military in both world wars.

Steichen was highly influential in persuading cultural institutions that photography was an art form, and in 1947 he became the Director of Photography at the Museum of Modern Art in New York, the first museum in the world to offer such a post. It was here in 1951 that he conceived and gathered up *The Family of Man*. It was an astonishingly ambitious project. More than 2 million photographs were sent in from all corners of the globe, depicting the shared human concerns under 37 different themes, including love and faith, birth and family, work and education, war and peace. From an initial selection of 10,000 pictures, he whittled them down to just 503 from 273 photographers, including many that have become iconic, such as Dorothea Lange's "Migrant Mother". Over the next decade these large black-and-white exhibition-sized prints toured 68 countries and were seen by an estimated 9 million people. Finally they came to rest in the castle in Clervaux in Luxembourg, the town where Steichen was born. Fully restored, they still attract many visitors and the project is now listed by Unesco on the Memory of the World Register.

If you go to the exhibition or study the catalogue, you will see just how the collection exploits similarities rather than differences, as in the pictures of the American family posing in their living room and the Bushman family posing in front of their hut. *The Family of Man* both inspires and instructs, and is an experience no travel photographer should miss. ❏

The Family of Man

The greatest photographic exhibition of all time – 503 pictures from 68 countries
created by Edward Steichen for the Museum of Modern Art

Prologue by Carl Sandburg

LEFT: Cover of *The Family of Man* catalogue.

dark, or you caught their bad side. With groups of more than three people you'll have to make sure you capture at least one frame in which no one is blinking, or someone's head is obscured behind another. Certain places have variations on the traditional "Say Cheese!". In Indonesia it is "Pepsodent!" (a popular brand of toothpaste). Or you could try one of your own: "Botox!" works quite well.

Lighting the face

Lighting is an important consideration in all portraiture. The ability to use a flash or studio lights differentiates the professional photo from the mass of amateur Flickr-ings.

In an ideal world it is always 8am on a peerlessly sunny morning, and the photographer needs to utilise only that one great light in the sky to get a perfectly exposed portrait. In reality, it rains, there are clouds and people stubbornly refuse to leave shaded areas. In these cases a portable "sun" is the solution.

The best lit shots are achieved with side lighting, as this emphasises depth and character in a face while avoiding pasty looks and red-eye. Try getting used to having your flash attached to a sync chord, rather than on your camera hot-shoe, so light can be directed from one side – get some practice in at home with friends before you travel. A sync chord also means that the flash can be hidden in a pocket of your bag or jacket and brought out quickly when needed – just bringing out a flash can frighten some people off.

The main objective of using a flash is to add a little light to the face and a glint to the eye, not to overwhelm it in a blitz of paparazzi-style full-frontal fury. Purists will reject the flash entirely. This is fine if you have time to manoeuvre your subject into an ideally lit area or you are shooting in black and white (or at high ISO settings) and want to have contrasty results.

A portable photographic umbrella, used with or without a flash, gives a soft, diffused light. Look for avail-able reflective surfaces – whitewashed walls, glass, water. Any background sheet (white or black are simplest and therefore best) can be set up in an impromptu "studio" in a backstreet. Sometimes, particularly in tropical areas, you can use the reflected light from the ground in the middle of the day to illuminate a subject who is, say, sitting in a hammock on a veranda.

Windows on the soul

Try experimenting with depth of field. It's a general rule that, since the eyes are the "windows to the soul", portraits should *focus* on them. You can emphasis eyes more effectively using a wide aperture (ƒ2, for example), leaving the rest of the face and background an artsy blur.

The classic portrait lenses are 85mm and 105mm. But that's not to stop you going in close with a wide angle. There may well be some distortion at the edges using anything wider than 24mm, but if the subject has, say, a nose worthy of Cyrano, then focus on it, distort it, illuminate it by flash and celebrate it in every way. ❏

Reference ▷

Focus, p.104
Flash, p.69
Lenses, p.113
Reflector, p.68

BELOW:

Close-up of a young woman from Gambia.

FESTIVE OCCASIONS

TYPE THE WORD "Festival" and the country or countries of your itinerary into an internet search engine, and it reveals an astounding number and variety of celebrations going on around the world. And though the chances of simply stumbling upon a festival are high, it is entirely possible to plan – and justify – a trip around the world, taking in a festival every day.

A messy crowd

Many of the most enjoyable incorporate some sort of mess. La Tomatina in Bunyol, Spain, usually held in early April, is one gigantic tomatoes maelstrom. Dumped in truckloads, tomatoes are ammunition for a no-holds-barred street fight while brave individuals attempt belly slides down the road. Cut a hole in a plastic bag and stick your lens through to protect the camera from an unwanted juicing.

A plastic bag might not be enough for Songkran, celebrating the Thai New Year. The unwitting foreigner often becomes the target of buckets of water and close-range high-velocity water pistols. A water-resistant pocket camera is needed. In spring, Holi is celebrated across northern India. This is a true festival of colours, and in order to get that special shot, the avid photographer will have to sacrifice a few shirts to the powdered dyes being thrown.

New Year celebrants

New Years are celebrated in many different ways and at many different times other than January 1, often coinciding with animistic harvest festivals. They are perfect occasions to observe both the traditional and the fun-loving side of a society.

In Tamil Nadu, southern India, New Year is called Pongal, after the sticky rice delicacy made on the day. Good photographic subjects are supplied by the Jellikattu bull running, which takes place across the state in makeshift

BELOW: Steer clear of high-velocity water pistols at Thailand's Songkran festival!

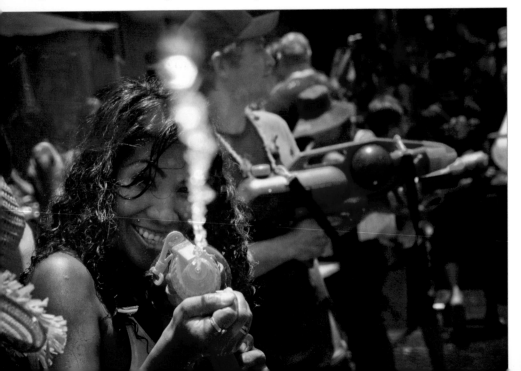

stadia – or just down the village main street. Farmers adorn their biggest and meanest bulls with coloured rice designs, attach money to their horns and let the animals loose to charge through the crowds who try to grab the cash. Several people get gored to death each year, so be careful how close you get to the action.

Possibly safer would be to stick to the Running of the Bulls in Pamplona. Here a very wide-angle lens and shooting position at pavement level on one of the sharp corners of the cobbled route will yield the most dramatic results of rushing beasts and men.

Riders and camel traders

Naadam, the annual sporting festival in Mongolia, gives rare chance to see bareback riders on the open steppe. Telephoto *lenses* will be essential to capture any horse-related action, and you might consider using the "sport" mode on your camera setting to take the action.

The event includes archery contests and wrestling, where a medium zoom (24–85mm) will be a good option.

Keep an eye open, as always, for detail shots; the wrestlers' elaborate leather boots, the differing designs painted on the doorways of yurts, and so on.

The Camel Fair in Pushkar, Rajasthan, in November is worth a trip. It goes on for weeks and attracts thousands of craggy and characterful camel traders from far out in the desert. Competitions include the search for the man with the longest moustache, and, naturally, a prize for the most beautiful camel.

The characters who turn up at events like Naadam and the Camel Fair offer great possibilities for portraits. They will be in good spirits, the sun will be shining, and whole landscapes seem to be etched on their faces.

Fancy dressers

For spectacle, nothing beats the Brazilian Carnival in Rio de Janeiro. This pre-lent occasion erupts throughout the Catholic world, while the world's largest street carnival takes place in August in Notting Hill, London, each August bank holiday. Get in close: in both Rio and London wild costumes

Reference ▷
Shooting angles, p.83
Lenses, p.113
Detail, p.241

BELOW:
New Year fireworks on Copacabana beach, Rio de Janeiro.

Fireworks

Fireworks are a splendid subject to photograph. The end of the Chinese New Year in Taiwan – where, unlike Hong Kong and China, fireworks haven't yet been successfully banned – is particularly noisy. The entire town of Yenshui, near Chiyai, erupts into pitched firework battles. Residents fire rockets at each other and lob boxes of firecrackers at local tattooed heavies who go into battle wearing nothing but swimming trunks to prove how tough they are.

Photographers are advised to adopt the opposite sartorial look; thick layers of clothing, gloves and a full-face motorcycle helmet are de rigueur to help avoid injury covering this one.

Firecrackers are notoriously difficult to shoot well; the noise and chaos at the time leads you to believe you have a great shot but later viewing will often show a disappointing puff of grey smoke. Use a fast shutter speed (1/500 sec) and maybe pump in a little flash to highlight the exploding rocket casings as they fly past.

Traditional firework displays, on the other hand, are easy to shoot: set your aperture to around ƒ11 and use a shutter speed between 15 and 30 seconds. Anything that explodes during the time the shutter is released will transform into a graceful shower of light streaks. Videos are much easier to use to record both the images and the sound.

and headdresses provide a perfect backdrop to shoot portraits. Opting for a close-up with a fast portrait-length lens, an 85mm ƒ2, for example, will capture their perspiration and expressions most vividly. Consider using fill-in flash to ensure an even exposure between the darker skin tones and glittering, over-exposed costume materials.

The annual Burning Man out in Black Rock Desert of Nevada is spectacular, too, in a New Agey sort of way – people in garish costumes or hardly any clothes at all construct elaborate statues and improbable homes out in the sand-flats. It's perfect for environmental portraiture.

You are likely to be asked by the organisers of the Burning Man to sign a paper promising not to market your photos of the event commercially.

Under canvas

Life for the photographer needs to be abstemious, and for the best results of such events as the Oktoberfest in Bavaria he or she should refrain from free steins of Weissbier. It's possible a few lucky shots will emerge through the blur, but you'll enjoy a better hit-rate if you are sober enough to focus and compose.

Maidens in low-cut dirndls and the boisterous carousers are perfect subjects for a portrait, of course, but you need to take account of ever fluctuating light conditions in a beer tent. At daytime it can often be a dark inside, tinted by sunlight filtering through whatever coloured canvas is used. *Fill-in flash* is recommended, and a slowish shutter speed (1/15 sec, perhaps) to help dissipate shadows cast by that flash.

By night the scene will be floodlit. Again fill-in flash is highly recommended. Flash has the advantage of sharpening anything touched by that instant of light – though if you push the ISO to 800, use a low-light lens (again the 50mm ƒ1.4 is extremely helpful) *and* make white balance adjustments for the varied light sources, you could come away with more spontaneous and atmospheric material.

Remember to keep checking your camera screen, blowing up a few selected

BELOW: Crowds gathered for a festival (mela) at the Kodungalloor Bhagavathy Temple in Kerala, India. The small aperture of ƒ13 and the distance from the camera of the foreground subjects make for good depth of field.

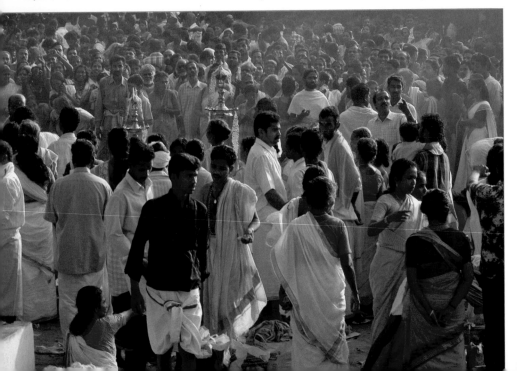

images to ensure they are as sharp as you think they are at first glance.

Pilgrimages

Festivals are often related to religious events, so you should consider the sensitivities of any particular religion to the issue of photography.

Pilgrimages offer a ready-made beginning, middle and end to a visual story. Try following along with the groups of penitents, some barefooted, as they walk across northern Spain towards Santiago de Compostela. Many villages in Catholic Europe and Latin America have saints' days when pilgrims process through the streets and up to an outlying chapel.

There are many seaborne pilgrimages, too. In Taiwan, the statue of Matzu, Goddess of the Sea, is taken on a two-week journey across the island, worshippers prostrate in the road waiting to be passed over by her palanquin carried by four foot soldiers, firecrackers exploding every step of the way.

Most religious festivals and rites occur annually at fixed locations, though the dates may vary – Easter

week in Seville, for example, and in the Philippines, where bloody crucifixions occur. The huge Melas in India go on for months, attracting larger crowds on each four-year cycle, and unbelievably massive ones once every 12 years.

Wedding practice

As a travelling photographer you'll make a good many friends on your way. Taking advantage of this "in" to a different culture is recommended. One of the best ways to do so is to offer your services to shoot local weddings. It's good practice and you'll have unfettered access to people you'd never normally get close to.

There can be high human drama here. Kurds and Arabs will fire guns into the air, and occasionally, when a little too carefree, into the crowd. In Chinese communities don't wait for the dancing to begin; people turn up, donate a red packet of money, eat, line up to shake hands with the happy couple, then leave. At Cantonese affairs mahjong players barely look up from their gaming tables on the perimeter. Indian weddings can go on for *days*. ❏

Reference ▷
Indoors, p.67
Flash, p.69
Motion blur, p.102
Depth of field, p.100, 114

BELOW: Standing out in the crowd along the boulevard in Century Park, Shanghai – using motion blur to isolate a figure.

Tackling Large Crowds

In any large crowd, it is important to find a viewpoint. Photographers are constantly scanning the streets for possible buildings to climb and rooftops to access, which can lead to cat-and-mouse chases with office building security personnel.

One way to give a sense of mass is to wait until the light is low and shoot a long exposure with your camera mounted on a tripod. A shutter speed of 1/4 to 1/2 a second in daylight will allow some detail of the moving people, a leg here or arm there, to still be made out. Any exposure longer than half a second and all movement becomes an *impressionistic blur*.

The best result is if you spot a solitary figure – or shoot enough frames that you find someone standing still in the crowd – since the moving people will appear to flow around that person like a river.

PERFORMANCE ART

DANCE IS MOST easily captured on video, and it takes a good deal of effort for a still photographer to convey movement in a moment,

A pair of ice figure-skaters twirling in Mall America; Sufi dervishes whirling in a sun-baked Anatolian courtyard; Cubans sashaying to a local salsa band; ballerinas prancing across the stage at the Bolshoi; Lion dancers leaping from pole to pole in front of a Singaporean temple, firecrackers exploding all around … dances and performances are rapid action affairs that require some kind of empathy from the photographer.

Try *motion blur* shots to accentuate the spinning motion; a shutter speed of around 1/8–1/4 sec should do it.

Dancers of Bali

BELOW: Legong dance performance in Ubud, Bali.

The Ramayana, a Hindu epic played out in Bali, is an example of a perfected performance tradition. As a photographer, you should aim to honour and mirror the natural fluency, pleasure and dedication of the performers. When you start to feel the action flow, you will be able to anticipate a certain movement, and know what to expect by the timbre of a voice. You can then focus on an anguished eye as it casts an accusing glare, or convey the passion of the poet as he reads his sobbing verse.

Such acute emotion needs a sharp image, so be sure to calculate the highest ISO/most acceptable grain (noise) quality compromise. Even taking into account the ever improving low light capturing sensors and noise reduction software, it is rarely recommended to exceed an ISO of 800. Consider using a monopod, which is lighter and less obtrusive than a tripod, and can give you an extra two stops of light to play with in low light.

If you are in the audience, try to choose a seat off to one side. You also need to be higher than the stage. This

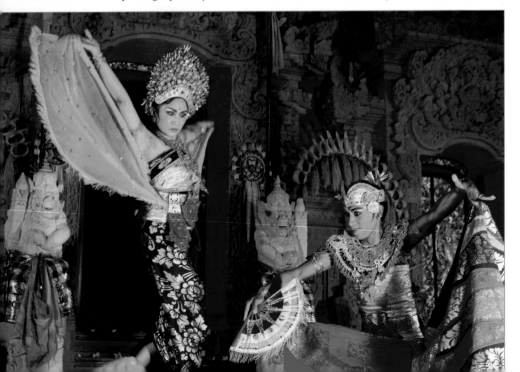

allows more perspective and depth to your pictures as you probe the performers actions with a longish lens. But be sensitive to the audience: dampen the shutter noise with a sweatshirt – performers should not be able to hear your shutter – and don't hamper other people's views of the stage.

Auditoria lighting

Most performances take place inside theatres or auditoria where stage lighting allows you to shoot between 1/125–250 sec. shutter speed at ƒ2.8, at ISO 400–800 sensitivity. In other words, it is marginal light; your pictures will have a lot of contrast in them.

Often tungsten stage lighting is used, which is warm; your pictures will turn out too orangey unless you select the tungsten light *balance* option on your camera. Take a light reading on a performer when they are at centre stage, using the spot meter setting on your camera, then switch to manual to avoid exposures jumping all over the show as you follow action across extremely variable set and lighting scenarios. And ensure your pop-up

flash isn't going to give you away – it wouldn't light up the stage at that distance anyway.

Monks in action

In some arenas you'll be welcomed to take videos and photos. The lively B-Boy Korean break dancers in Seoul, positively insist on you recording their show. The Tai Kwon Do monks of Shao Lin monastery are more Cirque de Soleil than vow of silence, these days, and go on global tours exhibiting their exceptional martial arts skills.

Again, a long lens is most useful. A low light telephoto like the ƒ2.8 70–200mm is ideal. Action is fast, so push the film speed to between 800 and 1600. In acrobatics one main actor usually dominates each act. Isolate that person and follow him or her doggedly through your lens. Keep the auto focus on "continuous" mode, so you will be ready to shoot any moment. During Tai Kwon Do exhibitions there's usually a demonstration of breaking tiles with feet and hands: pre-focus on the tiles so you are ready to shoot at the point of impact. ❑

Reference ▷
Motion blur, p.102
ISO sensitivity, p.103
Artificial light, p.67
White balance, p.106
Focus, p.104

BELOW:
Hokkien Opera performer in Penang.

Behind the Scenes

In order properly to convey a story of an event, you should try to get behind the scenes: a Chinese opera performer applying layers of make-up using a compact mirror underneath a bare bulb; the red-faced coach shouting and teammates cheering from the sidelines of the rink; the dervish in his day job as a bank clerk or rural postman; the blood, sweat and tears of hopeful young Flamenco dancers as they are put through endless routines in the school gymnasium.

Think of ways of building the story through photos of posters and flyers, costumes and make-up in shop windows, and other background relevant to the performance. Look at the audience, too, queuing expectantly for the show, and leaving afterwards with expressions of happiness – or disappointment.

SPORTS AND PASTIMES

TELEPHOTO LENSES are essential for photographing people engaged in sports and other physical pastimes. Digital zooms on compact cameras are not the same: they are an optical trick, merely cropping the edges off a wider image. Only a true optical zoom or fixed lens telephoto will give crisp, well-saturated images at a distance.

Lenses and settings

Big telephoto lenses are ungainly, though they often single out the professional from the amateur and can sometimes help you gain access to events otherwise closed to the public. But unless you are a fanatical football photographer, you can forget capturing the glint in Wayne Rooney's eye as he prepares to strike. Lenses of 600mm and upward are required, and their size, weight and cost are restrictive. The ranks of professional photographers covering the World Cup – their massive telephoto lenses supported by

monopods – are using company equipment. As digital capture quality and noise reduction software continue to improve, though, pretty good replicas can be attained using a medium price range 200–400mm zoom lens with image stabiliser on a camera with 1:1.5 sensor. This in effect gives you a portable and affordable 600mm option.

A fast shutter speed is essential for freezing sports action. Don't even think of shooting under 1/500sec. Here is where digital technology is a boon, with its ability to switch, shot by shot, to different ISO settings. It is best, for most competition sports, to fix the body on shutter priority and use an ISO of 400 to 800. For rapid action events inside stadiums, like basketball or badminton, you'll probably have to increase this to 1600.

Rhythm and rules

Sports that involve lots of passing or unexpected movement – ultimate fris-

BELOW: Chess players are ubiquitous in parks and usually so focused that it's easy to line up a good shot.

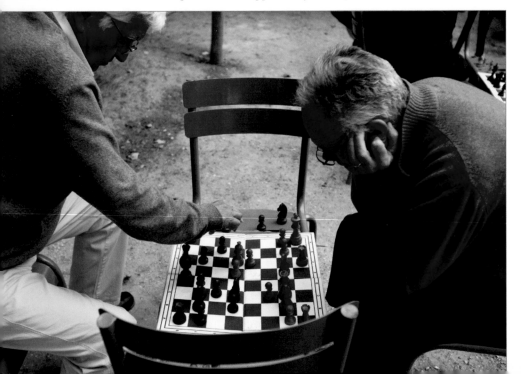

bee or Thai kickboxing, for example – are more difficult to shoot. Choose your angle and wait your moment – slightly off side and behind the goal at a soccer match, or the moment a ball is perfectly suspended during a tennis serve. Sometimes the look on the face of the defeated player is worth much more than that of his victor.

Get in close

Kids kicking around a ball in a dusty back lot, weekend cricketers on the church green or professional rally car drivers will all be 100 percent engrossed in their sport and not worried about the lone photographer – unless, of course, you get in their way.

The trick is to get close enough to re-create the feel of the fray in your images. Picking out an individual and panning along with him at a slowish shutter speed often helps (somewhere between 1/8 to 1/30sec is recommended). This works well with Dragonboat races, for example, where the panning effect increases the illusion of speed and also makes the large areas of water between competing boats seem suddenly inter-

esting. Forget having your camera on auto exposure mode all the time; a silhouette shot can sometimes work well.

Morning light

Pastimes that take place in the early mornings are a gift for photographers. Morning light is more ethereal and enchanting than sunset, and an early start often brings rewards.

Across China people gather in groups to practise ballroom dancing, synchronised fan dancing and outdoors karaoke sessions. In South Korea, the bicycle paths in Seoul on the Han River attract cyclists, joggers and kite flyers – try to get the kites backlit against the sun, their operators appearing as silhouettes. In Hong Kong, check out the early morning tai chi sessions and old men taking their caged birds for a stroll in Victoria Park. In Beirut, shoot strollers and domino players along the Esplanade. Across India the calm of morning is often interrupted by the booming outburst of the local Laughing Society. Joggers pound the pavements, dogs are walked in parks… before 9am, anything goes. ❑

Reference ▷
Lenses, p.111
ISO sensitivity, p.103
Shutter speed, p.101
The moment, p.92
Light & Time, p.57

BELOW:
Thai kickboxing calls for excellent timing – from boxers as well as photographers.

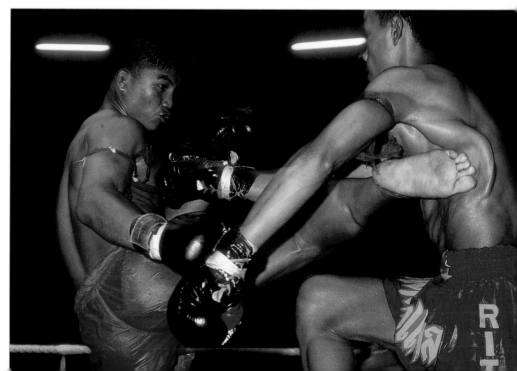

PEOPLE AT WORK

TO UNDERSTAND people in different countries, it is necessary to see how they work. Cities and countryside are dictated by the rhythms of daily life, of which work is a fundamental element. People at work offer an abundant range of images and situations for the photographer, and they can be used to build up a rounded picture of a place. One way of doing this is to range through a typical day.

Rush hour

BELOW: Sao Joaquim market in Salvador, Brazil. Shooting towards the "sweet light" creates strong atmosphere and mood.

Begin with the early morning rush hour. This is particularly tense on, say, Howrah Bridge in Calcutta, the busiest bridge in the world and scene of terrific traffic snarls – rampaging bullock, with cart in tow, careening into a group of pilgrims carrying aloft their eight-armed plaster deity. Beneath the Howrah is a choc-a-bloc flower market, spectacularly crowded at sunrise, with buyers selecting buds and blooms to transport as far afield

as Amritsar. Traffic police attempting to control this chaos make excellent subjects. Their job becomes most furious as workers flood into the main stations and bus terminals around a city. Catch commuters hanging out of the open doorways of intercity trains or riding on luggage racks on buses and vans. "How many people can you fit in an Indonesian bus?" goes the old joke. "One more!"

Chai wallahs and beggars

An entire industry of workers assist in the smooth running of a major train station and are worth focusing on: newspaper sellers, shoeshine boys, chai wallahs, ticket touts and cleaners. And there may be backpackers, down-and-outs and beggars. To create an effective sequence, consider shooting all the above from the same angle with the same lens, settings and lighting. The truth is revealed seeing the different individuals and the objects of their

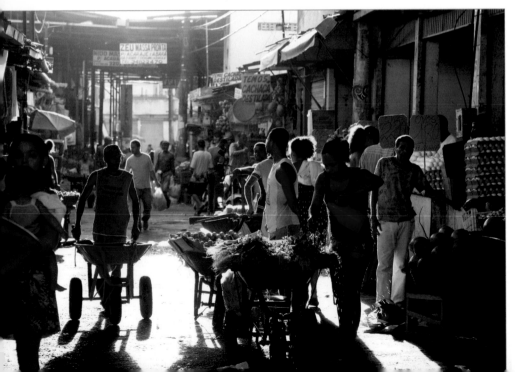

trade side by side. The less technical complexity in the shot, the more we focus on the subjects themselves.

City workers

Many workers will be heading to the office, looking put-upon. yawning, or are already on their mobile phones scheduling meetings. Go in for close-ups of facial expressions. Others will be heading to construction sites of impressive infrastructure projects and towering skyscrapers. In Dubai you'll see workers from a United Nation's worth of different countries.

Often access can be gained to the lower stages of a construction project, enough to shoot a sea of safety helmets, or people strapping on safety harnesses. Welders and grinders create sparks that spew out in golden arcs (when shot on a slow shutter speed of 1/15–1/4 sec). Size and *scale* are what to look for; a tiny silhouetted worker against a soaring empty framework of scaffolding.

In the countryside

The agricultural sector is still a major employer in many parts of the devel-oping world, farmers bending to plant new rice shoots in flooded paddy fields, others reaping the harvest of grain and loading it onto wooden barges across the Mekong Delta. In the developed world, the intensive agri-culture is often worked by migrants from many countries.

In summer, workers will be in the fields by dawn, putting in enough work before the midday sun drives them indoors. Farmhouses from the Andes to the Alps tend to conform to our most romantic impressions of rustic beauty and decay, but their inhabitants lead a tough life, which can be conveyed.

New Zealand's country roads become blocked by flocks of herded sheep. From Australia to Armenia, shearing season offers the photogra-pher a chance to cover farm workers in their manic and distorted ballet of wool and sharp blades.

Focusing on the efforts of a single worker and/or animal will often yield better results than trying to capture the whole scene, especially when the work takes place inside a dimly lit shed. It's

Reference ▷
Scale, p.85
Light & Time, p.57

BELOW: Picking grapes in a Douro Valley vineyard, Portugal.

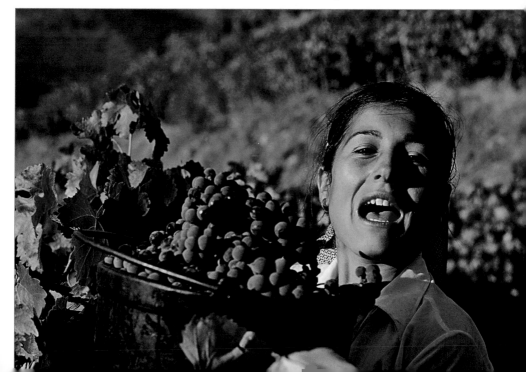

easier to control light in a confined or tight environment than a vast one.

Lunch breaks

Come lunchtime, people pour out onto the streets. Smokers congregate in their exclusion zones, others seek solitude on the same end of the same bench in the same park eating the same sandwiches every day for 20 years.

In the summer, parks in central London fill with office workers seeking a quick tan. In Bombay there's a thriving business of tiffin deliverers who pick up lunch boxes from the homes of doting wives, deliver them to the correct husband/office and collect and return the emptied tins afterwards.

Factories and workshops

Afternoons can get a little hot and drab for street shooting, so seeking access into an office or workspace will expand your horizons. Artisans are people with a passion for their work, and photographing people engrossed in their creative process inevitably makes your work more imaginative, too. Try shooting an artisan as you would do a portrait. It's not so much a matter of fancy effects or distorted angles, but more a careful study of concentration and practised repetition. The good thing is that, be your subject a Bengali mud cup potter, a Cuban cigar maker or a coppersmith in Aleppo, the nature of much craftwork is repetitive, allowing you to perfect angles and lighting in a few test cycles before the final cut.

On the other hand, watch the lighting. Covered souks or ageing colonial-era factories are notoriously dim places to shoot. Craftsmen are more likely to be concealed at the back of a dingy room lit by a fluorescent strip than sitting outside bathed in glorious streaming sunlight as the romantic photographer may prefer. Being selective helps; the Venetian glassblowers on Murano Island work their rainbow coloured creations over open flame, which adds warm tones and atmosphere to an otherwise cold setting. Light streaming through high windows in a dusty factory becomes angular sheets illuminating individual cigar rollers or coppersmiths; think in terms of size and scale.

BELOW: Making the best of the light at a workshop in Minas Gerais, Brazil.

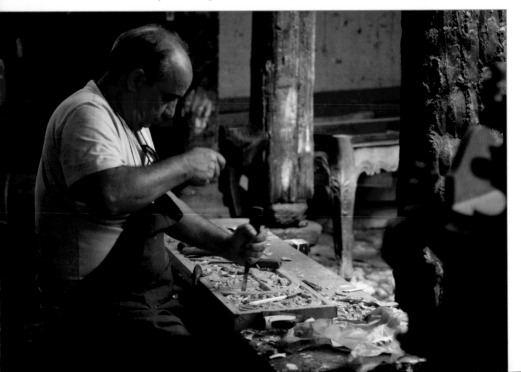

When photographing weavers at their loom – like in the cottage industries of northern Laos – try shooting through the parallel lines of thread, focusing beyond them on the artisan at work. Some off-camera flash, using a snoot extension tube to light just the worker, will leave the rest of the scene realistically dull but now imbued with an element of hidden mystery.

Thankfully, not all workplaces are drab and under-lit. The fantasy coffin makers of Ghana often make and display their creations on the street. These final resting containers are carved as elaborate fish or elephants. Some caskets honour the life and career of the deceased (a giant shoe for the cobbler), their aspirations (customised Benz limousines) or – perhaps the reason why they made it into an early grave – the beer and liquor bottle designs. A shot of the artisan lying inside one of his creations, for example, may work well.

The day's end

The rush to get home is similar to the morning commute, but faces may be happier and people may have a spring in their step. Capture an accountant as he grabs a bunch of flowers for his girl-friend at the Berlin U-Bahn or a banker hurrying to de-stress at an over-priced New York gymnasium. Some element of panning along with the subject to capture the vivacity of the moment would be an idea. The options are only as limited as your imagination and tenacity. Traffic jams occur. Emphasise them with long exposure streams of red tail-lights heading onto the freeway at dusk.

Nighttime in the city

And, of course, in some cities and cultures, the end of the workday is just the beginning of the working night. In Tokyo, salarymen pour into Roponggi District to drink at its hostess bars. Madrileños hit the tavernas and tapas bars until four in the morning. Nightclubs spark into neon life, from Topkapi Palace to Patphong Road.

Great shots can be had inside, especially if you are freed up to use the flash, but remember to either get permission from the owner first or to be very discreet using a high ISO and low-light lens. ❏

Reference ▷

Motion blur, p.102
Exposure, p.63, 108
Artificial light, p.67
Flash, p.69

BELOW:
High five at a bar in Seoul, boosted by a flash.

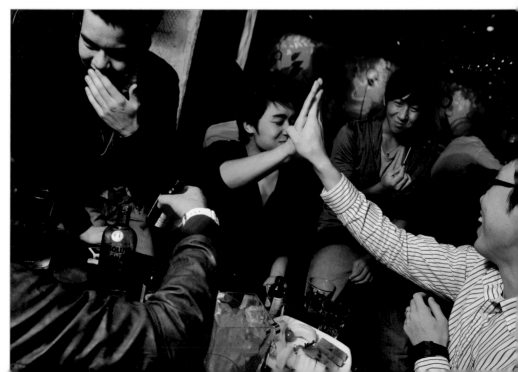

MARKETS AND BAZAARS

THE ANONYMITY of crowded places is a gift to the photographer. A video clip can fairly swiftly sum up the scene, but a six-foot tourist laden down with several thousand pounds' worth of shiny camera equipment is liable to create a stir even amid the hustle and bustle of the most hustling and bustling of markets and bazaars. Photographing markets properly means more than just a few clicks and away: they need time.

Remember the 30-minute rule: it takes half-an-hour before people begin to forget your presence. Only after this can the serious photos start to be taken. Exotic colours, Aladdin's caves, all manner of food, fabrics, kitchenware, clothes, bric-a-brac, frenetic action and haggling… all around the world these animated scenes are waiting to be snapped.

BELOW: An arresting angle from which to view these market traders in Hoi An, Vietnam.

Fish markets

The fish markets at Tokyo and Jagalchi in Busan, South Korea, are two of the best sites in Asia to view fishing fleets dock, unload, auction off and begin to gut and offer seafood for sale. They are also the best places in the world to eat fresh sashimi for breakfast.

Market traders, especially in tourist areas such as Barcelona's Boqueria, can get a bit fed up with the continuous influx of photographers who not only don't buy anything from them but also impede the arrival of customers who might. Purchasing 100 grams of olives or nuts is a small price to pay for their co-operation.

Stand off a way at first, and use a mid-range *lens*. The play of light on price tags sticking out of sacks of coffee in Saigon's Ben Tranh market makes an abstract image. Other traders will light up candles to bring good luck to the day's commerce. After catching the eye and gaining the confidence of a particular trader, move in closer and wider.

The Batik market in Solo, Indonesia, is teeming with tailors rolling up great expanses of exquisite hand-dyed cloth.

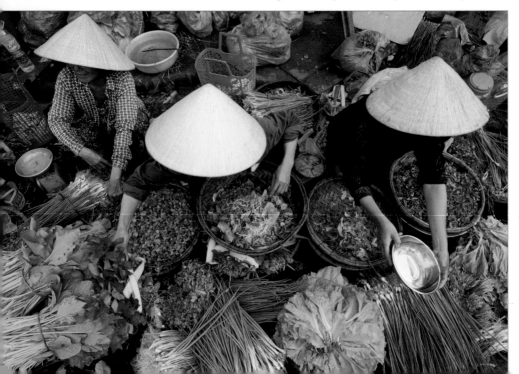

Most bazaars are divided into sections. The "wet market" area will be split between meat (sometimes "exotic" meat like dog and endangered species), fish, vegetable, fruit and spice traders. Hardware sections will include areas for cooking utensils, clothing and shoes, toys and electronics products.

Black market traders will be more evident at the fringes of a bazaar, selling knock-off watches and DVDs, ready to scarper the moment their lookouts signal the police – be careful not to be mistaken for a snooper.

Dark interiors

Often business is conducted beneath umbrellas or inside purpose-built sheds, so get used to the idea of using your flash to help bring out the colour and characters within. In cases where the interior is dark but you don't want to give your position away using a flash, you are left with two choices; a low-light lens (the 50mm f1.4 is ideal) or pushing the film speed up to a higher ISO setting.

Limitations are that the depth of field when shooting at f1.4 is very shallow and it's easy to get results where the subject moves a fraction and the whole thing is out of focus. With high film speed you'll get increased grain (noise) and contrast. These can be fine if you are looking for a certain effect, but general commercial usage prefers more fine grain images and balanced exposures.

Isolating scenes

If you are shooting in a particularly congested market, it may be best to isolate a particular area of action or person, for example someone weighing vegetables on scales in the foreground. In this case try using a very shallow *depth of field* (f1.4–2) to help draw out the individual from the crowd.

Or try panning in the general direction of crowd movement to create an atmosphere of energy and uniformity of purpose and direction. Alternatively you may desire to show the vast area and diversity of a market, in which case try a wide-angle lens, a greater depth of field (f8 and above) and shooting from a vantage point above the top of the front row. ❑

Reference ▷

Shooting angles, p.83
Panning, p.102
Flash, p.69
Depth of field, p.100, 114
Details p.241

BELOW:
Looking upwards this time, at the Thursday market on the steps of the church of Santo Thomás in Chichicastenango, Guatemala.

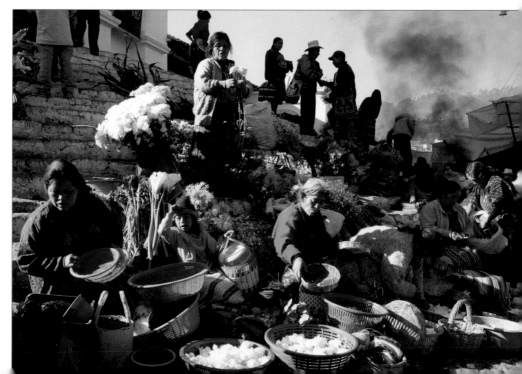

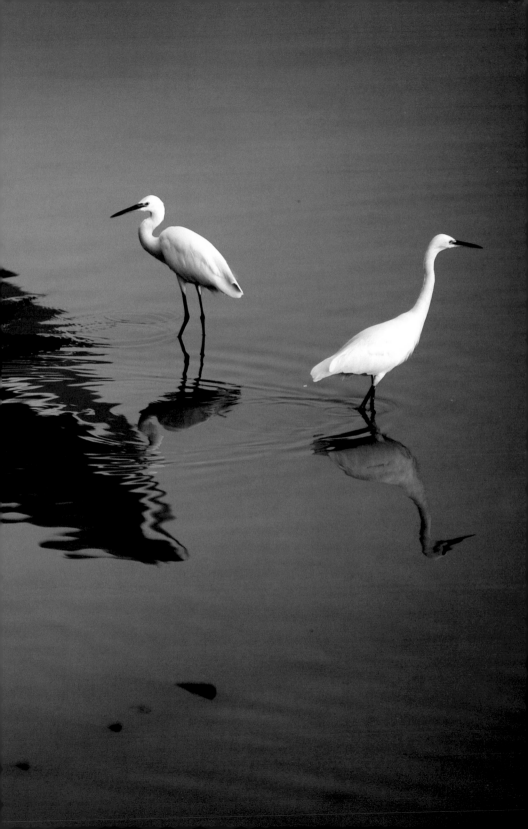

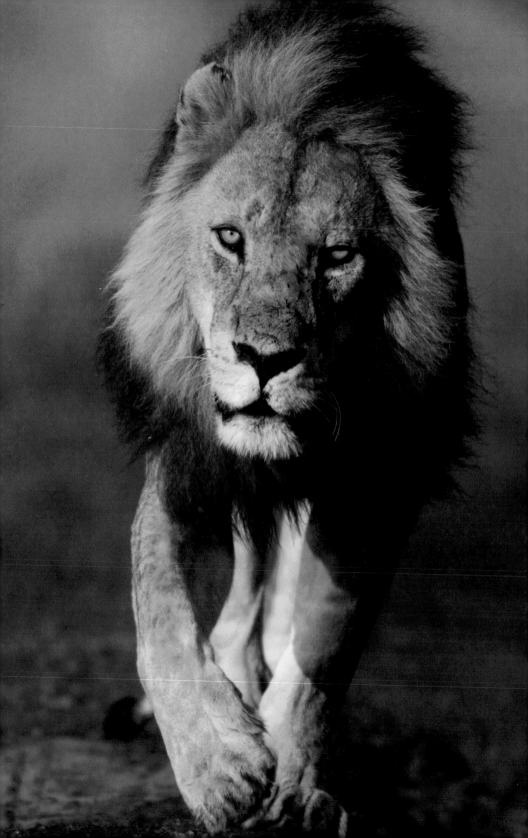

WILDLIFE

Taking pictures of big game is the dream of many travel photographers, but there are plenty of other animals in the wild to test your patience and skill

A safari in Africa or India is often a once-in-a-lifetime treat, and photography can greatly enhance the experience. But as an amateur, or even a professional new to wildlife photography, it is important to have realistic expectations. The media is saturated with beautiful wildlife images taken by specialists who spend months trying to get the ultimate shot, and nobody is likely to match those standards on a one-off holiday.

What distinguishes wildlife photography is its relatively low productivity and a need for immense patience. Wildlife moves and acts at its own pace: but if you take the time to really watch animals, rather than snapping and moving on, you'll increase your chances of getting interesting images, while enjoying a truly special encounter.

What to see where

Research your trip in advance. If general wildlife photography is your interest, Africa is undoubtedly the place to head for, with the likes of the Serengeti (Tanzania) or Masai Mara (Kenya) offering superb opportunities for novices. Winter is the best time to see the Big Five in Botswana – buffalo, elephant, leopard, lion, rhino – while South Africa, in particular Kruger National Park, is better for a

more budget-oriented DIY approach. To photograph a specific animal, you need to be more choosy. Uganda and Rwanda, for instance, are great for gorillas and other primates, India is the place to go for tigers, and Antarctica for the seasonal aggregations of Emperor penguins. There are many other places in between: brown bears in The Rockies, wolves in Yellowstone Park, Urang Utans in Borneo, sloths in Madagascar, elephants in Sri Lanka, pandas in China.

Researching behaviour patterns of specific animals will increase the odds

Main topics
ON SAFARI
LEAPING LEOPARD
BIRD PHOTOGRAPHY

PRECEDING PAGES: Egrets in Danshui harbour, Taiwan. **LEFT:** Lion of the Serengeti.
RIGHT: Chimpanzee with baby in the Gombe Stream National Park, Tanzania.

Reference ▷

Lenses, p.113
Memory card, p.294-6

of getting good action photographs. At what time of day is the animal most active? Read about typical social interaction, pack behaviour, courtship and mating. Be conscious of seasonal factors, too. In much of Africa wildlife photography is most rewarding in the dry winter months, when the vegetation is lower and animals tend to congregate around water, though late winter also comes with a higher chance of hazy skies and large tracts of ugly blackened grass as a result of bushfires. Check at what time of year animals are denning or engaging in other photogenic behaviour – there are few more impressive sights, for example, than the river crossings associated with the wildebeest of the Serengeti-Mara.

Patience required

Dedicated wildlife photographers might shoot hundreds of images as a sighting evolves. Imagine you spot a wild dog lying in the shade and stop to take a few photos, You keep clicking away as it walks around a bit, stops somewhere to drink, and is then joined by some other pack members. The photographic opportunities come hard and fast as

different individuals greet each other, then the whole pack sets off in search of food, with younger ones stopping to play along the way. A sighting like this might take up an entire afternoon.

Your footprint

You have to push yourself to get the desired results: get up long before dawn, stay out until after sunset, and do whatever it takes to capture action that might never happen – such as lying for hours in the mud or frying in the sun to get that perfect low-angle shot. And as with any demanding activity, it is tempting to take short cuts or push the situation to get a good result. In such circumstances, it is important to consider the consequences of our actions. Situations that come to mind include the impact a pushy photographer might have on denning animals (if adults are pressured to move den too early, it can lead to death for their young), or on the activity of diurnal hunters such as cheetah, or of blinding vulnerable antelopes with spotlights on night safaris. Capturing the beauty of wildlife in wild places is a great privilege, and at all times our footprint should remain minimal. ❏

Equipment and Logistics

Wildlife photography is an expensive pastime. This is because most animals are difficult to approach closely, and must be photographed from a distance using costly high-magnitude telephoto lenses. Aside from a decent high resolution digital SLR, you'll need at least two zoom lenses, for instance a wide-angle 24–70mm (17–24mm for DX sensors) and a 70–300mm telephoto. Where possible it is worth carrying a longer fixed lens of 400, 500 or even 600mm. A more affordable compromise is a 1.4 or 2x convertor, which will boost the capacity of your longest lens, but with significant loss of clarity and shutter speed.

To capture a sharp image of a moving animal, you need a high shutter speed, which in turn requires plenty of ambient light. Somewhat contradictorily, the most beautiful time for wildlife photography is early morning and late afternoon, when the light is at its lowest. To address this paradox, your telephoto lenses should be as "fast" as possible, which means a lowest f stop of 4 or better still 2.8. Unfortunately, fast long lenses are more expensive than slower lenses of comparable magnitude, so those on a

limited budget will probably have to make do with a lowest f stop of 5.6 or higher. Most long lenses are also too bulky and heavy to use without support – a large beanbag is ideal for shooting from a vehicle, but a tripod or monopod works better on foot.

Making conscious decisions about aperture and shutter speed – which dictate depth of field, as well as the capacity to freeze action – will greatly improve your photographs. Use the "aperture priority" setting, assuming your camera has one, to adjust these settings quickly according to the situation. A wide range of point-and-shoot cameras with superzoom and reasonably high resolution is available, but these aren't an attractive alternative to an SLR for keen wildlife photographers, due to the inferior quality at high magnification, and lack of control.

Lots of images require lots of memory capacity, ideally in the form of 8 to16Gb cards, which you'll seldom need to change in the heat of the action. But don't load all your adventures on to the one card – spread them among several cards for security's sake.

ON SAFARI

EARLY MORNING and late afternoon are ideal for wildlife photography, when there is a richly saturated golden light. This is also when animal activity peaks. Nocturnal animals still roam around after dawn, while cubs and pups are at their most playful, and grazers most visible, while predators often hunt towards dusk.

Early start

So it is best to start photographing in the early morning, take a midday break to rest and download or review images, then head out again in the mid-afternoon, returning after sunset. One exception is in heavily overcast weather, when the light is generally better in the middle of the day. And while overcast weather is usually too flat for big scenes, it can be good for portraits and macro photography, as the clouds create a soft-box effect to bring out intimate detail.

As a rule of thumb, photograph wildlife with the sun behind you, especially when it's high in the sky. In the early morning or late afternoon, however, you can play with more interesting options, backlighting the subject to create a rim-lit effect, or sidelighting it for additional texture and dramatic portraits.

Game drives

Wildlife photography is usually easiest from a vehicle, which functions as a moving hide in the places where animals are used to cars but unused to pedestrians. As with any hide, it is important to keep your voice down around animals, and to keep your body within the car. When approaching a subject, respect the distance it is comfortable with: instead of tailing and possibly harassing it, try to anticipate its next move and circle wide ahead of it. This way, the animal may approach closer than it would otherwise, and you get to fill the viewfinder

BELOW:
Dawn in the Mara – time to stop and take in the colour while on safari.

not with a retreating rump but with an animal walking headfirst towards the camera.

Unless you are looking for a special effect, the camera should be roughly at eye level with its subject. Where you have the choice, shooting through a window generally works better than from an open roof, unless the animal is very tall or where you are below the subject on a sharp slope. Increased distance will also flatten (i.e. improve) the angle, so try to park as far from your subject as lens capacity permits.

Game walks

Game walks cover less ground than drives, and because animals usually fear pedestrians more than cars, and large lenses are difficult to carry by hand, they tend to be less productive.

That said, the only way to approach forest dwellers such as Madagascan lemurs and great apes of Africa and Asia is on foot.

In such circumstances, a monopod or tripod is all but essential, and a lens with vibration reduction (image stabiliser) will be a huge asset. Game walks

are also good for macro photography of smaller animals such as frogs, chameleons and spiders.

Using flash

Most nocturnal animals can be photographed at night only, requiring a *flash*. Though cumbersome, hold the flash off camera, to eliminate an ugly "red-eye" effect. Built-in red-eye reduction facilities are less effective, and require a pre-flash that often prompts the animal to move before the shutter opens. It is best to avoid nocturnal photography of diurnal wildlife.

A flash can enhance daytime photography. In heavily contrasting light, for instance when an animal lies in the shade to avoid the midday sun, some *fill-in flash* can hugely improve the picture. And at dusk or dawn, slow or rear-curtain flash can be used to freeze and light the subject at a shutter speed slow enough to capture the red or purple tint in the sky.

Portraits

Animals, like people, have expressive faces, and you can have fun shooting

BELOW: Zebra at a watering hole.

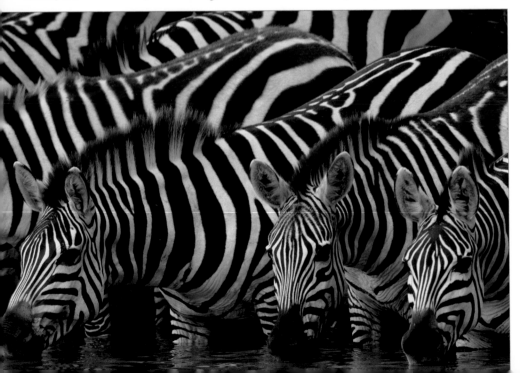

many different expressions from a single animal, particularly primates and predators. A strong portrait is usually free of clutter and has an unobtrusive out-of-focus background, obtained with a low ƒstop (between 2.8 and 5.6, depending on circumstances).

A sense of intimate eye contact can make or break a portrait: try to photograph your subject at eye-level, to use the eyes as the focusing point (rather than, say, the snout or forehead), and to click the shutter when the head is positioned so that a glint brings them to life.

Including the environment

When a photographer handles his first telephoto lens, the temptation is to zoom in as close as possible on the animal, and to ignore other compositional considerations. But pictures showing something of an animal's environment – a giraffe feeding on an acacia, a herd of elephants walking below Kilimanjaro, or a bear drinking at a stream – can often hold more interest than a portrait cropped so close that it could have been taken in a zoo.

Nevertheless, the maxim "when it doesn't add anything, leave it out," holds as true for wildlife as for any other photographic discipline, so when you do include an environmental feature in the image, make sure it adds to the composition. If, for instance, the highest magnification enforces you to include half a tree in the frame, you might be better off zooming back to include the whole tree.

The key is to look at the image as a whole, rather than just the main subject, before you press the shutter. And after taking a few shots, check the result on your camera screen, in case there is a disturbing element that can easily be dealt with by reframing and reshooting.

Action and behaviour

Patience, anticipation and luck all factor in when it comes to obtaining the ultimate wildlife photograph, depicting action, interaction or behaviour.

Should you come across animals in a promising setting, there will usually be some immediate images to be taken – portraits, maybe, or a framing showing

Reference ▷

Flash, p.69
Monopod, tripod, p.295
Portraits, p.206
Rule of thirds, p.78

BELOW: Maasai giraffe in the Serengeti, adroitly following the *Rule of Thirds* as it walks into the larger space in front of an umbrella tree.

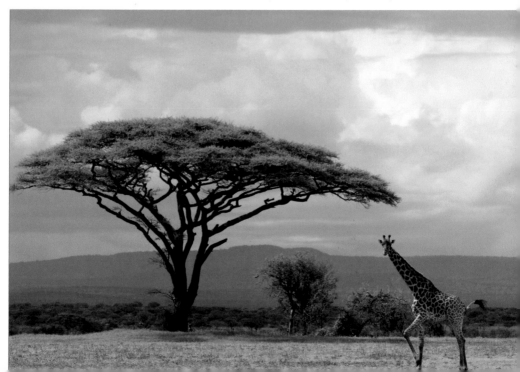

Leaping Leopard

Ariadne van Zandbergen describes a highpoint in her career as a wildlife photographer

Because wildlife photography is so demanding, and the best results so stunning, it is one of the most prestigious areas of photography. The BBC's Wildlife Photographer of the Year competition attracts thousands of entries and thousands of visitors queue to see the results at the Natural History Museum in London's South Kensington every year. There are several categories, including the Young Wildlife Photographer of the Year, and the prize for the overall winner, for what may be many years' patience, is £10,000.

Ariadne van Zandbergen, who has been photographing wildlife since 2000, describes what it's like finally to get a potential prize-winning shot:

"As a wildlife photographer, I'm of the opinion that a beautiful image of a dung beetle or antelope is worth ten times more than a bad shot of a shy leopard or endangered mountain gorilla. At least that's what I kept saying to myself when, after years of photography in the African bush, I'd yet to be able to get any half-decent shot of Africa's most elusive large cat: the leopard. Yes, there are places where these usually shy animals have been habituated to the point where they virtually walk up to vehicles, but they are exclusive and very expensive, and I hadn't been fortunate enough to visit them.

"My luck started to change one evening in the Serengeti National Park, when I spotted a beautiful female leopard at dusk. The initial sighting presented several problems: the light was very low, and the leopard was sitting far away on some rocks – too far away to frame decently or for flash photography. Aside from that, driving times in Serengeti are very strict, and I had to get back to camp. But the next morning at dawn, I headed back to the rock and scanned the same area to pick up a sign of this creature. And there she was, sitting on the other side of the same rocky hill. This time, I did get some shots, but the light was wrong, and the leopard was half obscured by some branches.

"After lunch, I returned to the same spot and found about 15 vehicles next to a gully nearby. I realised that my leopard had moved nearer to the road, where she was keeping low in a gully. I didn't feel like joining the other cars, which lay bumper to bumper, just to maybe see some spots through the foliage. Instead, I took an optimistic guess, and headed to a perfect 'leopard tree' standing alone in grassland about 300m from where the leopard was hiding, positioning myself at the perfect angle from the sun, and the ideal distance for my 600mm/f4 fixed lens.

"The sun sank lower in the sky, and more and more cars left what had thus far been a somewhat mediocre leopard sighting. About 40 minutes before sunset, mine was the only car left, and my optimism was fading. Another 15 minutes passed, and my leopard abruptly emerged from the gully, taking no notice of me as she walked towards the tree, stopping to look around several times, but never diverting from her path.

"After another 10 minutes, she stood in front of the tree, and I sat poised for action as she looked up, as if deciding whether to go up or not. Then without any warning, she made the leap, and I managed to capture a classic image of a climbing leopard. I couldn't believe my luck, but sometimes things just come together like that – payback, I suppose, for all the times when things haven't worked out so neatly." ❑

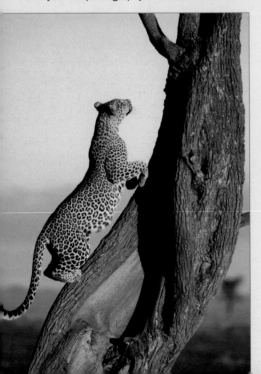

LEFT: Spot on: patience is rewarded with a leap.

a group of animals in its environment. But having taken these, ask yourself whether the setting and overall situation promises something more, and if so, sit, wait and be ready – it never hurts to be optimistic, and sooner or later you'll get lucky.

Anticipating the scene

In some circumstances, you might easily anticipate what will happen. An alert cheetah watching a distant herd of gazelle might suddenly get up to stalk its prey, a lion and lioness lying in isolation from the rest of the pride are almost certainly mating – a predictable process that typically endures for three days, with copulation occurring every 20 minutes. Elephants walking in the direction of standing water might well stop there to drink or play, while young jackals peeking out shyly from a den might relax and come out when their parents arrive with food.

Once you acquire the patience, you will find that a photography session is often more productive when you wait for a promising sighting to develop further than when you keep chasing around in search of something else. When waiting to photograph action, be prepared to *capture the moment*. Set your camera at a high *shutter speed* to freeze movement, and if necessary, push up the *ISO* for extra speed. Each instance of lion copulation, for instance, lasts for perhaps one minute and is proceeded by a flurry of growling, snarling and position changing, making it essential to line up afresh for every bout – and you might need a dozen tries to get the perfect shot.

Following the chase

Likewise, if you're waiting for a chase, or watching animals walk towards water, try to anticipate the next move and to position yourself accordingly.

An interesting technique for capturing a fast moving animal is *panning*, where you move your camera in a fluid motion together with the subject while you press the shutter at slower speed, so that it stays in focus but the background is blurred. Panning takes a lot of practice and some luck, so set your camera on motor and shoot away to get the one winner. ❏

Reference ▷

The moment, p.92
Shutter speed, p.233
ISO sensitivity, p.103
Panning, p.102

BELOW:
Wildebeest leap into the Mara River, Kenya.

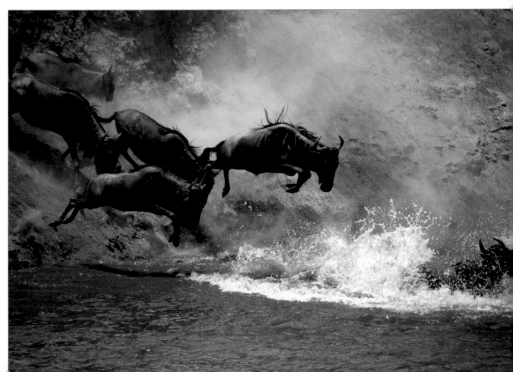

BIRD PHOTOGRAPHY

TRAVEL PHOTOGRAPHERS will feel happy if they get lucky and snap a colourful bird along the way – a brilliant bee-eater on a wire, a hoopoe among the pines, a macaw in a tropical canopy, a hummingbird feeding on a hibiscus flower. At best these are soft images, or distant blurs that need all the help a computer can later offer.

But if you are serious about taking bird pictures – particularly if you are going to an area known for its birdlife, such as the tropics, or areas of spring and autumn migration – you should consider your equipment. Ideally, you will have a DSLR with a "continuous focus mode". This continually changes the *auto focus* when you half press the shutter and it is particularly useful for following a bird in flight, as is a high-speed drive mode. A 400mm lens is the starting point for serious bird pictures, with an *f*stop as fast as you can afford. You should be able to push the shutter speed up to ISO 1000 to freeze any

BELOW: Flamingos glowing in the "golden light" of the afternoon.

movement. A monopod will keep the camera still – particularly important if you have a long lens – and if you are driving, you might consider some kind of clamp that will keep the camera resting on an open window.

Dawn and dusk are when birds are at their most active, and many birds are invisible for the best part of the day.

Open country

In open country, ground birds like plovers and francolins are problematic to photograph from a car, as the downward angle is too sharp.

Good subjects for a general approach are the brilliant bee-eaters that habitually perch at the top of shrubs. They often hawk from a branch or wire to which they repeatedly return, allowing you time to set up at the right distance and angle, and wait. Bee-eaters are members of the photogenic Coraciiformes passerines that include the beautiful roller birds, handsome hoopoes and the lovely kingfisher

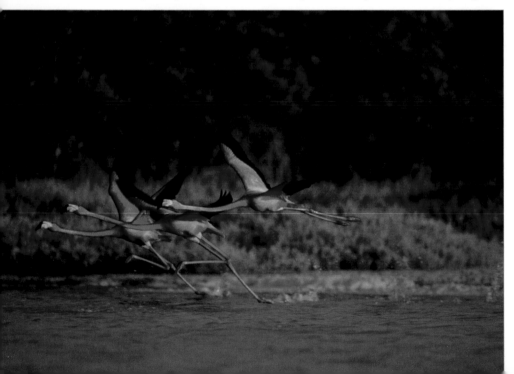

family, which populate the world in dozens of guises – you can't miss the pied kingfishers on a Nile cruise.

Birds of prey

Raptors in flight are the stars of bird life, though capturing them in crisp images is not easy: continuous focus and high ISO helps, and it has to be spot-on. The dark figure in the bright sky is less of a problem in high mountains, such as the Andes and Himalayas, where you can find yourself on a level with, or above, the circling condors and eagles.

Pine and temperate forest

By contrast, forest birds are generally difficult to photograph. The light is low and though the camera has fewer contrast problems to deal with, you seldom get a protracted view through the foliage. Temperate forest birds are not easy to spot, and when you do see them, they are often far away and high in the trees, giving an unflattering angle with the belly aimed towards camera. Be patient, listen for birdsong, and wait for the sudden appearance of a woodpecker from behind a tree,

the arrival of a flock of tits, or the tiny tweet of a goldcrest or firecrest.

Tropical forests

The vibrant colours of tropical birds, often easily found because of their loud calls, make them irresistable subjects, though they, too, can present problems when photographing from beneath. But even if the setting is awkard, by picturing them in their setting, allowing their habitat to show around them, you will at least prove that you haven't cheated and taken the pictures in an aviary or zoo.

Migrations

Far more promising are flocks of migrant and water-associated birds, such as the colourful flamingos and charismatic pelicans that gather around lakes and lagoons. These can make wonderful patterns of colour.

Spring and summer migrations also provide subjects, particularly when the birds have to cross stretches of water, such as the Bosphorus and the Straits of Gibraltar, arriving tired, static and ready to be snapped on the far shores. ❏

Reference ▷

Light & Time p.57
Focus, p.104
ISO sensitivity, p.110
Mountains, p.137
Flat landscapes, p.141
Rivers & Lakes, p.142
Forest & Foliage, p.148

BELOW:
Birds sharing a boat on the Casamance river, Senegal.

CLOSE UP AND MACRO

The minutiae of nature produce a weird and wonderful world of colour. Whether you go looking for it or stumble on it by chance, you should be prepared to get in as close as you can

Macro photography goes beyond close-ups, making images life-size or larger. It takes patience and perhaps some extra equipment (see opposite), the subjects are not always easily spotted, and often refuse to stay still while you line up your shot. Practise around the garden first, or in the grounds of your hotel.

Lighting is not always easy and conditions will vary enormously. Many insects and small animals like to bask in the sun, but others stay out of sight and are well camouflaged. Most wildlife is least active when the sun is strongest but bright sun and deep shadows also need dealing with. Sometimes it is better when the light is more even, towards the beginning and end of the day. While there is still dew around, many insects' wings are too heavy to fly, and are easier to photograph, while evening is a time for activity, when, for example, the scarab beetle digs in for the night.

Depth of field is important in extracting subjects from their surroundings and for giving them a three-dimensional quality. A fast shutter speed of around 200 will also help reduce any movement – the gentlest of breezes can make leaves flutter and antennae tremble. A tripod can be useful, but unless you plan to stake out a spot for any length of time, it may get in the way. Focus can be tricky, picking out, within a few millimetres, the point you want sharpest. Choosing one spot to focus on helps reduce the depth of field.

You will never be short of subjects: there are more than a million known species of insects alone. You should always be prepared for the sudden appearance of a gecko, toad, spider or moth, and you might even start to see cockroaches and bed bugs in a more positive light.

ABOVE: A great green bush cricket on a fern. By opening up the lens, the depth of field is reduced to a minumum, so that the insect stands out strongly against indistinguishable, neutral background.

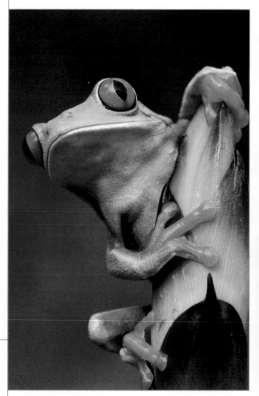

ABOVE: There's nothing like a red-eyed tree frog for getting good eye contact! It is hard to believe there can be so many colours in just one small creature.

LEFT: Butterflies like this Eastern Tiger Swallowtail, make lovely subjects, and obligingly like to open their wings and bask in the sun.

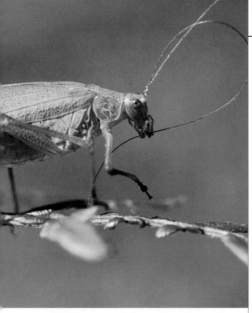

ABOVE: Leaves are one of nature's most abundant, and most endlessly interesting gifts. Backlit, this golden specimen shows the veins in detail, like the palm of a worn hand.

BELOW: This fly and a specimen of Passiflora phoenicea (Red Passion Vine) in Butterfly World, Fort Lauderdale, make a good double.

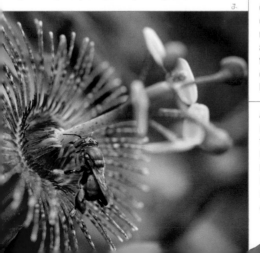

FOR THE BEST RESULTS

Because zoom lenses and many compact cameras have macro settings, a specialist macro lens is not always necessary. But general purpose lenses with a "macro facility" offer an inferior ratio to a dedicated macro lens on an SLR, which will usually have a reproduction ratio of 1:1 at the minimum focusing distance. Few lenses offer better than 1:1, but a 1.4x or 2x converter will increase the image size proportionately without loss of focusing distance. A dedicated macro lens will not only let you get staggeringly close but will also provide bitingly sharp results.

Macro lenses come in different lengths. A common length for studio work is 55mm, but a telephoto macro lens (105mm, for example) is better for wildlife, as you can work further away from the subject, which means that you are less likely to disturb it. If you are dedicating some time to macro work, a tripod is also invaluable.

Macro work requires depth of field and sufficient speed to freeze movement, so you need plenty of light. A reflector can't be beaten in terms of cost and ease of use, but the holy grail is a ring flash, which produces even light from a circular shaped flash tube. A straight ring flash is good for detail, but tends to give slightly boring and one-dimensional results. A more expensive ring flash is independently adjustable on two sides. Better still is a wireless macro flash system comprising independent mini-flashes, and capable of offering any combination of back, side or ring lighting.

ABOVE: Shallow depth of field picks out this Beavertail cactus flower at Joshua Tree National Park, California.
RIGHT: Direct flash on ladybirds (one of them might not be a lady) emphasises their shape.

DETAILS AND CLOSE-UPS

However good your photographs, they will benefit from a change of pace. The best way to achieve this is to ensure your shoot has details and close-ups that bring a different focus to your work

Professional photographers whose work is destined for publication as picture stories learn one thing very quickly, which is to give the art director a varied choice of image framing and image scale. The same thing applies in the non-professional world of photography for pleasure.

When photographs are presented together, in sequence or side by side, the viewer's eye wants changes of pace, otherwise a sequence of pictures, however good, can look boring. If you take most of your photographs at a 'normal' scale with both a middle ground and background and from a similar angle of view, they will lose impact if you show them together, such as in a slide show. Intersperse them with details, however, and you can liven up the visual experience. Above all, on the principle that less is more, detail can sometimes capture aspects of culture more aptly than can a wider view, and it does this by focusing the attention of both photographer and viewer more strongly.

Spotting details is simply a matter of getting used to having the smaller picture at the back of your mind. Subjects are all around you, and it is just a matter of looking at your surroundings at that particular scale – a commuter's hand gripped to a hanging strap, a puddle on a mountain pass. A memorable cover photograph by Don McCullin from El Salvador was simply two thumbs tied together behind a captured guerilla's back.

Learn to switch your frame of view from wide-angle to close-up – and remember to look up and look down, as by no means all details are at the level of your eyes. Of course you can always look for detail afterwards, cropping in close on details of pictures that you have already taken, but it's better to get it right from the start. ❏

Main topics
EVERYDAY DETAIL
ARTISTIC DETAIL

PRECEDING PAGES: Colourful South African baskets on sale in Cape Town. **LEFT:** Some Chinese New Year merchandise. **RIGHT:** At the herbal medicine market in Seoul.

EVERYDAY DETAIL

OFTEN, IT'S THE ordinary that spells out the cultural difference; what we all take for granted but is in fact distinct from the way other people do it. Something as simple as a table setting can be quite eloquent – a South Indian vegetarian thali clearly intended to be eaten by hand (even more so, food served directly onto a banana leaf), or Chinese dim sum, or a Japanese bento, or a few empty tinnies beside a barbecue in Australia.

A sense of place

Just by picking on a small object, you can sum up the atmosphere of a location: old brass plates on a bank in the City of London, a cafe au lait in a French zinc bar, bird cages hanging in a park in Chinese communities, mint leaves left in a glass of tea in North Africa, a pack of metal boules on a seat bench on the Côte d'Azur, stirrups on a stable door in Argentina, fishing nets and lobster pots on a the quayside of a Brittany port.

Look also for the mundane, such as peeling posters on a wall, and for the ambiguous, such as almost any view in a mirror.

Shops and markets

Markets, particularly open-air ones, offer endless variety of detail for all kinds of product. It might be a stall selling cheap plastic toys in China, or stainless steel pots and pans in India, boxes of lavender on France's Mediterranean coast, or freshly caught fish in the Caribbean.

This kind of shot, as the example of from the herbal medicine market on the previous page illustrates, usually work best when you close right in to exclude the surroundings. You can find patterns in trays of fruit and vegetables, images that are pure colour in an Indian spice market, or naturally composed still-lifes of freshly-caught fish with weighing scales, provided that your subject bleeds to the edges of the frame.

BELOW: The wine, newspaper, bar and stools immediately suggest France.

Most camera *lenses* will focus down to the necessary for subject areas that are typically less than half a metre across. Tight framing nearly always makes the difference.

Look especially for things that you don't find at home. For example, the red powder made from turmeric and lime for sale in Indian markets for marking the forehead with a tilaka, or dried lotus flowers in Egypt.

Shop windows can provide a further feel for a foreign place, particularly clothes shops, including hat shops, where the local attire is for sale. Photographing through glass is never easy, but go with the flow – include your own reflection in the corner of image to show you were there. The shops themselves may have interesting details: lamps and tiling, display cabinets and shelves, perhaps stacked with colourful, graphic bolts of cloth.

Hands on

There are also details in *people*, and while you might think that pushing in close for a view of a body part would just be too embarrassing, hands are accessible and easy. If you have already got to the stage of being able to photograph someone at an activity, it is completely acceptable to focus on their hands at work.

This might be a local craftsman at work, or a fisherman mending a net, or even a market trader whom you ask to hold up some wares.

For some reason, hands are never considered personal and private in the way that a face is, or even feet. And hands can be revealing, of the person and of the culture, particularly if they are doing something. Sometimes the hand will have rings, or the wrist bangles and beads. It may be bedecked with jewellery, such as at an Indian wedding, or a Tibetan with coral and turquoise saddle rings, or a Middle Eastern woman with a henna pattern.

Natural subjects

Nature does not exist only in the wild. There are cobwebs in urban environments, caged birds and flowers on window ledges, feral cats, and domesticated dogs that are often peculiar to the country. Check the pet shop to see what else people keep in their homes. ❑

Reference ▷

People at work, p.218
Markets/bazaars, p.222
Lenses p.113
Macro, p.236

BELOW:
Hands at work make an easy subject – here setting gems in Sri Lanka.

Using the Right Lens

Regular camera lenses are designed to work at normal shooting distances, and perform less well in close-up, which is why there is a limit to the nearest focus. Some lenses have a setting that allows you to focus closer, while compact cameras often have a simple "flower" icon that does the same thing. Magnification (expressed as 2X, 1.5X and so on) and reproduction ratio (expressed as 1:10, 2:1, etcetera are the usual ways of describing the degree of close-up imagery, and same-size (1X or 1:1) is the point at which close-up photography becomes photomacrography, or "macro". If you are especially interested in these very close ranges, consider buying a dedicated macro lens, which will give its best image quality and sharpness very close.

ARTISTIC DETAIL

ONE OF THE richest sources of detailed imagery is arts and crafts, which can provide the most graphic images. With them comes the man-made detailing of signage and architectural detail, images which can often stand alone.

When decorative details in architecture are at eye-level, shooting is simple: ideally approach them head-on so that you maximise the depth of field and, if they have pronounced verticals in the design, you also avoid *keystoning*. Use a fairly small aperture setting, also for good *depth of field*, as artistic details tend to look their best when everything is completely sharp and in focus.

Many architectural details, however, are well above eye-level, and for these, the reliable method is to step back and use your longest focal length len. The gamut of possibilities runs wide: Islamic tiles at the Alhambra or an Isfahan mosque, gar-

BELOW: Islamic tiles in Khiva, Uzbekistan.

goyles and sculpted saints on a European cathedral, Art Nouveau details on a Brussels house of the period, pietra dura inlay work at the Taj Mahal, cast iron decorative railings in New Orleans, gilded lacquer door details at the entrance to a Bangkok temple. You could also consider collecting themes, slowly building up a diverse library during your travels. For instance, the symbolism of the eye, which is universal, warding off evil. It is used huge on the great stupa at Swayambhunath, as protection on a Balinese outrigged prahu, as part of a massive video display at a Tokyo intersection. The blue nazar of Turkey (Masti in Greece) predates Islam as an amulet, and the Hamsa, an eye in a hand, can be found across North Africa.

Festive detail

When you come across a special occasion, such as a festival, continue to look

in detail. At an elephant festival in Jaipur, India, for example, the animals are elaborately painted and bedecked, but after photographing them all in procession with their mahouts, what about closing right in on an eye for an unusual and highly colourful detail that will cause a double-take in a viewer. And then you could add that to your "eye" collection.

Graphics

Calligraphy, sign writing and other man-made graphics are all redolent of place. Mis-spelled or nonsensical signs are often humorous. The language itself, especially if not written in Roman script, immediately conveys the part of the world you are in. Ideographic characters as in Chinese and Japanese Kanji can be rewarding subjects, not just because of their pictorial quality but because they are deliberately treated with more visual variety than are most scripts.

In Arabic countries, where life forms are not supposed to be represented, calligraphy is a high art. Look for professional calligraphists applying their craft – in Egypt, too, where artists will spell your name on a papyrus reed using ancient hieroglyphics.

Posters and display advertising can also be rewarding: many Indian movie posters, justly famous, are hand-painted; west African barber shop signs with hand-drawn hairstyles; neon restaurant signs competing with each other in a narrow Shanghai street. As well as closing in on these, look for contrasts that they may make with passers-by: the blonde Western woman advertising shampoo in a country where everyone has dark hair.

Abstraction

One further photographic possibility in close-up is to make *abstract* images by careful selection and cropping. Photographing detail already calls for a willingness to look at things with a different sense of scale from usual, and a step beyond this is to look within the detail for unusual or graphic compositions. Meaning and intelligibility are less important here than shape, pattern and colour, which you can find even in peeling paint or an old wall. ❏

Reference ▷

Keystoning, p.83
Depth of field, p.100, 114
Cityscapes, p.180
Abstract, p.162

BELOW: A close-up of a decorated elephant in Jaipur, India – add it to your eye collection.

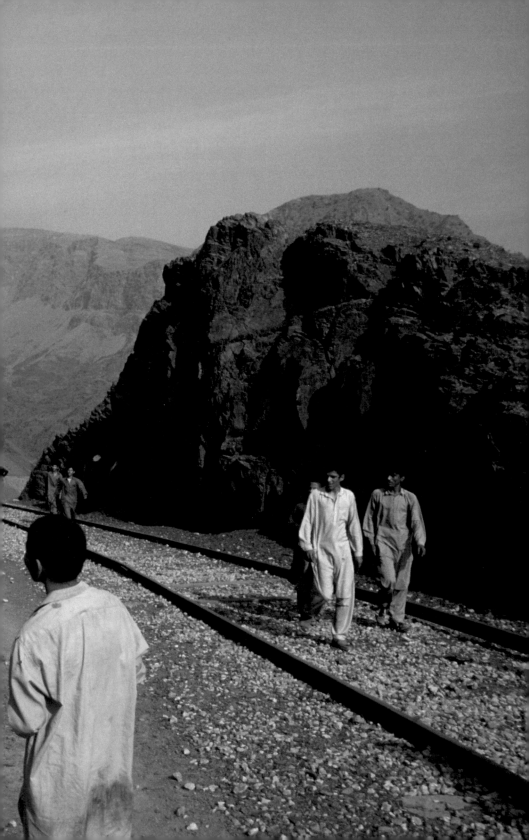

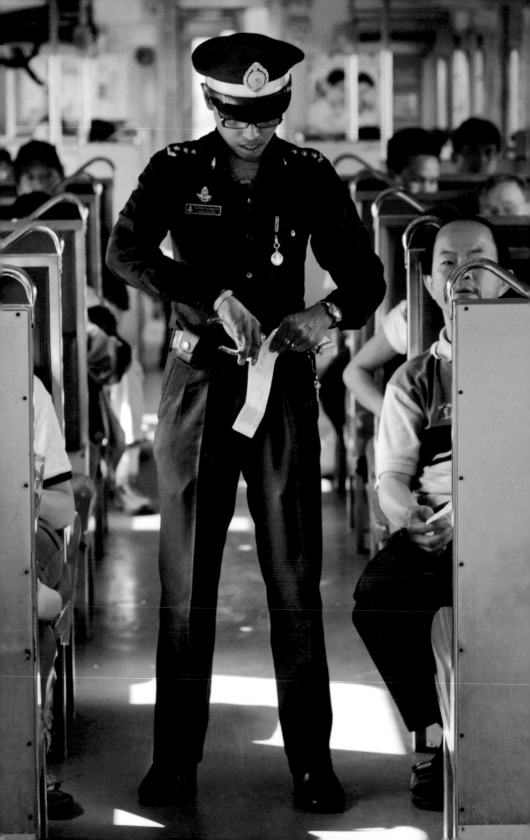

TRANSPORT

Planes and boats, trains and buses, bikes and cars: the vehicles that get travel photographers from place to place also provide a vital link in the tale that's to be told

Reaching your destination, and travelling between destinations, is a major part of the journey, but in photographic terms it is often neglected in favout of the eventual sites. But here is a great opportunity for a picture story, to stand alone or be a part of your journey project.

Journey photographs can be broken down into four kinds: the boarding scene, the vehicle, life on board, and views the transport offers.

Boarding scenes may start from home, and can be bus stations, railway stations, the quayside. Once abroad, they are often an occasion for great activity, from Indian porters carrying luggage on their heads to Burmese stevedores stripped to the waist ready to load fifty-kilo sacks of rice onto an Irrawaddy ferry. They can also be the occasion for theft and black market trading. This is the time also to consider having a picture or two taken with you in the frame.

Second, your transport itself may be worthy of attention, and you don't have to be a trainspotter to appreciate the sleek aerodynamics of a high-speed shinkansen pulling into a Tokyo station, while local buses in some countries, especially in Africa, South America and the Indian sub-continent, may have idiosyncratic paint-jobs and decoration.

Life on board is the third genre of journey photograph, with the greatest freedom of choice going to boats with freedom to move around. Trains and buses often offer adventure and interest among the passengers and stops allow vendors to offer their wares.

Finally, consider the passing scenes to photograph from your vehicle; one advantage is that you have an elevated view, on a lofty ship or bus, or on a train travelling through countryside and along coasts that are often hidden from the roads. ❏

Main topics
MODES OF TRANSPORT
AERIAL PHOTOGRAPHY

PRECEDING PAGES: A fascination for steam – up the Khyber Pass. **LEFT:** The ticket collector. **RIGHT:** Transport in Antigua, Guatemala.

MODES OF TRANSPORT

WHILE FOR SHEER photographic convenience there is nothing to beat the admittedly expensive option of hiring your own vehicle (*with* driver is always recommended), public road transport offers a dual choice: pictures *from* and pictures *of*.

Worldwide, buses are most frequently the traveller's friend, and while the slick variety with reclining seats and video may not be conducive to photography, local buses in many parts of the world can be eventful and full of atmosphere. When your bus starts to fill up with locals, the compensation for not being able to spread your legs is that you have acquired a crowd of companions to photograph. Overcome awkwardness at photographing strangers in confined surroundings by first striking up a conversation.

If at first you feel less than enthusiastic about taking that rickety-but-colourful beaten-up Colombian bus heading out of a market town up a

BELOW: View from the train. It's good to include some of the train as well, as here aboard the Calicut express.

dodgy mountain road, especially as it is creaking beneath the weight of passengers and lugagge, reflect that it can make a great shot being loaded up, with a wide-angle lens, or from a distance up the road with a telephoto.

Trains

Railways inspire more enthusiasm than most other kinds of transport, and they can certainly be photogenic. With space and time to walk through the carriages, look for slices of life, particularly on local trains in out-of-the-way places.

Each country has its own particular style, from a Bolivian train carrying Quechua women to the weekly market, or the slow train from Bangkok to Hua Hin, and good-natured photography is usually tolerated provided that you don't poke the camera too obtrusively into people's faces.

Look for vendors selling food and sweets, the ticket collector on his or

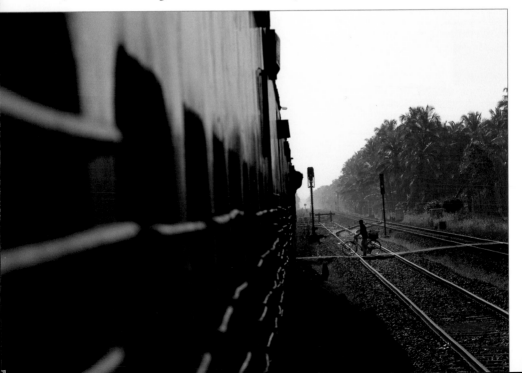

her rounds. Trains in India are always an event, with illegal peddlars and people riding on the outside of carriages.

If you photograph from the train, the movement may suggest a high shutter speed to counter camera shake, but equally the streaking motion blur of the landscape passing by with a slower shutter speed such as 1/30sec might be convey the sense of speed better. Try also stepping back to include part of the train in shot, such as the window frame or a passenger looking out.

At halts and railway stations there are further photo opportunities, although some countries have restrictions on photography here, particularly if you appear to be doing it intensively and professionally.

A major terminus like Chhatrapati Shivaji in Mumbai (formerly Victoria terminus) can provide a whole picture story, with period architecture and crowds of dabbawalas delivering lunchboxes to city workers from their suburban homes.

Heritage railways are a great source of material for shooting, and all over the world are becoming a part of the tourist infrastructure. They include the Darjeeling Himalayan Railway, nick-named the "Toy Train", the Eastern and Orient Express between Singapore and Bangkok, the North Yorkshire Moors Railway, featured in the Harry Potter films, and the Cuzco and Machu Picchu Railway.

Sleeper trains are always evocative, from the Transiberian Express, where a detail of a samovar or the panelled car interiors provide quality images, while Canadian Pacific runs special train breaks that take you into the wilds.

It is worth staking out viewpoints for photographing from a distance, such as bridges or bends in the track. A head-on view with a telephoto lens is usually effective, particularly with a steam engine billowing smoke.

Boats

Water transport is more varied than land vehicles, from canoes to lake steamers, inter-island ferries and cruise ships. They can also take you places otherwise hard to access. A boatman, for example, at one of Varanasi's ghats will give you views of

Reference ▷

People, p.205
Motion blur, p.102
Viewpoint, p.83

BELOW: Life on the water in the Mekong Delta.

Exotic Transport

Some countries, even some towns, have exotic vehicles that make good photographs. Many places have remained wonderfully resistant to the improvements in road safety that dull the interest. Buses can be spectacular old smokes while the idiosyncratic decoration of Pakistani and Turkish trucks are worthy of a full-blown photographic project – as are the 6,000 Fifties American cars in Cuba. Horse-drawn carriages are popular with locals as well as tourists, such as coches in Cartagena, Colombia (all red, while the ones in Santa Marta up the coast are all white), calesas in Vigan, the Philippines, hantours in Luxor, Egypt, and colonial-era carriages in Pyin U Lwin (formerly Maymyo), Myanmar. Meanwhile, donkeys, camels and buffaloes are still earning their keep by pulling carts.

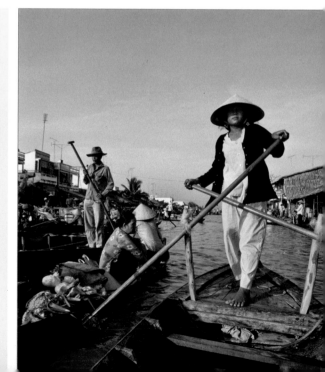

morning prayers and ablutions along the Ganges.

Hire an ancient dhow on the Nile, or a boat in Vietnam's Mekong Delta, rowed standing with two crossed oars by a young woman with conical hat. Your chauffeur, of course, is an essential part of the shot, usually best captured up close with as wide an angle of *focal length* as you have, so that you have the person and the water scene around.

From land, look for higher *viewpoints* so that you can look down at an angle on craft; a headland is one possibility, as are bridges. Fit a telephoto lens or use the longest focal length possible, and look in particular for shots of boats en masse, such as a fishing fleet in harbour or waterborne markets. The floating market south of Bangkok, for example, although now thoroughly organised for tourism, can still present a scene packed with life as the one-person boats loaded with produce and food being cooked jostle in the small klongs.

Public ferries offer a wealth of shooting opportunity, not least because they are real local transport, whether a typically over-crowded inter-island ferry in the southern Philippines, the commuter ferries in Lisbon or Istanbul, or the double-decker wooden boats plying the main Amazon river.

Cruise ships are a different world altogether, and the size and scale is something to aim for. Look for the best overview available, and if possible, talk to a crew member to see if there is special permission for other viewpoints.

Take advantage of the height above the water and the views from the top deck as you come into a Caribbean port, or approach calving icebergs in Antarctica. Arctic and Antarctic cruises are highly specialised, and there will usually be a photography expert on-board to point out photo opportunities and to give advice.

Cruising tall ships offer good opportunities for photographing the crew at work in the rigging.

Your own transport

Cycling is an increasingly popular way of seeing the world. IATA regulations permit bicycles to be carried on flights

BELOW: A wide-angle shot from a cruise ship on a Norwegian fjord – capturing the ship and fjord together.

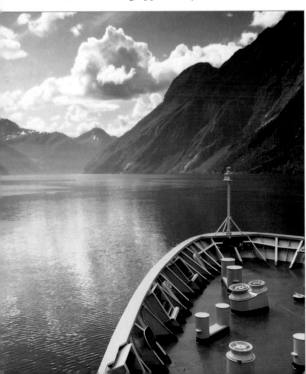

Cruise ship photographer

Aphotographer or "videographer" on a cruise ship sounds ideal, but it is a round-the-clock occupation, with little time for sight-seeing. Quarters are cramped and usually shared, and the pay is sometimes no more than the commissions you get for persuading passengers to buy their picture. On the plus side, you don't have to be a proven professional, and you will get to see different places. Lots of energy and enthusiasm may secure you a post, perhaps as one of several on-board photographers working for a photographic manager, who overseas printing and sales in the ship's photographic department. The main demand of such a job is a rapid learning curve, and if a photographer can succeed in these conditions, their confidence and ability will receive a boost.

with your baggage. Bikes are ideal for photography, giving you plenty of time and flexibility. Trail bikes also allow off-road opportunities.

Weight and bulk are key considerations on a cycling holiday, unless you are doing it in an organised way with a support vehicle to carry baggage. In any case, the more compact the camera, the easier it will be, and a single-lens mid-range super-zoom, for example, would be ideal.

Cycles themselves can be photogenic, from sit-up-and-beg sensible Dutch numbers and ranks of hire bikes to cycle rickshaws and taxis.

Motorcycling is possibly even more photography-friendly, as it takes care of some of the weight restrictions. Pack the camera well and carefully in a side pannier that is convenient to open without dismounting.

Horses and camels

Horseback has a lot to recommend it for photography in areas where you would otherwise be trekking – not least speed and comfort. But also, the horse gives you added height, which is always useful (if you are unfamiliar with the horse, hold the reins lightly when you stop to photograph).

It's worth mentioning camels here, as in desert regions from western Rajasthan to the Gobi you will usually find them on offer for riding in tourist areas. They are less tractable to novice riders than are horses, so rely on the guide if you want to stop the animal to take photographs (the extra height is very useful for flat desert landscapes).

The riding position is unfamiliar for most people, being on the rear of the hump (except for Bactrian camels, which conveniently have two humps for a central riding position). The swaying gait is moderately relaxed for shooting, but you should never undertake a long ride (several hours) without practice, as it can be hard on your spine.

And remember that a camel gets up and down in two stages, each of them putting you, the rider at a different angle, so lean forward after mounting as it rises on its forelegs, and lean backwards at the end of the ride as it first kneels. ❏

Reference ▷
Focal length, p.113
Viewpoint, p.83

BELOW: A slow shutter speed of 1/20 sec is enough to give the cyclists motion blur whist keeping the stationary bicycles sharp.

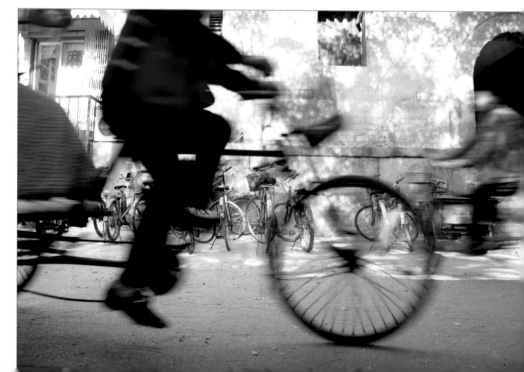

AERIAL PHOTOGRAPHY

A CHARTERED AIRCRAFT, fixed-wing or (even better) a helicopter, comes close to photographer heaven. It is expensive, but the cost varies from country to country, and also depends on the location. The United States, for example, has a higher percentage of private aircraft than anywhere else, and close to National Parks there are likely to be aircraft with pilots used to doing short pleasure rides.

The very first thing, which may decide your choice of aircraft and even if it is worth flying at all, is that you must be able to heave either your passenger window open or have the door taken off pre-flight. Photographing through plastic seriously reduces image quality. Not all pilots appreciate this, and not all are willing to open your side of the aircraft in flight, so check this point before anything else.

BELOW: The Grand Prismatic Spring in Yellowstone National Park, shot vertically downwards for more graphic results.

To make maximum use of expensive flying time, know in advance what subjects you are looking for and what kinds of image you will take; discuss these with the pilot, preferably over a map, as he/she will have to file a flight plan.

Oblique or vertical

There are generally two kinds of aerial image: oblique and vertical. Oblique shots are more usual, and easier to deal with. Once you have identified a target, such as a small offshore island, or a ruined temple, or a small lake surrounded by forest, make sure the pilot understands that he needs to keep it on your side of the aircraft and at a comfortable distance – not directly over, nor too far away.

Ideally, photograph it as you pass, with the aircraft flying slowly. Even better is if the pilot puts the aircraft into a gentle bank and drifts in towards the subject.

Vertical aerials are more challenging to organise, but they can produce graphically powerful results, as in this photograph (below) of Grand Pris-

matic Spring in Yellowstone National Park. The only sensible way to shoot vertically downwards is for the aircraft to fly in a tight circle, banked at around 45 degrees, with the target in the centre of the circle. This is not easy, as the pilot cannot see exactly what you see, and it may take a few goes.

The right lens

Zoom *lenses* definitely have the edge over fixed lenses, as changing lenses in flight wastes time over your target and can be tricky if the aircraft is moving a lot. Wide-angles are good for an overall view, and help overcome the common haze problem by using them while flying low – shorter distance to the ground equals less haze. But your vertical view may be restricted by the aircraft's wing tips or a helicopter's rotors. These move too fast for you to see anything but a pale blur, but a fast shutter speed will catch them on the image. A wheel may also get in the way if the undercarriage does not retract.

The widest you can normally use is 24mm equivalent focal length. At the other end of the range, a telephoto focal length of, say, 200mm equivalent may transmit too much camera shake, and there will be more haze effect also.

Noise and vibration

The noise and buffeting inevitable from having a window or door open makes it difficult for first-time aerial photographers to concentrate. If you are wearing headphones to communicate with the pilot you are unlikely to hear the shutter tripping each time. There is always some vibration, and this can interfere with calm composition. It can also affect your ability to judge sharp focus, so make sure than the auto-focus is working; many cameras have focus locks and switches that can be switched off inadvertently.

The movement makes it important to set a fast *shutter speed* to avoid motion blur, and shutter-priority is a sensible shooting mode. How fast depends on the focal length of lens (faster with a longer lens) and on your ability to hold the camera firmly, but to be sure never slower than 1/250 sec, and ideally at 1/500 sec or 1/1000 sec.

Reference ▷

Shooting angle, p.83
Lenses, p.113
Shutter speed, p.101

BELOW:
The Parthenon in Athens from an unusual angle.

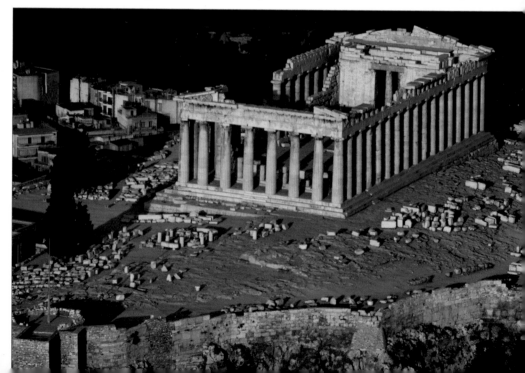

Reference ▷

Light & Time, p.57

Light & Weather, p.60

BELOW: The temples at Bagan, Myanmar, seen from a balloon in the early morning.
RIGHT: The venerable Star Ferries crossing Victoria Harbour, Hong Kong.

Avoid any vibration from the aircraft's engine by keeping your hands, arms and elbows away from the seat or any part of the airframe.

Also resist any temptation to lean out; the airflow can pull the camera out of your hands. Keep the camera strap secure around your neck, and if you fly with a door off, you need to be securely strapped in to your seat, and you should also secure your camera bag. Do not leave second cameras or lenses lying about: either keep them in the bag, or have a second passenger take charge of them and hand them.

Lighting

Lighting is critical in aerial photography, more so even than in normal landscape photography. Even from as low as 1,000 metres, the texture of buildings, trees and other features is on a quite a fine scale of texture, and unless there are some obvious real contrasts in tone or colour, the results will look disappointingly flat under any kind of cloud cover or when the sun is even moderately high. Although it may sound like too rigid a formula, the best lighting conditions are a low sun in clear atmosphere (good visibility, which the airport will have measurements and forecasts on). Clear and low bright sunlight casts distinct shadows, and for almost any subject, the longer they are, the better.

On a commercial plane

From a commercial aircraft there are occasions when you can make photographic use of a window seat despite the physical limitations, so it's worth having your camera accessible. Watch out for interesting cloud formations and sunsets/sunrises from commercial flying altitudes of about 10,000–12,000 metres (33,000–40,000ft).

To make the least of scratches and imperfections in the window material, press the lens right up against it, and use a fairly wide aperture (blemishes on the image can be removed later in Photoshop, and contrast can be improved). Be aware that some countries do not allow photography from overflights; the crew will know about this. ❏

Hot-air Balloons

Hot-air balloons are a wonderful alternative to aircraft or helicopter, and what they may lack in manoeuvrability and speed they make up for in photography by providing a silent, stable platform that moves slowly and smoothly – perfect for shooting. Typically you will be in one corner of a wicker basket, and as most hot-air balloon rides are in naturally scenic spots (the Serengeti for wildlife, Cappadoccia for the pillar-like landforms, or Bagan for the Burmese temples), the pilots know exactly what you will want. A good pilot under the right weather conditions can also manoeuvre the balloon in ways you might not have thought possible. Early mornings are best in most locations, because the air layers will still not have had time to mix, and the raking light will be ideal for photography.

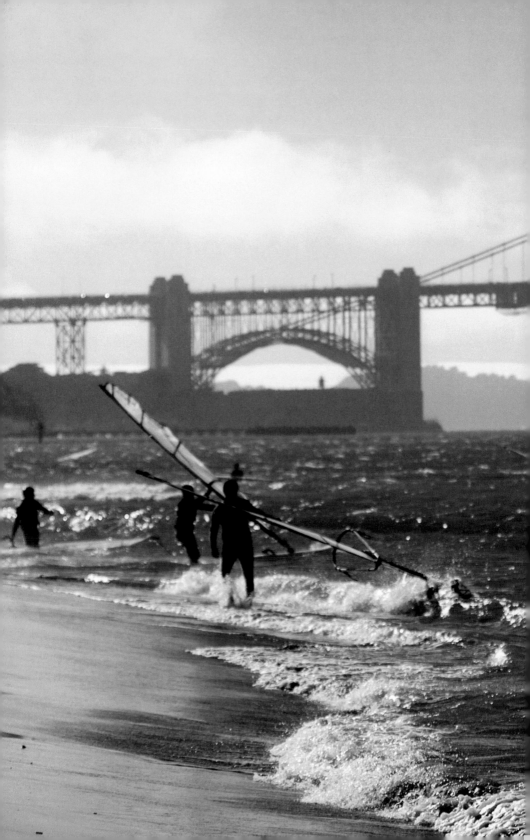

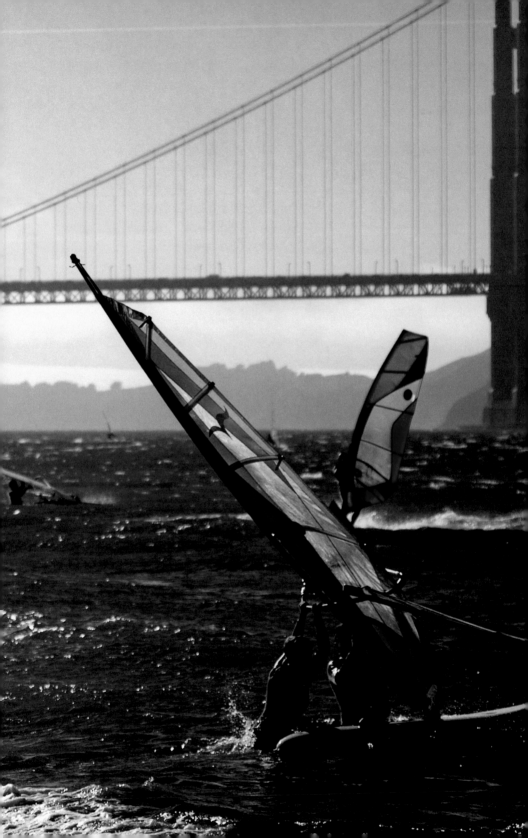

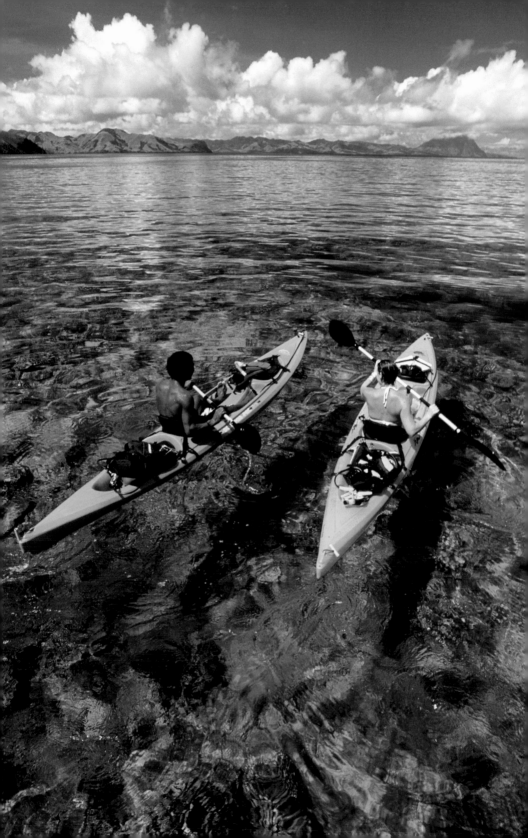

ACTIVE PURSUITS

Whether climbing a mountain or riding white water, the adventurous will want to share their enjoyment, but capturing the exhilaration and adrenaline rushes calls for careful preparation

The only way to photograph adventure is to participate in that adventure yourself. This doesn't mean you have to be an athletic adrenalin junkie. You simply need a sense of adventure and the ability to stretch yourself beyond your normal comfort zone. But before you take off, you should practise your adventure shooting skills. Amateur team sports are a good place to start. There you will learn to follow the action and after some practice your reaction times and techniques will improve dramatically. You will soon see the games as a photographer rather than a spectator.

Adventure photography is about telling a story with pictures. Being close to the action enables you to photograph both the subject matter and people's emotions as they unfold. Professional photographers will plan their trips from a mental image of each photo they want to shoot. This helps them decide which camera, lenses and other equipment they need to take and how best to carry them.

Invest in robust equipment. A strong camera body with a fast motor drive will give you an advantage when action is unfolding quickly. Good lenses with fast internal focus motors will also be worth their weight in gold – and are sometimes nearly as expensive. You get what you pay for. A camera pole can be made quite easily from a windsurfer mast and is valuable in many situations to provide unusual viewpoints. You will need a cordless remote. Also invest in a sizeable memory card: 8GB or larger is recommended.

There may also be environmental hazards. Safety should be a priority for yourself and those you are photographing. If you don't think its safe, don't do it! Above all, be positive and have a heap of fun. If you are having fun, you will take better pictures. ❏

Main topics
WATERSPORTS
MOUNTAIN PURSUITS
AIRBORNE SPORTS
UNDERWATER

PRECEDING PAGES: A blustery day in San Francisco. **LEFT:** Kayaking at Kadavu, Fiji.
RIGHT: Practise with some beach volleyball.

WATERSPORTS

CATCHING THE drama of the action of river or sea requires swift responses, fast shutter speeds and the agility to get out of the way.

Surfing

If you have a desire to photograph surfers, first consider that you could suffer broken bones, get run over, drown or become shark tucker. But when you get that one shot, it will all be worth it.

The safest and easiest place to take surfing images is from the shore and this usually requires a long *telephoto lens* like a 400 or 500mm prime and a *monopod*. If you want a leading brand telephoto they come at a hefty price. Sometimes a wharf, jetty or rocky outcrop will provide a closer, side view.

If you are comfortable in the water getting smashed by big waves, an underwater housing is the way to go. A housed SLR with a fairly wide lens (20mm or fisheye) will enable you to capture a surfer coming towards you inside a tube (breaking wave) and dramatic results are achievable.

This technique has potential dangers, so make sure the person you intend to photograph knows your location and your intentions. Wearing a helmet and a good pair of swim fins should be a common-sense priority. To gain confidence, and before making a huge camera gear investment, try a cheap throw-away waterproof camera or a compact digital underwater camera.

If your budget is huge, a door-less *helicopter* will allow you to shoot directly above the wave. Again, safety is paramount and a safety harness and tether line will allow you to hang out of the door for the best *viewpoint*. A 70–200mm zoom is your best option for aerial work. When surfers are changing direction at the top of a wave, it's quick action – and your *shutter speed* should also be quick (1/1000 second).

BELOW: A long telephoto lens is advised for shots of surfers from the shore.

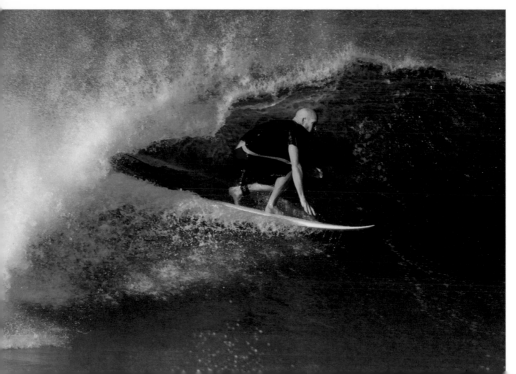

The one essential ingredient for great photos is *good light*. If you have some artistic flair and shoot around sunrise and sunset, outstanding images will often be created.

Kite surfing

In strong winds kite surfers will jump over waves, do rapid turns and launch themselves to astonishing heights. It's all fast-paced action that needs shutter speeds of 1/1000 second or even faster.

Images of the kite surfer completely airborne against a blue-sky tend not to be stimulating. Trying to capture the kite surfer and the canopy all in one shot is okay if the canopy is low to the water. If, however, the canopy is high above the surfer, it will all be much smaller in the picture area and consequently less dramatic.

It's easier to photograph kite surfers than surfers because they only need shallow water and often come close to shore. If they do come close, watch out for a huge plume of water from the board which can catch you out and give your camera a salt-water shower it doesn't need. A plastic camera cover is good if you think it may come into the firing line.

If you only want to invest in one lens a 70–200mm zoom is the obvious choice. A spectacular shot to watch for is a high-speed kite surfer riding his/her board parallel and close to the shore on which you are standing. The board will be closest to you, creating a narrow triangular plume of wake in front of the surfer who is leaning back and almost skimming the water surface behind it. Use fast motor drive and try to catch this action near to sunrise or sunset when dramatic golden sunlight kisses every droplet of water.

Kayaking

It's reasonably safe to shoot from a kayak provided it's a long stable boat with a large cockpit. If you haven't paddled a kayak before, get professional safety training and take a few trips before bringing your camera.

You cannnot paddle and photograph at the same time. While you are paddling, your camera will be safest in a CPS (camera protection system). The main options are a clear bag (Aquapac),

Reference ▷

Monopod, p.295
Lenses, p.113
Viewpoint, p.83
Light & Time, p.57
Protection, p.298
Panning, p.102

BELOW: Kitesurfing at the Gold Coast, Australia, the motion blur achieved by panning.

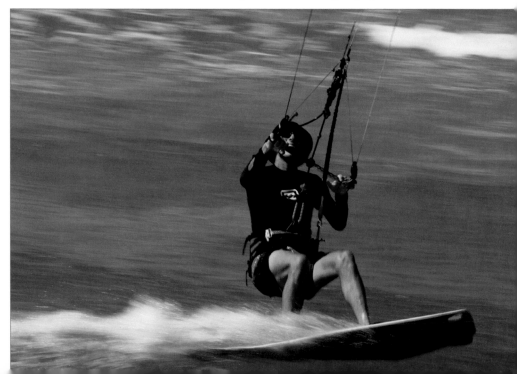

watertight plastic case (Pelican box), or a kayak dry bag. The first option is the easiest as it is small enough to stay on the deck attached by a bungee cord, whereas the other two will need to be stowed under the spray deck, making quick access more difficult.

Lenses from wide to telephoto can all be useful but a mid-range 24–70mm zoom is the most popular choice. A circular polarising filter will reduce reflection and enable you to see through the water surface. As you rotate the filter you will also see the sky become bluer. These only work well when your camera is at right angles to the sun.

Remember to get close and fill the frame with your subject. If you are *panning* with a moving kayak, experiment with slow shutter speeds (start at 1/15 sec) to emphasise the action. Watch out for overcast skies, which create flat lighting, especially on water.

Rafting

BELOW: Rafters in the thick of the action.

Rafting can be wild and wet, depending on the grade of the *river*. A good vantage point on the riverbank will open exciting possibilities. Be sure to wear a wetsuit and a good lifejacket or buoyancy aid and have a safety line. Then you can concentrate on taking good photos.

Using a wide lens (24mm) and a slow shutter speed (start at ½ sec) will enable small apertures for good depth of field. Pan with the raft as it goes by and adjust shutter speeds so that bodies are sharp but arms and paddles are *blurred* with action. If you are close enough, *fill flash* set on rear curtain sync will produce fill light and sharp detail. If you get it right your preview screen will boast wild images which shout "action".

On board the raft, your DSLR will need to be protected from wild water. The best option is a quality underwater camera housing, albeit rather expensive, with a glass dome port (better than plastic) to accommodate a wide lens. An underwater flash unit will help put light in shadow areas. Don't overdo the flash. Just "kiss it with light". *F*8 and 1/250 sec (flash sync speed for many cameras) should be close, although gorges can be dark and may require an increase in ISO. ❏

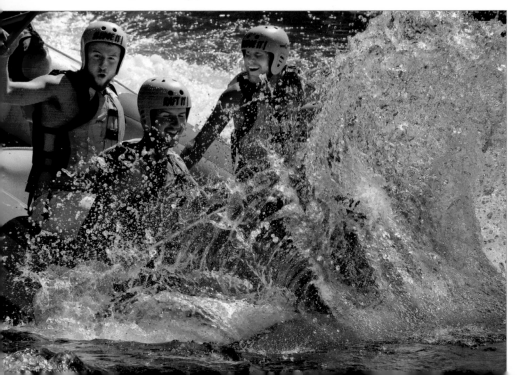

MOUNTAIN PURSUITS

PHOTOGRAPHING activities that take place in the mountains is a combination of people shots, great views, close ups and wonderful scenery. The mix can provide a dramatic story.

Hiking

Carrying a DSLR on a long hiking trip can be tiring. If you have a serious kit with a body, several lenses, flash, batteries, tripod etc, it will be heavy. Think carefully about the type of images you wish to shoot and then make your *gear* selection accordingly. If you try to carry it all you will risk serious fatigue and a sore neck and shoulders.

A variety of lenses are used for *landscape* photography. Wide-angle lenses (14–24mm or even a 24–70mm) are fine if you are standing in front of a huge vista. Slight distortion is not an issue as there are not too many straight lines in nature to worry about. The telephoto, however, is by far the most impressive lens for landscapes and also distant people in the landscape shots. When a 70–200mm zoom is zoomed out to 200mm it tends to compress backgrounds and gives a real impression of size. You might also consider a lens that will be good for *close-ups* of plants and insects.

A dedicated or on-camera flash is handy for fill flash when including people who are close by in your landscapes. Number one priority is a well-padded camera bag with a comfortable harness and a high quality rain cover. If part or your entire hike includes forest or bush, you will need a *tripod*, a camera timer function or, better still, a cable release or wireless remote. A small compact lightweight tripod will do the job and easily attach to your bag. When walking long distances it's easier to have your hands free.

In among tall trees on a clear sunny day contrast can make correct exposure difficult. This is a perfect case for

BELOW:
Taking a break in Yosemite National Park.

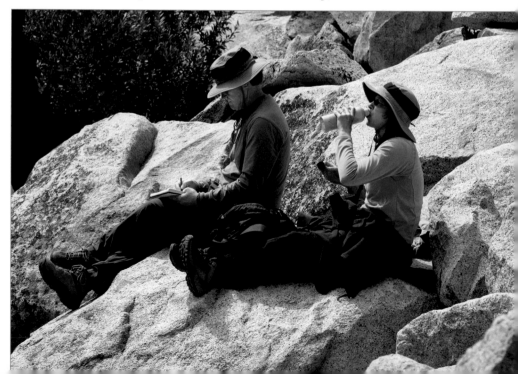

shooting *HDR* (high dynamic range) images. Take five or seven images with one stop of exposure difference. If shooting seven you start at three stops under-exposed and finish at three stops over-exposed. The extra one is at normal exposure. You must use a tripod to shoot exactly the same scene and use aperture priority so only the shutter speed changes. You will then have recorded the correct exposure in virtually every part of the scene.

Some top-range DSLR's will shoot all these images in one burst on motor drive. Back on your computer you will then blend all seven images together to make one. The finished image will show wonderful detail and correct exposure across the whole image, even areas normally in deep dark shadow. Photomatix is generally regarded as the best programme for blending HDRs and its quite user-friendly.

Climbing

To be an adventure sports photographer you often have no choice but to be part of the activity and good at it. Climbing certainly requires skill and strength even without a camera. Don't even think about photographing climbing until you are at an advanced level of training. Suspended on a rock face is not the place to be opening and closing a large camera bag. Take only the camera body (a small light DSLR is perfect sense) and lens (24–70mm zoom is versatile) you intend to use and carry it in a small belt/bag which can be swivelled around your waist.

Many climbing enthusiasts will already have a bucket load of butt shots, so look for better angles than below. A side view of a climber is often overlooked but has merit. One of the best options is to set up a fixed rope on another route. With a set of ascenders you could even take advantage of two or three different positions during a photo shoot.

Once you have settled in a steady position you will be ready to capture emotion on the climber's face and also some dramatic background. The most dramatic *viewpoint* is from above and the best way to shoot it is to lead the climb yourself. If you need more camera gear haul it up in a Pelican box

BELOW: The perfect frame: hikers in Arches National Park, Utah. Bright colours help to make them the centre of interest.

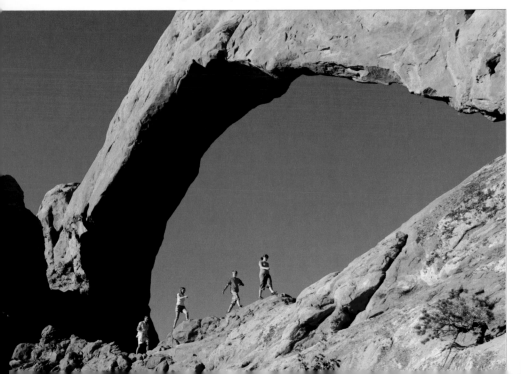

with plenty of inside foam padding and then pull up your rope so it's out of the shot. A good zoom lens should enable you to shoot variations without constantly changing position.

You won't get so many facial expressions from above because climbers, constantly looking for footholds, rarely look up. Try to persuade your climbing friends to wear photo-friendly coloured clothing and perhaps a red helmet, so they don't get lost in the background. One simple piece of equipment will give viewers the impression you, as photographer, are hanging in space. It is the camera pole, which can be held away from the face or even lowered over an overhang.

Great care is needed to ensure every piece of *equipment* is well secured. You don't want it falling on anyone.

Skiing

Follow a few simple rules and you will get the most from your photo shoots on the mountain slopes. You can't take good photos if you are cold, so dress warmly and wear a hat. Fingerless gloves are better than none when han-

dling the camera. You should not wear the camera dangling from your neck by its strap or under your jacket when skiing or snowboarding – if you fell, the camera could injure you. Snow, ice, water and cameras don't mix so keep your electronics dry in a good quality bag and try to avoid falls. A hip pack integrated with a daypack is a nice stable way to carry it.

Be particularly careful to check all bag zips are in good condition and secured. You don't want to see your gear plummeting into depths of snow when you are riding the chair lifts. Battery life will always be shorter in *cold conditions*, so always carry a fully charged spare in a pocket close to your body to keep it warmer. It will then perform better. Murphy's Law says that the most outstanding photo opportunity will present itself at the moment that your battery runs out of power.

Watch out for other mountain users. Skiers and snowboarders move very fast and collisions can hurt. It is better not to stop under the crest of a hill or in fact anywhere where people coming from higher up the mountain can-

Reference ▷
HDR, p.303
Viewpoint, p.83
Equipment, p.294
Protection, p.298

BELOW: Joshua Tree National Park, California. The red helmet and bright clothing help to set the climber off against the rock.

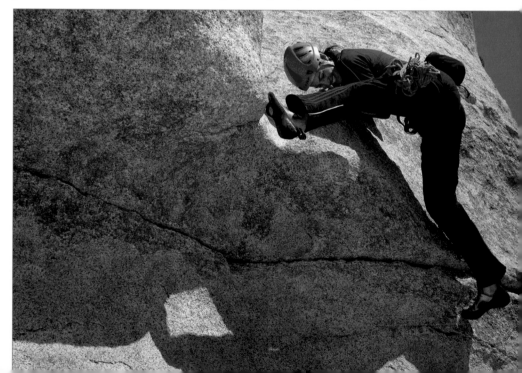

not see you. It spoils the fun if you get injured or indeed injure someone else. If you absolutely must stop in a precarious spot to take a picture remove your skis or snowboard and stand them up in the snow to give other riders a clear indication of your whereabouts.

That's got the rules out of the way, so let's look at technique. Shoot when the winter sun is low in the sky and use a UV filter to protect your lens and reduce blue discolouration in spectacular *mountain scenes*. Use slow shutter speeds (1/125th second) for landscape shots and fast shutter speeds (1/1000th second) to freeze the action. Most skiers wear bright colours which look great against the white backdrop.

Snow is highly reflective and tends to fool most cameras' metering systems. The camera will read from many different parts of your picture area and when they are all white and bright it thinks to itself "wow that's bright" and reduces exposure value, making the shot too dark. This is easily resolved by simply adjusting your *exposure* compensation setting to plus 1 stop. Keep reviewing your images to check expo-

sure and don't forget to change the setting back to normal once you have finished on the mountain.

You may be able to capture some good action if you persuade your friends to build a jump and then photograph them as they do crazy tricks. Snow boarders are good at this so they may be keen for a photo shoot. Lying down in the snow and shooting as they go overhead makes everything look more dramatic.

Some *fill flash* can be useful to put in detail but don't overdo it. Tuning its power down by up to one stop looks natural and it's hard to tell that flash has been used.

If you have enthusiasm, dog-headed determination, work well with people and have an eye for a good picture, your patience will eventually be rewarded with a truly fantastic image.

Mountain biking

Photographing mountain bikes and cycling in general can be an exhilarating experience with plenty of action and lycra. As well as the rural landscape, great views and colourful riders,

BELOW: Lens flare, sun star and silhouette all feature in this shot of skiing in the Colorado Rockies.

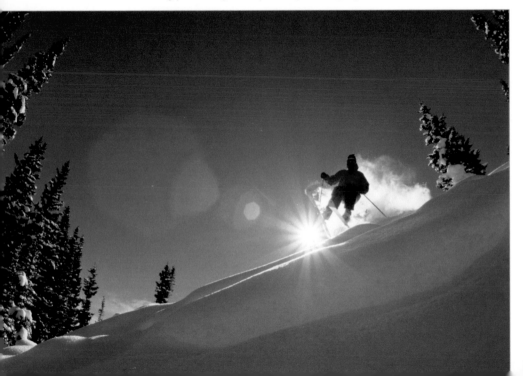

there are opportunities to try out your technical skills such as "pull zooms" and using longer *exposures*.

A good medium range zoom (35m–80mm) is ideal for most situations, meaning that you carry minimum gear and avoid having to change lenses in dusty, wet or dirty conditions.

For static shots at viewpoints make sure you place riders on "*thirds*" or at "strong points". With action shots ensure that they are riding into positive space. Look around for suitable framing such as trees, but also be inventive and maybe try photographing riders through a bike wheel (spokes and all).

Taking photos of a race has gritty action. Try a few "pull zooms" by matching your pull back with the speed of the rider. If done well, the rider should be distinguishable and in focus, while lines of trees, ground and other riders streak towards the edges of the frame.

Less adventurous but equally pleasing are good longer exposure shots. If your camera is indicating that a shot should be taken at 1/250 second, go into shutter priority and bring this down to say 1/60–1/15 second. The camera will work out a newer, higher F-stop setting, giving greater depth of field. You can either use a *tripod* or hold the camera steady and let the rider come through the frame and be slightly *blurred* indicating speed and action. Or you can slowly pan with the rider as they pass, which should keep the rider reasonably sharp and give you a blurred background. See what works best. Take plenty of lens cleaner, cloths and plastic bags to protect the camera.

Placing a camera onto the bike or rider is sometimes referred to as using a "suicide camera". With no guarantee that it will survive, it really should be nearing the end of its natural life. Gaffer tape can place the camera almost anywhere, but of course the main problem is how to release the shutter. Near to the handlebars is pretty easy, as is anywhere around the body or head of the rider. Beyond that, you need to have your own system for firing the shutter, either with an extension cable or remote control. These can be stunning shots, and make a fitting end for a retiring camera. ❏

Reference ▷

Mountains, p137
Snow, p.154
Fill-flash, p.112
Rule of thirds, p.78
Motion blur, p.102
Light effects, p.298

BELOW:
Bring the shutter speed down to below 1/60 sec to capture the motion and pan to give a blurred background.

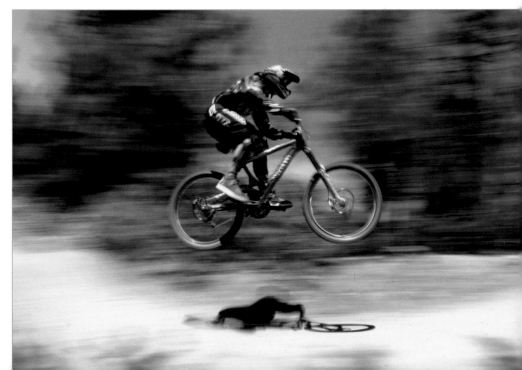

AIRBORNE SPORTS

CAPTURING a figure flying through the air is a tricky business that needs preparation and a head for heights.

Paragliding

Paragliding is freedom and about the closest you can get to flying like a bird. Pilots of these wide sleek canopies can glide at speed and cover a lot of ground in a short time, making photography difficult. Photographing paragliders from below tends to give rather boring results. Unless you can see dramatic cloud formations or the moon, the sky rarely provides an interesting background and doesn't give the viewer a sense of place or *scale*.

A better option is to perch on top of a steep cliff, as paragliders will often fly at your level and sometimes below you. These adventurous men and women of the sky tend to relish the thought of seeing good images of themselves in action. You need to be ready, as they will often perform daredevil turns and

BELOW: Western Cape, South Africa. Paragliders are best taken from about the same level, with a strong background for context.

swoops once they spot a photographer with a long lens.

A good 70–200mm zoom lens is perfect. Vibration reduction is a useful feature in low light. However, it makes little difference at *shutter speeds* faster than 1/500 second (recommended for paragliding) and should be turned off. You will need to pan with the subject and use focus tracking. As far as aperture is concerned, the old quote "$f8$ and be there" is a good one. If the sun is in front of you and low in the sky it will cause sun flare (odd-shaped blue spots) in the lens which will spoil your picture.

With good concentration and fast motor drive it's worth trying to capture that split second when the paraglider blocks the sun as it glides through, making a stunning *silhouette*.

Taking good photos of yourself while flying a paraglider may be restricted to holding out a lightweight camera at arm's length. Mounting an

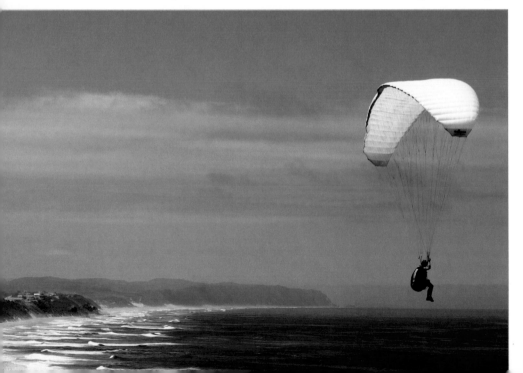

expensive camera on the canopy or yourself probably isn't an option, as it may become a dangerous appendage during landings. Many flying machines are used for *aerial photography*, including the powered paraglider.

Bungee Jumping

Viewpoint options for bungee jumping are from above, from below, from the side or even a camera going down with the jumper. If you can persuade the bungee operators to allow you access to the jump platform it provides a dramatic viewpoint. With a harness and tether line you could lean out over the edge beside the jumper and your photo will give the impression they are jumping off the edge of the world.

A fisheye lens is a perfect choice to give that "edge of the world curvature" and an aperture of *f*11 or smaller will give enormous *depth of field*. This will allow you to preset the focus to provide a DOF of 0.4 metre to infinity (at *f*11). Use aperture priority, aim the camera below and adjust your ISO to give a *shutter speed* of 1/1000 sec. Set your camera on its fastest motor drive. Some of the high-tech DSLRs will produce up to 11 frames per second. Finally, frame the shot and pick some points on the landscape to help you relocate your viewpoint quickly.

To ensure that your jumper will come into your picture area give them a quick briefing and also ask for a nice body position, although you won't always get it. It's a pretty crazy thing they are doing and nerves will be kicking in. If you have the luxury of deciding their clothing colour, too, pick something that won't get lost in the background. Red always works well in a landscape as it complements the greens.

You are now ready to shoot, so organize a countdown with the jumpmaster. You need to be ready because it all happens extremely quickly. When it gets to "go" be aware of the jumper beside you. Once you sense that gravity is taking over, press and hold the button until the camera buffer fills and it stops shooting. This could be as many as 30 images in one burst. If you have done your work well, one of those images will be a winner. ❏

Reference ▷
Scale and depth, p.85
Shutter speed, p.101
Silhouette p.64
Aerial photos, p.254
Depth of field, p.100, 114

BELOW:
Bungee jumping from Bob's Peak, Lake Wakatipu, New Zealand.

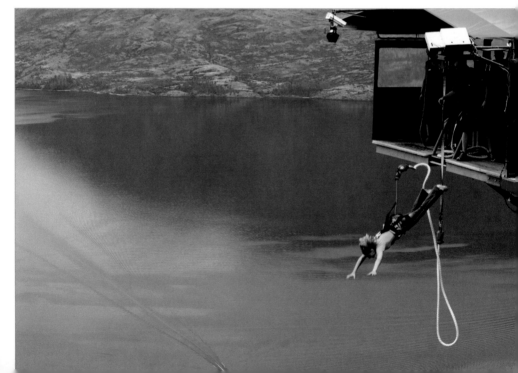

UNDERWATER

The majority of people in the world will never scuba dive, and sharing your underwater photographs is a great way to show them some of the exotic creatures that inhabit the sea.

Whether in the Red Sea, off the Yucatán or on the Great Barrier Reef, excited newbie divers straight from their first open-water dives often ask experienced underwater photographers how best to get started taking pictures in this new environment. The advice they get is not always what they want to hear. It's most likely to go something like this: "go away and do 200 dives and then come back and ask me again". There is a good reason for this answer. Once you are completely relaxed in the underwater world and everything you do there becomes second nature then you may be ready for the underwater photography challenge. It's a challenge because time is short, cameras were never meant to go underwater, greater depths dull your senses (nitrogen narcosis), make colours disappear, and fish are not good models because they rarely keep still for long enough to be photographed.

Once you become committed to photography in the briny you will be tempted to start breaking the basic dive rules, such as:

1. Holding your breath to get closer to fish because air bubbles spook them.

2. Running low on air because the best photo opportunities always seem to come at the very end of a dive.

3. Seeing an interesting photo subject below and then going to a greater depth than you first intended.

Try not to break the rules and try not to break the coral (perfect buoyancy control with your BCD should keep you off the fragile coral reef).

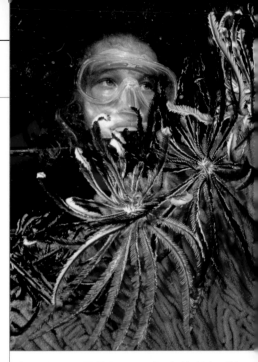

ABOVE: Wananavu. Fiji. Placing a young diver beside this beautiful crinoid-laden gorgonia fan has given the picture human interest and size. Diagonal composition also enhances the image.

ABOVE: It's difficult to shoot small corals while floating free. Find a bare patch to settle down on and avoid breaking delicate corals.

BELOW: Diving the Taioma wreck, Motiti Island, New Zealand. Without prompting, the red pigfish arrived right on cue.

RIGHT: The Queen angel fish in Yucatán is very colourful and photogenic. Patience and perseverance will eventually reward you with a great shot.

EQUIPMENT

Unfortunately Nikon no longer make the Nikonos underwater camera and at this stage seem unlikely to make a digital version. Your only option is either a compact camera or a DSLR in an underwater housing. One or better still two underwater flash units will bring lost colours back to life. Seawater carries many organisms which reduce visibility and make your pictures look hazy and as though snow is falling when you use flash. The best way to reduce this is to use an ultra wide lens (10.5 or 16 mm fisheye, 20 mm prime behind a dome port), get very close to your subject and mount your flashes on long flexible arms so they side light rather than illuminate snow like particles in front of the lens. Because light falls away quickly underwater upward angled shots will give you nice light from the surface. Working on manual exposure, meter the surface ambient light first and then aim a little flash, again using manual flash power settings, on to close objects in your foreground.

Use either a 60mm or 105mm macro lens behind a flat port if you want to photograph minute critters like nudibranchs or gobies. Try not to handle them. They are fragile. TTL metering usually works well for macro when there is not much light in the background.

ABOVE: Careful timing and luck is needed to capture Sweetlips framing a diver on the Great Barrier Reef. Their reflectivity will require low power strobe settings.

BELOW: A turtle cruising the shallows. They are usually quite speedy and difficult to photograph.

DESTINATION CALENDAR

Everywhere in the world has a prime time to visit, when there is a festival, when the flowers are out, when the sky is at its bluest and the weather is kind

One of the important aspects of travel photography is knowing when to go where. Some decisions are fairly obvious, but sometimes the schedule is out of your hands. Good preparation for any trip is essential to get the best shots, given the season and location. Check websites to see when local festivals are held, as there are hundreds happening around the world on any given day. You might want to photograph them – but you also might want to avoid them. The more homework you do the better.

Classic events are Carnival in Rio, Oktoberfest in Munich, Chinese New Year, and the Pushkar Camel Fair in India. Go by the seasons with spring in the European Alps, summer in Mongolia or the New England Fall. Not all trips can be centred around such famous festivals or locations, but some basic research will reveal what might be expected. It is not a good idea for example, turning up in Western India through June and July not realising that the monsoon is sweeping through. Not that this will stop you from taking some fantastic photographs, but you do need to plan for it. Extreme wet, heat or cold conditions need special preparation and possibly some specialist equipment.

The best or most favourable climate often coincides with the peak tourist season. So whilst the majority flock to Egypt in the winter months, returning with photographs showing hordes of visitors, it can be worth thinking of visiting outside the busiest times. It can be hot and there might be some early starts in the day, but there are more hours of daylight and the heat of midday can be avoided. Peaceful views across a quiet Valley of the Kings at 6am, or the solitude of a brooding Karnak Temple at 3pm, with a few individuals for scale rather than hundreds, can make it all worthwhile. ❑

Month by month
JANUARY
FEBRUARY
MARCH
APRIL
MAY
JUNE
JULY
AUGUST
SEPTEMBER
OCTOBER
NOVEMBER
DECEMBER

PRECEDING PAGES: Ipanema Beach, Rio de Janeiro; exploring the Louvre, Paris. **LEFT:** Oasis in the desert. **RIGHT:** Cruising off Alaska.

JANUARY

Antarctic

It's summer in the Antarctic and, though it's expensive, you only have to take your camera to the end of the earth once – your pictures will help you see it again and again. Don't forget a polarising filter to cope with that bright white light.

Costa Rica

At this time of year the tropics are especially welcome. And the vibrant colours of the sparkling rainforest, with its dazzling birds, the sharp blues of the rugged coast and the soaring mountains of the interior give a wide variety of subject matter.

Havana, Cuba

Get there while the photogenic old American cars are still on the road! People are friendly, and usually don't mind being photographed. There is wonderful crumbling colonial architecture, making graphic shapes in the bright light, and the countryside, still

BELOW: Vintage car in Cuba.

worked largely by hand, is extremely picturesque. Get that hand-rolled cigar shot.

Mt Kilimanjaro, Tanzania

You saw it when you flew into Dar es Salaam, now go back and get the pictures of this spectacular, yet easily conquered mountain. Be prepared for the hike, and use your zoom or long lens to capture the wildlife that will be all around you.

St Petersburg, Russia

This Russian city was built for snow. Take a sleigh ride and capture the richness of Tsar Peter's grand city, with sparkling interiors of its churches, theatres and museums. Prepare for low lights and a wide aperture, and experiment with black and white.

Torres del Paine, Chile

This is pretty much the end of the world, and a trip to National Park is not for the faint-hearted. The rewards are wild and choppy lakes, and spectacular mountain scenery, still snowy in what is now high summer. Go

trekking, hire a horse and four-wheel drive vehicle.

Big Sky Resort, Montana, US

Great skiing – and great shots. With over 5,500 skiable acres, this resort has everything going for it – skiing, snowboarding, cross-country, snowshoeing – so it's the place to get real action pictures and thrilling videos. There's a good après-ski life, too, with opportunities for candid people pictures.

FEBRUARY

Azores, Portugal

This is the time to go whale watching in the middle of the Atlantic. The mainland seems a long way away, making you feel closer to these wonderful creatures. Be prepared to be patient… and be ready to snatch the moment when they breach – or when their flukes wave a majestic farewell.

The Camargue, France

This is the best time to see flamingoes as they carry out their courtship rituals and nest in their thousands, creating wonderful graphic images. At the day's end they take to the air in huge flocks. Arles, Van Gogh's chosen town, is capital of the Camargue, a colourful place with the bright patterns of the traditional cloth, worn by Camargue's cowboys.

The Nile, Egypt

A classic destination, following in the footsteps of the early photographers. Take a Nile cruise and keep your lens focused on the banks of the historic river, where small farming communities seem little changed since Biblical times. Use a long lens or zoom for the birdlife, and go as wide as you can on the temples. Photographed and painted for centuries, they are much more impressive in real life, so they present a huge challenge to the travel photographer.

Cape Town, South Africa

Take the Garden Route, the most scenic in the country, as it wends it way along the beautiful coast – but don't expect botanic gardens. Instead there's

BELOW LEFT: Feluccas on the Nile. **BELOW RIGHT:** Countryside near Cape Town.

extreme adventure, wonderful beaches and great views. Not far away are the bucolic wine lands of Stellenbosch – keep your hand steady.

MARCH

Guatemala

In Guatemala, one of the most vibrant of Central American countries, villagers are still distinguished by their particular dress. Holy Week (the one before Easter) excites the whole country, and there are the added benefits of jungle wildlife (howler monkeys, toucans) and Mayan ruins.

The Holy Land

Follow in the footsteps of the pioneering photographers who headed here soon after the camera was invented. Nazareth, Bethlehem, Jerusalem, Mount Sinai, the Sea of Galilee and River Jordan... see what they look like today in these politically hot countries, and offer your own take on these places of Abraham that produced the Western World's three principal faiths.

BELOW: Fresh strawberries in Guatemala.

Japan

This is *hanami* or cherry blossom time, when temples and shrines are shown off at their best. You can follow their trail north as they blossom from January through to June, with blooms lasting around ten days. Catch the cherry blossom festivals elsewhere – including the National Cherry Blossom Festival in Washington DC.

Las Vegas, USA

March Madness is a high time in Las Vegas, when people come to bet on the Collegiate National Basketball Championship – well, you want to there when the action is on. The buildings and their neon, completely over-the-top designs and ornamentation, offer terrific possibilities for the photographer, as do the diverse characters who come here to bet.

Seoul, South Korea

One of Asia's fastest growing cities is always buzzing, and everyone has a camera. But you don't have to go far to find an undisturbed countryside of mountains, monasteries, paddy fields

and fishing villages, where a foreigner with a camera is an unusual sight.

Uzbekistan

Bukhara and Samarkand are the romantic cities of the Silk Road. At this time of year it is still cool, but in May days are sunny and tilework on the mosques will sparkle. Photography, including video, is permitted in the museums and monuments, for which there is a small charge.

APRIL

Alice Springs, Australia

Uluru (Ayers Rock) behaves like a changing colour chart throughout the day. At this time of year, when it's not too hot and vegetation is green, see what hues you can seduce from Australia's most famous outcrop as well as the nearby Olgas. Aboriginal art is worth capturing, too.

Greece and Turkey

This is when sites such as Delphi are vibrant with spring flowers, and olive groves are carpeted with red yellow and blue. The Pindos hills, too, ignite in colour, while across the Taurus mountains of Turkey, wild crocuses, primulas, and narcissi cover the hills.

Oregon Trail, US

Follow in the footsteps of the pioneers to make your own visual traveller's tale. Settlers used to set out in April when the grass was starting to grow, to ensure their horses would be fed all along the route. In Nebraska wildlife refuge you can still see bison – with a bit of Photoshopping you could put the herds back on the Great Plains.

Paris, France

Time for romance on the streets of Paris. Visit Rodin's seductive garden and use vignettes, vaseline on the lens, rose-tinted filters, or try to match the black-and-white 1950s classic shot, Le Baiser (The Kiss) by Robert Doisneau.

Seville, Spain

There are few more colourful events in Europe than Seville's Spring Fair, the horses and riders all gorgeously decked

BELOW:
Uluru glows in the evening light.

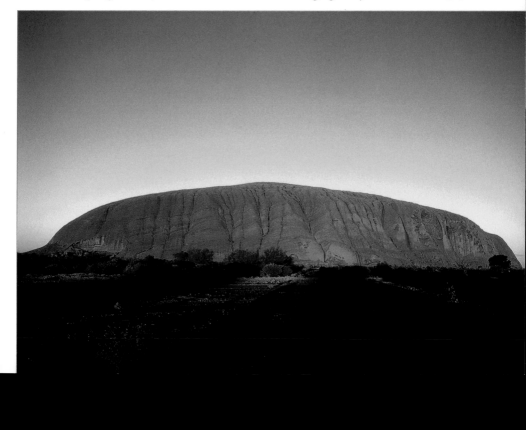

out. The celebrations go on all night, adding to the photographic challenge.

Shanghai, China

March to May is the best times to visit Shanghai, which has hot summers and cold winters. The reason to reach for your camera is the skyscrapers, the 21st-century buildings that throw up so many shapes and offer so many possibilities. Visit the world's highest observation deck on the Shanghai World Financial Center to get rooftop views, or stay at the Park Hyatt Shanghai, which occupies the building's 79th to 93rd floors.

MAY

Bali, Indonesia

The dry season lasts from April to September, and is the best time to visit this magic island of many religions and infinite festivals, with kites, fireworks and the constant sound of the gamelan. A good audio capability is needed for your video – or bring a separate field recorder.

BELOW: Paddy fields in the Sideman Valley, Bali.

Cappadocia, Turkey

Rock formations known as "fairy chimneys", rock-cut churches, and even rock cave hotels make this an extraordinary land to photograph. It's centred around Göreme, an old monastic settlement, where Byzantine frescoes are well preserved. Balloon trips will give you a striking overview.

Grand Canyon, Colorado, US

Rafting and kayaking are some of the adventure sports in this natural wonder, which is always a challenge to photographers. If you're into watersports, take a separate waterproof or underwater camera to combat the spray. It will also be sand- and dust-proof. There are great opportunities for video clips here, too.

Great Wall of China

This is the best month to visit this man-made wonder. Expect blue skies and good views of the surrounding mountains. Simitai is the best place to visit, and is less crowded than at much-restored Badaling, but expect a climb. Take a wide angle to give of idea of the great sweep of the wall.

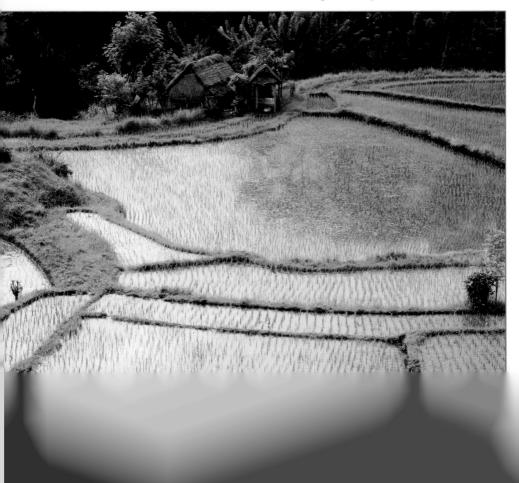

Bulb fields of Holland

The Dutch bulb fields come into bloom from late March to mid June, especially in the province of Zuid Holland, where displays are shown off in Keukenhof flower gardens near Amsterdam. Their colourful ranks make wonderful patterns, as do the blooms that are discarded by the thousand – all the growers want is the bulbs.

Mountain Railways of India

India's five mountain railways – the Darjeeling Himalayan Railway, Kalka-Shimla Railway and Kangra Valley Railway in northern India, and the Nilgiri Mountain Railway and Matheran Hill Railway in the south – are spectacular journeys that curl upwards to hill resorts established under the British Raj. They are ideal for a video story, too.

JUNE

The Amazon, Brazil

June to October are generally considered the best times to visit. If you go at the beginning of the season, the plants and vegetation are not so thick, making it easier to spot wildlife in the trees.

Bangkok, Thailand

Damnoen Saduak in Bangkok is just one of many floating markets in Thailand, albeit the largest. These offer a wonderful opportunity for photographing people, while the shapes of the clustered boats with their wares make graphic images.

The Galapagos, Ecuador

It probably won't be long before they close the islands to tourists – or further reduce their numbers – so get your photos while you can. From June to November the cooling Humboldt current brings fish, followed by birds, including the albatross, and the famed blue-footed boobies start their mating rituals.

Yosemite National Park, US

This is about the best time to visit the park that Ansel Adams so brilliantly photographed. Everything is open and the crowds are yet to descend, but beware of mosquitoes towards the end

BELOW LEFT: A toucan in the Amazon rainforest.
BELOW RIGHT: The Damnoen Saduak market in Bangkok.

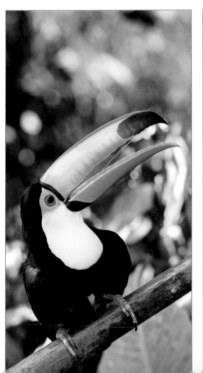

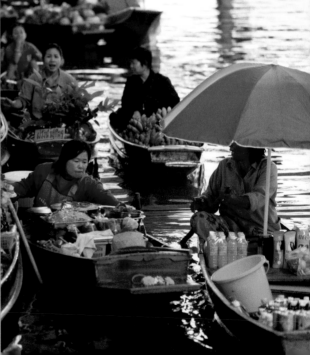

of the month. Tours for photographers are on offer.

Midsummer, Scandinavia

The longest day invites celebration around the northern hemisphere, when the "white nights" have a curious, almost electric light. It's particularly important in Scandinavian countries, with bonfires and plenty to drink. The midnight sun provides undiminished light and great photo opportunities.

Transylvania, Romania

Midsummer is when livestock is in the high meadows, vegetation is rich and the land looks sweet. Transylvania still has some of the most authentic farmlands in Europe, where life has changed little for centuries. But the 21st century is rapidly heading its way, so get the pictures while you can.

BELOW LEFT: A lake in Finland. **BELOW RIGHT:** The Tiber and St Peter's in Rome.

JULY

Dyer Island, South Africa

Go cage diving in Shark Alley for the chance of getting a close-up snap of the Great White Shark. On the boat, there's a chance to see them breaching in the high season. And on the island there are Jackass penguins and Cape Fur Seals.

Lake Titicaca, Bolivia/Peru

This is the time to be on top of the world: 12,500 feet up, South America's largest lake has more than 40 islands to explore. Its residents' costumes are among the most striking in South America, and you can see women spinning and men knitting their beautiful garments.

London, Great Britain

Britain's capital is never too hot in summer, when the city gravitates out of doors. Evidence of a social season remains, with Wimbledon Tennis, the Hampton Court Flower Festival, open-air theatre and opera, and so much else that digital photographers should come prepared with a whole bunch of memory cards.

Milford Sound, New Zealand

This is the rainy season in South Island's spectacular landscape – but

that means that its waterfalls are at their most exuberantly gushing, and the foliage lusciously green. The scenery all around Fjordland National Park is wondrous, and there are plenty of outdoor activities to get involved in – and to shoot.

AUGUST

Alaska, US

Summer in Alaska is all too brief, so make the most of it. Wildflowers arrive, the wildernesses can be explored, and air safaris can give you terrific views of the mountains and glaciers. Take long lenses and polarising filters.

Mount Fuji, Japan

July and August are the best times to climb towards that familiar snow-capped summit, which remains very cold throughout the year. Take warm clothes and join the visitors who make the climb overnight, with glowing torches, and from the chilly summit capture the spectacular sunrise the next day.

Prokletje, Albania

The adventurous travel photographer will make his or her way to the Prokletje – the Accursed Mountains – in the north of Albania, one of the most remote parts of Europe, filled with pristine rivers and lakes with undisturbed wildlife and a large population of butterflies.

Rome, Italy

It's hot in August in Rome, and most people decamp for the country or seaside. Shops and restaurants close. This means you get the usually abrasive, noisy city more to yourself, and you can photograph monuments and sites without too many people in the way.

Swiss Alps

With some of the world's best known mountains, such as the Eiger and the Matterhorn, this was the high point for early European travellers, and it still has classic scenes. Summer hills are populated by bell-clanking cattle and good-natured hikers. Board one of the many local railways – or get aerial photos in a hot air balloon.

BELOW:
Milford Sound, New Zealand, with Mitre Peak.

Tanzania/Kenya

The great migrations of wildebeest and zebra from Tanzania's Serengeti Plains to Kenya's Masai Mara National Reserve runs from July to September, and is one of the most impressive wildlife sights in the world. By the water in the early morning there will be guaranteed great shots.

Tibet

No longer forbidden, but still endlessly fascinating, Tibet really does make you feel on top of the world. Beneath the clearest of blue skies, the mountains and gorges stand out sharp as pins. Photography is today generally allowed in monasteries, but the visitors from China make good subjects, too.

SEPTEMBER

Iceland

Go early in the month to witness the great sheep round-up, followed by a roundup of wild horses. Shepherds and herdsmen are on horseback and you can join in, too, getting a loftier

BELOW: The Potala in Lhasa, Tibet.

view. These are timeless scenes in the less visited part of this geologically fascinating country.

New England, US

It's a cliché, of course, but it is so spectacular that your finger won't stop clicking. Beneath the bluest of skies, the red and gold autumn leaves can look almost too vivid, leaving you with little to manipulate on your computer when you get home.

Porto, Portugal

The *vindima* (grape harvest) in the Duoro valley makes a good photo story, from the slopes on the upper reaches of the river, where the vine leaves are burnished red, to the famous port wine cellars in the attractive city of Porto. Ask around to find grapes being trod in the old-fashioned way.

Ulan Bator, Mongolia

This is a good month to visit Mongolia and the Gobi desert, when temperatures are at their lowest. Out on the steppes, the light is phenomenal and the scenery, with horsemen and flocks

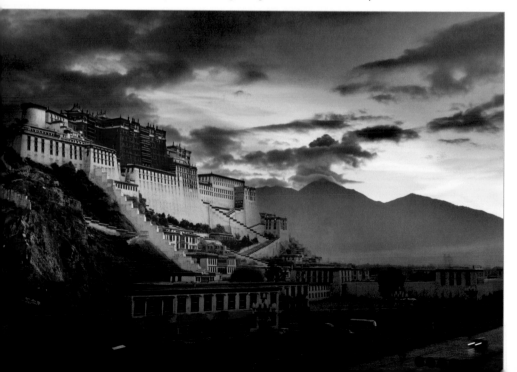

of sheep, is inspiring. Photography is generally forbidden in temples and monasteries, but is okay in museums, monuments and national parks, where a small fee is charged.

Yangtse River, China

The Three Gorges Dam, opened in 2008 and displacing 1.3 million people, has taken a little of the glitter off this classic river cruise. Nevertheless, the Yangtse's gorges are still dramatic – a wide-angle lens will get it all in, but will reduce the drama. Stick to a standard lens for the best results.

OCTOBER

Angkor Wat, Cambodia

There is no getting around the tourists at this phenomenal sight, so you could use the trick of taking several pictures to make them disappear (*see page 304*). Nearby Siem Reap, a poor town with burgeoning tourist hotels, is full of visual ironies. But check out the other temples nearby, which look timeless in the early morning light.

Arizona and Utah, USA

It's hard to take a bad picture in this part of the American Southwest, and at this time of year the colours of the rocks and earth are rich and warm. There's also a chance of storm clouds as monsoon weather threatens, which is always dramatic. Go during the week to avoid crowds and look out for the interesting *Arizona Highways* photographic magazine, or visit their website: www.arizonahighways.com

Bhutan

From subtropical lowland to dramatic mountains dotted with ancient monasteries, Bhutan offers a wide variety of subject matter. Added to this are colourful festivals and good trekking possibilities. It is a uniquely expensive country to visit, so your pictures will be at a premium. And it is a once-in-a-lifetime trip.

Kerala, India

The best time to visit this photogenic southern part of India is from October to April. Street scenes and dance are part of the pleasure. Travel by boat

BELOW:
Along the backwaters of Kerala.

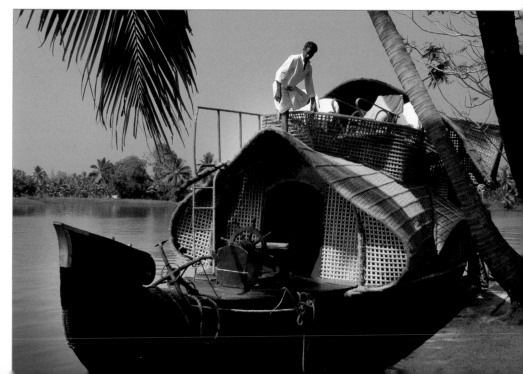

around the backwaters, among the houseboats and fishing nets. A long lens is recommended.

New York, US

You may know it from photographs, but it's nothing like taking your own. The Empire State, Ellis Island, Rockefeller Center… there are so many musts. The skyscraper canyons of Lower Manhattan are designed for creative photographers to play with, and there are fantastic views from Brooklyn.

NOVEMBER

Annapurna, Nepal

October and November are the best times to attempt the Annapurna Circuit, one of the world's great treks, with fantastic view of the Himalayas. There is lots of cultural interest, too, in the villages with Buddhist and Hindu shrines.

Baja California

Sea kayaking here is near perfect. Take a long lens for the whales, dolphins, sea lions and turtles, and keep your

camera in a waterproof bag. An additional waterproof or underwater camera would pay dividends.

Buenos Aires, Argentina

The streets of Argentina's capital turn purple when the jacaranda comes into bloom in spring, adding to the vibrancy of the city and covering the pavements with their brilliant snow. And of course there's the tango – you have to have a close up of those stiletto-toed dancing heels.

Chichén Itzá, Mexico

This is a prime time to visit the best preserved Mayan complex in Latin America. Hire a horse to get a different view of the site and its surroundings, and take a long lens for bird watching. Tourists are bussed in from the coast between 10am and 3pm: stay at a hotel near the site to see it at less crowded times.

Marrakesh, Morocco

The souks and bazaars offer a special challenge for photographers and they can be richly rewarded. The colours here, of cloths and spices, are magnifi-

BELOW LEFT: Exquisite tilework in Marrakesh. **BELOW RIGHT:** The Empire State Building in New York.

cent: and it will be a test of your skills to negotiate people pictures. Hiring a guide for the day is one answer.

Day of the Dead, Mexico

This is an extraordinarily macabre annual event, of skeletons and skulls, altars and tableaux, music, masks and costumes. Add some fireworks and you have a brilliant photographic assignment anywhere over the country.

Venice, Italy

There is a melancholy air to Venice after the visitors have left, and Venice adds to this with sea mist and rain, the puddles reflecting the architecture admirably. This is a place to think about details, and about the sombre side of La Serenissima.

DECEMBER

Agra, India

Go for the obvious and see how you can improve on it: the Taj Mahal under a full moon. October to March is the time that most people visit, as the

weather is cool. Yes, it can get crowded – so photograph the domestic visitors and fly-by tourists.

Andaman Sea, Thailand

This paradisiacal corner of the planet has everything going for a photographer: hundreds of islands and turquoise waters that look as if they have been Photoshopped, plus beautiful sunsets. It's a place for underwater photography, too.

Rio de Janeiro, Brazil

Ipanema, Copacabana ... the beaches are, of course, the place for people snapping – just be careful to keep the sand out of your camera. For a more spectacular view of the city, take your camera hang gliding.

Shibam, Yemen

In the "Manhattan of the Desert," hundreds of high-rise mud-brick buildings huddle together, like a mirage out of the desert. The city presents wonderful photo opportunities, and anybody looking at your pictures is liable to be infected with the travel bug. ❏

BELOW:
The Grand Canal in Venice, with the Rialto Bridge.

Moveable Feasts

Chinese New Year You can catch this in cities around the world, usually in February. Best places to go are Hong Kong and Singapore. Set your aperture to "Sport" to catch the swirling dragons, or just keep the video rolling.

Carnival It happens all over the Catholic world, usually in February, though some years it slips into March. Nice, Tenerife and Rio de Janeiro are the biggest pre-Lent carnivals, providing fantastic opportunities for brilliant pictures. Look out for other local winter folklore events, from Belgium to Bulgaria, that take place at this time of year.

Ramadan Once the sun goes down the fun begins: around Saltanahmet in Istanbul, and in Cairo and elsewhere in Egypt when coffee houses are open through the night and nobody seems to sleep.

✺ INSIGHT GUIDES AT HOME
TRAVEL PHOTOGRAPHY

P REPARATION

What to Take and Planning the Journey

Though much of the pleasure of journeys lies in discovery and surprise, prior planning pays the dividend of getting you to places at the right time and not missing out on something that might be happening just down the road. This of course is why travel guides were invented, and you wouldn't expect us not to sing our own praises.

Maps are also essential, although consider Google Earth as a free online resource. As photographers we can also gain all kinds of information from looking at already-published good photography of the destination. Apart from our guides, look for any recent or notable coffee-table books.

While travel guides such as our Insight Guides have the advantage of presenting carefully researched information that has been edited for usefulness and packaged in one convenient volume (that works without power, needless to say!), online resources are immensely valuable if you know how to filter through the huge numbers of sites

that may or may not contain the information you are looking for. Google Earth, for example, is an amazing resource of maps and satellite imagery. There are also many weather sites that will give not only forecasts for any destination, but satellite overviews to give you an idea of moving weather patterns.

Equipment

The amount and kind of equipment depends on the level of commitment you are making to the photography in your trip. It will also depend on whether you already have your preferred camera and lenses, or are using a forthcoming trip, and this book, to guide you.

Digital cameras now come in a bewildering variety of types, with no general agreement on how they should be classified other than at the inexpensive end (compacts, aka point-and-shoot) and at the high end

(digital SLRs with interchangeable lenses, abbreviated to DSLRs). In between, manufacturers continually try to set themselves apart with different styles, but we call all of these – from high-performance compacts to fixed lens SLRs (including super-zooms) to non-SLRs with interchangeable lenses – mid-range cameras. If you are choosing for a trip, the real factor is how much a part of your travelling photography will fill. And if you will be travelling with DSLRs, consider having the sensor cleaned professionally before you leave.

Level 1: Light and easy

For travellers who want to enjoy recording what they see and experience but who do not want to obsess about photography. A compact will probably do, but certainly not a camera with interchangeable lenses.
1 x compact camera
1 x extra memory card
1 x image storage drive
1 x notebook

Level 2: Photography a part of travel

When the photography is important, even essential for full enjoyment of travelling, but does not actually drive the journey or take first place.
Camera A mid-range camera will be fine for this, or else an entry-level DSLR with perhaps two zoom lenses.
1 x mid-range camera, eg a superzoom, or non-SLR that accepts interchangeable lenses, or entry-level DSLR.

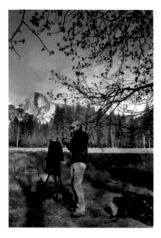

Accessories
1 x charger for camera battery with cable
1 x multi-socket adaptor.
1 x pocket tripod
1 x extra memory card
1 x card reader (with USB II cable to connect to laptop unless it fits directly into a port)
1 x small cloth for wiping down wet or dusty equipment
1 x image storage drive (unless you are carrying a laptop, in which case a card reader and SB II cable)
1 x notebook

Level 3: Committed to photography
For those of us who consider ourselves first and foremost photographers, with the goal being an exciting and successful photo-take by the end of the journey, possibly even with some sales in mind. Definitely a DSLR with a range of lenses that covers wide-angle to telephoto, and a full complement of accessories.

Camera
1 x DSLR body
1 x charger for camera battery with cable
1 x multi-socket adaptor
(optional) 1 x spare camera battery, fully charged
(optional) 1 x spare body. Expensive but good insurance. If you have already upgraded from one model to a newer one, perhaps take the old body along for this purpose.

Lenses
1 x wide-angle zoom
1 x telephoto zoom
perhaps 1 x speciality lens such as a macro, depending on your special interests
All fitted with UV filters. And lens shades for all.

The pros and cons of a tripod

The idea of tripod shooting tends to divide photographers, particularly those travelling, for whom movement and flexibility are paramount.
Pros For low-light shooting, such as a night-time landscape or a dimly-lit interior, they are almost essential for professional results, as they permit low ISO and small apertures.

They also allow you to shoot water in slow motion for that misty, slow-motion effect for seascapes, waterfalls and streams. Another use is multi-shot panoramas; indeed any multi-shot technique described under Processing.
Cons Against this, a tripod is extra bulk and weight, and you may consider that the extra noise from a high ISO setting *(see page 103)* is a small price to pay for being always to shoot handheld.
What to choose When choosing one for travelling, go for light, strong and foldable. Materials such as carbon fibre, though admittedly expensive, are ideal. The tripod should extend to head height, but if

it has, say, four telescoping sections it will still fold up compactly. The tripod head is every bit as important. Ball and socket heads are the most compact, but an additional rotating head is great for panoramas.
Pocket tripods There are also smaller and lighter-weight alternatives. A pocket tripod is not to be dismissed out of hand, because while it offers you no height, it does fix the camera, and can do all that you might need if you can find a surface to place it on, such as a low wall, a table, counter, or even hold it on one side against a vertical wall. One tip: always hold a pocket tripod to increase pressure against the surface.
Monopod Another possibility for stability is a monopod, which can also double as a walking stick; in fact, adding a small tripod head to a trekking pole also works very well. A monopod should enable you to reduce substantially the maximum shutter speed for a handheld camera.

Filters
1 x rotating polarising filter. Most other front-of-lens filters such as colour-balancing or graduated are redundant because the same effect can be achieved when processing, but only a polarising filter can create those dark rich skies, heighten contrast and control reflections. Maybe more than one, depending on the diameter of your chosen lenses.

Accessories
1 or 2 x extra memory card(s) in sealed holder
1 x card reader (with USB II cable to connect to laptop unless it fits directly into a port)

1 x rubber bulb blower brush for very occasional dust removal from sensor
1 x small compressed air can, not for sensor cleaning but for cleaning dirt from corners on camera body and lens barrel
1 x small cloth for wiping down wet or dusty equipment
1 x small flashlight for working in low light
1 x sun compass, though the equivalent and even more effective is available as an app for some mobile phones, such as the iPhone. (optional but recommended)
1 x tripod, with carrying strap or case. If not, a pocket tripod.

PREPARATION
PROCESSING
SHOWING
GLOSSARY

music player like an iPod. And remember that once you have had to format the camera's memory card once full, to make room for new images, the copy you downloaded to the laptop is no longer a backup – it is now the only copy. Travel photography professionals use the laptop for primary storage and at least two independent hard drives for backup – and, naturally, store the backup drives in different pieces of baggage! In any case, the principle of backups is that a small amount of effort and planning insures against the unthinkable.

Laptop on the road

Carrying a laptop as extra baggage when you travel is not to everyone's taste, but it certainly has advantages for committed travel photographers. As just mentioned, a laptop makes it easy to manage downloading and backing-up, but it also allows you to

review, edit and process images as you travel.

One tip is to process small versions of selected Raw files soon after you have shot them and while the image is fresh in your mind. In Photoshop, for example, the settings, however complicated, including dodging and burning, will be saved as a small separate file, called a sidecar file, and

(optional) 1 x quick-release plate and camera plate for tripod head
(optional) 1 x on-camera flash, if your camera does not have one built in
(optional) 1 x spirit level that attaches to camera's hot shoe
1 x collapsible reflector for portraits and lighting shadow areas
1 x GPS (optional), though some cameras have this built in
2 x pocket-sized independent hard drives (at least 100 GB each) with connecting cables
1 x notebook

Power and cables

Digital photography is hungry for power, and lost without it. Precaution #1 is to make a list of the power accessories you need for all your equipment (see above for a starter list), and check them off as you pack.

Mains power comes in two flavours, 110–120v and 220–240v, but fortunately most chargers accommodate both. Less convenient for travellers is the range of sockets and plugs, which include American two-pin (straight), European two-pin (round) both thin and thick (shaver sockets are usually the latter), British three-pin (square) and the angled two-pin (sometimes three-pin) favoured in Argentina, Australia and China. There are a number of websites giving this information, including the old stand-by Wikipedia (http://en.wikipedia.org/ wiki/Mains_power_around_the_world). A travel multi-adapter will get you through these, and for such exotica as old-style British large and small three-pin (round) as found in parts of India, the easiest solution is to buy an adapter locally.

Be warned that hot-wiring in an emergency (stripping the cables

and inserting the ends into a socket with matchsticks or toothpicks) is dangerous! There are alternatives to mains power, including portable solar chargers and an inverter with a car lighter attachment (inverters step from DC to AC).

Backing up

Digital images are unfortunately as easy to lose as to take. While memory cards are extremely reliable and technical failure unlikely, human error, loss and theft can result in irreplaceable loss,

Human error includes hitting a delete button, mistaking a card with recent images on it for an empty one, and overwriting filenames. The essential precaution, always, is to make at least one copy of your images.

On a trip of any length it is unlikely, also, that your memory cards for the camera will have sufficient capacity. If you are carrying a laptop with you, the procedures are simple: First download images daily onto the laptop's hard drive; then, for extra precaution, copy these downloaded images onto a removable, stand-alone drive, such as a pocket hard drive or a mobile phone or a digital

Breakages and Repairs

Damage, such as from dropping a piece of equipment, is bad news at the best of times, but more so on the road, far from your friendly service centre. Frankly, there is little you can do in the case of an internal failure with a digital camera, but there are solutions to such things as a broken part from a lens shade. Be very wary of dismantling equipment

unless you are thoroughly familiar, but if you can see what is wrong and it is mechanical, you may be able to work on it. Two items are useful: one is a small roll of duct tape, which is strong enough to hold anything together, and a two-part bonding agent such as Araldite, for sticking things (like that bit of lens shade) back securely.

when you return home this will make a useful starting point for the real processing of full-size images.

A laptop has another advantage on the road, which is to give you access to most of the destination research you are likely to need, as mentioned above.

Packing and carrying

When it's not in your hand, a camera needs some sort of case, and unless you have simply a compact or a mid-range camera with a fixed lens, you will almost certainly benefit from a camera bag carried on the shoulder. There are alternatives, such as pouches that strap to the waist, or a multi-pocket photographer's vest, but the shoulder bag is the classic. It can be light, simple and unobtrusive (good if you don't want to look like a photographer), or padded out with lens and other compartments. Points to watch for are rapid access (as part of this, adjust the strap so that it sits at a convenient height relative to your waist) and a secure cover or flap so that access to others is restricted! Tough and weather-proof material is a distinct advantage for the traveller. This is the bag to work from when you are out shooting, but if you have a serious amount of equipment, as in Level 3 above under 'Equipment', you may find it worth investing in a camera case for transport. This needs to be tough enough to stand knocks while holding its contents softly, and lockable. Camera bags with wheels and retractable carrying handles are popular among some, while others favour the camera backpack style.

THINGS TO CONSIDER

Distant travel almost inevitably pitches you into cultures and situations that are unfamiliar, and what you might not think twice about photographing at home may carry some sort of restriction abroad. The issue for photographers is usually one of permission and access: can I shoot? As you can see below, the possible restrictions tend to be either cultural, or official and legal.

Local regulations

Formal, official restrictions have the virtue of normally being well posted. **Military bases**, **airports** and **docks** are, in fact, restricted for photography in most countries of the world, but there may be local

additions, such as bridges in India. It is also generally better to avoid photographing **police**, except tourist police and those in such well-known tourist spots as central London and Times Square.

Be aware also that some countries (France, for example) have stricter privacy laws than others; in general, you can photograph freely in public places, but not always from a public place to a private property.

International travel

In these days of everyone carrying cameras, negotiating customs should be no problem, unless you are moving a lot of expensive equipment through a country with corrupt officials or a remote border checkpoint, in which case do not make a show of them.

For your own country's customs clearance, you may find it wise to take with you proof that you purchased

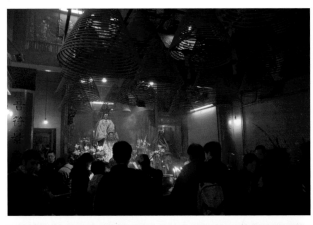

Local customs that should be observed

Local customs are not necessarily the same as yours, although broadly speaking, human nature is more similar than different internationally.

Good manners and a ready smile will ease your way through the vast majority of culture-shock situations. Human nature and general social conduct tend to override exotic cultural differences, and as a foreigner (a polite foreigner, that is) you will usually be given dispensation for not knowing all the local customs.

The majority of situations in which photography is not welcome divide into two: those that stem from religion, and those from national pride. Many of the former apply to and around places of worship (which also tend to be interesting places to photograph), and it's important to both ask and to watch out for signs prohibiting photography.

Christian places of worship tend to be more relaxed than most, except for some sects, while many Muslim and Hindu places of worship prohibit photography inside. But ask first and you may find there are ways of getting images – for example, you my not be allowed (if a non-Muslim)

into a mosque, yet find that you can photograph the interior from the steps outside. You may be able to take pictures inside Buddhist temples (see above).

Religious restrictions may extend beyond the place of worship, most notably in the case of Islam; in many Islamic countries, it is not done to photograph women.

While not strictly to do with photography, removing footwear when entering a house and some other buildings is practised in some Asian countries (notably Japan, Burma, Thailand, Laos, Vietnam, but also parts of India and Indonesia), and is important to remember.

The other source of restrictions stems from national pride, and includes photographing poverty and, sometimes, minority ethnic culture. This last varies widely, because while a source of pride (and tourist revenue) in some countries, in others where there is internal conflict there may be problems. Ethnic culture and dress may even be considered officially a sign of backwardness. Overall, in any doubtful situation, first observe what other people do, and second, ask permission.

your equipment at home. If you do decide to take advantage of lower prices in, say, Hong Kong, check that the duty in your own country will not negate the discount (and that duty may vary between cameras and lenses). Remember, by the way, to re-set your camera's date and time information to your new destination. If you forget, some browsing and cataloguing software will later allow you to correct this, but it is tedious.

Security and insurance

It may sometimes look as if everyone in the world has a camera, but they remain a target for theft. The simple solution is to carry your camera at all times, but unobtrusively when you are not using it. Always be attentive, and watch out for the occasions when everyone is most vulnerable, such as boarding a bus or train or checking in at the airport, or simply just too excited by a photo opportunity to pay attention to anything else.

If you travel with a companion, one person should always be with the baggage. And little things, such as if you sit at an open-air cafe, put the carrying strap of your camera bag inside one leg of your chair. Carry a lock and either chain or reinforced cable for other occasions. Should you insure? If you feel unwilling to cover the cost of replacement yourself, then yes. But be aware that insurers will only pay up if the loss or damage was not your fault. That would not include carelessness such as leaving a camera bag in a cafe or, worse still, in an unlocked and unattended vehicle.

Protecting your camera

If your journey will take you away from the normal routes and conveniences, you will need to consider power for battery recharging and so on (see "power and cables"),

and also which, if any, of the following physical conditions that are potentially harmful to equipment may apply: dust, water, heat and cold. Dust is a killer, especially to any exposed moving part, which includes focusing and zoom functions on a lens. Keep equipment sealed when not absolutely needed, and also consider taking a set of ziplock plastic bags. You can even work a camera by putting it in one of these bags, then cutting a hole for the lens and securing this with a rubber

band around the lens. This simple technique also works in rain. Most heat and cold problems arise from sharp temperature changes (from moving in and out of air-conditioning or heated interiors) that can cause condensation on external and internal surfaces. The solution to this is either to make the temperature change gradual if possible (such as moving in out of the cold first to a porch or entrance before moving into real warmth), or to seal the equipment inside a box or case.

Cleaning sensors

Interchangeable lenses, which are the great advantage of DSLRs, also create an ongoing problem, as dust can enter the camera body when you remove them. Even the tiniest speck that makes its way to the sensor will leave an annoying dust shadow on the image, and although software like Photoshop has clever tools to repair the blemish seamlessly, the ideal is a perfectly clean sensor. Some cameras have partial solutions, such as mechanically shaking the sensor slightly to dislodge dust, but in the end, your sensor will need occasional cleaning. The Catch-22 here is that camera manufacturers strongly recommend you don't touch it yourself because of the major risk of scratching it, and yet they charge considerably to clean it for you.

First, before (and after) a trip, check for dust shadows as follows: stop the lens down to minimum aperture, aim the camera at any plain surface like a wall or bedsheet, de-focus the lens as far as possible, use auto metering but set a long shutter time, like one second, then take the picture while moving the

camera around. The result should be absolutely no detail in the image and a grey-ish mid-tone. On preview, zoom in to the maximum and scroll along the entire image. If there is dust, it will be visible. If so, either spend the money for cleaning or attempt it yourself.

There are two levels of cleaning: non-invasive and full-contact. For the first you need a squeezable blower (not one with propellant, and not your own breath for fear of spitting) and a small torch. Operate the camera's cleaning mirror lock-up function with the lens off, and in a really clean environment shine the torch onto the sensor and look for dust (maybe with a magnifying glass). Blow thoroughly. This is something you can also occasionally do while travelling (but always in clean still air). The full-contact method involves a cleaning kit, available from professional dealers consisting of sealed one-use-only swabs and a solvent specifically designed for the kind of sensor you have. The risk of damage is entirely yours, and fully successful cleaning is not easy, especially around the corners.

PROCESSING

GETTING THE MOST OUT OF YOUR IMAGES

Back home from a trip comes the pleasurable experience of reviewing and collecting together all the images. And to make sure that it is pleasurable, there are a number of procedures to follow, partly safekeeping, partly housekeeping. The aim is to transfer all the images, in a logical order, onto a secure hard-drive so that you can then begin looking at them, selecting and processing.

Downloading safely

The very first thing is to download the image files to a secure location. Secure means a hard drive that stays at home, whether on a home computer or as a separate, removable hard drive.

Depending on how many images you have taken and how much hard-drive space they occupy, you should, by the end of the trip, have at least two sets (see "backing up" on page 296), perhaps one on a laptop and another on a small external hard-drive, or on a dedicated portable image storage device.

Also recommended is a second copy of all the images on a second hard-drive, known as a back-up. Don't skimp on a back-up, which you should keep physically in a different room. The reason is that digital files, so easy to save and transfer, are easy to

lose and delete by mistake. There is also a small possibility of a hard drive becoming corrupted.

The consequences of losing images that were hard-won on an adventurous journey are not worth comtemplating!

For even extra safety, some photographers make a copy on non-magnetic media, such as DVDs. A very basic way of downloading files, once you have hooked up your portable drive to the home hard-drive, is simply to drag and drop them.

You have better control, however, as well as the chance of re-naming them, if you use a browser, of which there are many available, including the basic software that comes with most cameras.

Organising

Organise your images in a logical way, which typically means folders within folders. There are two steps involved:

one is to decide the hierarchy of folders that suits your way of working, the other is to number or name the images consistently. Remember also that the images from this recent trip have to fit in with your other images. Recommended if you do much travelling is to make a nested hierarchy of folders, by place or by time, or both.

Captioning and keywording

One of digital's great advantages is that all kinds of information can be embedded in the image file. Indeed, many of the camera settings are transferred automatically.

Later, using almost any software that allows you to view the images, you can add information that only you have, such as the location, what was happening, the names of people in the images, and so on. If you want to sell images, this is absolutely essential, because potential buyers

Numbering and naming strategies

• All your images in a single number sequence, with or without your initials at the beginning, eg 000002345.jpg
Pros: simple. Cons: long numbers, and not all software reads numbers the same way, meaning that you might have to begin with a string of zeroes; also difficult to correct mistakes.
• Two-part number organised by overall sequence, eg 321_139.jpg Pros: organisationally simple, allows second part of number to be small. Cons: need to remember first-part sequence.

• Two-part or three-part number organised by date, eg 2010_01234. jpg or 2010_March_103.jpg Pros: easier to search. Cons: None.
• Two-part number organised by place, eg Tanzania_0436.jpg Pros: easy to search, descriptive for travel photographers. Cons: need to remember that different trips to the same place go in the same main folder.
• Add description to any of the above, eg 321_139_zebras.jpg Pros: descriptive. Cons: makes name longer, maybe too long for some software.

Inspector Import New Email Slideshow

Projects | Metadata | Adjustments

General

Rating:	
Badges:	
Caption:	Little Karim
Keywords:	Hushe King
Version Name:	DSC_0365
Image Date:	09/09/2008 05:34:15 BST
Aperture:	f/7.1
Shutter Speed:	1/640
Exposure Bias:	-0.7ev
ISO Speed Rating:	ISO 200
Focal Length (35mm):	120.0mm
Focal Length:	80.0mm
Lens Minimum (mm):	18.0mm
Maximum Lens Ap...:	5.0
Lens Maximum (mm):	135.0mm
Lens Model:	AF-S DX Zoom-Nikkor 18-135mm f/ 3.5-5.6G IF-ED
Pixel Size:	2592 × 3872
File Name:	DSC_0365.JPG
File Size:	4.04 MB
Credit:	Gulliver Images
Copyright Notice:	
Object Name:	
Camera Model:	NIKON D80
Project:	Pakistan 2008

Keywords EXIF IPTC Other Archive

search for images online by entering relevant words. Hence, enter relevant keywords for all your saleable images.

If you are travelling with a laptop (see page 296), a useful tip is to do captions and keywords as you go along, on the road and while the facts and places are fresh in your mind. There is often "downtime" in a journey, such as waiting at an airport, or on a train, or even just a lazy morning spent in a losmen in Indonesia, and you will appreciate these little spurts of effort when you get home and are looking at hundreds, even thousands of images.

PROCESSING IMAGES

What happens next, after storing your images safely on either the computer's hard drive or a separate hard drive, depends on how you chose to shoot them.

Going back to image format under Camera on page 105, if you shot JPEG or TIFF, your images are already processed. This doesn't mean to say you can't improve them, but the procedure is different.

If, however, you shot Raw, you not only can but must process them, and it's at this stage that you really choose how the image will look, bringing out all the best qualities of richness, colour, brightness and tone.

Workflow checklist

• **Check the Auto suggestion**: all processing software has a default auto adjustment, which the engineers have thought long and hard about. Try it out, if only to get a second opinion. It may be perfect for you, and if not may make a convenient starting point for...
• **Set the black and white points**: except for special cases like foggy or misty scenes, most images look best when the darkest tone is just black and when the lightest tone is just white, but with no clipping at either end. Always do this before adjusting the overall brightness so that you can judge that next step better. The procedure depends on the software. In Photoshop, leave the highlight and shadow clipping warnings on, then drag the Exposure slider until just before the highlight warning comes on, then drag the Blacks slider until just before the shadow warning comes on.
• **Adjust the mid-range**: keeping the darkest and brightest points a fraction short of clipping, brighten or darken the image overall until it looks right. The main peak of the histogram should be near the middle for a typical image.
• **Set the white balance**: either choose from one of the presets in the list, or use the grey dropper on any part of the picture that you know ought to be neutral (such as a shadow on a white wall, or unpainted concrete).
• **Local adjustments**: The better software now allows you to dodge and burn. This alone should convince every photographer to shoot and process Raw; it takes advantage of the exposure range from Raw's extra bit-depth. Ansel Adams (see page 138), the epitomy of a "straight" photographer, made great use of local adjustments. He wrote, "A certain amount of dodging and burning was required to achieve the tonal balance demanded by my visualization."
• **Sharpening**: this should always be the last action on any image, because although it has the effect of making the image look crisper and livelier, it also throws away some image information and, if you overdo it, introduces unpleasant edge effects. The right amount of sharpening depends on how an image is going to be displayed, so always check it like that – on-screen, or as a print.

Accordingly, here we have first Raw processing and next, post-processing, which you can do to the JPEGs and TIFFs, and even to the just-processed Raw files that you will have saved as JPEGs or TIFFs. There are now many programs that will do a similar job, combining processing and post-processing, including Photoshop, Photoshop Elements, Lightroom, Aperture, Corel PaintShop Photo, DxO Optics, OnOne Phototune, and also software from camera manufacturers, some of which is available at no extra cost.

Raw processing

There are now more than 200 different Raw formats, as camera manufacturers devise their own – there is no standardisation. This demands that the software developers keep up to date, and naturally the main ones do. Don't be worried, by the way, if you hear any scaremongering about not being able to open the files at some date in the future; in the world of computing, Raw formats are not rocket science.

The heart of the software for processing a raw image is called a Raw converter, and it may stand alone, like Adobe's Camera Raw which Photoshop uses, or be buried within a lot of other post-processing choices, as happens in Lightroom, Aperture, DxO Optics and most others.

Raw processing software does three main things automatically, before you get the chance to make your own adjustments: it works out the colour from the Bayer filter in front of the sensor; it applies a tone curve to lighten the recorded image, which is always darker than acceptable to the human eye; and it applies a colour "look" from built-in profiles or from your own (see "camera profile" opposite). All of this is hidden from the user.

Raw processing allows you sidestep any of the processing settings that the camera menu offered and go directly to the raw data. White balance is a good

Camera profile

This can be a once-only set-up and still be very useful. The idea is to make a tiny file exactly for your camera that can be stored and pulled up in the Raw processing software. Fortunately, Adobe have one free for download, and it's called DNG Profile Editor, with easily documented steps posted online. The ideal way to use it is to first get a 24-patch colour target, like the Macbeth ColorChecker, and photograph it under even and predictable lighting, such as a cloudy day. Following Adobe's instructions, it's a simple matter to open the shot in the profile editor and create your own camera profile, which for ever after you can access from the processing software (such as Photoshop and Lightroom). The advantage is that the processing will be tailored for any idiosyncracies that your camera model may have.

example of this. You can forget any settings that you had on the camera; here in the Raw processor you can choose again, and from a similar list of presets (sunlight, shade, etc.), and then tweak the colour temperature from bluish to straw-coloured and the tint from red to green.

Raw processing also lets you recover some darker and lighter tones in many images that would otherwise have been lost during in-camera processing. The reason is that the raw format has a greater bit-depth and so a greater potential dynamic range (the actual dynamic range depends on the camera's performance and on the scene). This makes the Exposure control more important than the simpler Brightness control.

In fact, the latest crop of processing software have so many sophisticated features, including local adjustments with brushes and gradients, that the options can be confusing at first. This is why experienced photographers devise their own workflow for processing. This means following a set procedure in order. There are many options, but the one we summarise on page 300 is fairly standard and covers the key points.

While it may not seem completely obvious at first, it is important for most images that their range of tones fills the range from black to white. If not, they will have a slightly "flat" appearance. Technically this is called setting the black point and white point, meaning that the darkest tone in the image should be right on the edge of being black, and the lightest tone should be right on the edge of being white. Different processing software deals with this in different ways, but all will show the histogram, and all have some kind of indicator for "clipped" highlights and shadows (see also page 109 in Camera).

The standard procedure for most images is for the shadows and highlights to be almost, but not quite clipped (a few situations, such as a soft misty scene, may be better left "flat"). With the image's tones stretched out like this, you can then adjust the overall brightness to your preference; this means in reality lightening or darkening the mass of

middle tones, which is usually where most of the interest in a photograph lies. A point to note, however, as in the panel on page 300, is that software manufacturers go to a lot of trouble to devise automated settings – typically you click on Auto or a similar button – and very often these will do the best for the image. At the least, they are always worth trying out to see if you like the result before continuing. When you save your processing settings, it is never as Raw (by their nature, Raw files cannot be over-written, which is also good protection against mistakes). The usual choices are JPEG for emailing and sending to websites, TIFF for storing on the computer and for printing, or DNG, which stands for Digital Negative and is a kind of quasi-Raw format supported by most software.

Bit-depth

The terms 8-bit and 16-bit are often used in processing and post-processing. You also hear about cameras capturing images in 12-bit and 14-bit and saving them like this in Raw files. And 32-bit crops up when you use HDR (see page 303). All of these are shorthand for "…per channel", and they refer to the bit-depth of an image. Bit-depth means the number of bits of information used to record the colour of a single pixel. The more there are, the more accurate the result, and also, the greater the potential dynamic range. However, 8-bit images have more colour information than our eyes can see, some 16 million, and almost all computer monitors are 8-bit. So the need for greater bit-depth when processing or adjusting images is only during processing, because at the end the image will be turned into regular 8-bit. Received wisdom has it that you should do post-processing in 16-bit rather than 8-bit, so as to avoid such possible blemishes as "banding" in smooth areas like the sky. In theory this is true, but the differences between 16-bit and 8-bit editing are usually impossible to notice in a final image.

Post-processing

If you chose not to use Raw when photographing, and saved JPEGs or TIFFs instead, then your images are already processed, an important distinction. Nevertheless, many of the same controls will work: brightness, saturation, contrast, colour balance and so on. The difference is that the processing doesn't have access to all the original capture data, and so there will be some loss of quality.

All this is obvious in Photoshop, but other processing software designed for photographers, even Lightroom (which is from the same company as Photoshop), obscure the difference. Nevertheless, even if you

saved JPEGs or TIFFs, it is still very likely that they can be improved in brightness, contrast, colour balance or saturation – or all of these.

However your processing of software presents its capabilities, it still makes sense to follow something like the procedure described in the Workflow checklist box. A word about maintaining image quality, and this applies also to any extra work you do on already-processed Raw images that have been turned into JPEGs or TIFFs: it's a wise precaution to convert these 8-bit images temporarily into 16-bit while you work on them, as the box Bit-depth on page 301 explains. Actually, some processing software does this automatically without

making a fuss, and returns a normal 8-bit image at the end. Unfortunately, the large range of processing software available, and the inevitable desire of their manufacturers to make each one seem special and different, means that you cannot avoid investigating this kind of working detail before deciding which one to buy and use.

Post-processing offers extra procedures that go beyond normal processing choices. One of these is local lightening and darkening with enhanced contrast in a way quite different from dodging and burning by hand. It uses sophisticated calculations, and is a feature of top-level software such as Photoshop (which calls it Highlights/Shadows).

For pulling detail out of dark shadows and recovering very bright ones it is invaluable, although it needs to be used with some restraint if you want the result to look natural.

Another post-processing feature is drastically altering the "look" of a photograph, such as giving it an antique look, or sepia-toned, or adding some punch. In fact, once you get into the world of third-party plug-ins, there is no end to the special effects that you can apply to any image. You want to add some motion blur to the camel race you photographed in Morocco? Yes, possible. Or add some selective de-focusing to a view of Venice that makes it look like a toy scene? Of course. All things are possible, though

The common processing tools

Different processing and image-editing software present these tools differently, sometimes with different names, but the following are the most common tools for processing digital images.

Exposure/Brightness Usually a slider. Strictly speaking, Exposure is reserved for Raw processing, where there is often extra dynamic range.
Contrast Usually a slider.
Saturation Usually a slider, increasing the richness of colour. A variety of this is **Vibrance**, which protects from clipping.
Levels A slider below a histogram. Alters brightness, contrast and is also a way of setting the black and white points.
Tone curve A 45-degree adjustable line that allows more delicate adjustments than does Levels; adjusts brightness, contrast.

Black point tool A dropper used to select a point on the image below which value everything is black.
White point tool A dropper used to select a point on the image above which value everything is white.
Gray point tool (White balance tool) A dropper that sets whatever point on the image is clicked to neutral grey, shifting all other colours to fit.
White balance One or two sliders to adjust colour temperature and red-green.
Chromatic aberration Sliders that correct colour fringing on contrasty edges.
Sharpening tool Applies sharpening to detail across the image
Noise filter Reduces the appearance of noise, although often at the cost of some loss of sharpness.
Crop tool Drags in the sides to change the shape and size of the frame.

Straighten tool By drawing a line along any line in the image that you want to be horizontal or vertical, automatically rotates the image to straighten it.
Spot remover A brush that repairs dust shadows and blemishes by replacing the area intelligently with surrounding pixels.
Local adjustment brush A brush that is combined with some of the above tools, such as Brightness, Contrast, Colour Balance to make adjustments only on selected areas of the image.
Local contrast adjustment Set of sliders (Shadows/Highlights in Photoshop) that adjust detail, contrast and brightness in local areas automatically.
Grayscale converter Set of sliders that turn a colour image ito monochrome, allowing individual colours to be converted to specific tones of grey.

they may stray from the idea of simply documenting a journey.

Perhaps one of the less drastic additions that you can make to a digital photograph is to give it the look of a particular film. Kodachrome, Tri-X and Polaroid in particular were, in their time, both distinctive and popular. A number of software programs now offer this, accurately worked out, and the result is not so much a special effect as a subtly different version.

Black-and-white

Earlier, on page 158, we looked at when to think about black-and-white instead of colour. In film, this was an irrevocable choice right at the start – you loaded a roll of black-and-white negative film and that was that. Now, however, things have changed completely with digital, because in one or two processing clicks you can create a black-and-white image from colour, and with amazing control over

the tones. It certainly helps to think in monochrome when you're taking the picture, but all the advantages in making the final image lie in post-processing. Some cameras have black-and-white or sepia settings, but while it may be tempting to shoot like that because you get an immediate result, it is much better to think like that but shoot in colour, then do the work later on the computer.

Actually, shooting in black-and-white takes away the many options that we'll describe now. However, if your camera allows you to choose Raw and black-and-white, then you will get a black-and-white preview, which is useful feedback, but you will still have all the colour information in the Raw file.

The reason why post-processing is the place to create black-and-white is because processing software can use the colour information captured at the time to let you choose how dark or light you would like each colour to be.

The closest film equivalent to this is putting a strongly coloured filter over the lens when taking the photograph, and adjusting the exposure to suit, but even this doesn't come close to the control you now have digitally.

Software programs treat this in a variety of ways, but most feature sliders for each colour (red, blue, green, yellow and more), and when you make the black-and-white conversion, you raise or lower each slider to lighten or darken the tone.

For example, you have a colourful Caribbean carnival scene in front of a blue sea. One dancer has a bright red dress. The software allows you to choose between, say, an almost-white dress against a dark sea – or vice-versa. This is an obvious example, but all kinds of subtlety are possible. You can tweak some greens in a landscape so that they pop out brightly, or gently lighten skin tones on a travelling companion who has had a little too much sun.

Saving the image as Grayscale may seem the obvious thing to do, but if you want to add some colour tint, stick to regular RGB.

Exposure blending/HDR

Back on page 63 we introduced the relatively new concept of bracketing exposure in contrasty (high dynamic range – HDR) situations as a way of capturing all the tones in a scene. This is not the same as just bracketing exposures then choosing the best. There is now software that will first combine a range of exposures (provided that the camera was steady and the scene remains the same throughout), and then convert them to an ordinary TIFF or JPEG that contains all the tones. This has special value in travel photography where you have a range of scenes and all kinds of unpredictable lighting. There are two fully-automated ways of doing this, and both begin with a sequence of exposures photographed in the way described on page 63. Both require special software. The first way is called exposure blending, which merges the images by taking the "best" exposure for each part of the scene pixel by pixel. There are sliders to allow for personal taste, and the results are "realistic" in the sense that the final image still looks like a normal photograph. The second method is HDR tonemapping. HDR imagery is a way of combining a range of exposures into a single image file with a much higher bit-depth (*see box on page 301*) of 32 bits per channel. This part is not at all complicated, but

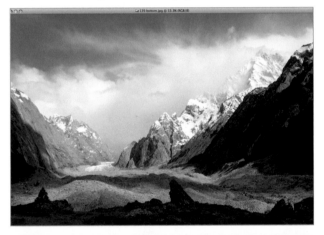

the image is unviewable on a normal monitor, which is only 8-bit. It looks very contrasty indeed. The clever step is converting this HDR image into a normal 8-bit one, and the procedure is called tonemapping. There are now many software programs that will do this, each in a slightly different way, and include Photomatix and Photoshop. The software makes its adjustments to brightness, contrast and saturation in local areas across the image, and in the course of this enhances detail. It is quite tricky to get a result that looks photo-realistic, but many people like the slightly otherworldly effect, particularly on skies.

Removing people

Combining exposures is not the only software post-processing trick that can be useful.

When you're in a popular tourist spot that has just too many other people in view for your liking, such as at a famous monument or archaeological site (see page 195), and you would prefer a more deserted feeling, take advantage of another technique that involves a stack of images that you shoot in sequence. Imagine you are in front of Angkor Wat, it's late afternoon and the five towers are bathed in golden light. Impressive, apart from the dozens of figures scrambling up and down the steps, some in garish T-shirts. Well, there is a solution, as long as the people keep moving, which they usually do in these circumstances, and it doesn't involve shouting at them. Having found your ideal viewpoint, simply stay in exactly the same spot for several minutes, and take the same photograph over and over again, with the people in different positions. As with bracketed exposures for HDR, frame each

image in exactly the same way (though the software can tolerate some differences if you don't have a tripod with you). This is something that Photoshop can deal with later, by means of combining the images in a "median mode". Median is one kind of average, in which single most common feature in a stack of images is chosen. As the people move between frames, as long as you have enough images in the sequence, the software will choose the bits of monument rather than the people. The more images you take, the more successful the software will be at eliminating the unwanted crowds.

Increasing depth of field

Yet another clever image-stacking process that is a boon to close-up and macro enthusiasts and can also be very interesting for landscapes is focus blending. Once again, the camera needs to be kept steady for a sequence of images that are identical in every respect except one – the focus setting. It's an unavoidable feature of optics that at close distances the depth of field is less, and while there are many ways of using this shallow depth of field to advantage, so that for example a tiny insect stands out from the blurred surrounding plants, as we saw on page 236, imagine having infinite depth of field. As long as nothing moves (no breeze wafting a flower head, or a dragonfly that sits still for several seconds), simply compose the image, set the focus to manual, focus on the nearest part of the scene, and then take a sequence of photographs, making small adjustments to the focus of each one until you finally focus on the furthest part of the scene. The software used here for this example shown above is Helicon

Focus, and the procedure is extremely user-friendly: choose the set of images and click for the automated result.

Stitching panoramas

We saw earlier (page 160) how to shoot an overlapping series of images for later combining into an elongated panorama. Back home and at the computer, you can do this with stitching software. Having processed the sequence, which should each have an overlap of approximately one-third to a half, they are then loaded into the software, which does three things: it aligns and assembles them, adjusting the shapes slightly if necessary; then it blends them so that sky tones merge imperceptibly; and finally outputs them as a single image which you can then crop. Because content recognition in computing is now so advanced, the assembly is automatic, although if there are large featureless areas, such as on a foggy day, you may need to help adjust manually. There are many brands of stitching software, including PTGui and Stitcher, but if you already have Photoshop, its Photomerge function is all that you need. The final image will need cropping, and not only to cut out unevenness at the edges if you shot the sequence handheld, but because of natural distortion. With a standard lens, and even more so with a wide-angle lens, swivelling the camera around for the sequence actually creates an image that should project onto a curved surface, so laying it flat as a two-dimensional photograph means that the sides will be taller vertically than the centre. Unless you like this unusual shape, bringing it back to a rectangle calls for using distortion tools in image-editing software, such as Photoshop's Warp.

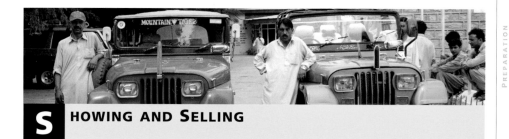

S HOWING AND SELLING

SHARE YOUR EXPERIENCES AND MAKE MONEY

The experiences of travel and journeys cry out to be shared, and as you have captured your experiences (hopefully!) visually and digitally, they are in a near-perfect form for doing this. The best choices for doing this are as a slide show delivered online or on a CD or DVD, but also, of course, they can be printed and then framed and hung, or even prepared in the form of a book.

PICTURE SELECTION

Selecting the best

The first step is to select the top images from all that you have shot. This is an essential and even creative procedure, and while there are many personal ways of doing it, the following is tried-and-tested approach. First, group your images into "intended shots"; for example, you may have taken just one or two of a landscape you were confident

about, or a dozen or more of a portrait where you were trying to capture just the right expression. Second, choose the best from each of these groups, based on framing, timing, expression, exposure or whatever other variable there was. Third, allocate these images into one of three sets: First Selects, Seconds and Overs, based on your value judgment. Overs are basically uninteresting, Seconds are competent, and First Selects should be, by your standards, very good. How you proceed with these next depends on what you intend to do with the images, as below.

Telling a story

Any journey has the potential to become a narrative story, rather than just the source of a number of different individual images, so travel photography more than most other kinds suggests story-telling. The travel sequence and your experiences along the way can be the theme for the

story, or you may find a more compact storyline in one of the events or places you photographed. Given the variety of ways of displaying your images, consider treating your imagery as a narrative, possibly accompanied by a text account. Like journeys, stories begin and end, and these both should catch the attention of a viewer or reader. Particularly if you intend to share your images in the form of a blog or a slideshow, first outlining the story and its sequence, then assembling the relevant images for this, will be very valuable. Think also, in the case of a long presentation (several web pages or half-an-hour or more slideshow), of pacing the sequence of images, varying scale and subject, and building up to your best images.

DISPLAYING

Website and forum

The online choices divide between a blog or similar on your own website, and contributing to picture forums that have their own format, such as Flickr. The latter involves no effort whatsoever, but even your own blog or image gallery is made relatively simple by many programs, even some processing software such as Adobe Lightroom, with already prepared templates. Web design is a subject in itself, but as you are mainly concerned wth displaying photographs, you do not have to be complicated. In fact, from this point of view, the less fancy and distracting (as with Flash, for example), the better. This also argues for avoiding a multitude of colours on the screen, and keeping the

background simple and neutral. White, black, grey are all in their different ways friendly towards photography; other colours or textures are not.

[flickr screenshot image]

Slideshow

Digital slideshow programs such as Powerpoint and Keynote, coupled with music compilation programs such as GarageBand and the movie viewer application QuickTime, make professional presentations straightforward and very accessible. You assemble the images in order, choose a transition and timing for each (simple dissolves are the default), add title and captions, and music and/or a recorded commentary, and the slideshow software can then export the show to a movie format that will play on anything from a full widescreen television to an iPod. The golden rule is, keep it simple and let the pictures speak for themselves, making an exception only for titles to explain what follows. Avoid fancy wipes and unusual special effects. They may be fun to do, but if your aim is to present something resembling a professional travelogue of your best photographs, do you really want visual distractions?

Planning a slideshow is similar to planning a movie or a television documentary, and in the case of travel photography is almost always going to be a narrative. This is where story-telling comes in, as above, and also where the editing you have done into Firsts and Seconds pays off. If you were simply selecting the best, as for a blog or gallery printing, you might wonder about the value of those Seconds. Just as the less-spectacular establishing shots and cut-aways are an essential art of video filming, so the just-competent still images have their use as linking slides and for continuity and setting the scene. Your journey is likely to have more than one destination; it will help to establish a transition from one location to another, and a shot of your transport, for example, might do this, even if the image itself is nothing special. And, speaking of video, if you took along a

camcorder with you (see page 118), consider mixing stills and live action. This can be very effective visually. For example, if you have some great portraits and close-ups in an open-air market, how about preceding these with a slow panning shot from the camcorder from a distance? You can show the result either by making a DVD and sending to friends to view on a computer or television, or use a digital projector and screen (which can be hired). Beware of music copyright restrictions, particularly if you intend to show your travelogue show to what legally constitutes an audience rather than to a few friends. Tempting though it may be to add a famous movie track like *The Mission* or *Seven Years in Tibet*, these are not free for this kind of use!

Printing

High quality digital prints to colour archival standards that exceed those of wet printing are now within everyone's reach, thanks to recent developments in desktop inkjet printing, pioneered by Epson. If you like the idea of making your own prints, these printers, with eight or more inks, are relatively affordable, and there is now a wide range of top quality paper to suit, from manufacturers such as Hahnemuhle, Fuji, Somerset. Otherwise, there are many printing services available, from local shops to online; Kodak for one offers high quality at very reasonable prices (www.kodakgallery.co.uk). If you are planning to show these prints in a gallery-like setting, or just hang one or two on your wall, consider the variety of framing procedures. There are many, but the classic is to first mount the print in a white card matte and then mount this in wood or metal glass-fronted frame.

SELLING YOUR IMAGES

How ideal if we could all pay for our travel adventures by selling the pictures afterwards to travel companies and publishers of magazines, books and websites. It is indeed possible, but by no means easy, as this is a highly competitive and price-conscious market, and it demands a professional approach. There is a considerable demand for good, relevant images, and because the travel industry is so huge, travel destinations and the things and events you photograph along the way have good potential for selling. "Sell"

in this sense means licensing the right to use – almost no-one ever gives up all title to their images. There are standard rates for usage, and they are calculated on such criteria as size on a page, circulation, position (cover or interior if a magazine or book). This might sound daunting, but all the major stock agencies (see below) have online price calculators that anyone can use. Be aware, however, that because so many other photographers also want to sell their photographs, it has become a buyer's market for all but special and unique images, and prices have been falling for some years.

Picture Libraries

The market for travel photography rests mainly in picture libraries (aka stock libraries and stock agencies), and all of these are online, so that potential buyers can search any of a number of sites to look for a particular image. They range from massive sites with millions of images (such as Getty, Corbis, Alamy) to boutique special interest agencies focusing on particular geographical areas or on themes such as ecology. Some are very choosy about accepting new contributors, others (like Alamy) are essentially open to all. It's a good idea to check out a variety of the library sites that you might be thinking of applying to join to see what they have already, and the standard of imagery, so as to decide what better you could offer. And also check their terms and conditions for contributing. They will deduct a percentage of each sale, and this varies from agency to agency, but you could expect to receive more or less half of the sale. Another valuable approach is to make a search of

destinations you have or will visit as if you were a buyer – it can reveal surprisingly useful information.

Worth approaching...

As indicated, many libraries have their established photography suppliers, but if you feel your pictures are good enough there is no harm in approaching them. In addition to the "Big Guns" try the likes of Axiom, Panos Pictures, Still Pictures, Tips Images, AWL Images, Photolibrary.com, Robert Harding.

The so-called Microstock agencies (such as iStockphoto; Fotolia; Shutterstock; BigstockPhoto; Crestock) take a lot of material but the return is usually minimal as each unit goes for less than £10. However, it's worth bearing in mind that some photographers have made a lot of money from these agencies and whole businesses have been created. Check the internet for the latest up-and-coming agencies who want to build up their stock.

Model Release

The value of an image increases greatly if you have a model or property release, because then it can be used for commercial rather than just editorial purposes. Commercial means for advertising and for selling a product, while editorial means newspapers, magazines and books in which the picture is simply showing the scene or the person for what it is. Commercial clients will pay much more money, but if the picture is made available as stock, you have no control over how the picture will be used. It could be used to sell anything, from car insurance to pregnancy testing kits. As a result, the client needs to know that the person in the picture, or whoever owns the building or thing being shown, has no objection to its use, and this is where a signed release form comes in. Stock agencies have such blank forms available on their sites for download to be printed. If you can persuade the person you photograph, for example, to sign the form, you then have the right to sell the picture for almost any use, and while you might feel embarrassed asking, in practice, many people will do so, especially if you give them something in return, which could be simply a print of the picture for their own use.

Quality and Content

Your first step is to be accepted by a stock agency as a supplier of images. There are so many millions of images taken that they are rigorous about what they accept. They want only images that will sell – and so should you – therefore they look for two things: technical acceptability and good content. Rejections are commonplace, but are always on commercial grounds, and if yours are rejected, instead of feeling disgruntled, think clearly and improve your submissions. Technically, images are typically rejected for the following reasons: over- and under-exposure, over-sharpening, dust and blemishes, fringing (chromatic aberration), over-processing, weird processing. Most clients (and therefore the agencies) want images that look like normal photographs, not paintings (so forget HDR tricks and strange filters).

As for content, remember that this is travel photography, which is only one part of the stock photography market (a market, incidentally, where professionals plan assignments with a shooting script and spend money to get it right, with professional models). A lot of the sights that you come across may not be so special to experienced picture buyers as you think. It's as well to be under no illusions about sudden selling success, for the principal reason that many of your fellow travellers have had and continue to have the same idea, so that the libraries are awash with imagery of popular sights.

There are three broad solutions. First, have better or more special images of a well-photographed site than anyone else. Not easy, because popular sites like the Grand Canyon or the Eiffel Tower have been photographed millions of times; nevertheless, there is still a demand for images simply because they are so popular, and what clients want is something different and original. Second, have images that are unique and interesting, which depends on your imagination in hunting out the special in travel; there are no formulae here, but possibilities include an amusing visual coincidence or event that has universal appeal; images that can be used to symbolise something abstract like safety, danger, happiness; or an extremely old person (meaning a centenarian). Third, target potential buyers. If you can see that a particular magazine is interested in particular topics or themes, contact them directly.

Selling Direct

Instead of sending your pictures into the morass of agency stock, you could target a particular publication. Plenty of newspapers and magazines run regular competitions and invitations for you to send in pictures with the chance of being published. Seeing your name in print may boost your confidence.

Many travel writers today are expected to take their own pictures, and most publications are more than happy to sacrifice quality for cost. Some travel articles and pictures, particularly on the net, are published without payment of any kind. But if you have a great set of pictures you should consider who might benefit from them. Travel guide publishers, such as Insight Guides, want to know who has good pictures, even if they are not immediately required. Who else would want to know, for example, that you have a wonderful set of pictures on Ghana? Is the country in the news? Could these be background pictures for stories about football or business?

Don't think about travel in its narrow sense: there are wildlife magazines, property magazines, lifestyle magazines. Carry out thorough research of current publications, at a large bookstall or through such annuals as the Writers and Artists Yearbook and The Freelance Photographer's Market Handbook. Think of other outlets, too: charities, newsletters, tour operators and tourist offices.

Prepare to explain, in a couple of sentences, why your pictures are special – and why the publication should want to run them. Call the publication and ask to speak with the picture editor. If you are unable to, ask to speak to somebody in the office, or get his or her email. Send two emails, the first explaining what you have to offer, and saying that lo-res images will follow. Then send the images. Four will suffice. If you send the images in the first email, they may well go directly into the trash. Follow up with a phone call the next day.

In summary...

- check out picture libraries for standard and terms
- what makes your material so special/unique?
- do you have model releases?
- do you have a story to tell?
- do your pictures have a special slant?
- is your destination in the news?

G LOSSARY

UNDERSTANDING THE TERMINOLOGY

8-bit refers to 8 bits per channel in an RGB image, with a total of 24 bits. Because most monitors are 8-bit, this is standard for viewing colour images. An 8-bit image can have over 15 million possible colours. See **bit-depth**, **RGB**.

16-bit refers to 16 bits per channel in an RGB image, with a total of 48 bits, giving more colours than the human eye can see, or that most monitors or printers can display. It is used, however, for processing images to avoid loss of quality. See **bit-depth**, **RGB**, **banding**.

32-bit refers to 32-bits per channel in an RGB image, with a total of 96 bits, and is standard for high dynamic range file formats. See **bit-depth**, **RGB**, **HDR**.

A

aerial perspective An impression of depth in a scene created by atmospheric haze, which makes the distance seem lighter, less saturated, and lower in contrast.

angle of view The angle that the lens includes of a view. Approximately 50 degrees is considered standard; much less than this is wide-angle, much more, telephoto. See **long-focus lens**, **telephoto lens**, **wide-angle lens**.

aliasing The unwanted jagged appearance of diagonal lines (jaggies) in a digital image caused by the square shape of pixels.

anti-aliasing The smoothing of jagged edges on diagonal lines

created in an imaging program, by giving middle values to pixels between the steps.

aperture The approximately circular opening inside a lens that can be enlarged or reduced to control the amount of light passing through. See *f* **number**/*f* **stop**.

aperture priority A camera metering system in which the photographer chooses the aperture and the shutter speed is adjusted accordingly. See also **program mode**, **shutter priority**.

application (also **program**) Software designed to make the computer perform a specific task. So, **image-editing** is an application.

artifact A visible error in a digital image unrelated to the subject of the photograph.

aspect ratio The ratio of height to width of an image. A full-frame DSLR, like 35mm film, has a 3:2 aspect ratio.

auto-focus Camera system that focuses the lens on a chosen point. Most use either contrast measurement or phase detection or both.

automatic exposure Camera system that measures the light about to fall on the sensor and adjusts the aperture, shutter speed, ISO sensitivity or a combination of these to give an exposure that aims for the least loss of information.

available light The already-existing artificial lighting in a night-time or

indoor scene, that is not specifically designed for photography. Tungsten, fluorescent and vapour discharge lighting are the main sources.

B

backlighting Lighting from behind the subject and towards the camera position.

backup A copy of a file made for safety reasons, in case the original becomes damaged or lost. Making regular, usually daily, backups is essential working practice in digital photography.

banding Digital imaging error in which a gradient, such as a blue sky shading from light to dark, shows distinct bands instead of being smooth. Making strong processing adjustments, especially in 8-bit, is one cause. See **16-bit**, **artifact**.

barrel distortion Lens defect in which straight lines close to and parallel to the edges appear bowed outwards. Very common in zoom lenses, but can be corrected during processing. Fish-eye lenses have extreme barrel distortion. See **pincushion distortion**, **fish-eye lens**.

bit Binary Digit. The basic on-or-off, zero-or-1, digital unit.

bit-depth The number of bits per pixel in an image, usually measured by channel for an RGB image. For example, a bit depth of 8 refers to 2 to the power of 8, which gives 256 steps – per channel. The higher the bit depth, the more colours can be

shown, and the more dynamic range can be captured (depending on the performance of the sensor). See **8-bit**, **16-bit**, **32-bit**.

black point The point on the scale of tones in a digital image that is set to pure black (0 on the scale 0-255). Accurately choosing the black point when processing helps give optimum image quality without losing shadow information. See **white point**.

blur Unsharpness in an image caused either by not focusing accurately or by movement of subject or camera that is too fast for the shutter speed. See **motion blur**.

bounced light Technique for softening shadows and broadening light by aiming a light at a white wall or ceiling, often used with an on-camera flash that can be tilted.

bracketing Shooting technique in which a sequence of different exposures is made without moving the camera. This is either to guarantee an accurate exposure in uncertain lighting, or to capture a high dynamic range for later processing. See **exposure blending**, **HDR**, **tonemapping**.

brightness The level of light intensity. One of the three dimensions of colour. See **hue** and **saturation**.

browser Imaging software that searches for and displays images in real time on a computer. See **database**.

C

calibration The process of adjusting a monitor so that it works consistently with others, such as scanners and printers.

camera profile A small digital file that records the way a particular camera captures colour and tone, and is then used during processing to adjust the image accordingly. Normally made by the user, photographing a colour target. See **colour target**.

CFL a fluorescent light bulb that has been compressed into the size of a standard-issue incandescent light bulb.

chromatic aberration Lens aberration in which different wavelengths of light are brought

to focus at slightly different points, causing both unsharpness and colour fringes. Very common, but can be corrected during processing. See **fringing**.

clipping Normally applied to highlights in a digital image, and meaning over-exposure that creates bright areas that are solid, featureless white. See **over-exposure**, **highlight**.

cloning In an image-editing program, replacing one area of an image with a copy of another area. Used extensively in retouching and removing unwanted elements.

close-up Generally, a close view of a small subject. Specifically, a reproduction ratio of between 1:10 and 1:1. See **reproduction ratio**, **macro lens**.

CMOS (Complementary Metal Oxide Semiconductor) Energy-efficient design of sensor used widely in better digital cameras.

CMYK (Cyan, Magenta, Yellow, Key [Black]) The four process colours used for printing.

colour cast An overall shift towards one obvious colour, which may be due to choosing the wrong white balance, but can be preferred in some cases, such as a rich sunset. See **white balance**.

colour depth See **bit-depth**.

colour target A carefully printed card with a range of standard colours and tones, used for calibration and for making camera profiles. The most widely used is the Macbeth ColorChecker. See **camera profile**.

colour temperature Technically, the temperature that makes things glow at certain colours (red, yellow, white, blue, etc). Practically, the measurement used in white balance (for example, 5000-5500 K is sunlight).

compact camera Small digital camera with fixed lens, for entry-level amateurs or for carrying unobtrusively.

CompactFlash One of the most widely used kinds of removable memory card in digital cameras.

compression Digital technique to reduce file size without losing

significant, or any, information. Commonly used in cameras to make better use of space on the memory card.

contrast The range of tones across an image from darkest to lightest.

copyright The rights granted in law to the person who creates an original work (in the case of photography an image). Copyright can be licensed, transferred or assigned.

cropping Reducing the image area by closing in one or more sides of the frame, in order to make a more effective composition.

cut-away in video, a shot taken at the same scene or location, though not necessarily of the same subject, that can be used during editing to add variety or cover up video mistakes while preserving the audio. Shooting around the subject is generally good technique.

D

database Software that collects, stores and then displays digital files, such as images. Differs from a browser in that it can function even when it no longer has access to the original image files. See **browser**.

dedicated flash On-camera flash that is designed to fit a specific camera, linked directly with the camera's internal circuitry for automated operation.

default The standard setting or action for just about anything, including settings on a camera or in processing software.

demosaicing The first step in in-camera processing of a digital image, in which the colour information is interpolated.

depth of field The distance between the closest and most distant parts of a subject that appear acceptably sharp in an image. The smaller the lens aperture, the greater the depth of field.

depth of focus The distance that the lens can be moved towards and away from the sensor and still give an acceptably sharp image. The smaller the aperture, the greater the depth of focus.

diffraction A form of lens aberration in which light rays are scattered by the sharp edge of the aperture, causing unsharpness. Particularly notable at small apertures, and one of the disadvantages of stopping down.

digital zoom A false zoom effect used in some digital cameras; information from the centre of the image is enlarged by interpolation. Real zoom is optical.

dissolve In video or slideshows, a transition between clips or frames in which one fades into the next over a fraction of a second to a few seconds.

download In digital photography, transferring a digital image from camera to computer or hard drive.

dpi (Dots Per Inch) A measure of resolution in printing. 300 dpi is the standard resolution at which to prepare a digital image for this. See **ppi, resolution.**

DSLR Digital Single-Lens Reflex camera

dynamic range The range of tones from dark to light, either in a scene, or that an imaging device like a camera or monitor can distinguish. The higher the dynamic range, the more of both shadows and highlights can be seen.

E

exposure The total amount of light allowed to fall on the photographic medium (photographic film or image sensor) during the process of taking a photograph.

exposure blending Software technique that produces a single image from several differently-exposed images, aiming to preserve highlights and shadows together. See **bracketing**.

exposure compensation Camera control that allows the photographer to override the automatic exposure by shifting the results brighter or darker.

exposure latitude The amount of over-exposure or under-exposure that a sensor can tolerate for an image and still produce an acceptable result.

exposure meter Device for measuring the amount of light falling on a subject or reflected from it. Most meters are built into cameras, but there are separate hand-held models.

eyeline In composition, the sense of direction imparted to an image because a subject is looking that way.

F

ƒ-number/ƒ-stop The unit for measuring the practical effect of a lens aperture. The lens focal length divided by its effective aperture. The series – ƒ2.8, ƒ4, ƒ5.6, ƒ8 and so on – is in steps of a factor of two, so that at each higher number, half the amount of light reaches the sensor.

fade See **dissolve**.

fast lens A lens that can gather more light than most, because of a wide maximum aperture (such as ƒ1.4).

file format The way in which a digital image is written and stored, Formats commonly used for photographs include **TIFF** and **JPEG** (the latter is also a means of compression). See **TIFF, JPEG, Raw.**

filename The text description of a digital file.

fill flash A deliberately reduced burst of electronic flash designed to light up shadows rather than completely change the lighting appearance of a scene.

filter An optical filter fits in front of the lens to add colour or tone to the image; a software filter in an image-editing program has a similar effect, but can be designed to do much more – basically it alters some quality of part or all of the image.

fish-eye lens Extreme wide-angle lens in which the curvilinear distortion is left uncorrected to give an angle of view that can be wider than 180 degrees. See **angle of view, barrel distortion**.

flare Non-image-forming light that degrades image quality. Caused by scattering and reflecting on the surface of a lens or inside, typically when a bright light shines directly into the lens, or when a large area of the view outside the image area is bright.

fluorescent light Artificial light in which electricity excites a sealed gas which in turn causes phosphors on the inside of the glass to glow. Lacking a full spectrum, it can be a problem for photography and may produce a weakly coloured result. See **CFL**.

focal length The distance between the rear nodal point of a lens and the focal plane (were the sensor is) when the lens is focused on infinity. The standard way of describing lenses according to their angle of view. See **angle of view, long-focus lens, standard lens, telephoto lens, wide-angle lens**.

focus blending Software process that combines a series of images of the same scene but each focused differently, in a way that favours the sharpest parts of each. The result can be an image that appears to have infinite depth of field.

fringing An error in an image, related to chromatic aberration, in which high-contrast edges acquire a colour border, often purple.

G

gamma A measure of the contrast of an image, expressed as the steepness of the characteristic curve.

GB See **gigabyte**.

gigabyte Approximately one billion bytes, or one thousand megabytes.

global correction Colour correction applied to the entire image.

golden section In composition, division of the image frame in which the ratio of the smaller part to the larger is the same as that of the larger to the whole. Generally thought to be aesthetically pleasing.

grayscale A sequential series of tones between black and white; also an image mode lacking colour information used in software processing.

H

halo A bright line around the edge of part of an image, often due to over-sharpening and excessive HDR tonemapping. See **HDR, sharpening, tonemapping**.

hard disk, hard drive A sealed unit composed of one or more magnetic disks used for data storage.

hardware The physical components of a camera, computer or other digital device, as opposed to software.

HDR (High Dynamic Range). A digital image format with 32 bits per channel, that is capable of recording all the tones in any scene, from darkest to brightest. Cameras cannot capture HDR in a single image, so the process involves combining several exposures into one. See **32-bit**, **dynamic range**, **tonemapping**.

high key Style of image made up of only light tones.

highlight The brightest part of a subject or image. See **clipping**.

histogram A map of the distribution of tones in an image, like a bar chart, from dark at the left (0) to bright at the right (maximum 255). The height at each point shows the number of pixels.

Hue The property of colors by which they can be perceived as ranging from red through yellow, green and blue, as determined by the dominant

hyperfocal distance The closest distance to the camera that looks sharp in the image when the lens is focused on infinity.

PREPARATION

I

image-editing program Software, such as Photoshop, for processing and manipulating digital images.

image compression See **compression**.

image stabiliser Lens or camera system using micro-motors and image feedback to make near-instantaneous compensation for small handheld movements. Makes sharp images possible at slower shutter speeds.

image stacking Software technique in which images that are framed identically but vary in some other way (such as small movements in the scene) are combined and can be processed all together. See **exposure blending**, **focus blending**, **median**.

incident light The light that falls *on* a subject, as opposed to the light reflected *by* it.

incident light reading Exposure measurement of incident light, usually made with a hand-held meter, that is independent of the brightness of the subject.

interpolation Software procedure in which missing data is estimated and filled in. Used, for example, in re-sizing images. See **demosaicing**.

ISO (International Organization for Standardization) Progressive rating of the sensitivity of a sensor or film to light. Doubling the number, as from ISO 200 to ISO 400, represents twice the sensitivity. The low default for most digital cameras is ISO 100 to 200, but high sensitivities can reach a few thousand.

J

jaggies See **aliasing**.

JPEG (Joint Photographic Experts Group) Pronounced 'jay-peg', a file format for compressing images in ways that are usually not noticeable to the eye). See **compression**, **file format**.

K

KB See kilobyte.

Kelvin (k) Unit used to measure the colour of light based on temperature. Red and yellow light has a lower kelvin than does white or blue. See **colour temperature**, **white balance**.

keyword In captioning an image, an entry that describes one important fact about the subject, which other people can use when making online searches.

key reading Exposure reading of what the photographer thinks is the most important part of the image.

kilobyte Approximately one thousand bytes.

L

layer One level of an image file, separate from the others but which can be combined with them.

lens speed The quantity of light that a lens can transmit from a scene to the film, usually expressed as its ƒ-number. See **fast lens**, **ƒ-number**.

local contrast The contrast range found in small areas of an image.

long-focus lens Lens with a focal length longer than that considered to

give normal perspective. In practice, for a DSLR, longer than 50mm. See **telephoto lens**.

low key Style of image which is overall dark in tone.

LZW (Lempel-Ziv-Welch) A lossless method of compression used for TIFFs. See **compression**, **TIFF**.

M

macro lens Lens designed to give the best image quality at magnifications close to life-size.

matrix metering TTL metering system in which the exposure is measured from different areas of the image, then compared with a library of different types of image already analysed.

MB See megabyte.

median In imaging, a kind of average that selects the most common element. Used in median filters on a stack of images to, for instance, remove automatically people moving about in a scene. See **image stacking**.

megabyte Approximately one million bytes.

megapixel One million pixels, a measure of sensor size.

memory card A small solid-state removable storage device that fits in a slot in the camera and onto which the images shot are stored. See **CompactFlash**, **SmartMedia**, **Memory Stick**.

MemoryStick One kind of removable memory card, used in Sony digital cameras.

mid-tone The areas of an image that are approximately average in tone, midway between the highlights and shadows, equivalent to a reflectance of 18%.

modelling In lighting, the effect that shows volume and form by shading.

model release A permission form allowing the photographer to make full commercial use of an image of a person.

motion blur Streaking blur caused by movement of subject or camera too fast for the shutter speed. See **blur**.

multi-pattern metering See **matrix metering**.

multi-shot Shooting technique in which several images of the same scene are taken, varying one quality, such as exposure or focus, so that they can all then be specially processed together. See **focus blending**, **exposure blending**, **HDR**, **image stacking**, **tonemapping**.

N

nodal point One of two points in a lens at which light rays entering converge (the front nodal point) and light rays leaving diverge (rear nodal point). Practically, the optical 'centre' of the lens.

noise Random pattern of small spots on a digital image caused by non image-forming electrical signals. An artifact. See **artifact**, **ISO**.

O

over-exposure More light than the sensor can cope with to form an acceptable image, causing lost highlights. See **clipping**, **exposure**, **highlight**.

P

panning Swinging the camera to keep a moving subject centred in the frame.

panorama A wide view, elongated frame, often used for landscapes.

pincushion distortion Lens defect in which the shape of the image in which straight lines close to and parallel to the edges appear bowed inwards. Very common in zoom lenses, but can be corrected during processing. See **barrel distortion**.

pixel (PIcture ELement) The smallest unit of a digital image, usually square, each one reocorded by one photosite on a sensor.

pixel depth See **bit depth**.

polarisation Reducing the normally random vibration of light waves to a single plane.

polarising filter Filter that polarises light entering the lens, often used to reduce reflections and darken blue skies.

post-processing Digital adjustments to an image with software that follow the normal processing procedure. See **image editing program**.

ppi (Pixels Per Inch) A measure of resolution for a digital image. See **dpi**.

processor A silicon chip that functions as a small computer, designed for performing specific functions in a digital camera or computer.

program mode One of several ways in which an automatic camera can be set to operate by the photographer so that different priorities can be selected. See **aperture priority** and **shutter priority**.

property release A permission form allowing the photographer to make full commercial use of an image of a building or other piece of property owned by someone else.

Q

QuickTime A multimedia framework developed by Apple for displaying video and interactive displays.

R

RAID (Redundant Array of Independent Disks) A stack of hard disks that function as one, but with greater capacity and with built-in safety functions against data loss.

RAM (Random Access Memory) The working memory of a computer.

Raw proprietary film format unique to each camera manufacturer in which all the captured image information is retained. Normal in-camera processing is not applied.

rear-curtain flash A DSLR camera's flash synchronisation system in which the flash is triggered at the end of the exposure. In this way, a time exposure from existing light is added to a sharp flash capture of movement.

reflected light reading Exposure measurement of the light reflected from a subject – the normal method of camera exposure systems.

reproduction ratio The relative proportions of a subject and image. If the image were twice the size of the subject, the ratio would be 2:1.

reproduction rights The licensing of copyright in an image for a specific use. See **copyright**.

resolution The level of detail in an image, measured in pixels (e.g. 640x480 pixels or 300 dpi).

RGB (Red, Green, Blue) The primary colours used in digital cameras and in monitors.

rule of thirds A compositional rule of thumb that recommends dividing the image frame into nine equal sections and making major divisions into thirds.

S

saturation The purity of a colour.

scanner Device for making a digital image from film.

sharpness The subjective impression of resolution and detail in an image.

sharpening Software process in an image-editing program for creating the impression of sharpness, by increasing edge contrast. See **image-editing program**.

shutter priority A camera metering system in which the photographer chooses the aperture and the shutter speed is adjusted accordingly. See also **program mode**, **aperture priority**.

sidecar file Small digital file that records such things as the processing steps, so that they can be reproduced. See **image-editing program.**

single-lens reflex (SLR) Camera design in which the lens that exposes the image can also be used for viewing.

SmartMedia One of the most widely used kinds of removable memory card in digital cameras.

software Program that allows a computer to perform tasks such as image-editing.

standard lens Lens with a focal length that produces an image with a perspective similar to that of the unaided eye. For full-frame cameras, 50mm is usually considered to be the standard lens. See **angle of view**, **focal length**, **long-focus lens**, **telephoto lens**, **wide-angle lens**.

stitching Software process that assembles a series of overlapping digital images of the same scene and adjusts them to produce a single, smoothly integrated image. See **panorama**.

stock photography Photography offered, usually online, for paid use.

stopping down Reducing the size of the aperture of a lens.

symmetry In composition, the equal distribution of points, lines or shapes around a centre or central division in an image.

T

TB See **terabyte**.

telephoto lens Design of long-focus lens that allows the lens to be more compact. See **long-focus lens**.

terabyte One million megabytes. See **megabyte**.

thumbnail Miniature on-screen display of an image.

TIFF (Tagged Image File Format) A file format for digital images that supports CMYK, RGB, and grayscale files with alpha channels, and the most widely used standard for high-resolution digital photographic images.

time exposure Although imprecise, a shutter speed much longer than would capture sharply normal subject movement, and so approximately longer than a few seconds. The effects on the image depend on what is moving, but flowing water, for example, appears more like mist.

tone curve On a graph that plots input brightness against output brightness, the curve starts as a 45 degree line. In image-editing software, altering the shape of this curve affects the brightness and contrast of the overall image. An S-shape, for example, increases contrast.

tonemapping A software procedure in which local contrast is adjusted, used particularly in making 32-bit HDR images viewable in 8-bit. There are many versions. See **32-bit**, **local contrast**, **HDR**, **tonemapping**.

transition In video and slideshows, the style of moving from one clip or image to the next. See **dissolve**, **wipe**.

tungsten light Artificial light created by heating a filament of tungsten wire electrically until it glows. Once the normal indoor illumination, it is gradually being phased out in the West in favour of CFL. See **CFL**.

U

unsharp mask A sharpening technique achieved by combining a slightly blurred negative version of an image with its original positive.

under-exposure Giving an emulsion less light than is needed to form an acceptable image. In a transparency, or in a print from a negative, the result is lower contrast, dark tones, lost detail in the shadows and muddy highlights.

upload In photography, sending an image file online to a server.

USB Universal Serial Bus) The most common interface and port between cameras, computers and other digital devices for transferring digital images and other files.

UV filter A physical filter placed in front of the lens that absorbs ultraviolet (UV) light, useful in landscape photography, particularly in mountains, for cutting through haze, reducing blue casts and enhancing saturation. See **colour cast**, **filter**, **saturation**.

V

voice-over In video, a voice audio track independent of the scene, usually recorded later.

W

wide-angle lens Lens with an angle of view wider than that of a **standard lens** for the format.

white balance Adjustment of overall colour to neutralise the appearance, made in-camera or during processing, on the principle that the bright highlights are neutral in colour.

white point The point on the scale of tones in a digital image that is set to pure white (255 on the scale 0-255). Accurately choosing the white point when processing helps give optimum image quality without losing highlight information. See **black point**, **clipping**.

Widescreen An image aspect ratio more elongated than the standard 4:3 and 3:2, increasingly becoming standardised as 16:9 in line with High Definition Television.

wipe In video and slideshows, a transition from one clip or image to the next in which the new pushes the old to one side. See **dissolve**, **transition**.

workflow An organised and planned sequence of digital photography from shooting to final processing.

Z

zoom lens Lens with a continuously variable focal length over a certain range. Wide-angle zooms and telephoto zooms are the two main groups.

FURTHER READING

General

Magnum Magnum by Brigitte Lardinois, Thames and Hudson (2009)
The World's Top Photographers: Photojournalism by Andy Steel, Rotovision (2009)
Our World Now by Reuters, Thames and Hudson (2010)
The Great LIFE Photographers by John Loengard, Thames and Hudson (2009)
Through the Lens: National Geographic's Greatest Photographs, National Gegraphic Societey (2009)
National Geographic: The Photographs, National Geographic Society (2008)
Work: The World in Photographs by Leah Bendavid-Val, National Geographic Society (2008)
The Family of Man by Edward Steichen, Museum of Modern Art New York (1996)

History

The Photograph: A Visual and Cultural History (Oxford History of Art) by Graham Clarke, Oxford Paperbacks (1997)
Photography: A Cultural History by Mary Warner Marien, Laurence King (2010)
Masters of Photography: A Complete Guide to the Greatest Artists of the Photographic Age by Reuel Golden, Carlton Books Ltd. (2008)
50 Photographers You Should Know by Peter Stepan, Prestel (2008)
Memories of a Lost World: Travels Through the Magic Lantern by Charlotte Fiell, Fiell Publishing Ltd. (2010)
The Genius of Photography by Gerry Badger, Quadrille Publishing (2007)

A Century of Colour Photography by Pame Roberts, Andre Deutsch Ltd (2008)

Photographers

Henri Cartier-Bresson (New Horizons), Thames and Hudson (2008)
Ansel Adams' 400 Photographs, Little, Brown & Company (2007)
Don McCullin by Susan Sontag, Jonathan Cape Ltd (2003)
Southern Frontiers: A Journey Across the Roman Empire by Don McCullin, Jonathan Cape Ltd (2010)
Margaret Bourke-White: The Early Work, 1922-1930, David R Godine, Publishers Inc (2007)
Wilfred Thesiger: A Life in Pictures, by Alexander Maitland and Wilfred Thesiger, HarperCollins (2004)
Felice Beato: A Photographer on the Eastern Road, Anne Lacoste and Fred Richtin, J. Paul Getty Museum (2010)
All the Mighty World: The Photographs of Roger Fenton 1852–1860 by G Baldwin, Yale University Press (2004)
The Wonderful World of Albert Kahn: Colour Photographs from a Lost Age by David Okuefuna, BBC Books (2008)
Carleton Watkins in Yosemite by Weston Naef, J. Paul Getty Museum (2009)

Portraits

Portraits by Steve McCurry, Phaidon Press Ltd. (1999)
Looking East: Portraits by Steve McCurry, Phaidon Press Ltd. (2006)
In the Shadow of the Mountains by Steve McCurry, Phaidon Press Ltd. (2009)
The World's Top Photographers: Portraits by Fergus Greer, Rotovision (2004)
In Focus: "National Geographic" Greatest Portraits, National Geographic Society (2004)

Landscape

The World's Top Photographers: Landscape by Terry Hope, Rotovision (2005)
Yosemite, Ansel Adams, Little, Brown & Company (1995)
Ansel Adams: Landscapes of the American West, Quercus Publishing Plc (2008)
Visions of Paradise, National Geographic Society (2008)

Wildlife

The World's Top Photographers: Wildlife by Terry Hope, Rotovision (2004)
Spirit of the Wild by Steve Bloom, Thames and Hudson (2008)
Eye to Eye by Frans Lanting, Taschen (2009)
Wildlife Photographer of the Year by Rosamund Kidman Cox, BBC Books (annual)

Handbooks

The Photographer's Eye by Michael Freeman, UK Ilex Press, US Focal Press (2007).
Michael Freeman's 101 Top Digital Photography Tips, UK Ilex Press, US Focal Press (2008)
Photographer's Market, Writer's Digest Books (annual)
Digital Landscape Photography: In the Footsteps of Ansel Adams and the Great Masters by Michael Frye, Ilex (2010)
Digital SLR Expert: Landscapes by Tom Mackie, David & Charles Ltd (2008)
Transient Light by Ian Cameron, Photographer's Institute Press (2009)
Practical HDR by David Nightingale, Ilex (2009)

ART AND PHOTO CREDITS

INDEX